MW00812546

Contemporary Art
Underground

Contemporary Art Underground

MTA Arts & Design New York

Sandra Bloodworth
Cheryl Hageman

Preface by
Janno Lieber

Foreword by
Hilarie M. Sheets

Contents

Page 2: Firelei Báez, *Ciguapa Antellana, me llamo sueño de la madrugada (who more sci-fi than us)*, 2018, NYCT 163rd Street-Amsterdam Avenue Station. Photo: Osheen Harruthoonyan.

Opposite: Derrick Adams, *Around the Way*, 2019, LIRR Nostrand Avenue Station. Photo: Emil Horowitz.

PREFACE

Janno Lieber

Chair and CEO of the Metropolitan
Transportation Authority

As MTA Chair and CEO, I look forward to the public response
to each installation of new artwork in the transit system.
They always bring joy and sense of place to neighborhood
residents and commuters—perhaps none more so in recent
years than the mosaics by Yayoi Kusama and Kiki Smith at
LIRR's new Grand Central Madison terminal.

These works remind us of the power transit has to bring
people together. Our system is where millions of New Yorkers
and tourists alike commingle daily and prove out the world's
greatest experiment in tolerance and diversity. The pro-
grams of MTA Arts & Design—the visual art, the music, and
the poetry—all contribute to the richness of the experience
customers get when they use our system.

From the beginning, the intention has been to signal
respect for riders. Every selection is considered through the
lens of equity and diversity, with the artists and their cre-
ations intended to speak to those who live and work in the
vibrant and varied communities we serve. Anyone who scoffs
that the arts are exclusively for elites need only look to the
subway and rail network to see the program's positive impact.
The arts are for everyone, and I look forward to admiring
everything still to come through MTA Arts & Design.

Alex Katz,
Metropolitan Faces,
2019, NYCT 57th
Street Station.
Photo: Etienne
Frossard.

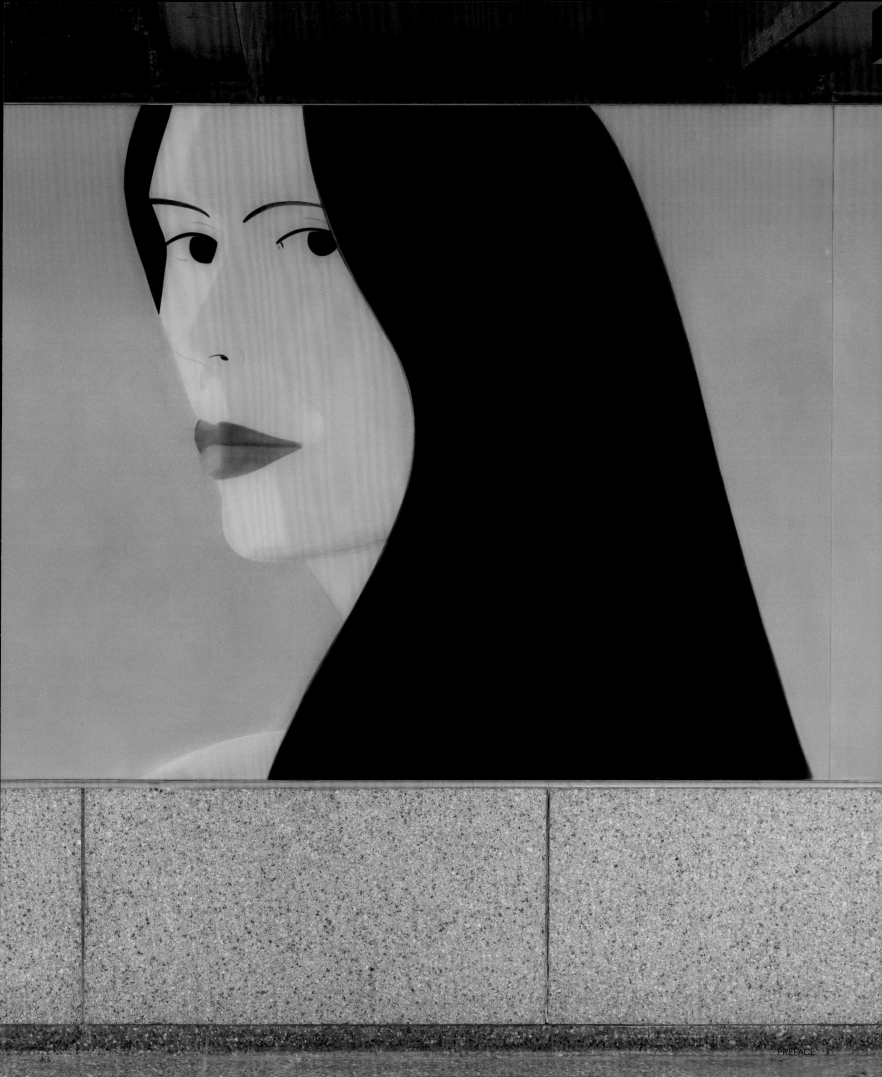

FOREWORD

Hilarie M. Sheets

The much-heralded opening of New York's Second Avenue Subway in 2017, with high-profile artworks by Sarah Sze, Chuck Close, Vik Muniz, and Jean Shin integrated throughout the four new stations, focused public attention on the kind of commissions that MTA Arts & Design had been doing steadily since it began in 1985. With the completion of several other mega construction projects—most recently the 2023 opening of Grand Central Madison with dazzling artworks by Yayoi Kusama and Kiki Smith—MTA Arts & Design has given New Yorkers more reason to cheer.

While people still love to complain about their commutes, the MTA's groundbreaking art program has led the way in changing perspectives and elevating the experience. Their site-specific projects by a broad spectrum of well-known and emerging contemporary artists—nearly 400 installations to date—have helped to create a sense of character and place at subway and commuter rail stations throughout the MTA. The unexpected—or daily—encounters with artworks become cinematic frames in the personal journey of millions of people traversing the system every day. With 68 percent of the projects by artists of color and women, the MTA's permanent collection comes closer to reflecting the diversity of its audience than the holdings of most museums—now widely striving to improve their numbers of underrepresented artists.

The MTA's ever-growing public art collection is joined by ambitious permanent artworks at other recently built transportation facilities unveiled since 2020, including LaGuardia Airport's Terminal B and Terminal C, Newark Liberty International Airport's Terminal A, and the Moynihan Train Hall. Not since the WPA era in the 1930s has the city seen such a confluence of new infrastructure projects employing contemporary artists as a key element.

On the heels of the popularity of the permanent artworks at Moynihan Train Hall, produced in collaboration with Public Art Fund, a program of rotating art installations for the train hall and for Penn Station, was launched in 2022. Art at Amtrak

curator Debra Simon cites MTA Arts & Design as inspirational. Simon has tapped artists including Saya Woolfalk and Karen Margolis for temporary projects, confident in their ability to scale up to public space from their earlier works for the MTA.

In 1979 Boston pioneered the first art in transit program in the United States, overseen by Pallas Lombardi and the Cambridge Arts Council. Sandra Bloodworth, director of MTA Arts & Design, is quick to recognize Boston as an important early model for the New York program. Originally called Arts for Transit, this effort was launched as part of the MTA's overall rehabilitation three years after New York City passed Percent for Art legislation in 1982 requiring art be part of capital building projects.

MTA Arts & Design, in turn, has been a major influence on other cities building commissioning programs for public art within their transit systems. "New York has been a real leader in exploring and pushing the boundaries of tried-and-true materials," says Maya Emsden, executive officer of Metro Art in Los Angeles. After New York, Los Angeles has the largest program nationwide, with more than 140 artists commissioned for permanent integrated artworks in LA Metro's 100-plus stations, followed by robust and growing programs in places including Chicago, Charlotte, Houston, and San Francisco.

In the 1990s, MTA Arts & Design began selecting artists who work in two-dimensional mediums—painting, drawing, printmaking, collage, photography—to translate their ideas into mosaics, opening up the range beyond those working three-dimensionally who had typically made public art. Bloodworth thinks Elizabeth Murray's 1996 mosaic project for Lexington Avenue and 59th Street was pivotal in attracting other well-established painters to agree to adapt their work in durable materials for the transit environment.

In the decades since, MTA commissions have helped expand the roster of artists now working regularly in the

Diana Al-Hadid, *The Arc of Gradiva,* 2018, NYCT 34th Street-Penn Station. Photo: Peter J. Kaiser.

public sphere. Firelei Báez's first public art project, a mosaic completed in 2018 at the 163rd Street/Amsterdam Avenue station, led directly to her monumental commission in the same medium unveiled at the Buffalo AKG Art Museum in 2023. Eamon Ore-Giron's 2019 mosaic at the Bay Parkway Station in Brooklyn precipitated his permanent installation completed in 2023 for UT Landmarks in Austin and a commission in progress for LA Metro's Wilshire station.

Derrick Adams has come to devote a large part of his practice to temporary public projects, including works for Art at Amtrak, Rockefeller Center, and Art on the MART in Chicago, since completing his eighty-five glass panels throughout the LIRR Nostrand Avenue Station. "Working on public projects helps strengthen my flexibility muscle and informs what I'm doing in the studio," says Adams, who found the process of navigating the MTA's myriad constraints to be generative.

Many of the best artists working today are embracing the constellation of opportunities to bring their work outside museums and galleries—whether to transportation hubs or to New York's green spaces like Madison Square Park or the High Line, both with flourishing public art programs developed over the last fifteen to twenty years.

"You get a virtuous cycle of all of these initiatives reinforcing each other and helping to define New York City as a place of creativity and innovation and cultural progressiveness," says Nicholas Baume, artistic and executive director of Public Art Fund, which regularly sites temporary projects in Central Park, City Hall Park, and Brooklyn Bridge Park. "We have this recognition now that public art makes places more livable, more interesting, but also can really reflect the values of who we are."

Public Art Fund President Susan K. Freedman believes the MTA's transformed stations have become "celebrated civic spaces." As she notes, "Having art in transit contexts, where a huge section of the public is experiencing it, is an entry point that is fundamental. It distinguishes the city and makes citizens feel a sense of pride and excitement."

INTRODUCTION

New York's Underground Art World

A collection of artworks rivaling some of the most prestigious contemporary art museums in the world lives deep beneath the streets of New York City. More than 400 permanent artworks have been commissioned by the Metropolitan Transportation Authority (MTA) over the past four decades. MTA Arts & Design, founded as Arts for Transit in 1985, brings art to the public and makes New York's transportation system more inviting by giving each station a unique identity. By 2014, 267 artworks from emerging and established artists had been installed in the subway and rail stations. Elizabeth Murray, Roy Lichtenstein, Sol LeWitt, Jacob Lawrence, Romare Bearden, and Nancy Spero were only a few of the artists with global name recognition commissioned during the program's first thirty years.

Contemporary Art Underground features the more than one hundred artworks completed by Arts & Design between 2015 and 2023. This book offers a behind-the-scenes look at how these works were conceived, fabricated, and installed, depicting the way this process evolves in mosaic, glass, and metal and detailing how art in subway and rail stations becomes part of the place. Artists such as Nick Cave, Jeffrey Gibson, Saya Woolfalk, Alex Katz, and Yoko Ono are just a few of those whose work is now part of the New York public transit experience.

Aesthetic considerations have been part of the subway experience from the very beginning. When the Interborough Rapid Transit Company (IRT) became the first operator of New York's underground rapid transit system in 1904, the system was a wholistic work of art adorned with now-priceless terra-cotta and mosaics by some of the finest arts and crafts terra-cotta manufacturers of the day, including Grueby Faience Company, Rookwood of Cincinnati, and Atlantic Terra Cotta Company. This great civic work, designed by architects Heins & LaFarge, lived up to its mandate that stations "be designed and constructed, and maintained with a view to the beauty of their appearance, as well as to their efficiency."

By the 1980s, the consolidated subway system had fallen into a now-legendary state of disrepair. Billions of dollars would need to be invested to save the system and attract riders. The push for improvements encompassed service, infrastructure, and safety. In the background, Percent for Art legislation was slowly being adopted by governments across the nation. In 1982 New York City joined this movement to incorporate art in municipal capital improvement projects, such as schools, libraries, and courthouses. A few years later, the MTA followed suit. As stations were rehabilitated, art was introduced as part of the strategic framework for regeneration.

The extensive efforts to bring the transit system into the twenty-first century have resulted in a remarkable collection that has been called "New York's Underground Art Museum." The city's original subway stations are now more than 120 years old. As subway and rail stations have been built and

Opposite: Detail of Maureen McQuillan, *Crystal Blue Persuasion,* 2018, NYCT 36th Avenue Station. Photo: Etienne Frossard

Below: Terra-cotta plaque depicting Robert Fulton's steamship, *The Clermont,* NYCT Fulton Street Station. Photo: Andrew Garn

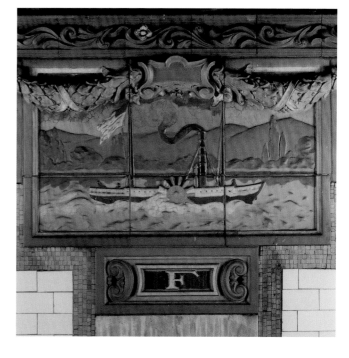

Artist Darryl Westly (left) at the fabrication studio. Courtesy of Glasmalerei Peters Studios.

restored over the years, the collection has continued to expand with the installation of thoughtful and surprising works of art that bring delight to the transit system. These artworks are not just subterranean or in elevated New York City Transit territory; they can also be found within the Long Island Rail Road and Metro-North Railroad stations. Collectively, the years 2015 to 2023 brought unprecedented changes in this network of subway and rail stations. Five new stations and a new terminal were built. Several dozen stations were renewed. In one community, four MTA bridges over rail lines were replaced, with artwork as a major design feature.

The MTA system serves one of the most diverse places on earth. From its earliest days, MTA Arts & Design has focused on the relationship between artists and communities. While female-identifying and BIPOC artists remain underrepresented in most major museum collections, they currently make up 47 and 37 percent of the artists in the Arts & Design collection respectively. Diversity among the artists commissioned stems from a selection process that has always valued gender and racial equity and draws from an inclusive pool of candidates mindful of the community being served.

Each commission is initiated by a selection panel made up of arts professionals with ties to the community and agency representation. Elected officials and community representatives are invited to attend to serve in an advisory

capacity and fully participate in the process. The selection panel meets twice, first to develop a shortlist of finalists and then to review the proposals and to award the commission. Criteria include artistic excellence as seen in the professional portfolios, and connection to the community is an important consideration. Arts & Design does not present a theme to the artists, as the vision of the artwork for the project should be through the eyes of the artist. The direction given is to create artwork that will speak to the people who use the station and live in the surrounding community. This is the only direction, as the goal is for the creativity of the artist to flow, to create an environment where the artist's vision comes though, proposing a concept that is fresh, unique, thoughtful, and mindful of those for whom they are creating art. The artist selection panel is directed to select artwork that they believe will enhance the station and create a meaningful experience for those who travel through.

Arts & Design has led the way in commissioning artists who had little or no public art experience. Nearly thirty years ago, Arts & Design began to look at its public art practice differently. At the time, public art was being made almost exclusively by artists, mostly sculptors, dedicated to the field. Aside from outdoor mural projects, painters and other two-dimensional artists had been largely excluded from consideration for public commissions, which significantly limited the pool of artists. Arts & Design saw the potential

for two-dimensional artwork of any medium to be translated by mosaic artisans into something permanent and in doing so, revived the mosaic industry. This shift in approach simultaneously opened the doors for many artists and strengthened the quality of work being produced. In later decades, the same thinking was applied to various types of glass for elevated stations. With an administrative team of arts professionals that understands how the translation process works with fabricators, artists were able to create public artworks without prior experience with the medium.

Selecting the artist is the first step, one of many. From selection the artists are contracted to develop their proposals while selecting a fabricator to interpret their work. The Arts & Design team works in tandem with the artist and fabricator to ensure that the result is a faithful interpretation of the artwork. Durability has always been a requirement for art installations in a public environment, especially in a location as challenging as the New York transportation system. Even today, mosaic, glass, and metal continue to be the most durable materials widely available. These materials are elevated to an artform through the hands of experienced art fabricators who work closely with the artists. While the artist conceives the work and brings their vision to the place of installation, the fabricator is a critical collaborator in the process.

Elizabeth Murray, *Stream,* 2001, NYCT Court Square-23rd Street Station. Photo: Rob Wilson.

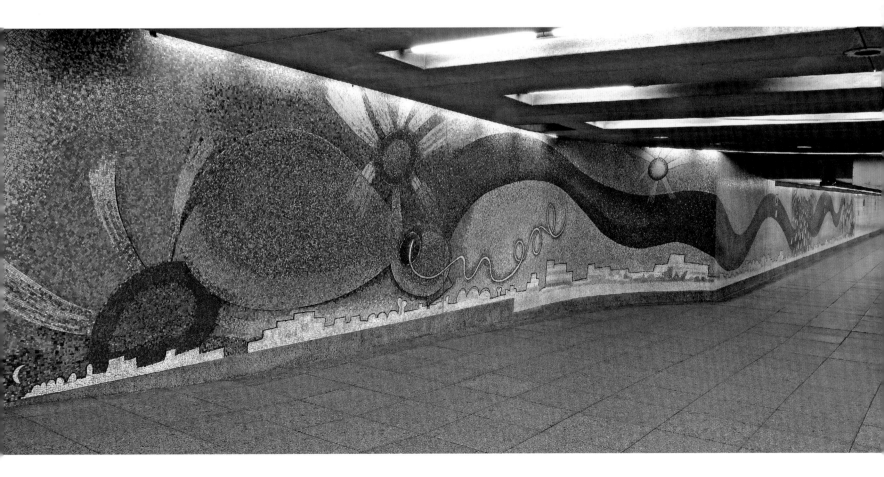

Arts collaboration is not limited to artists, fabricators, and arts administrators. Integrating artwork into the transit environment requires the support of architects and design professionals. New stations and terminals, like 34th Street-Hudson Yards and Grand Central Madison, offer a rare opportunity to define the space in a way that allows the artist's vision to soar; placing art in a station that has been there for a hundred years or more poses a different challenge. In both scenarios, there is a thoughtful exchange that must occur between Arts & Design and the design team envisioning the space.

In 2016 a short-lived but impactful program was adopted to develop a new design vision for subway and rail stations. Charged with modernizing the look and feel of an aging system, the initiative introduced new materials and technology, increased transparency to create safer spaces, improved wayfinding, and brought significant opportunities for art. More than thirty projects included here were born out of this effort.

Monika Bravo,
Duration, 2017,
NYCT Prospect
Avenue Station.
Photo: Peter Peirce.

Public art has matured and is now mainstream. Gone are the days of the genre being labeled "plop art." Once an anomaly, public art is now a given, expected by all. Thanks to the implementation of Percent for Art legislation, there are now more than 350 active programs in the United States, and public art has become the standard for many types of government projects. Much of this is because of the success of public art programs like the "Underground Art Museum" administered by MTA Arts & Design.

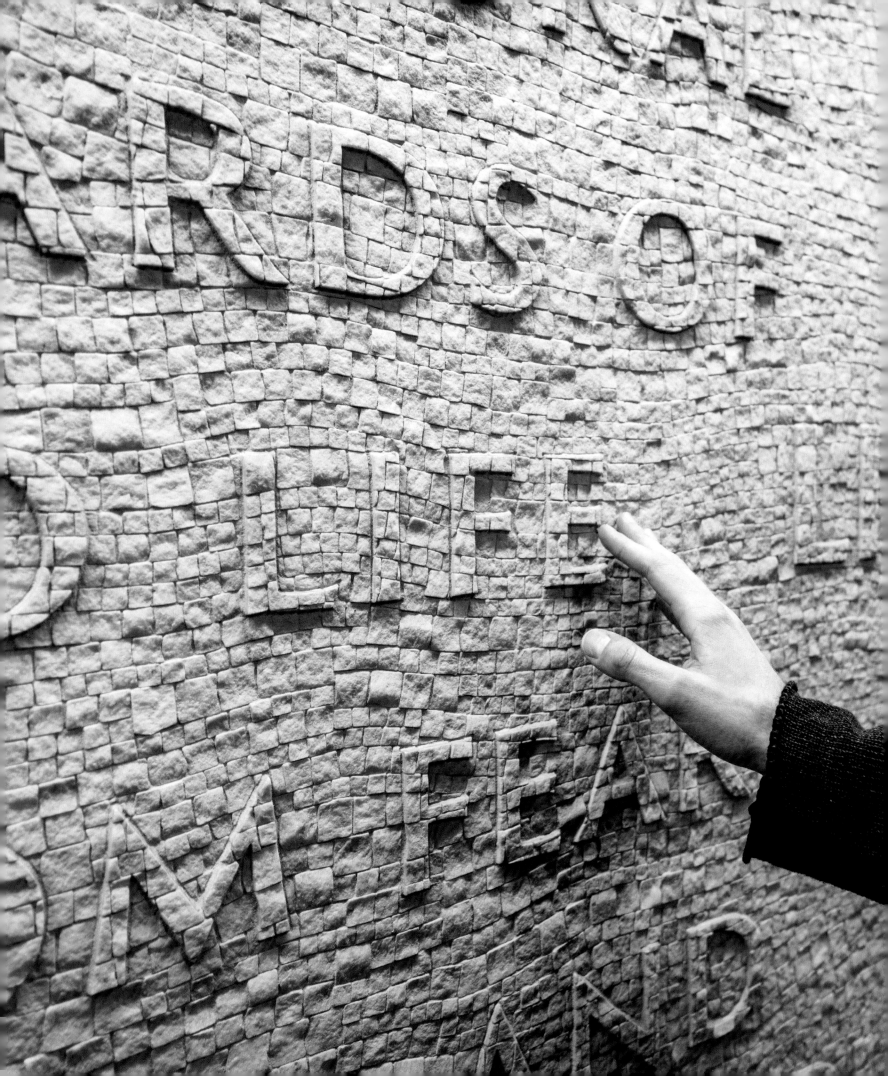

WTC Cortlandt

Located below the World Trade Center on the 1 line, Cortlandt Street Station (as it was named at the time) was all but destroyed on September 11, 2001. The structural steel beams crumpled, and the roof of the station collapsed, buried under the debris of the fallen towers. Amid uncertainty about clearing the site just steps from Ground Zero, now hallowed ground, discussions arose about permanently closing the station. The priority for the site redevelopment was respect for the footprint of the towers and planning for a new World Trade Center complex. However, without more viable options for the PATH train and the subway stations, the MTA and the Port Authority decided to keep the original locations for both stations, using the 1918 design drawings for that section of the 1 line tunnel, with the station remaining part of the World Trade Center site. Rightfully, the Memorial took precedence, along with site redevelopment and its utility work. The subway station was the last component to be rebuilt. 1 line service resumed on September 15, 2002, but the station did not reopen until September 8, 2018, seventeen years after the original station was destroyed and almost one hundred years after it opened.

Between 2002 and 2015, there were various agreements between the MTA and the Port Authority regarding the scope and costs of the rebuilding of the subway station. In 2014 the MTA took over the rebuilding of the 1 line station, and MTA Arts & Design began the process of selecting an artist to develop public artwork for the site. Few MTA artist selection processes have been more emotionally charged. The challenge and responsibility to choose an artist for the devasted station were daunting, given its unique location and place in history.

A panel of arts and design professionals was assembled, including those who knew the site well and were familiar with the planning and commissioning of the 9/11 Memorial. The criteria for selection were clear to the panelists; the station required an artist with extensive experience in the public realm. A pool of highly experienced artists was evaluated on the basis of their past work, and from that group, four artists were selected to submit site-specific proposals. Finalist Ann Hamilton's proposal was deemed the strongest in its reference of the site, its sensitive connection to the architecture, and its consideration of commuters who use the station. The panel described her proposal as "mesmerizing and powerful, bringing a calming quality to a charged place." Noting that her proposal acknowledged the tragic history of the site in balance with the core ideals that animate our aspirations for civil life, the panel awarded to Hamilton the commission for artwork at the station that would be renamed WTC Cortlandt.

Detail of Ann Hamilton, *CHORUS,* 2018, WTC Cortlandt Station.
Photo: Jessica Naples-Grilli and Kara Gut.

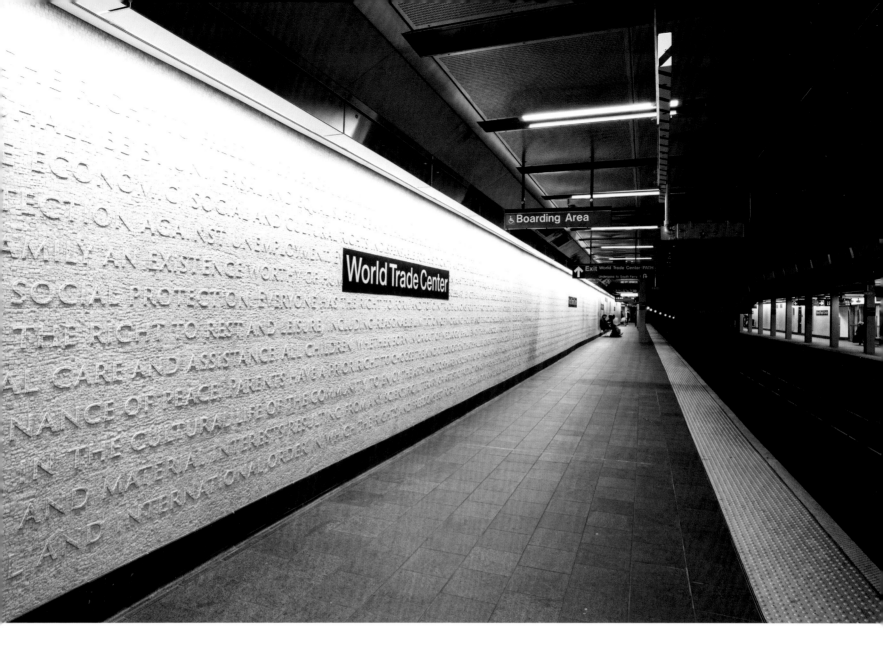

CHORUS. Photo: Thibault Jeanson.

ANN HAMILTON
CHORUS, 2018
WTC Cortlandt ❶

Known for her poetic vocabulary in immersive environments, Ann Hamilton is internationally acclaimed for her ability to respond to a site's architecture and social history. In 2012 Hamilton's *the event of a thread* was presented at the Park Avenue Armory, a cultural venue in Manhattan that focuses on unconventional artworks that incorporate the soaring spaces that are its hallmark. In its vast space, Hamilton's ephemeral, multi-sensory, spatial experience referenced the architecture of the building and its history of congregational gatherings. In an interview with Art 21, Hamilton described the installation: "*the event of a thread* is made of many crossings of the near at hand and the far away: it is a body crossing space, is a writer's hand crossing a sheet of paper, is a voice crossing a room in a

paper bag, is a reader crossing with a page and with another reader, is listening crossing with speaking, is an inscription crossing a transmission," and adding, "It is very intimate and yet large and anonymous, so this kind of quality of solitude and being in a congregation or group of people . . . I think the feeling of that is very comforting."

Hamilton's proposal for WTC Cortlandt drew upon her background in textiles. She created a mosaic weaving in marble using words from the preamble to the 1776 Declaration of Independence and the 1948 United Nations Declaration of Human Rights as its warp and weft. The interweaving of the words in these national and international documents fills the platform walls to form a continuous field.

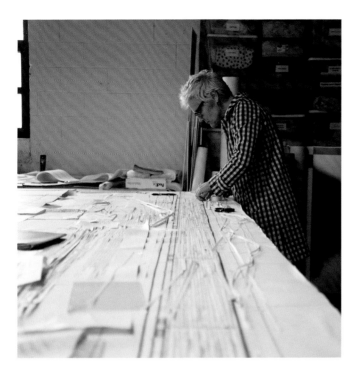

Ann Hamilton creating a working design for *CHORUS* at her studio. Photo: Jessica Naples-Grilli and Kara Gut.

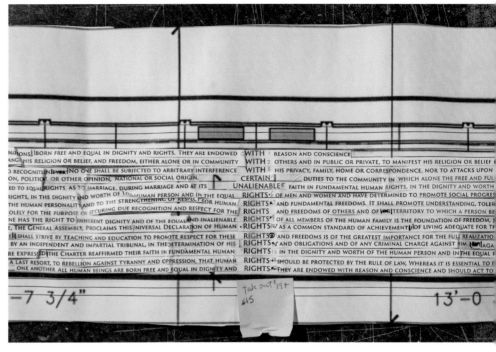

Detail of a working design for *CHORUS*. Photo: Jessica Naples-Grilli and Kara Gut.

The words emerge to draw the attention of each passerby from, in turn, another composition, a refrain, a song stitched step by step along the platform's length. The title, *CHORUS*, expresses this musicality and refers to a choir whose song is carried by the unison of individual vocalists—in much the same way the integrity of cloth is held together by the work of every individual thread. In Hamilton's words: "The legal foundation of contemporary civic institutions recognizes and protects rights crafted in a belief in the covenant of words and their possibility to remind us of where we are and to imagine and enact a future we can't yet touch. These underground intersections and crossings of texts and people are the social, legal, and institutional pillars that underlay cultural life above ground." In *CHORUS,* Hamilton's unique ability to create an intimate and engaging experience in a public space is on full view. She creates a profound experience that is both meditative and affirming, reminding us of the highest aspirations of the human spirit.

The challenges of rebuilding were enormous. With many opportunities for the art to become politicized and to sort through and understand the potential political challenges of installing *CHORUS* at this revered site, Hamilton presented her vision to the chairman and the executive team from MTA and New York City Transit as a way to build consensus. The proposal was wholeheartedly embraced by all the attendees. One executive who had been at the site immediately following the attack voiced his full support,

Concept design for *CHORUS*. Courtesy of the artist.

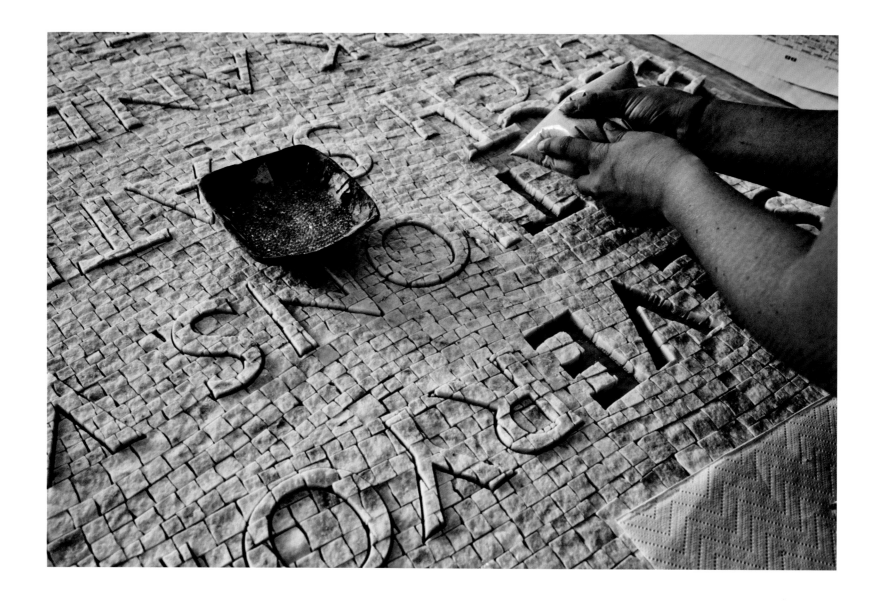

CHORUS in fabrication at Mayer of Munich's studio. Photo: Markus Jans.

promising to do whatever it took to bring Hamilton's vision to fruition.

This positive first step in consensus-building and all the steps that followed were met with the same response: "What can we do to help?" In meetings with stakeholders, Hamilton's proposal was embraced by Community Board 1, the 9/11 Memorial & Museum, and all community leaders who saw it, so the project moved quickly to the next phase of design approval and fabrication.

Persuading multiple designers, architects, and engineers to agree to trust the vision of an artist in decisions that are commonly theirs is almost unimaginable. Yet it happened. Repeatedly, the answer was "yes." Hamilton refers to it as a "chorus of yeses." It was a testament to the power of art to tell our shared story and the strong emotions that came from our shared experience.

Hamilton's original proposal represented the text with embossed paper and demonstrated her desire for the text to be raised to bring tactility to the words. The words

in CHORUS beckon our hands to touch, to trace their outline, and in this reflexive response the abstraction of the language becomes an embodied immediacy magnifying the words and the intensity of their meaning in this historic and emotionally charged place.

Hamilton not only selected historic documents in her address to this site, but she also worked with graphic designer and artist Hans Cogne, to select and set the font for the text. They chose Trajan Sans Bold, a modern font that evolved from the classical letters on the panel at the base of Trajan's Column in Rome, which commemorates a ruler known not only as a soldier–emperor but also as a benevolent philanthropic leader of social welfare policies. They worked together to determine the size of the letters: small enough to relate to the hand but large enough to be read from across the platform, and the letter and word spacing to emphasize the vertical spines that structure the composition.

The artist envisioned the project be made in a material associated with public memorials. Hamilton chose to

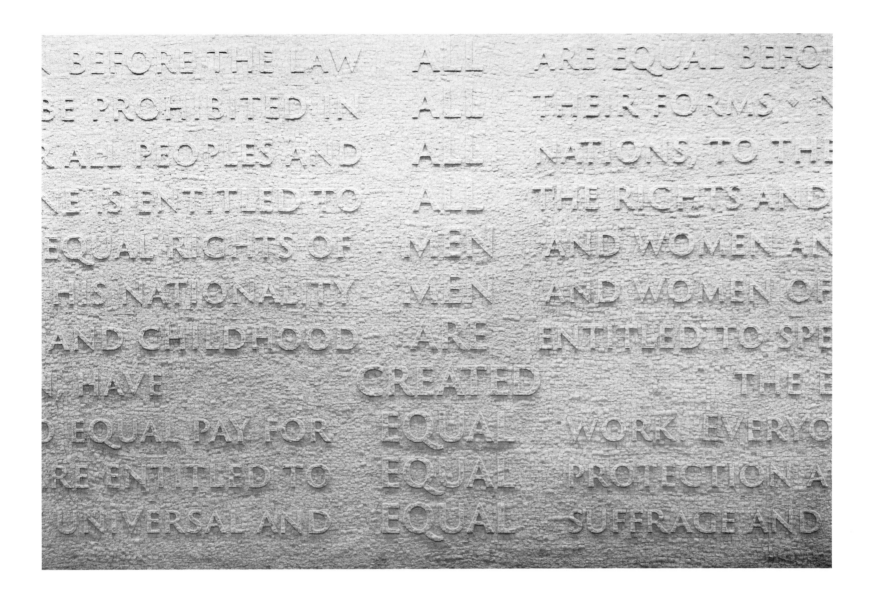

Detail of *CHORUS*.
Photo: Peter Serling.

collaborate with the fabricator Mayer of Munich to construct this work in a mosaic field of white marble. Together they conceptualized the method of taking the letters out of the field.

Mayer's innovative translation honors the subtle appearance of the embossed letters in Hamilton's original proposal. The fabricator began by constructing a flat field of white marble mosaic, laying one stone after another by hand to establish the organic rhythm of the background. The ground was then divided into irregular puzzle-shaped sections for transport, initially to the water-jet cutters and then later for transport to New York. Each letter was water-jet cut from the mosaic ground and then set back into place resting upon two millimeter glass pearls. The modest lift creates a drop shadow across the lines of text. Achieved through a technically complex process, this measure of low relief provides a tactile quality and ultimately makes the words legible up close and across the platform.

While the work is intended to be read, *CHORUS* is also designed to be touched. This aspect of the work offers another level of engagement, inherently connected with memorials and monuments. As people walk by, they reach out and trace the words with their fingers, both mindful of the words and the intensity of their meaning, which is magnified in this historic place.

The installation of the field of text in raised marble mosaic was the most challenging mosaic installation in Arts & Design's history. With nearly 600 linear feet of mosaic whose every line must be level, nothing could be left to chance. The installation took three months to complete. The marble mosaic text on the white-on-white tactile surface is fully integrated into the station architecture, with the balance of the wall finishes in Calcutta Lincoln, the domestic white marble named for its use in the Lincoln Memorial.

Ann Hamilton speaks of the way viewers encounter the work: "As you walk along the platform, reading at the pace and rhythm of your footsteps, your eye will naturally alight on or pick out, words or phrases that strike you, and when you

return to the station, you'll see them again. They'll repeat for you like a refrain." The structure of the work is in the alignment of the documents in a concordance and is based on the intersection of a keyword in one document within the body of another. On the southbound platform, the composition is vertically organized by seven spines of repeating words from the preamble to the Declaration of Independence.

"all men are created equal"
"we hold these truths"
"that all men are created equal"
"with certain inalienable rights"
"these are life liberty and the pursuit of happiness"
"to secure these rights"
"is the right of the people"

The occurrence of these words in the Universal Declaration composes the horizontal lines. Hence the word "equal" in the vertical list intersects in the horizontal with these lines:

"the right to **equal** pay for equal work"
"all are entitled to **equal** protection against any discrimination"
"genuine elections which shall be by universal and **equal** suffrage and shall be held"

While a concordance typically organizes a text in a non-narrative way, it is important to note that a concordance is also an agreement, a harmony, and in Hamilton's project, this speaks to the possibility and hope of working together to achieve the aspirations in these foundational documents.

In September 2018, the rebuilt WTC Cortlandt Station was received with the equivalent of a *Hallelujah Chorus.* Artists have the extraordinary ability to use their vision and creative process to create deeply meaningful civic places. With *CHORUS*, Ann Hamilton created a place that speaks to our highest ideals. At the pace of walking, the woven text of her tactile walls moves us through the station, acknowledging its historic significance and embracing the rights embodied in universally shared declarations.

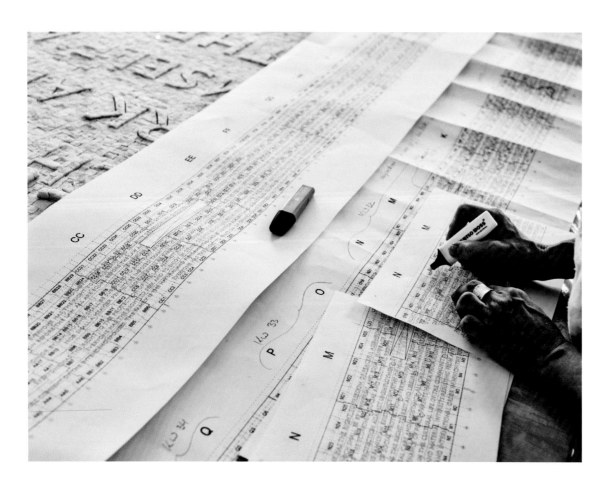

Mayer of Munich's installation guide mapping the mosaic panels. Photo: Markus Jans.

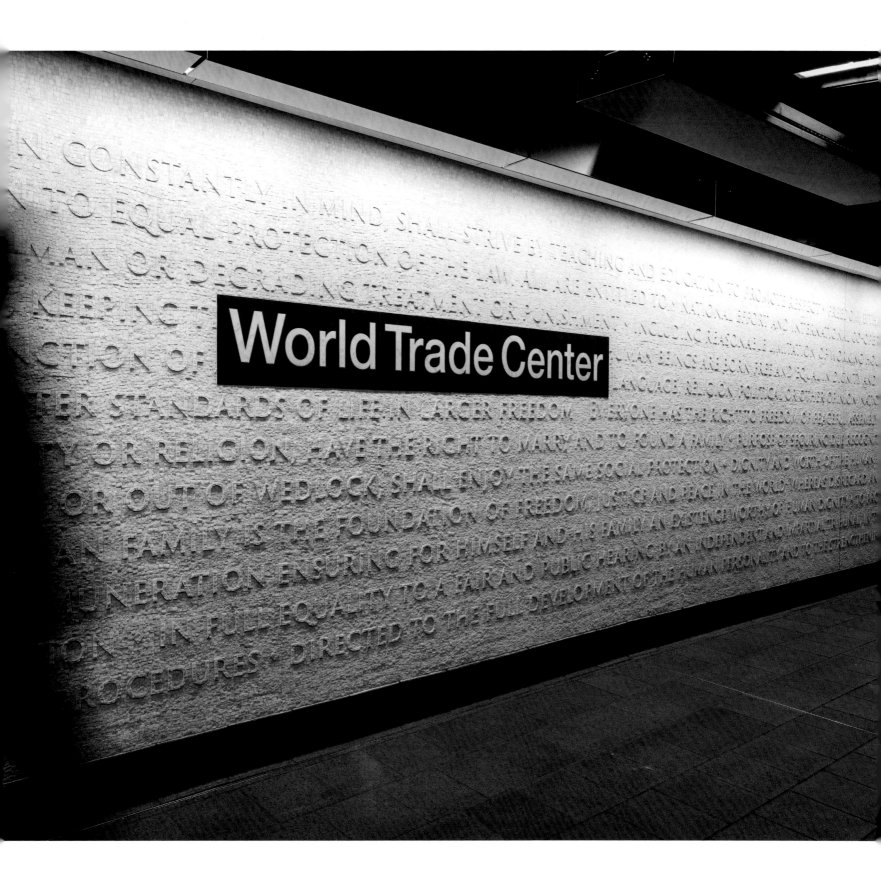

CHORUS. Photo:
Jessica Naples-Grilli
and Kara Gut.

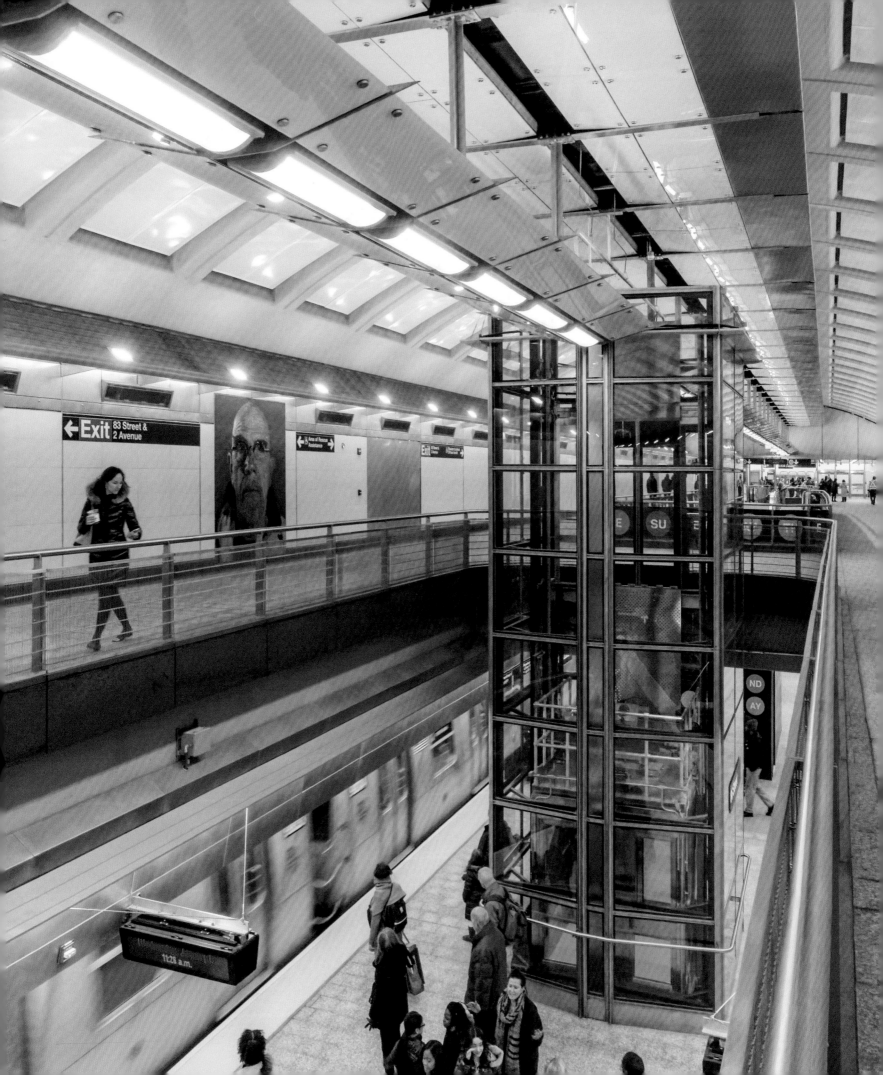

Second Avenue Subway

Nearly one hundred years after the "Second Avenue Line" project was first proposed, Second Avenue Subway service began on January 1, 2017. When the doors opened to considerable fanfare, it was already widely known that the opportunity to create artwork for these high-profile projects had been given to Jean Shin, Vik Muniz, Chuck Close, and Sarah Sze. The commissions were awarded years earlier, following outreach to approximately 2,500 artists and art organizations and a multi-year selection process. The artworks were officially announced at a press event at the Museum of Modern Art on December 19, 2016, the same day the *New York Times* ran a feature story on the projects in the Art and Design section. At the opening, *New York* magazine hailed the Second Avenue Subway as "a world-class art museum."

Few New Yorkers can recall riding the Second Avenue El, seven-and-one-half miles of elevated service from Lower Manhattan to Harlem that operated from 1880 into the 1940s or the Third Avenue El that ran until the 1950s. Many do remember the decades of over-crowding that followed their removal while the IRT Lexington Avenue Line was the only train serving the Upper East Side and East Midtown. Even after the Second Avenue Subway construction became highly publicized, the idea that it would ever be completed felt to some like urban legend.

While the skeptics doubted, others planned. DMJM Harris (now AECOM) designed stations with high ceilings, bright, column-free spaces, and long sightlines for better visibility. The largest and longest extension of the subway system in decades was built with an overall budget of $4.45 billion. MTA Arts & Design had the rare opportunity to work with design professionals envisioning an entirely new space. Art location and medium, the key factors in architectural integration, were carefully considered. The team knew the impact of the art would be significant.

Mezzanine and platform levels of the 86th Street Station. Photo: Jeff Goldberg/Esto.

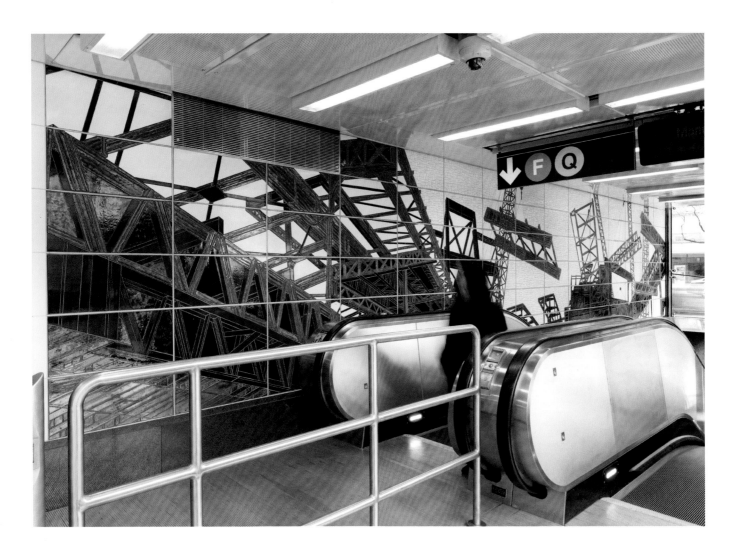

Left: Artwork at the street-level entrance to the Lexington Avenue/ 63rd Street Station. Photo: Etienne Frossard.

JEAN SHIN
Elevated, 2017
Lexington Avenue/63rd Street Ⓕ Ⓠ

Jean Shin proposed an artwork structured around an experience. *Elevated* is a name-defying journey, designed to be experienced as riders move from street level down to the platform. Known for site-specific installations made from discarded material such as plastic bottles, lottery tickets, and umbrellas, here Shin collected and repurposed stories and images rather than objects. She researched collections and photograph archives at the New York Transit Museum, the New-York Historical Society, and the Museum of the City of New York. Her completed work is a re-imagining of a period in New York City transit history that lives just beyond the collective memory of today's riders: the longtime presence and transformative removal of the Second and Third Avenue elevated tracks.

The artist explained, "When I was looking at the Elevated, I was struck by how the Second Avenue Subway Station is going to seem like a new intervention into that neighborhood, but in fact, it's an old idea that has ebbed and flowed. And

before there was the subway station, there was the elevated, and I really wanted to bring those conversations together. As contemporary commuters go into the subway, they would have an understanding of what was present before and what's absent now as they experience the new station."

Elevated is installed on four levels of the station. Each section uses a different medium and fabricator. The material variations—ceramic tile, glass mosaic, and laminated glass—help to emphasize the artist's intent for each composition.

At the street level entrance, the interior walls are wrapped with ceramic tile fabricated in Greene County, New York, by master ceramicist Frank Giorgini. Low-relief images of robust reddish-brown steel beams and flat gray silhouettes of construction cranes rise and fall against a white background. Riders descending on the escalator are briefly immersed in the dismantling of the massive structures.

During her research, Shin found an interview in which a rider remarked that they would miss moving among the

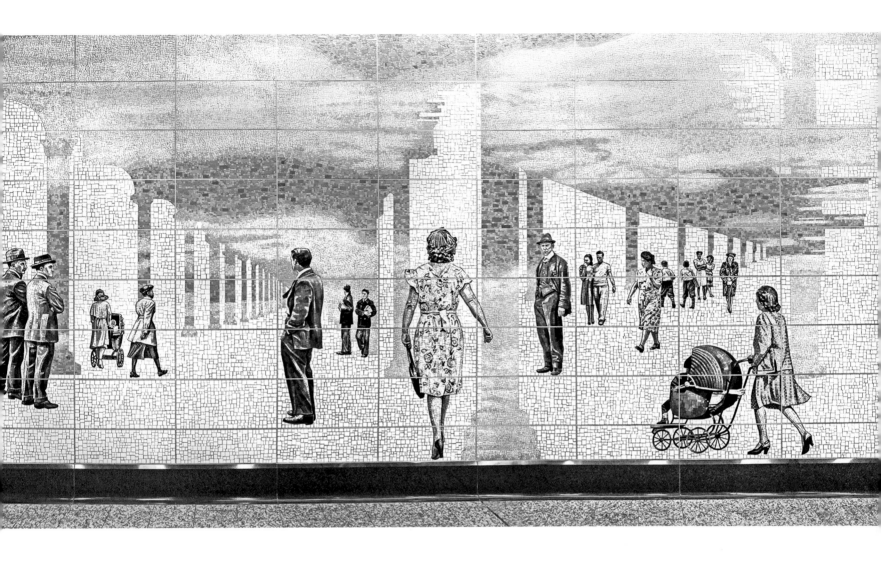

Above: Artwork on mezzanine level. Photo: Rob Wilson.

Right: Artwork near elevator on Brooklyn-bound platform. Photo: Etienne Frossard.

clouds. The comment inspired the mural on the mezzanine level, a scene fabricated by Miotto Mosaic Art Studios in glass mosaic. Dozens of people stand below a picturesque blue sky revealed in the shape of the elevated structure that had previously obstructed the view. Anonymous figures found in archival photographs have been assembled to witness this moment of transformation. The black-and-white figures, presumably elevated riders, and Second Avenue subway riders exchange glances like fellow commuters.

Shin notes, "I love the fact that it's a subway station and people are seeing the work every day, so they're going to get pieces of the story, and over time, they might pick up on another moment and another detail, so the story really unfolds over a lifetime. For many of the people, their subway really is the place that they identify with every day."

At both platform levels, semi-transparent mirrored-glass panels separate the elevator area and the train tunnel. Shin used a compilation of archival photographs for this location as well. Fabricated by Tom Patti Design, the fifty-five glass panels capture the cityscape using historic photographs taken from the elevated platform. The artist has extracted the tracks to note its absence. The reflective quality allows riders to see themselves within the golden light of these vintage scenes.

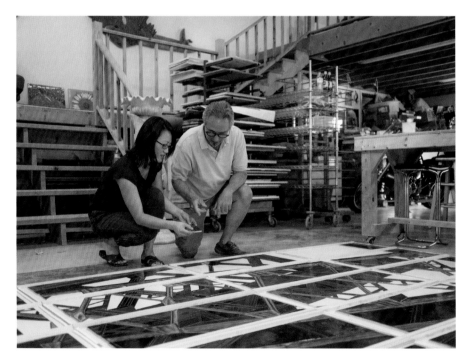

Above: Jean Shin with Frank Giorgini at his studio. Photo: Lester Burg

Top: Proposal for *Elevated.* Courtesy of the artist.

VIK MUNIZ

Perfect Strangers, 2017
72nd Street Ⓠ

Known primarily for photography and his use of unconventional materials to recreate famous works of art, Vik Muniz developed his proposal as another playful twist on the familiar. *Perfect Strangers* is an homage to the everyday people seen on the subway and streets of New York. Life-sized mosaic figures celebrate the city in depictions that read like a snapshot of New York. Muniz staged family, friends, and acquaintances, dressed up and posed to represent the more than three dozen "characters" that appear in the mosaic installation. In his proposal, the Brazilian-born artist commented, "People come to New York to see the attractions, but one of the city's main attractions is its people: diverse, absurdly casual and original."

The artist explains his process, "When picking the characters . . . I wanted them to be very mundane, people who you expect to see in the train station, but with a little bit of an element of surprise." Many carry books, bags, and tools of their trade. Some check their phone or glance at their watch. A woman holds her high heels; nearby another juggles a child and stroller. The characters are dressed for variety of activities. Some bear gifts of flowers and balloons. The items alone are insignificant, but the details combine to illustrate a moment in time.

Muniz's wife and children are included, as are gallerists, professional associates, and acquaintances such as his landlord, his accountant, and a local barista. Many have adopted humorous personas for the project. The artist shows himself comically spilling his briefcase. A uniformed police officer, a construction worker, and a nurse are just a few of the occupations represented. Jazz saxophonist George Braith is portrayed with his custom sax. French chef and restaurateur Daniel Boulud and Sikh actor and designer Waris Ahluwalia, both friends of the artist, stand in as themselves. The artist

Mezzanine and platform levels of the 72nd Street Station. Photo: Jeff Goldberg/Esto.

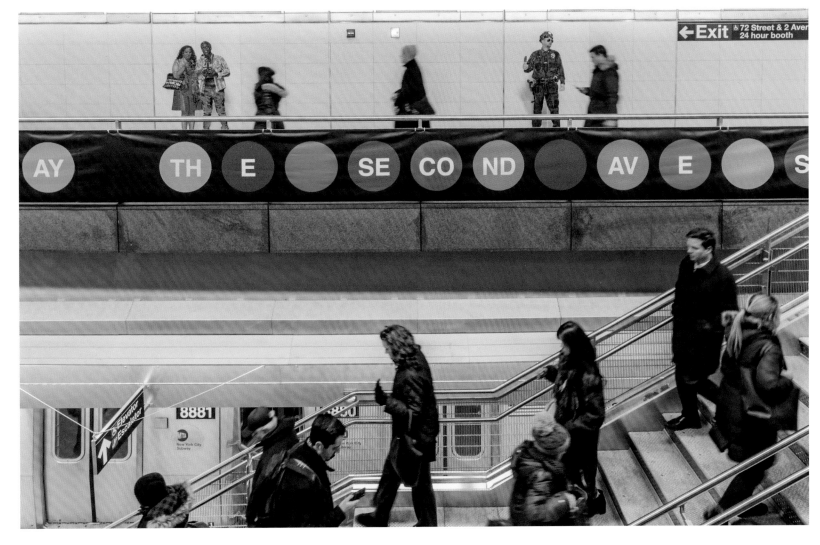

JR is shown near the 72nd Street entrance. Even the recognizable individuals have an air of familiarity about them. As Muniz notes, "I wanted them to be normal people. I know lots of normal people. I kept thinking: Who would make the perfect stranger?"

While the work is intended to be light-hearted, the power of representation is meaningful. The inclusion of a gay couple holding hands was recognized as a first for non-political, permanent art in New York City. The cultural diversity shown is equally significant. Queens-resident Sumana Harihareswara had tears of joy when she saw the mosaic of a woman of South Asian descent dressed in a sari. As she explained to a reporter covering the opening day festivities, "I don't think I've ever come across subway art before that makes me feel so seen. This woman could be my aunt, she could be my cousin.

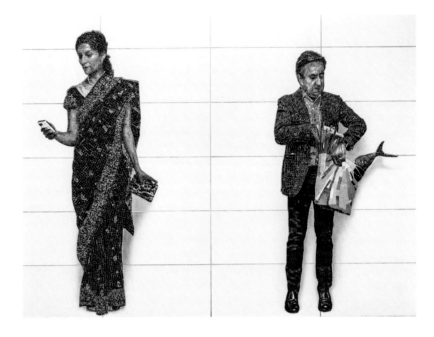

Opposite: *Perfect Strangers* during fabrication at Mayer of Munich's studio. Photo: Sammy Hart.

Above, right, and below: Details of *Perfect Strangers*. Photos: Patrick J. Cashin; Jeff Goldberg/Esto (below).

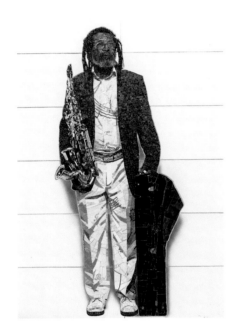

Details of *Perfect Strangers*. Photos: Patrick J. Cashin.

Representation matters. There is no feeling quite like seeing yourself cemented into the infrastructure of New York. It lets me know that my city loves me."

The installation stretches the three-block length of the station, appearing throughout the mezzanine, in entrance areas, and at street level. Fabricated by Mayer of Munich, the mosaics blend realism of the faces, hands, and select details with an abstract interpretation of the clothing. More than three dozen figurative insets are placed within water-jet-cut openings in the station wall tiles. Painted shadows add to the illusionary effect. Mayer also fabricated the laminated-glass component, featuring a well-dressed man with a bouquet installed near the street-level elevators.

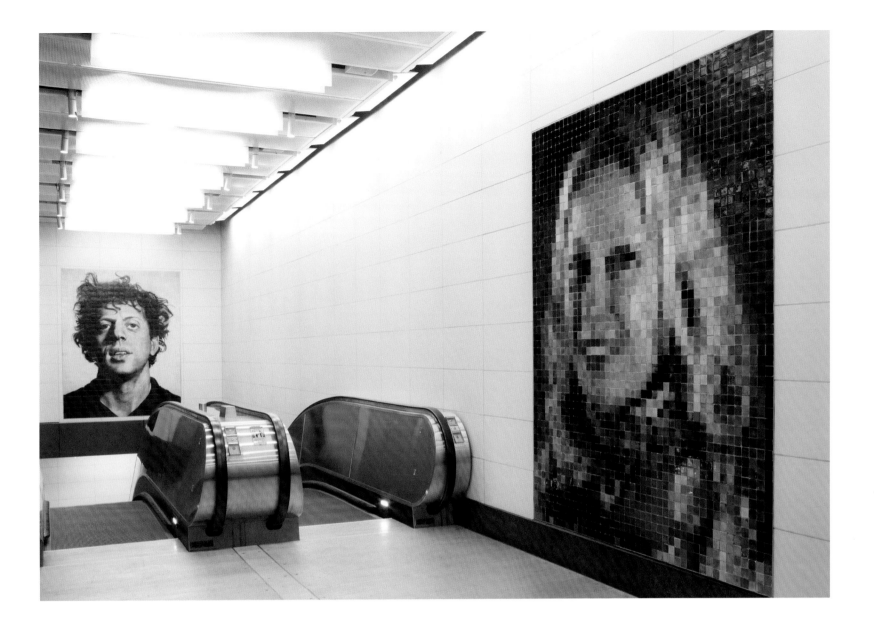

CHUCK CLOSE

Subway Portraits, 2017
86th Street Ⓠ

Portraits of *Phillip Glass* (left) and *Cindy Sherman* (right) from *Subway Portraits*. Photo: Nafis Azad.

At the 86th Street Station, Chuck Close chose to include family members, friends, and fellow artists in his project collectively known as *Subway Portraits*. Many of the sitters are recognizable figures such as Kara Walker, Alex Katz, Cindy Sherman, Lou Reed, and Philip Glass, but the selections were carefully designed to reflect the diversity of individuals using the subway. The twelve large-scale portraits feature several of the artist's best-known techniques rendered in glass and ceramic mosaic and stoneware tile, reflecting the artist's multiple reinventions of his style of portraiture.

Close was proud to have his work on view for all in the subway. He felt the images might mean more in that democratic setting, independent from the art world. After some initial apprehension about the works being realized in the new materials, he came to understand the language of the mosaic medium and appreciate that it would ensure the artworks survive for future generations, remarking, "I think it's a leap of faith on both of our parts [working with mosaic fabricators]. You know, they've got to see if they can figure out what I'm trying to do, and I'm going to hand it over to them, and I'm going to have limited feedback until the thing is essentially done and on the wall."

Two self-portraits and eight additional works were fabricated by Mosaika Art & Design. Magnolia Editions made the two ceramic tile portraits. Translating Close's artwork into these permanent durable mediums required a painstak-

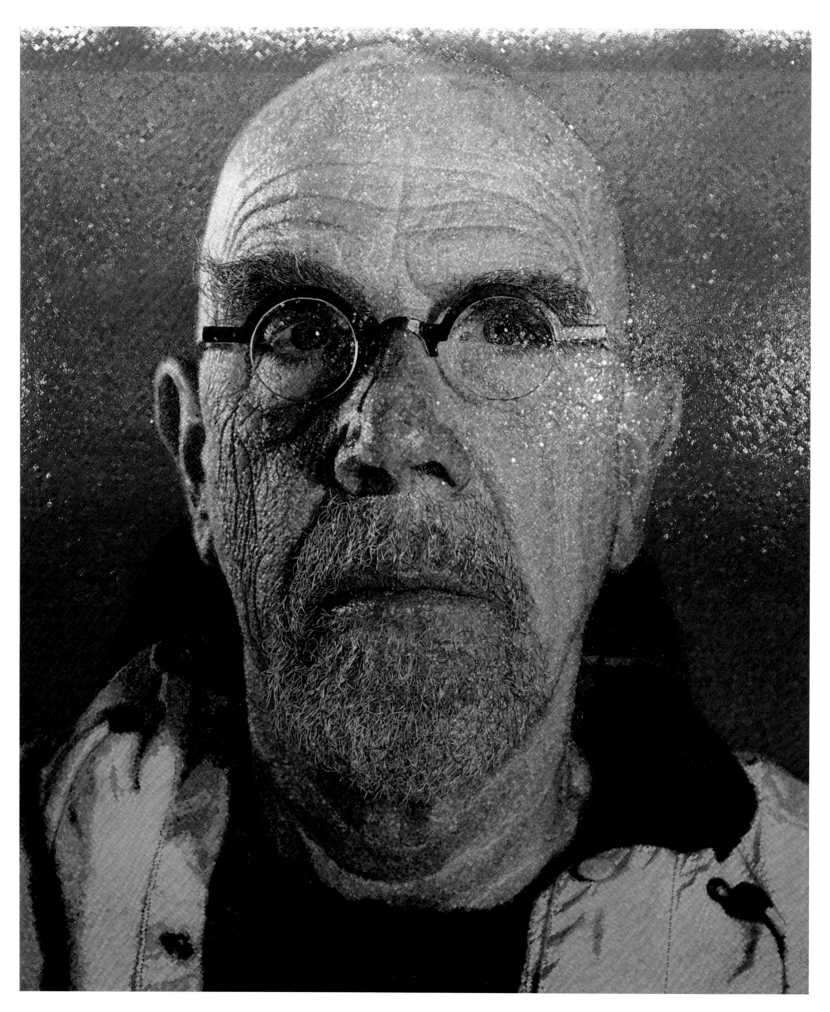

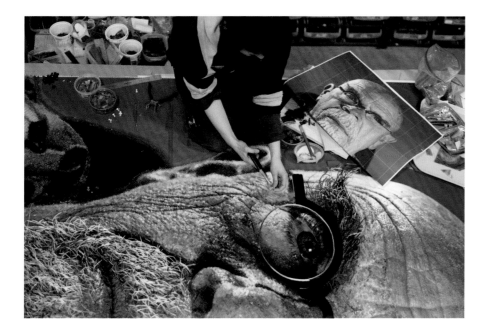

ing analysis and precise color matching. Mosaika recalls an intense collaborative process, first decoding the color theory that Close spent fifty years perfecting and then mastering the translation of hundreds of colors and textures into specific glass or glazes used to replicate the shades and hues. The success of these mosaics lies in the innovative contemporary arrangements of the mosaic pieces, and the precise application of Close's color theory. Matching the smalti color was not enough. Particularly in the swirl paintings, the fabricator found that if one color was off, the optical blending effect collapsed. There were numerous re-glazings and reworkings that occurred as Mosaika developed the varied ceramic and glass techniques used to interpret the works.

Portraits of Kara Walker and Cecily Brown face one another on the mezzanine. The originals were created in a print series that Close dubbed "felt stamp." In these portraits, the mosaic translation was done with Byzantine glass smalti, hand cut into tiny wedge pieces, tumbled to a matte finish, and assembled in small concentric rings, using approximately 900 pieces of glass per square foot.

At opposite ends of the station, portraits of Cindy Sherman and Zhang Huan appear rendered in hand-glazed porcelain tile. Grids are of the utmost importance in Close's

Opposite: *Self-Portrait (Yellow Raincoat)* from *Subway Portraits*. Photo: Osheen Harruthoonyan.

Above: *Self-Portrait (Yellow Raincoat)* during fabrication at Mosaika Art & Design. Photo: Osheen Harruthoonyan.

Below: Detail of *Alex Katz* from *Subway Portraits*. Photo: Osheen Harruthoonyan.

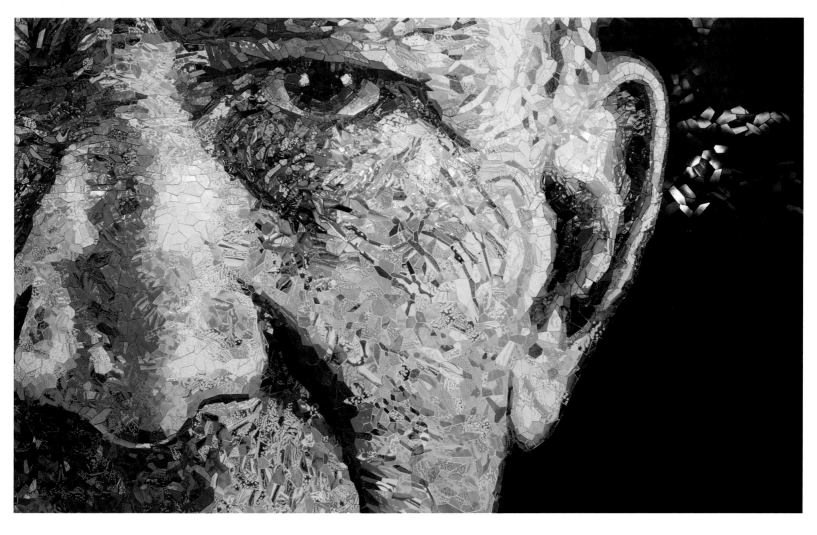

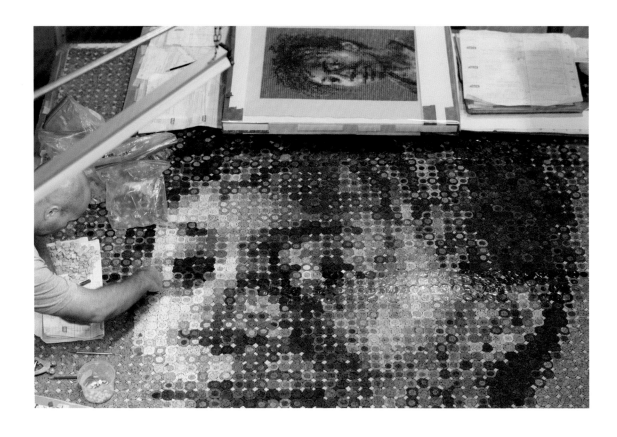

Left: *Kara Walker* during fabrication at Mosaika Art & Design. Photo: Osheen Harruthoonyan.

Below: *Zhang Huan* during fabrication at Mosaika Art & Design. Photo: Osheen Harruthoonyan.

Bottom: Portrait of *Lou Reed* during fabrication. Courtesy of Magnolia Editions. Photo: Donald Farnsworth.

work. Whereas the tile used in the Sherman portrait is placed in a horizontal/vertical grid, with each square measuring approximately 1.5 inches, Huan's 2-by-2-inch tiles are laid at a 45-degree diagonal. More than 450 glaze formulations were developed to describe the subtle nuances. Flashes of color applied to the outer edges and corners of every tile bring the images to life.

An altogether different mosaic translation was used for the portrait of Alex Katz which is based on an original print that Close referred to as a reduction linoleum cut. The ceramic rendition of Close's work has a quality described by the fabricator as "crunchiness," achieved through a curdled effect for the gray-scale glazes and hand-cut faceted shapes used for the tiles, inspired by the jagged cuts of the lino print.

The showstopper, *Self-Portrait (Yellow Raincoat)*, is an exceptional example of photo-realism in mosaic. The stained-glass micro-mosaic contains more than 250,000 individual ungrouted glass pieces. Each piece was hand cut from multicolored glass sourced from artisanal glass shops across the United States. While most of the mosaic is composed of small squares and rectangles placed at a 45-degree angle, some were cut into tiny slivers, set with tweezers, to achieve the intricate detail of the eyes and facial hair. The most detailed areas of the mosaic contain upward of 3,700 pieces of glass per square foot.

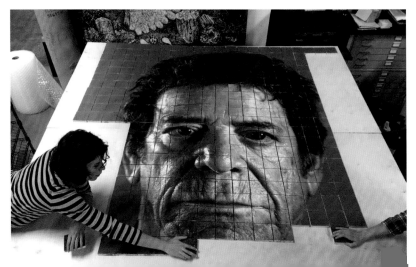

SARAH SZE

Blueprint for a Landscape, 2017
96th Street Ⓠ

Above: North
entrance to the
mezzanine. Photo:
Jeff Goldberg/Esto.

Below: Sarah Sze
reviewing her design
for *Blueprint for a
Landscape.* Photo:
Amy Hausmann

Sarah Sze's artwork is an immersive installation. Measuring roughly 14,000 square feet of printed porcelain wall tiles, it is by far the largest artwork in the MTA Arts & Design collection and one of the biggest public artworks in the world. *Blueprint for a Landscape* comprises nearly 4,300 unique tiles digitally printed in a ceramic glaze. As riders descend into the subway station from street level or rise from the lower platform, the dynamic imagery swirls around them.

The work contains only nine colors: eight shades of blue plus white. The color combinations vary at each entrance, as does the type of energy depicted. Wind and water surge through the scenes. Sze explained, "I wanted to use tile as if it were one large piece of paper."

Fabricated by Alcalagres, working with Estudio Cerámico, the digitally printed tiles were produced in Spain using pigmented ceramic inks. Each tile was labeled to indicate location

Left: *Blueprint for a Landscape* during installation. Photo: Trent Reeves.

Below: Mezzanine. Photo: Jeff Goldberg/Esto.

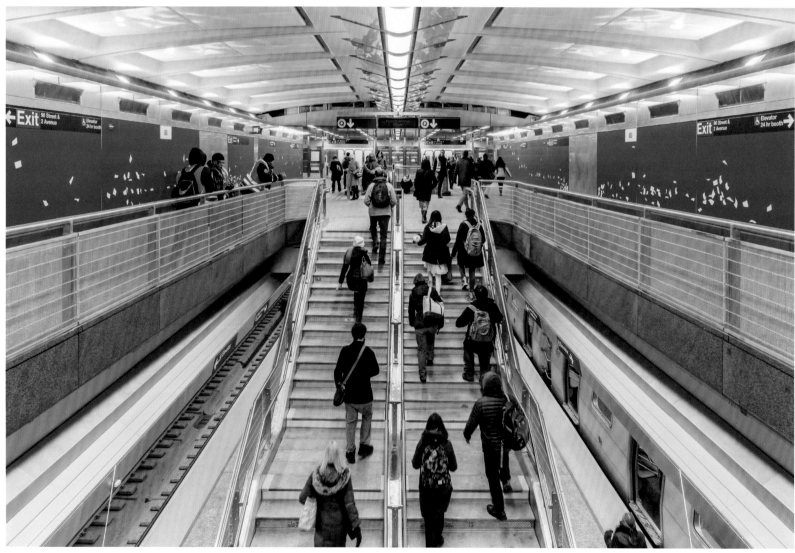

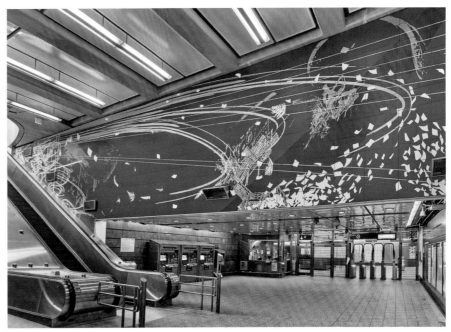

Blueprint for a Landscape. Photo: Trent Reeves, Tom Powel Imaging

and orientation. The crates of tile were shipped to the station and clipped to a framing system already in place. Custom colored vinyl strips fill the joints between tiles to provide continuous color across the interior walls.

Referring to the title of the work, Sze noted, "A blueprint is a two-dimensional drawing of three-dimensional space." Sze, the daughter of an architect, is known for complex constructions. Often working with everyday objects, she makes elaborate installations, paintings, sculpture, and video pieces that explore time, space, and technology.

Sze draws on elements from her sculptural work and takes inspiration from Italian Futurism, a movement focused on motion, and speed. The imagery of *Blueprint for a Landscape* accelerates, building in intensity then dissolving into nothingness. At the entrances, architectural line drawings rendered in multiple-point perspective capture structures that are anything but still. High-rise buildings, scaffolding, water towers, and chairs seem as free as the birds and bubbles floating among them. The sense of weightlessness is most apparent on the mezzanine. The passage, stretching from 94th to 96th Streets, uses only two colors of glaze. Set in a sea of deep blue, a whirlwind of white sheets of paper rendered in a wood-block style are shown being blown across the expanse. As trains enter and exit the station the rush of air from the platform below brings the scene to life.

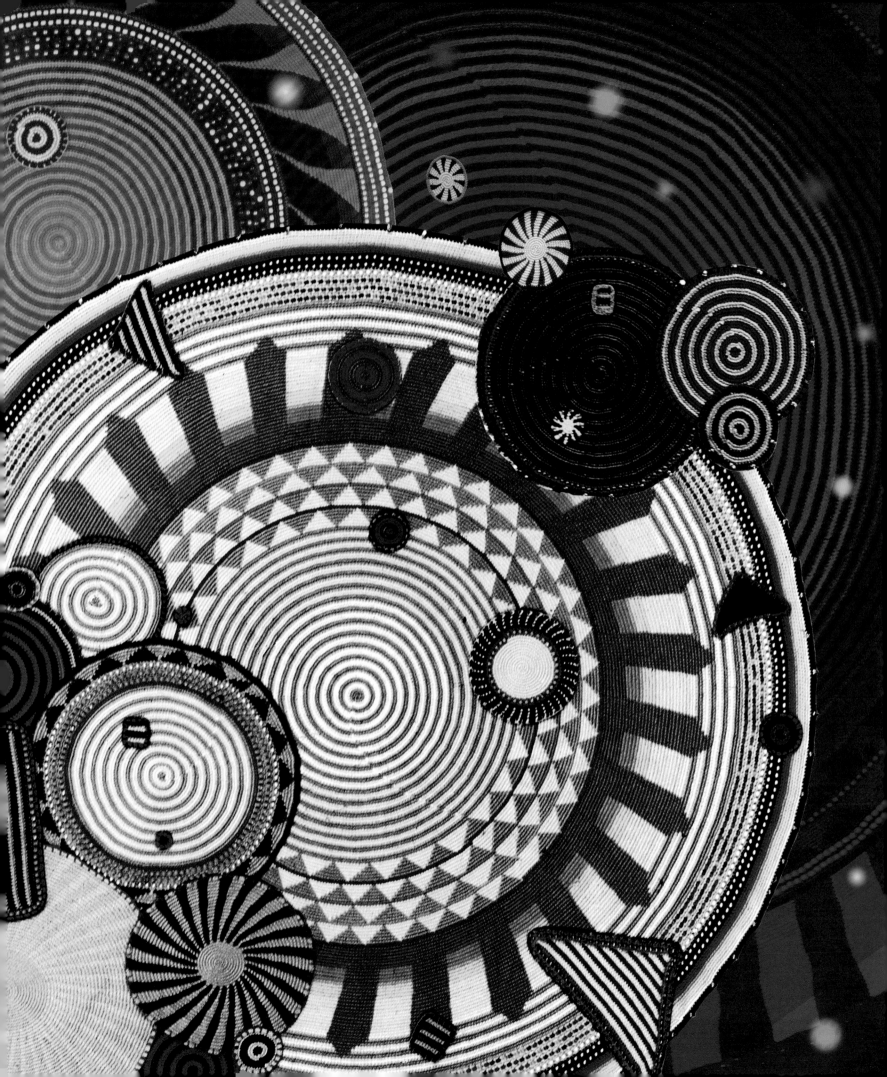

34th Street-Hudson Yards

3

The Manhattan terminus for the 7 line was the first new station added to the New York City subway system in twenty-five years. 34th Street-Hudson Yards Station, designed by Dattner Architects, opened in September 2015, extending subway service to the Far West side of Manhattan. The station offers easy access to the Javits Center, the north end of the High Line, and Hudson Yards, a part of Manhattan that has been developed at an astonishing speed.

The Hudson Yards neighborhood is now a major destination for shopping, dining, and the arts. The Shed, designed by Diller Scofidio + Renfro, can physically transform to meet the ever-changing needs of the performing and visual arts space. Nearby the High Line Plinth, on the spur at 30th Street and Tenth Avenue, offers a public venue for contemporary art. Nestled among numerous high-rises featuring luxury apartments and office space with waterfront views, art galleries and art fairs are making their home in Hudson Yards too. In an area that until recently lacked subway access and greenspace, Bella Abzug Park, formerly known as Hudson Park and Boulevard, now provides an urban oasis above the station. Glass canopies designed by Toshiko Mori Architects define the station entrances at street level. At the heart of this vibrant new arts scene, prominently featured in the 34th Street-Hudson Yards Station, is the artwork by fiber artist Xenobia Bailey, whose colorful crochet and needlecraft pieces have been featured in exhibitions, television, and film.

Original artwork for Xenobia Bailey, *Funktional Vibrations*. Courtesy of the artist.

XENOBIA BAILEY

Funktional Vibrations, 2015
34th Street-Hudson Yards ❼

Funktional Vibrations is a soaring, three-part mosaic that makes Xenobia Bailey's "aesthetics of funk" a permanent part of the 34th Street-Hudson Yards Station. The concept of Funk was ingrained in Bailey from birth, and it continues to permeate her psyche today. For more than forty years, she has been crafting works that takes inspiration from the distinctive culture of the fun-music era of the 1960s and 1970s. Bailey's forms are heavily influenced by her interest in material culture and the environment in which she grew up.

The artist was raised in the Pacific Northwest, in the Central District, a segregated neighborhood of Seattle. At the time, exclusionary practices implemented by the majority reserved much of the city for whites only. The minority populations lived together in the unrestricted area. Bailey's multi-cultural community was made up of African Americans, Native Americans, Asian Americans, and Pacific Islanders. Early on Bailey's home was warmed by a wood-burning stove and many colorful afghans. The afghans her mother used to animate their home remained long after the stove was upgraded. Every chair had one and the beds were layered with multiple examples. Bailey fondly recalls their patterns and textures, how the family wrapped up in them, and how

her mother was constantly moving the blankets around creating new compositions. "She bought big afghans at the Salvation Army and Goodwill stores. She would drape them over the sofa and chairs in the living room and created a kaleidoscope of changing textiles."

While a student of ethnomusicology at the University of Washington, Bailey was shown films that featured various aspects of the culture with the music being studied, including textiles. Bailey was enthralled by the material culture, and it became her dominant interest. Many of the Eastern cultures were already familiar to Bailey through the diverse community in which she was raised. As her curiosity about material culture grew, so did her enjoyment of fabric. Bailey worked as a costume designer for Black Arts/West in Seattle. She learned to crochet while pursuing an industrial design degree at Pratt Institute in Brooklyn.

The joyful, colorful, multi-cultural environment and sounds of her youth are the foundation for Bailey's creative process. Bailey coined the phrase "Funktional Design" to describe the practice used by African American homemakers of present and past to introduce beauty through resourceful means. Building on this legacy and the power of the music,

Below: Xenobia Bailey's proposal for *Funktional Vibrations.* Courtesy of the artist.

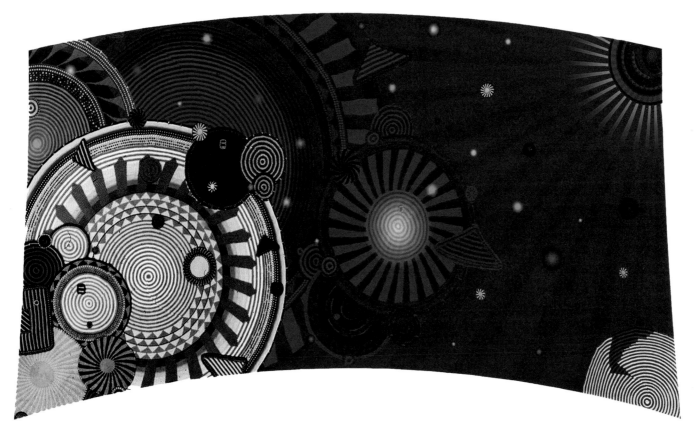

Below: Miotto Mosaic Art Studios' sample for *Funktional Vibrations*. Photo: Rob Wilson.

Bottom: Mosaic sample by a fabricator who was not selected for this project. Photo: Rob Wilson.

she creates works that seem to pulsate as they share their feel-good energies with the viewer.

In May 1998, while participating in an interdisciplinary residency at the Atlantic Center for the Arts in Florida, Bailey had a pivotal experience with artist Nick Cave that permanently altered her artmaking. Bailey was experiencing a moment of indecision about the direction of her work, when Cave, a mentoring artist-in-residence at the time, took her crocheted mandalas from a box and put them up on the wall. This moment influenced the evolution of her work from predominantly wearable pieces, such as large sculptural crowns inspired by African headdresses, to include installations of flat, textural tapestries, usually large scale and wall mounted. During that workshop, Cave also took participants to secondhand stores and yard sales, astonishing Bailey with his ability to "see gems in what others may view as junk." She observed how the accumulation of objects was reflected in his practice. Similarly, on group walks in the woods, Cave turned dead bugs into treasures, connecting with her deep appreciation for beauty in the simple things.

Bailey's parents were the children of sharecroppers, who lived by the *Farmers' Almanac*. The popular guide for outdoor activities forecasts the weather and ideal times for aspects of farming, fishing, and gardening. Predictions are tied to astronomy and astrology, among other factors. Bailey's thinking often draws on the universe for guidance. Her art practice has been an active engagement with the cosmos.

For her proposal for the 34th Street-Hudson Yards Station, Bailey crocheted large, vibrant mandalas, an element often found in her work. Mandala is a Sanskrit word referring to both "circle" and "center." In Hindu and Buddhist traditions, the symbol is used in meditation and sacred rites. It is an intrinsically spiritual image, often composed of concentric circles and repeating patterns, that has been used to focus and reach higher thought or symbolize an ideal universe. Using yarns and beads, Bailey created a proposal through tapestry crochet, a technique where contrasting color yarns are used simultaneously to make flat geometric forms. Bailey digitized these forms and employed a deep blue background for the mandalas. Contrasting bands represent rays of sunlight, contributing to the intense cosmic energy of the work.

Of the four finalists who submitted proposals for the project, three were already well established in the art world, yet Bailey captured the commission through the magic that was created when she held her crocheted pieces in her hand. She spoke of the "aesthetics of funk," tantalizing the

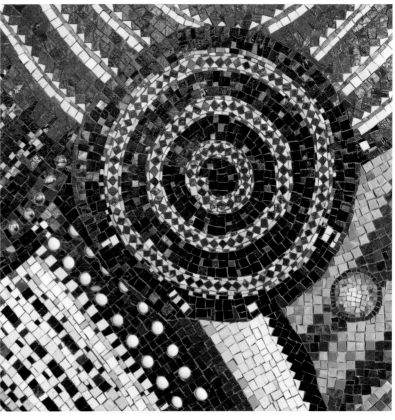

Left and below:
Xenobia Bailey
reviewing inverted
mockup. Courtesy
of Miotto Mosaic
Art Studios.

selection panel with the idea of infusing the new subway station with the joy of *Funktional Vibrations*.

It was important to Bailey that the qualities of the fiber-based artwork come through in the mosaic translation. Artists often consult multiple fabricators to better understand how their work will be interpreted into the final material. Mosaic samples produced by two different mosaicists yielded distinctive results. Bailey preferred the textile stiches conveyed in the sample made by Miotto Mosaic Art Studios. She felt Miotto best captured the nubby characteristic of yarn visible in her crochet.

Miotto worked with Travisanutto Mosaics to fabricate Bailey's artwork for three locations in the station. Every project has its own unique challenges. In this case, extra attention was given to the medium and the station surfaces. As the crocheted works were photographed, digitized, and enlarged, the colors shifted. In visiting Bailey's studio, Miotto suggested a color chart of Bailey's palette with the actual yarns she used. This ensured the mosaic smalti would match the original hues of the yarns, resulting in the brilliant blue and vermillion smalti that were matched perfectly to the

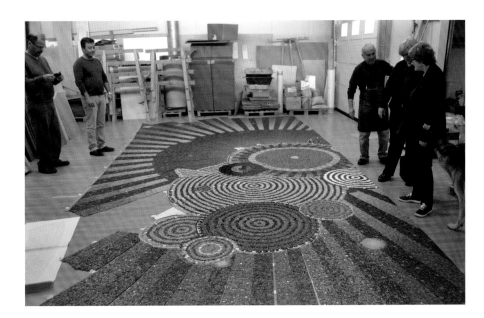

artist's palette. Speaking of her experience with Miotto, Bailey remarks, "We see color the same way, see the same intensity. He sees the same dynamics. We were talking and making with one head."

The mosaic was produced in tandem with Miotto at Travisanutto Mosaics studio in Spilimbergo, Italy. The region is known for glassmaking and mosaic production. The Mosaic School of Friuli in Spilimbergo has trained many of the mosaic masters around the globe including Miotto, while hand-made glass has been produced on the island of Murano for generations. Bailey felt mosaic to be in Miotto's

blood, just as her own art making practices were ingrained at the core of her being.

To understand the complex forms of the station design, Miotto built a maquette to study the architectural scale and address engineering challenges. The finished mosaic appears as two lunettes, stretching across both the 34th and 35th Street station entrances on Hudson Boulevard, and inset into a recessed ceiling dome at the 34th Street entrance. Achieving these unusual and irregularly curved shapes took considerable planning. Issues encountered during the installation of the dome led Miotto to request that a scale

Above: *Funktional Vibrations* during fabrication at Miotto Mosaic Art Studios' associate studio, Travisanutto Mosaics. Photos: Fred May (left), Sandra Bloodworth (right).

Left: *Funktional Vibrations* during installation. Photo: Rehema Trimiew.

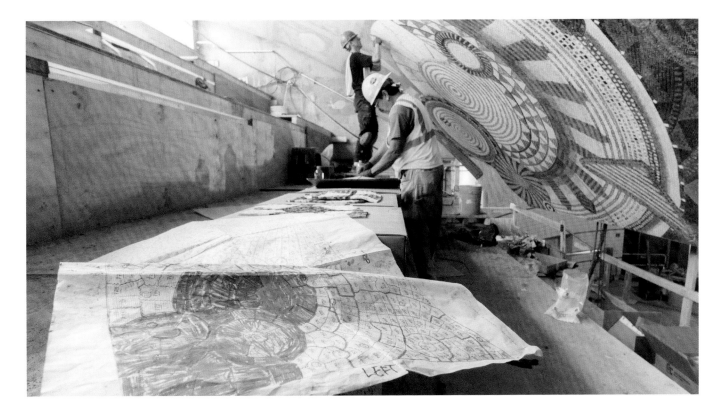

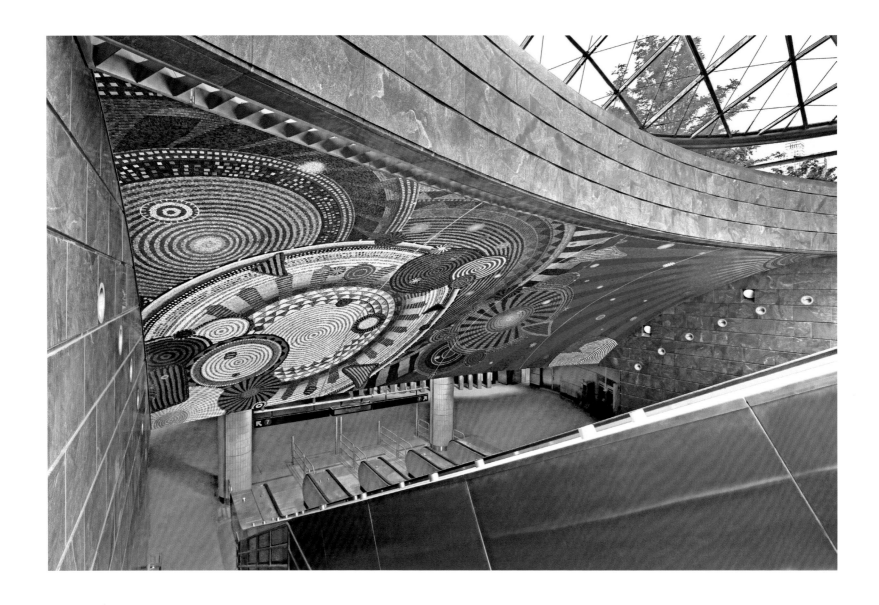

Funktional Vibrations.
Photos: Rob Wilson
(top); Rob Wilson
(above); Sid Tabak
(opposite).

model of the precast substrate for the entrance be made by the concrete fabricator. When it came to fabricating and installing the third work almost a year later, Miotto waited until the wall was built, and field measurements could be taken so the art could be fabricated to exact measurements. This was done, resulting in a perfect fit for mosaics within the square architectural feature above the stairs and escalators at the north entrance.

Bailey's mosaics crown the station. Iridescent glass offers a glittering quality. Set within the pulsating imagery of the mandalas, the dome location includes mosaic depictions of Atlantic Records vinyl albums from Bailey's collection. The artist intends *Funktional Vibrations* to speak to the universal idea of creation, while embodying the "aesthetics of funk." When designing the imagery, Bailey strove to make the patterns timeless, personal, and familiar. She wanted the artwork to be something viewers would not tire of, like a favorite blanket that appreciates in affection over time. Bailey hopes riders receive the mosaic installation as "their wake-up moment in the morning, like a cup of coffee" or a "warm spot at the end of the day."

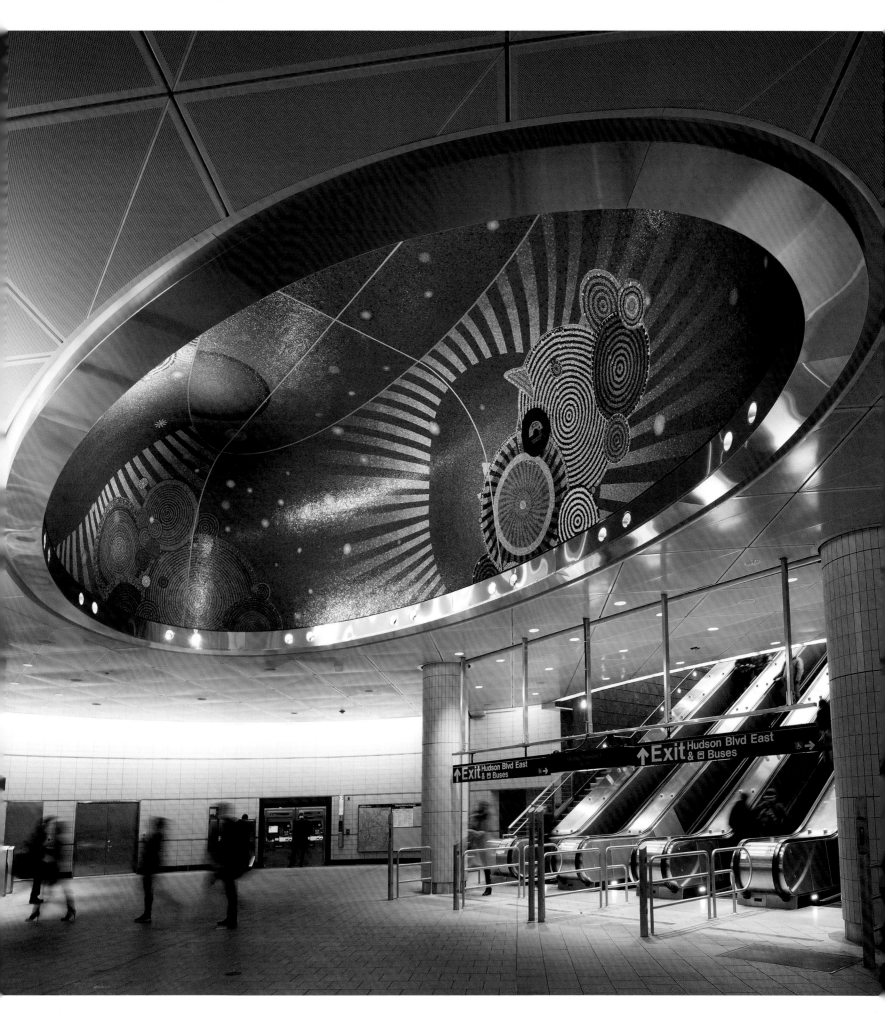

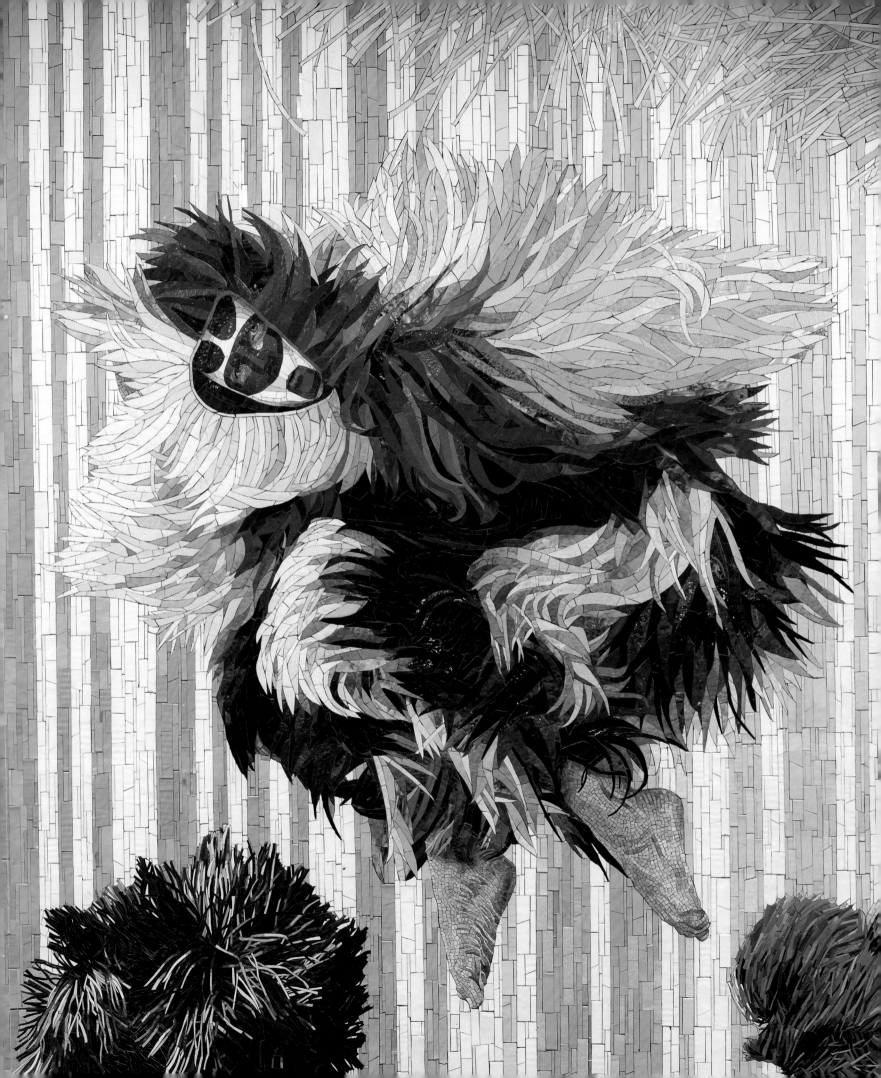

Times Square-42nd Street

Times Square is renowned as "the crossroads of the world," a place that draws international visitors and New Yorkers alike to a nexus of culture and fantasy, of energy and surprise. Beneath the streets is a subterranean crossroads, the convergence of the main arteries of transportation across the city.

Times Square, then known as Longacre Square, was the site of one of the original twenty-eight stations on the IRT subway line. Shortly after making its debut as "42nd Street and Broadway" in 1904, the station and surrounding area was renamed in reference to the New York Times Building above, opened the same year. Today Times Square-42nd Street Station is a labyrinthine complex serving nine train lines and offering in-system transfer to seven more. Given its size and the volume of riders who pass through New York City's busiest station daily, it's appropriate that the station features an exceptional number of artworks.

Two of the earliest installations, Jacob Lawrence's *New York in Transit,* 2001, and Roy Lichtenstein's *Times Square Mural,* evoke the experience of the contemporary rider and present a vision for the future. Lawrence's straphangers mosaic, rendered in a limited palette of earth tones, contrasts with the vivid primary colors of Lichtenstein's vision of a shiny bullet train. The fantasy image of the future was designed in 1990, and fabricated in porcelain enamel in 1994, but was not installed until 2002. During a seven-year period, additional works by Jack Beal, Toby Buonagurio, and Jane Dickson were added, celebrating both the subway experience above and below ground and the New Year's festivities for which Times Square is internationally famous.

In 2019 major renovations to the Times Square Shuttle and the construction of a new entrance below One Times Square and a new passage linking Times Square and the Bryant Park stations, provided three expansive wall surfaces for a new artwork commission. To stand out against the bustle of Times Square, the artwork would need to be big and bold. To be successful, it would need to connect with the energy of the site. Artist Nick Cave's proposal did all that and more. His work *Each One, Every One, Equal All* features nearly fifty of his signature *Soundsuits,* wearable sculptures that camouflage, protect, and empower the body. The works—inspired by African ceremonial costume and masks, couture fashion, and Carnival—are created from an assortment of materials that has included synthetic hair, beads, buttons, bags, twigs, trinkets, toys, sequins, and silk flowers, just to name a few. The pieces are typically designed to be worn. The name *Soundsuits* refers to the noises produced by the materials during movement. Describing the Times Square figures, Cave explains, "These *Soundsuits* will act as friendly, otherworldly, guardians and guides where there are no preconceptions around race, gender, or class and the viewer is forced to look at each without judgment."

Detail of Nick Cave, *Each One,* 2022, Times Square-42nd Street Station. Photo: James Prinz.

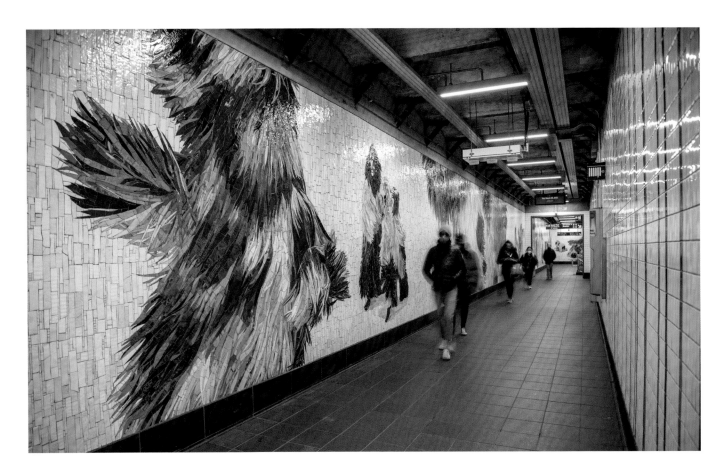

Left: *Every One.*
Photo: Trent Reeves.

Below: *Equal All.*
Photo: James Prinz.

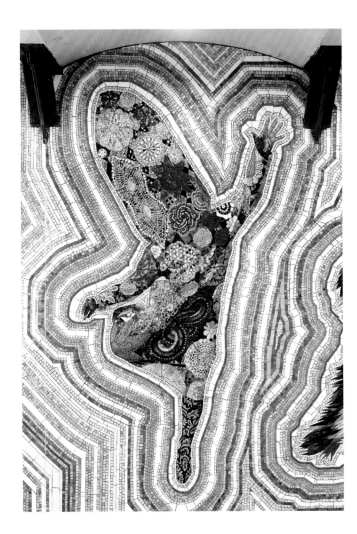

NICK CAVE

Each One, Every One, Equal All, 2022
Times Square-42nd Street Ⓝ Ⓠ Ⓡ Ⓦ Ⓢ ① ② ③ ⑦

Nick Cave is a multi-disciplined artist, educator, and self-described messenger. The label fits. His artworks include more than five hundred *Soundsuits* and other forms of sculpture, performance, video, and installation. His background in fashion and dance is evident. Cave's works are often bright and cheerful on the surface, while at their core they speak to the ongoing struggle for social justice and respond to police brutality and gun violence. Cave made his first *Soundsuit* from twigs in 1992, in response to the beating of Rodney King by officers of the Los Angeles Police Department. It was designed to be a second skin, a form of protection in a world that too often judges people based on their gender, race, and class. In recent years his practice has been increasingly focused on public works.

In his proposal the artist stated, "Times Square is one of the busiest, most diverse, and fabulously kinetic places

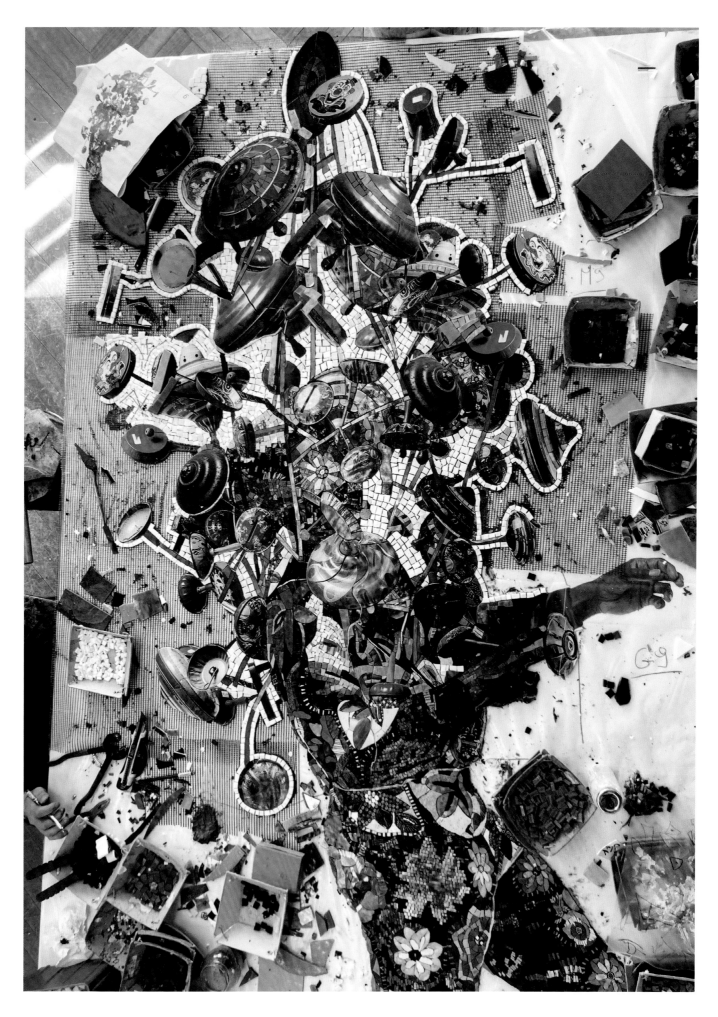

Right: *Equal All* fabrication in-progress. Mosaic interpretation of a 2009 *Soundsuit*. Courtesy of Mayer of Munich.

on the planet. For this project I took the above-ground color, movement, and cross-pollination of humanity, bundled it into a powerful and compact energy mass that is taken underground and delivered throughout the station and passage."

Each One, Every One, Equal All is a celebratory work composed of mosaic and video that functions as a whole, but it can also be considered in three parts, referred to individually as *Each One, Every One,* and *Equal All*. The mosaic is based on source photos of Cave's *Soundsuits* taken by James Prinz and reconfigured into new compositions. *Each One, Every One, Equal All* covers more than 4,600 square feet in full, making it the largest mosaic in the system to date. The work carries a powerful message of equality and representation. Its name makes clear that the artwork, and the celebration, is meant for each and every one of us.

Each One is installed at the foot of the One Times Square entrance. Nearby *Equal All* can be seen after riders pass through the turnstiles or approach the Shuttle from elsewhere in the station complex. *Every One* is at the opposite end of the 42nd Street Shuttle platform in the new passage connecting Times Square–42nd Street to the 42nd Street–Bryant Park Station. Cave was conscious of the ways people would move through each of those spaces—one outside of the turnstiles, one in a space where riders can stop comfortably, and one meant to pass through quickly. The artwork's scale, density, and level of detail at each location is designed accordingly. Additionally, each section has a distinct background that supports the artist's intent.

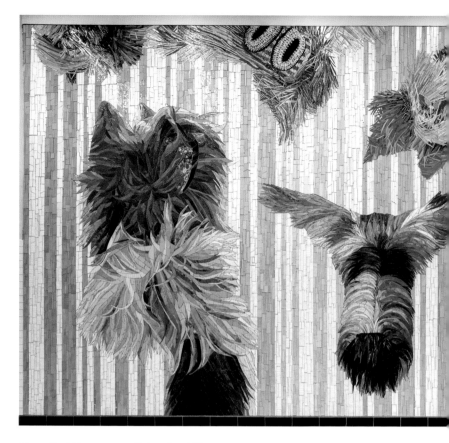

Above: *Each One.*
Photo: James Prinz.

Below: *Equal All.*
Photo: James Prinz.

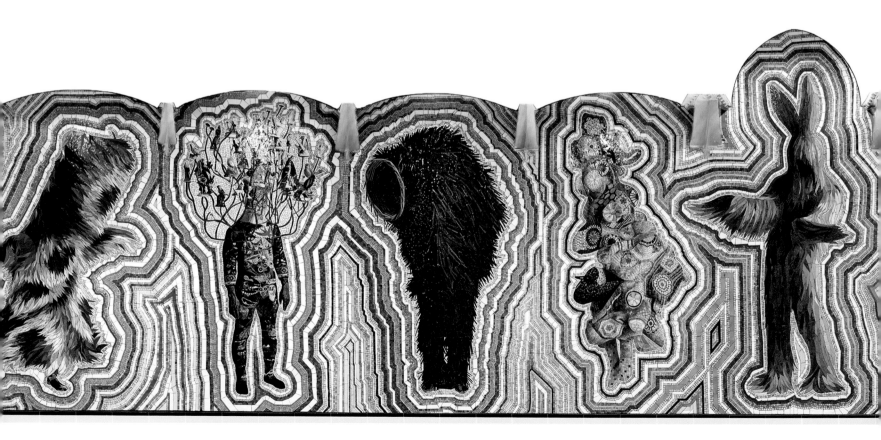

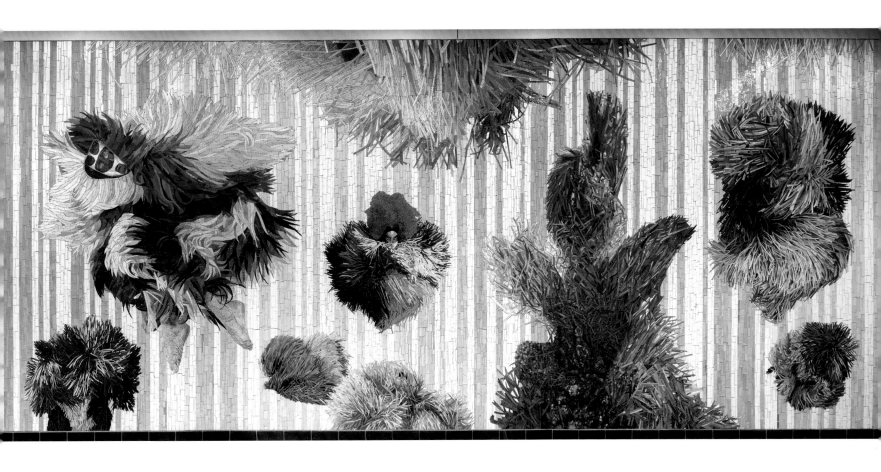

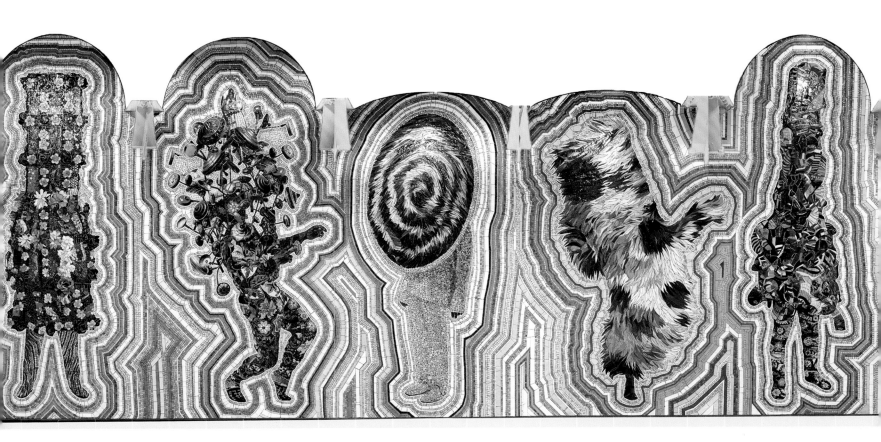

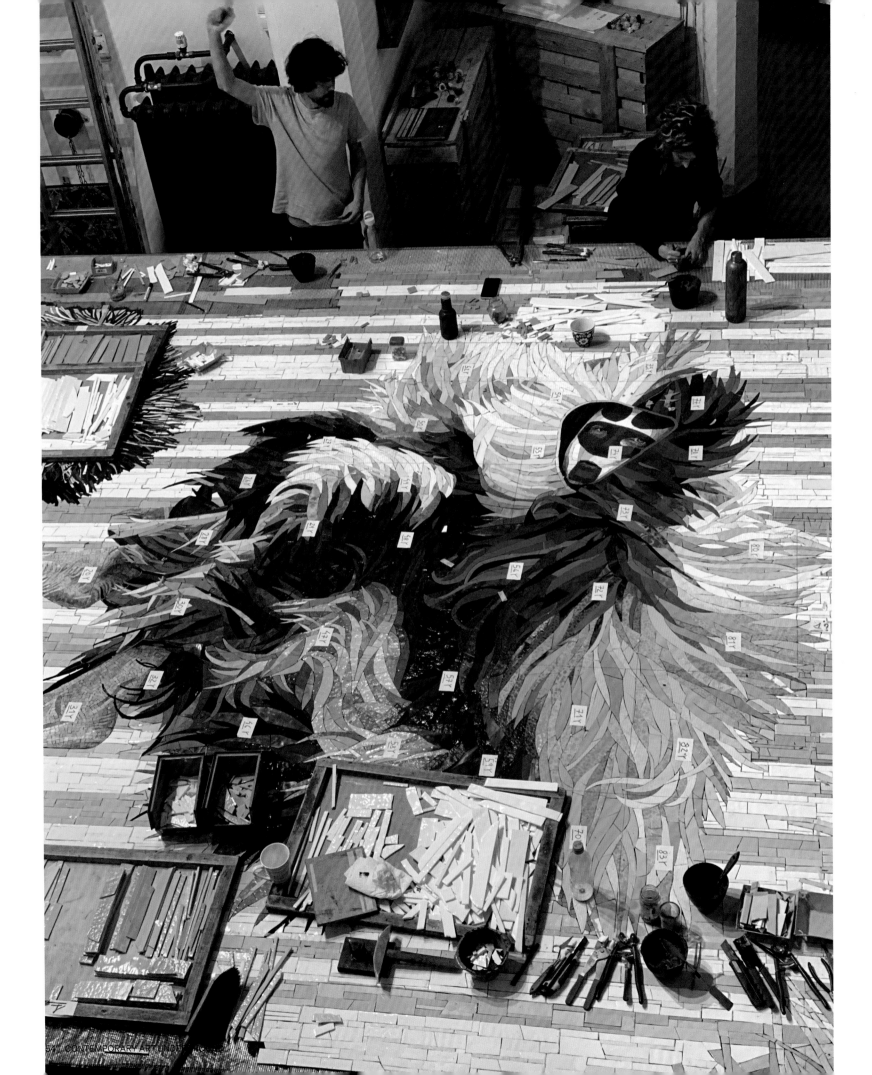

Opposite: *Each One* during fabrication. Courtesy of Mayer of Munich.

Above: Nick Cave at Mayer of Munich's studio. Photo: Sammy Hart.

Each One is installed directly below the One Times Square building, whose rooftop is home to the famous New Year's Eve ball drop. The mosaic is 14.5 feet high, the tallest of the trio. Broad vertical stripes in grays and silver extend the full height of the wall, connecting with the active plaza above. *Soundsuits* depicted are caught mid-jump, suspended off the ground or rounded into polka dots or ball-like forms. The vertical stripes and lively shapes reinforce a sense of objects rising and falling, as a nod to the popular annual event.

Equal All is the showstopper. The piece is composed of twelve of Cave's *Soundsuits*, shown true-to-size and with a degree of detail that comes close to the original sculptural works made over a period of twenty years. A wide array of mixed-media materials is depicted including vintage toys, ceramic birds, hot pads, doilies, bags, hats, bugle beads, wire, twigs, sequined appliqués, and tole flowers. The *Soundsuits*

are grounded and neatly contained in the space between knee braces and the ceiling barrel vaults. The concourse wall offers multiple angles for viewing and the opportunity to interact with the work. The effect is approachable and hugely inviting. It's no surprise that this is the location where people linger.

Collaboration—essential to all Arts & Design projects—is particularly important to *Each One, Every One, Equal All*. While holding closely to a strong personal vision, Cave is a collaborator. At the heart of this process is designer Bob Faust, Cave's partner and design collaborator. Faust works with Cave in whatever way is needed. His guidance is quietly present as he offers an additional or adjacent perspective. He may ask questions, even when he knows the answers, to push a little and give the opportunity for others to go deeper into understanding what Cave is intending.

Faust's influence is most visible in the radiating line motif of *Equal All*. Many of the original *Soundsuits* captured on this wall are louder than the works made of hair and raffia. They also represent a sizable portion of Cave's practice. To amplify the energies they give off Faust recommended colorful, concentric radiating rings as a means of expressing a shared energy exchange or communication occurring between the *Soundsuits,* suggesting that they are speaking to one another and to passersby. The lines buzz with uncontained excitement. Cave and Faust knew the design had to work for those experiencing it at close range or from 100 feet away. These pieces are the most intricate and reward those who take a close look at the astounding detail.

The technical success of *Each One, Every One, Equal All* is directly tied to the quality of the collaboration between artist and fabricator, Mayer of Munich. In early 2020, Cave and Faust visited Mayer's studio for the first time. Prior to that meeting, it was a leap of faith for Cave to envision his materials of choice, often soft knitted and crocheted fabrics, flowing hair and raffia, or delicate twigs, rendered in hard glass mosaic. Mayer pushed the limits of their own craft to develop innovative ways to convey Cave's mixed media materials in glass. In addition to traditional mosaic techniques, *Equal All* uses printed glass in the toys and ceramic birds, painted glass in the buttons, etched glass in the doilies, varying sizes and cuts of glass to suggest everything from hair to sequins, and millefiori beads to add delicate detail that softens the look of the glass tesserae.

Mayer's mosaics capture the essence of Cave's *Soundsuits,* and many feel as if they are being seen in motion. The *Soundsuits* that were photographed as static sculpture stand in contrast with those that capture the flowing color and movement associated with their performance. There is a vivacity that makes it easy to imagine the clang or swoosh sound being emitted. This dynamic quality is most pronounced in *Every One* where the *Soundsuits* appear to be rushing down the corridor, strands of hair and raffia swinging and swirling.

Every One during installation. Photo: Cheryl Hageman.

Every One. Photo: Marc A. Hermann.

Every One goes big on scale, color, and movement. The largest piece of the commission, the work combines mosaic and an accompanying video. Constructed on a repurposed track bed for the original 1904 IRT station, the Connector extends 360 feet between the stations at a width of only 10 feet; Cave's work is designed to make the narrow space feel comfortable and inviting.

Three strategies work together to cover the substantial surface area and overcome the spatial challenges. First, an oversized, shifting scale is used for the more than two dozen *Soundsuits*. The effect makes the space feel bigger than it is and helps to disguise the change in ceiling height. The figures are a welcoming presence, and the sense of motion ushers riders through the space quickly. Secondly, the video component allows viewers to experience the wearable sculptures through performance. A three-minute video is presented on the digital advertising screens at the mid-point of the Connector on the quarter-hour. Several of the *Soundsuits* that can be seen in static form in the nearby mosaic appear activated through dance in the video. As Cave said, "*Every One* places viewers within a performance, directly connecting them with the *Soundsuits* as part of an inclusive community of difference."

The most significant feature is the doubling-effect of the corresponding architectural finish on the wall opposite the mosaic. Set against a white background like the mosaic, the south wall of the passage echoes the colors and concentrations of the *Soundsuits* in ceramic tile color-banding. The design was created by Cave and Faust, in tandem with the 42nd Street Connector architects di Domenico + Partners. Portland-based Clayhaus produced the tile in a limited palette of ten colors selected by the artist. Vertical stripes in canary, clover, lilac, dark denim, and blue Hawaii mirror the color and rhythm of the artwork on the north wall. The fluid spacing between the tile bands mimics the breaks in the *Soundsuit* placement and builds on the sense of movement in the mosaic. The dialogue between the glass mosaic and ceramic tile creates a memorable, immersive experience.

Each One, Every One, Equal All is an exceptional work with many notable attributes, but there is an understated detail that seems to connect the three mosaics: the hands. Many of the *Soundsuits* were photographed while being worn by Cave. Seeing the hand of the artist rendered in such detail is a beautiful element of the artwork, but it also serves as a reminder of the many hands involved in Cave's process and all who worked to interpret it in mosaic and realize a public artwork at this scale.

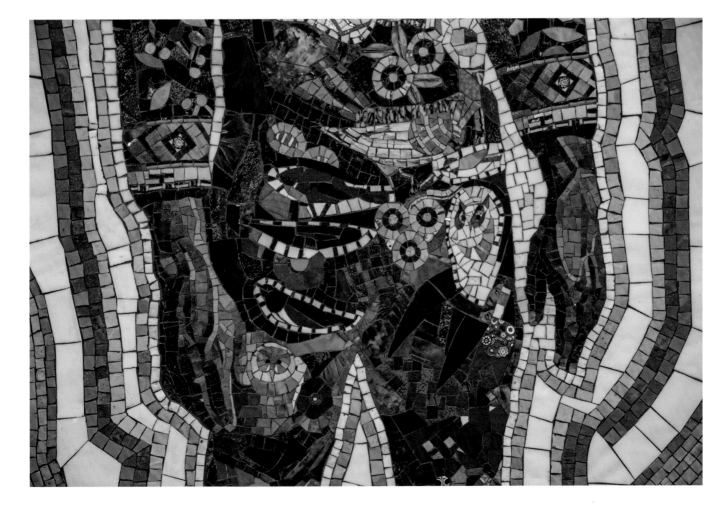

Detail of a 2006 *Soundsuit* depicted in *Equal All*. Photo: Trent Reeves.

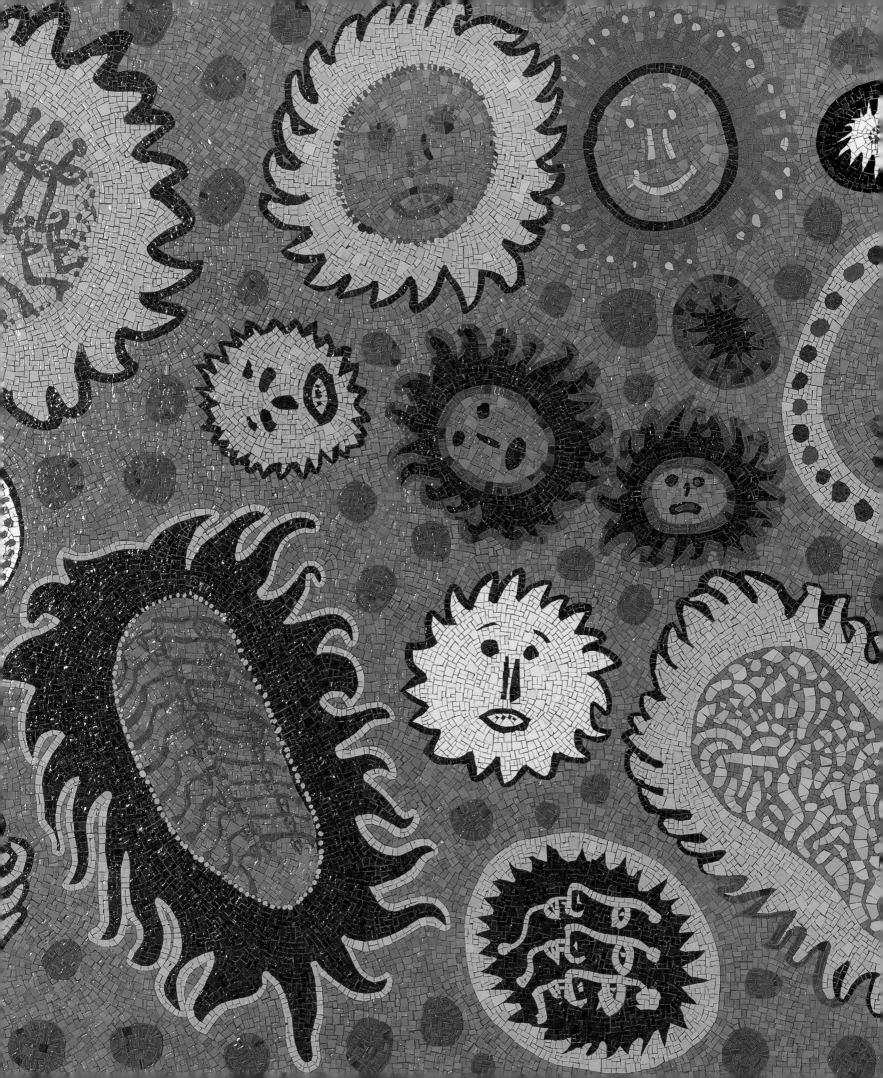

Grand Central Madison

Monumental mosaics by Yayoi Kusama and Kiki Smith welcome travelers within the sweeping architectural spaces of Grand Central Madison. Opened on January 25, 2023, following more than six decades of planning, the new terminal brings the Long Island Rail Road to the east side of Manhattan. The new multi-billion-dollar space, constructed underneath Grand Central Terminal, descends fifteen stories below grade and runs the length of five city blocks.

With its sleek lines and reflective materials, Grand Central Madison presents a modern interpretation of Grand Central Terminal, the neoclassical structure completed in 1913. The arched portals establish a continuity between the two terminals, while Grand Central Madison's white Turkish marble contrasts with the creamy Botticino Classico marble used for the interiors at Grand Central.

The architectural vision for Grand Central Madison belongs to the team at DMJM Harris, now AECOM. Early in the design process, Arts & Design, in collaboration with the chief architect, identified the four arched alcoves on the mezzanine as ideal locations for mosaic artwork. Integrating a unique piece within these features would aid wayfinding and support the character of the space. Today passengers ascending from the platforms are greeted by mosaics by Kiki Smith. Her Long Island vignettes link the landscape along the route with the city destination. The scenes are nested in the arched niches, a form evocative of Grand Central Terminal and a key element of the original design, creating an architectural and artistic vision connected across two decades that feels both familiar and entirely new. The south

end of the Madison Concourse, near the Terminal entrance, has been transformed by Smith's *River Light.* The points of light scattered on a blue field of mosaic suggest the sunlight glinting on the East River and reference celestial bodies, connecting to the famous sky ceiling of Grand Central.

Yayoi Kusama's *A Message of Love, Directly from My Heart unto the Universe* is installed on the wall across from the Ticket Hall on the Madison Concourse. The artist drew images from her *My Eternal Soul* series, typically shown within large squares arranged in an oversized grid, to create a flowing composition that extends more than 120 feet and spills energy and joy out into the passageway.

Grand Central Madison was built for transportation, but the works by Kusama and Smith have made it a popular arts destination. Both artists were chosen in 2020 through the MTA's standard artist selection process. Seven finalists developed site-specific proposals for the highly competitive process. Kusama and Smith both created designs that were true to their practices and responsive to the needs of the space. The selection panel had no doubt that Kusama's vibrant colors and universally appealing iconography would appeal to New Yorkers and travelers from near and far. As well, they were enthusiastic that Smith's work would deliver her stated intent to "connect Grand Central Terminal—and its celestial ceiling—with the Long Island land and seascapes for all traveling to and from Long Island." Now part of a "Cultural Corridor," the artworks are highlights on a roster than showcases all facets of the Arts & Design program featuring photography, digital art, poetry, and music performances.

Detail of Yayoi Kusama, *A Message of Love, Directly from My Heart unto the Universe.*
Photo by Kerry McFate. Courtesy of Ota Fine Arts, David Zwirner.

YAYOI KUSAMA

A Message of Love, Directly from My Heart unto the Universe, 2022
Grand Central Madison · Long Island Rail Road

Acknowledged as one of the world's most popular artists, Yayoi Kusama is best known for her compulsive mark marking and installations that walk the line between illusionary and hallucinatory. Kusama's Infinity Mirror Rooms and polka-dot motifs draw a crowd.

Kusama moved to the United States from her native Japan at the age of 27 and spent a formative period in New York beginning in 1958. She was a frequent subway rider, and in November 1968 staged a brief but memorable nude happening in a subway station. The unsanctioned performance piece lasted only a few minutes; she fled when the police arrived.

For fifteen years Kusama immersed herself in the ground-breaking art scene of New York and Europe, but she was unable to gain the level of art world attention accorded her male friends. Kusama later returned to Japan in 1973, and she later voluntarily placed herself in a psychiatric institute in Tokyo where she has lived since 1977. Working daily in her studio across the street, she channels her inner world into brightly colored art. Kusama has a gift for turning her own feelings into a cheerful, spiritual affirmation for others.

Despite the passage of time and difficulties faced during her years in New York, Kusama's fondness for the city has not diminished. *A Message of Love, Directly from My Heart unto*

Below: *A Message of Love, Directly from My Heart unto the Universe.* Photo: Kerry McFate. Courtesy of Ota Fine Arts, David Zwirner.

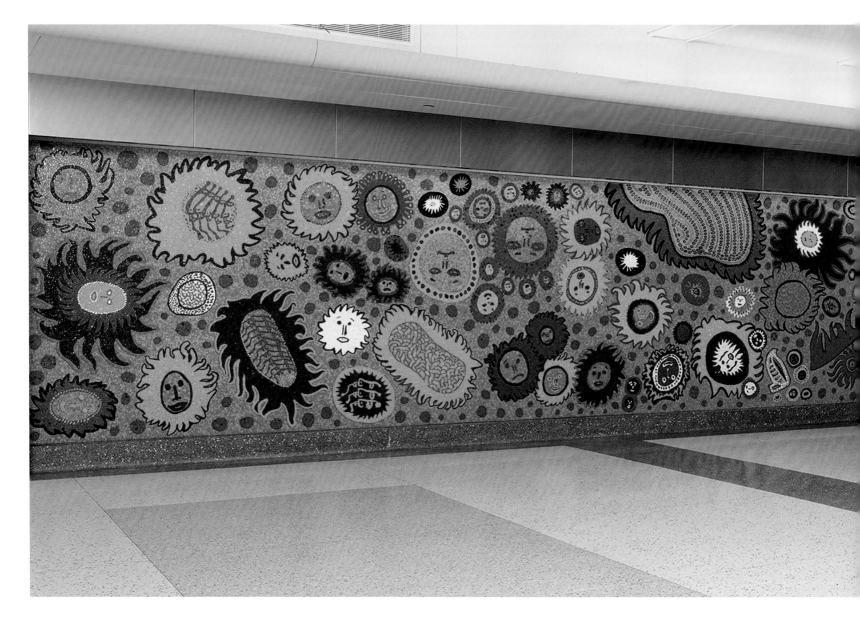

the Universe is Kusama's first permanent public artwork in New York and her largest mosaic piece in the world. The Grand Central Madison commission provided her with an opportunity to share her feelings and devotion with New Yorkers. The artist, who is also known to be a prolific writer of poetry and frequently assigns dark, revealing, and complex titles to her work, shared a tender poem to accompany this ebullient piece:

This is Yayoi Kusama.
I offer you a message of love,
directly from my heart unto the universe.
May you all experience the true beauty of loving humanity.
Human life is beautiful.
My wish is to deliver this vision,
with all that is my life,
to the people of New York.

The visually complex mosaic is composed of elements immediately recognizable from Kusama's well-known series My Eternal Soul, begun in 2009: smiling suns, rayed-amoebas, female figures, snaking shapes, pumpkins, and thousands upon thousands of dots.

Unlike the typical presentation of works from My Eternal Soul—multiple paintings arranged in a grid, wrapping the gallery walls to become a form of installation—the Grand Central Madison mosaic is a single, linear piece. Its sense of infinity comes from its length. Set on a tripartite field—white at center with red-orange on the left and blue on the right, the biomorphic forms appear to be on their own journey, implying a subtle sense of travel. Kusama commented she intended them to be perceived as coming or going, adding, "It could be you; it could be me."

The lightly textured surface of the glass mosaic reads differently from Kusama's obsessive brushstrokes, but the undulating quality and vivid colors gives a sense of vibration. The dots are almost effervescent. Nothing is lost in the translation of Kusama's imagery rendered in small pieces of monochromatic glass, a medium that seems

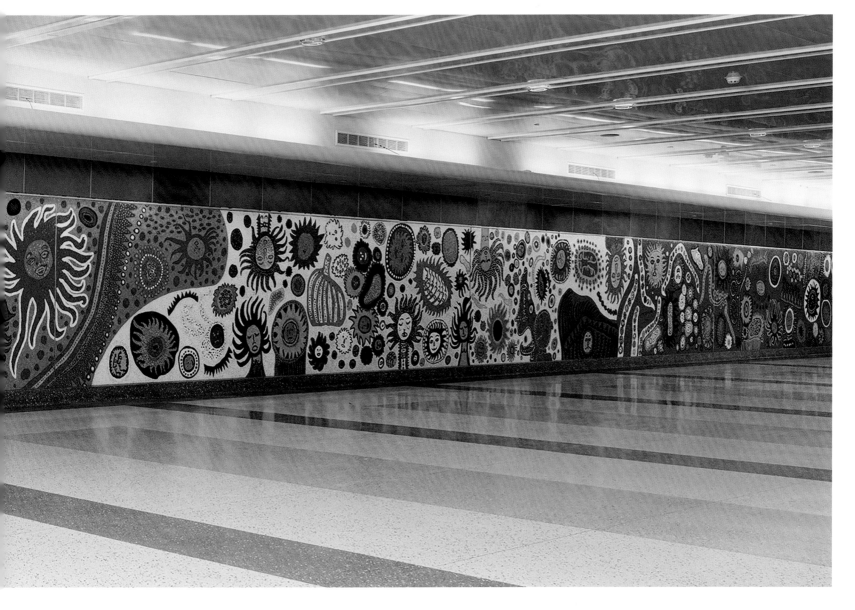

Drawing annotated with color assignments for the mosaic elements.

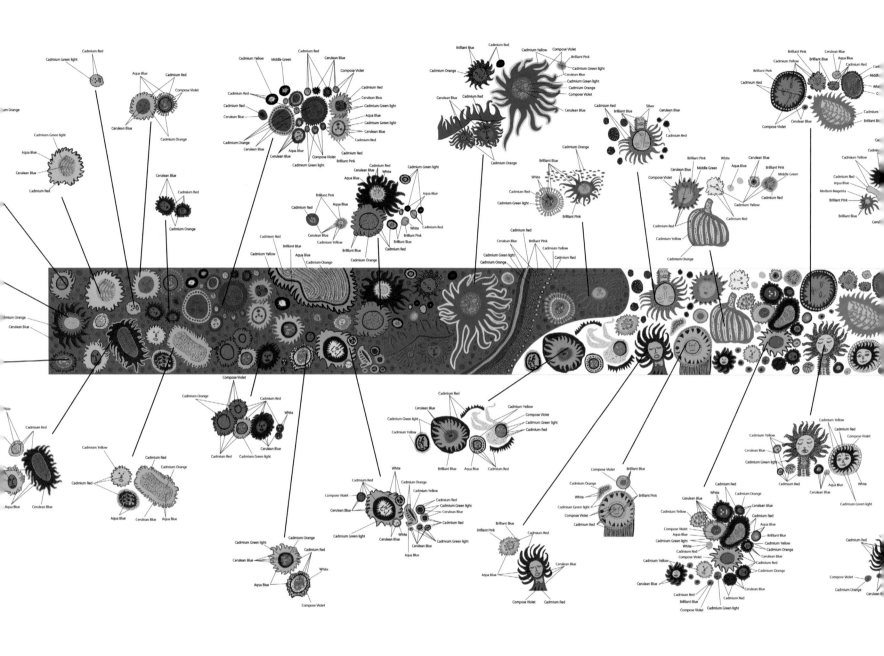

Details of the mosaic tesserae used to replicate the paint colors used in Kusama's original artwork. Photos: Rob Wilson.

Silver

Cadmium Yellow

Cadmium Green Light

Middle Green

Aqua Blue

Brilliant Blue

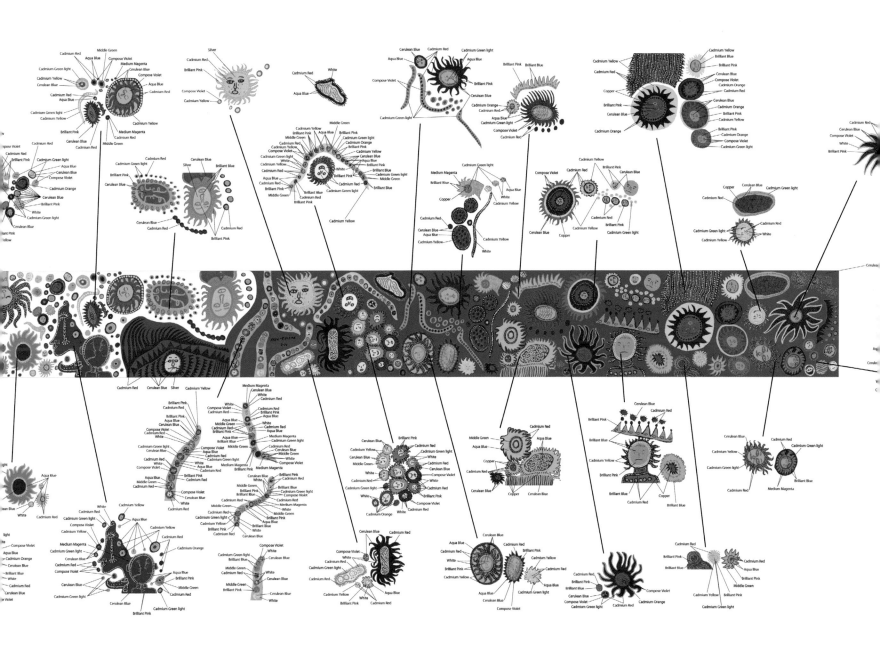

Cerulean
Blue

Compose
Violet

Medium
Magenta

Brilliant
Pink

Cadmium
Red

Cadmium
Orange

Copper

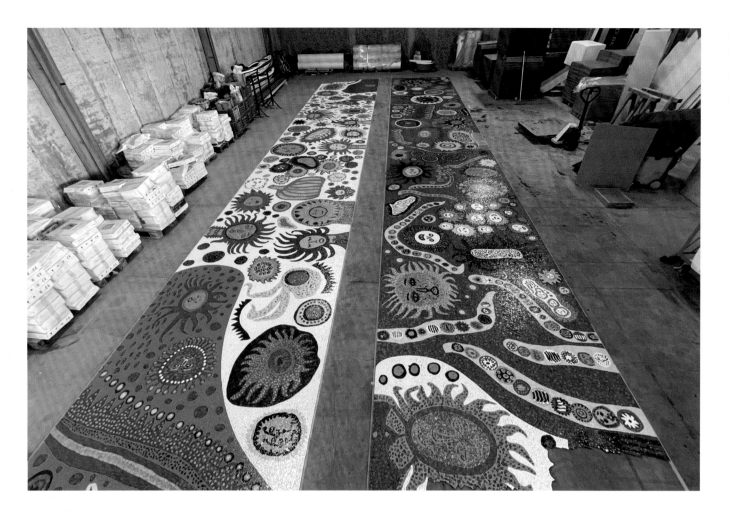

A Message of Love, Directly from My Heart during fabrication. Courtesy of Miotto Mosaic Art Studios.

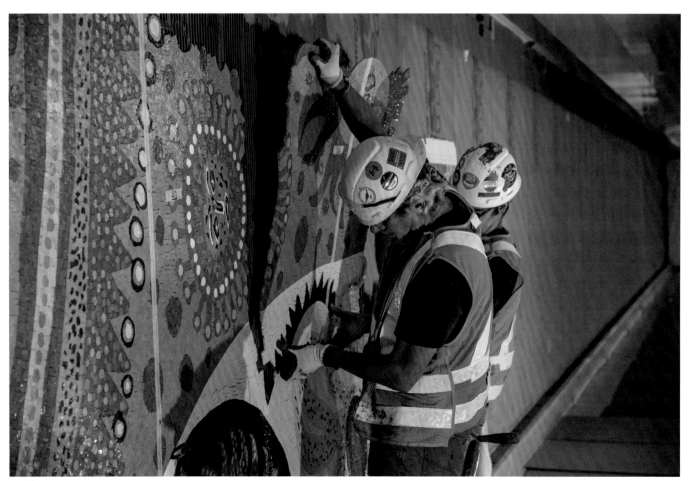

Stephen Miotto installing *A Message of Love, Directly from My Heart unto the Universe.* Photo: Trent Reeves.

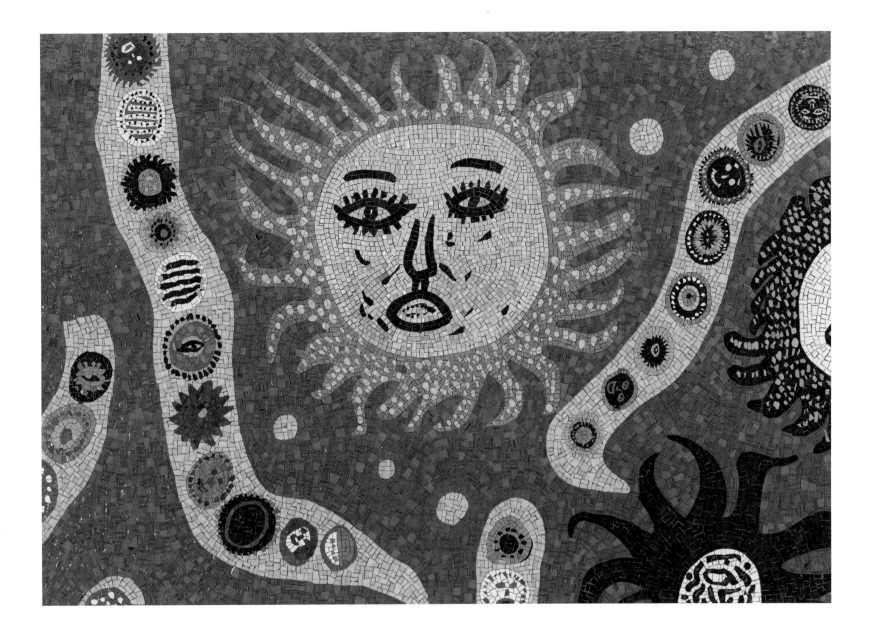

Detail of *A Message of Love, Directly from My Heart unto the Universe*. Photo: Kerry McFate. Courtesy of Ota Fine Arts, David Zwirner.

well suited to repetitive mark making.

Kusama chose Miotto Mosaic Art Studios to translate her artwork into the durable medium of glass mosaic. Miotto, in upstate New York, worked in partnership with Travisanutto Studio in Spilimbergo, Italy. The mosaic studios have ties going back to the 1970s.

The first challenge in fabrication was precise color matching of Kusama's palette. Fabricators using traditional glass mosaic techniques begin with a kiln-fired glass disc the size of a dinner plate, sometimes called a pie or pancake. The shape is smooth and even on the side where the molten glass cooled. Variation along the top surface and perimeter is natural. Just as painters may use a wide range of colors to mix and shade tones, fabricators typically pull from a vast reserve of available glass colors when constructing mosaics. The color accuracy for the Grand Central Madison mosaic was critical to the artist.

Kusama's studio dissected the original artwork to identify a palette of thirteen colors, plus white. The fabricators approached Mosaici Donà Murano of Donà Stefano to create custom glass colors for the most accurate match of the original artwork. The glass palette approved by Kusama's studio includes metallic white-gold (silver) and copper-tinted gold glass.

The fabricators cut the glass pancakes into strips that can be easily worked into smalti, the individual hand-cut glass tesserae used to assemble the mosaic. Smalti are roughly one-half-inch square and one-quarter-inch thick, but variation adds to the handmade character of the medium. The custom-colored smalti are mixed with other shades of glass for rich effect.

The mosaic arrived at Grand Central Madison assembled on mesh in two-foot sections. Each section was numbered and ready to be installed by the mosaicists who prepared the wall and affixed to the surface as if assembling a giant puzzle. Planning for and making the mosaic took more than two years, but the installation of Kusama's work was completed in only seven days.

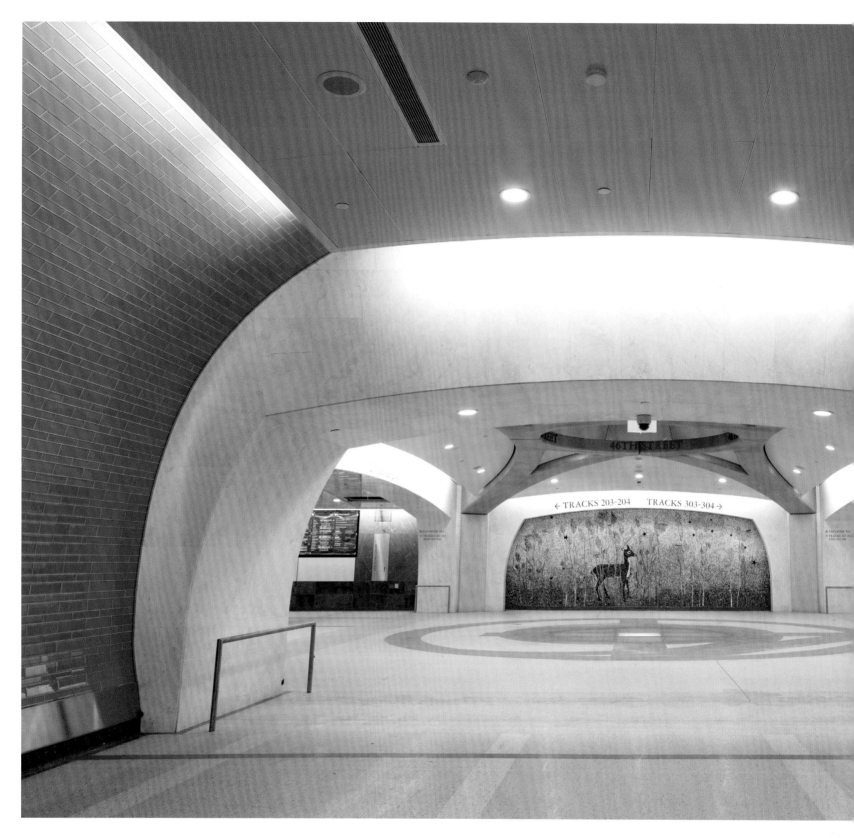

The Presence. Photo:
Anthony Verde
Photography.

KIKI SMITH

River Light; The Presence; The Spring;
The Sound; The Water's Way, 2022
Grand Central Madison · Long Island Rail Road

Nature has always been central to Kiki Smith's work. Her multi-disciplinary practice, which includes sculpture, drawing, printmaking, textiles, and photography, has been a passionate exploration of the sensuality and vulnerability of the body and its connection to the natural world.

The daughter of sculptor Tony Smith and opera singer Jane Lawrence, Smith was born in West Germany in 1954. Raised in South Orange, New Jersey, she moved to New York in her early twenties and has lived and worked in New York City and upstate New York for most of her career.

Largely self-taught, Smith studied briefly at the Hartford Art School in Connecticut, but her training as an emergency medical technician may have proved more influential. Her early work was an investigation of human anatomy and bodily processes. Life and death have remained a concern throughout the artist's practice. Over four decades of art making, Smith's work, rich in symbolic representation and narrative elements, has explored images of femininity and spirituality, with a shift to the animal kingdom in recent years.

Despite her success working with architect Deborah Gans on the stained-glass rose window for Eldridge Street Synagogue and her many other achievements, Smith was reluctant to take on a large-scale public art commission. She found the idea alluring, but she was most comfortable making her own work at a relatively small scale—in her words, "No bigger than a bread box." Her thinking changed while working with Magnolia Editions to produce a suite of twelve tapestries that create a "mythical world wherein human and animal forms entwine with natural phenomenon." Seeing her work translated into a new medium at a larger scale sparked an interest in making natural scenes of flora and fauna for public spaces.

The selection panel assembled to choose artists for Grand Central Madison was drawn to Smith's ideas immediately. Her well-developed proposal was conceived with the people who use the terminal in mind, a tenet of

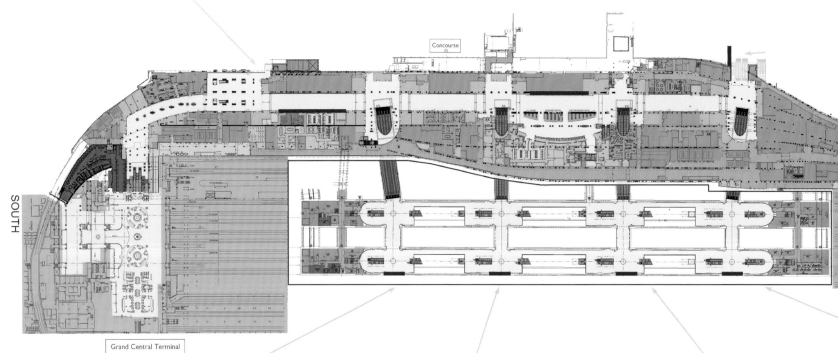

SOUTH

Concourse

Grand Central Terminal

45th Street Cavern
WATER STREAMS

46th Street Cavern
DEER IN MARSH

47th Street Cavern
ROCKS ON THE COAST

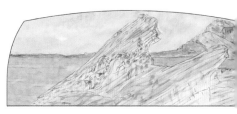

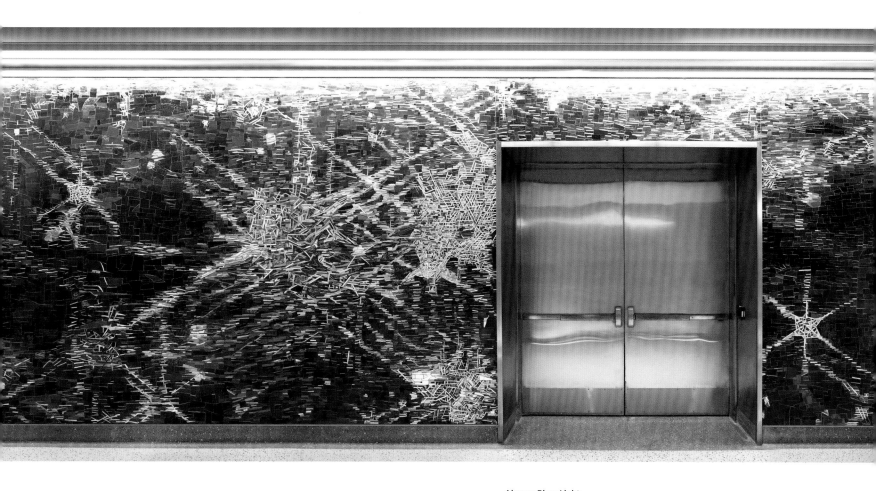

Above: *River Light.*
Photo: Anthony
Verde Photography.

NORTH

Left: Proposal for
artwork at Grand
Central Madison.
Courtesy of the artist.

Smith's original
proposal was revised
during design
development.

3th Street Cavern

RANCHES

the Arts & Design program reiterated at the start of every panel process. Smith's thinking was remarkably similar to that of the architects. Understanding the depth of the terminal, the artist felt it important to use calming color and imagery that would make riders feel grounded and safe. She also wanted to acknowledge the connection between Grand Central Madison and Grand Central Terminal.

Mayer of Munich fabricated Smith's five mosaics, totaling more than 1,400 square feet. The artist had worked with Mayer to produce paintings in glass periodically over the last twenty-five years, but Grand Central Madison was their first mosaic project together, and the artist's first ever mosaic. A considerable amount of trust is required when an artist's work is being transposed into an unfamiliar material. Despite their working history, Smith recalls anxiousness early on and difficulty watching the hands of others produce her work. Ultimately it was a powerful and positive experience for the artist who visited the studio multiple times during the fabrication period. Smith notes that the act of letting go was part of the process.

Upon entering the concourse of Grand Central Madison at 43rd Street, travelers encounter Smith's *River Light.* The mosaic depicts sunlight glinting on the East River, a daily sight

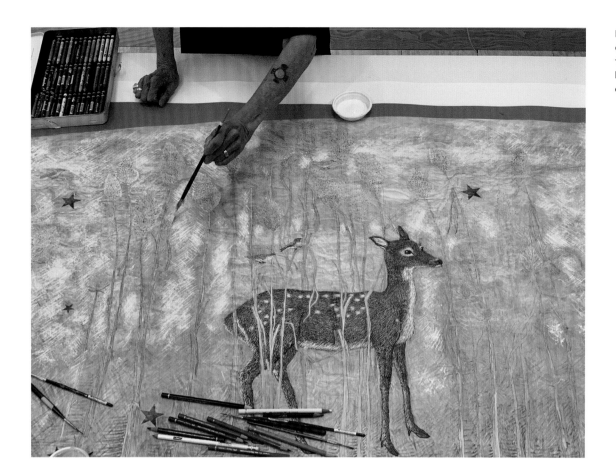

Kiki Smith working on the original art for *The Presence* in her studio. Courtesy of the artist.

for countless New Yorkers. Familiarity makes the moment feel no less special. Like seeing the night sky full of stars, the scene feels different but equally mesmerizing every time. Rendered in exquisite detail, the mosaic dazzles. Spots of white glass behave like points of light dappled across the deep blue background.

Rendered in rich blue glass tesserae, the work builds on Smith's cyanotype *Light of the World*. Smith often revisits images in her work across various media. For her Grand Central Madison proposal, Smith applied this transformative process to familiar subjects, including the surface of the East River and a deer in marsh reeds, and to new source material collected in Long Island. As she describes the process, "I need to go to a place, go somewhere and see something, learn the nature. There are climate zones, birds, the ocean landscape—all things I will need to see to refine my imagery. I take photographs, make drawings on site, and then watercolors or more drawings. Watercolors are scanned; drawings are turned into acetates, which are turned into photolithographs, which are then printed and collaged. These different pieces are hand colored to create new images . . . The source materials grow into new life. You go to a place—either natural or architectural—and it tells you what to do. The land and spaces tell you what to do. You want it to have love in it . . . it has to feel like love, have a caring intent."

Four of Smith's mosaics are installed on the mezzanine level of the terminal, reached by train or 150-foot escalators down from the concourse. Arched alcoves create a shadow-box effect for the roughly 200 square feet of mosaics in each of the four niches at the entryways above the train platforms. Rendered in a range of styles, the vignettes act as portals to the diverse ecologies of Long Island, while infusing the quiet dignity of the space with a sense of wonder.

The Water's Way (45th Street niche) depicts streams cutting their way through rocks to larger bodies of water. The rocks in the image are fabricated from Nagelfluh, a German stone common to the Bavarian Alps. The most abstract of the mosaics, Smith was surprised to find this piece to be the most challenging and ultimately most exciting translation. Inspired by postwar Brutalist mosaics, the composition uses larger pieces of glass and hard-edge geometry to interpret the collage aesthetic of Smith's mixed-media work, originally made on paper.

The Presence (46th Street niche) features a small deer paused among tall, golden marsh reeds. The deer, an animal that typically lives in a herd, is depicted in the company of birds enjoying a moment of peace, tucked away in safety and solitude. Prismatic light from a crystal spinning in the artist's studio unexpectedly threw rainbows across the scene, lending an air of magic. The happy accident is forever captured in the mosaic scattered among a constellation of Smith's iconic blue stars—Ursa Major, Ursa Minor, and the North Star.

Wild turkeys, native to Long Island, strut in a lush forest setting in *The Spring* (47th Street niche). Smith, who has kept a limited palette for most of her career, pushed her use of color for the Grand Central Madison commission. The result is most noticeable in this mosaic. In response Mayer expanded their vocabulary for Smith's work, creating fused glass pieces for the feathers that build on the rich tones and highly detailed linework seen in the original artwork. Vibrant hues blend into rich earth tones when viewed from a distance.

Original artwork for *The Sound.* Courtesy of the artist.

Rain clouds empty in*to The Sound* (48th Street niche), depicting an atmospheric moment on a Long Island Sound beach. A lone seagull flies among swirling clouds above the water's choppy surface, in the 28-foot-wide mosaic, the largest on this level. Rendered in a style that most closely resembles Smith's tapestries, the fine linework reads like a tightly knit textile.

Summing up the Grand Central Madison commission, Smith comments, "Each mosaic is a meditation on the paths that animals, water, and the stars travel through the land and the sky."

Above: Mayer of Munich team member Installing *The Sound*. Photo: Richard Lee.

Below: Detail of mosaic turkey feathers in *The Spring*. Photo: Kiki Smith.

Opposite: Detail of *The Water's Way*. Photo: Kiki Smith.

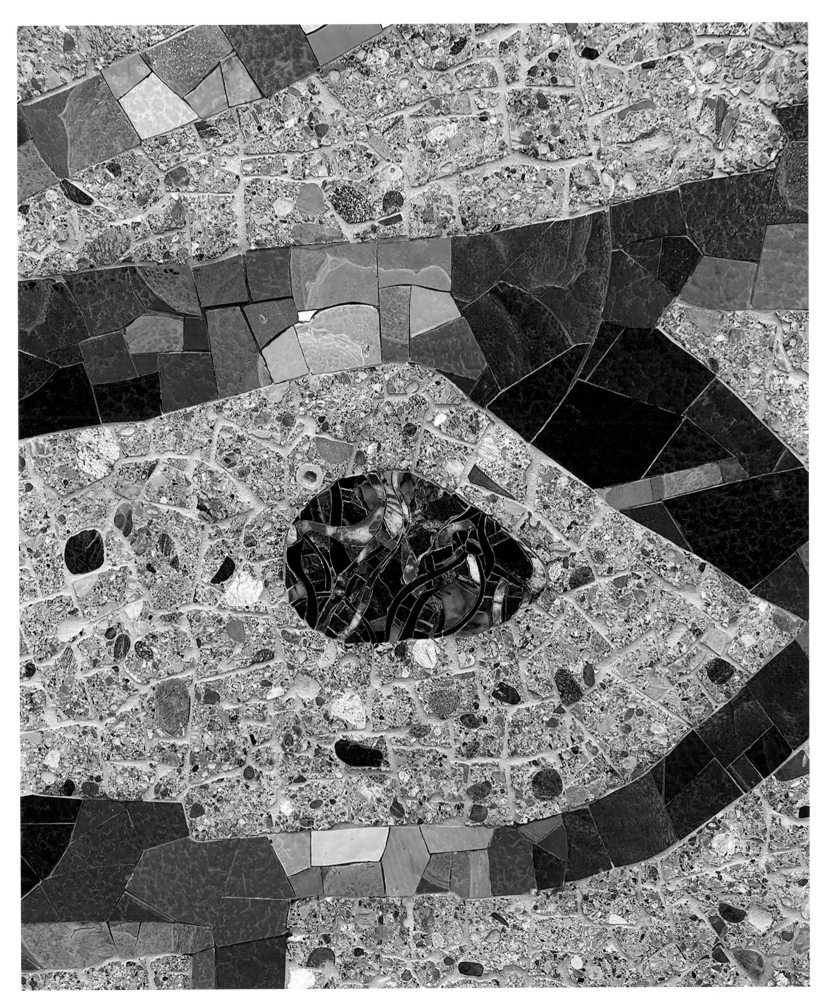

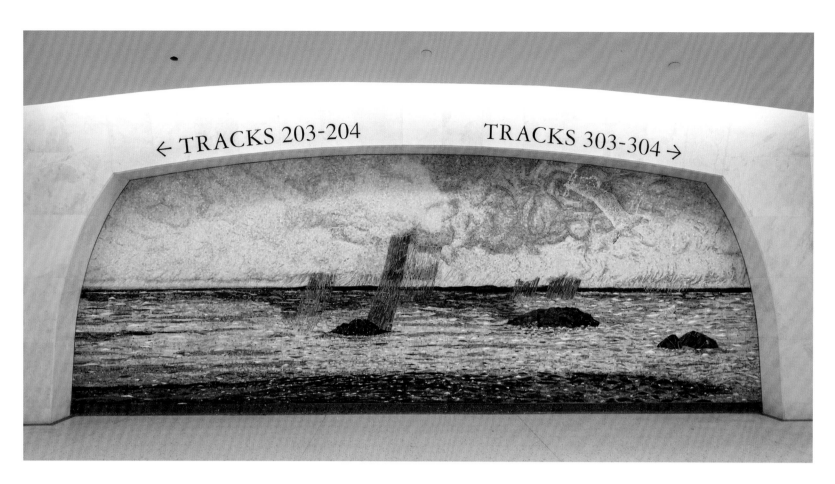

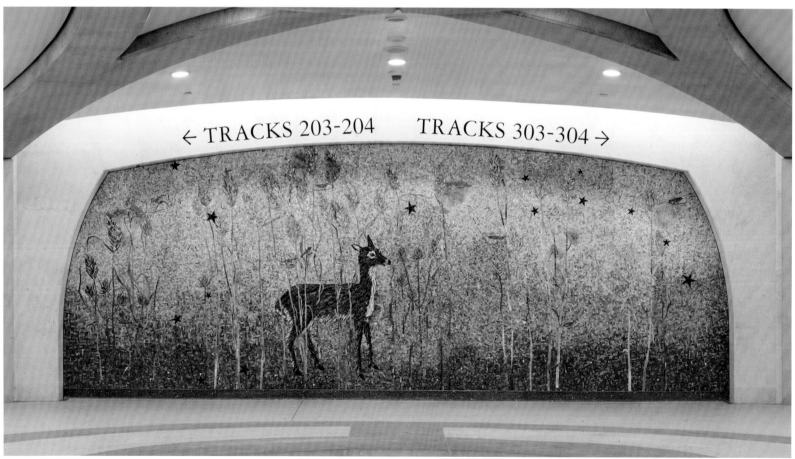

Clockwise from upper left: *The Sound,*
The Spring, The Water's Way, The Presence.
Photos: Anthony Verde Photography.

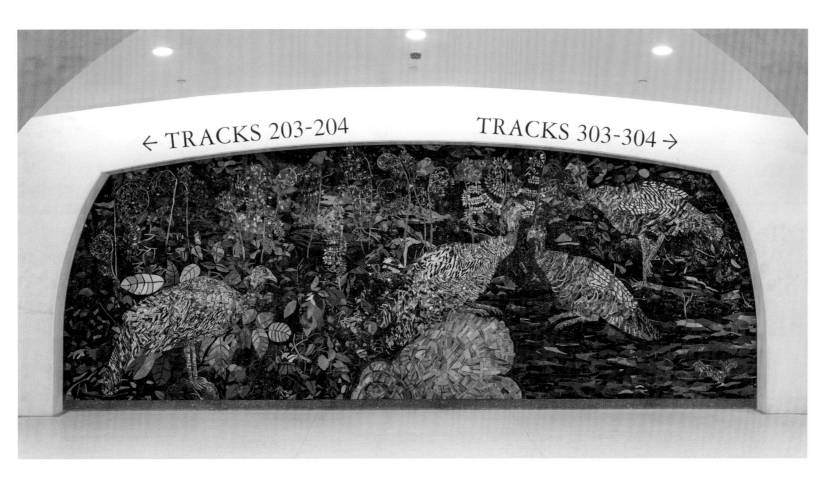

A New Look for Stations

A major initiative to modernize stations led to new mosaic, glass, and metal works by more than two dozen artists, including Alex Katz, Yoko Ono, Mickalene Thomas, Firelei Báez, Rico Gatson, and Nancy Blum. In 2016 the MTA was challenged to create a contemporary transit experience through a series of rapid improvements to the passenger journey. The New York City Transit Capital Program Management team, MTA Arts & Design, and Grimshaw Architects developed a comprehensive vision, articulated in new station standards and first implemented in nineteen New York City Transit stations and then widely adopted by the commuter rail lines. Grimshaw's design concept took inspiration from the iconic subway signage created by Unimark Graphics led by Bob Norda and Massimo Vignelli. A fixture of the MTA system since the 1970s, the Helvetica font and clean, bold graphics have global recognition. The thinking was subtly applied to station aesthetics to produce a sleek, modern look.

The initiative brought aging stations into the twenty-first century. Navigation for riders was improved through added technology and simplified signage. Transparent barriers improved visibility and contributed to a greater sense of safety. Responding to the variety of architecture in the system, the program introduced contemporary lighting and a neutral color palette, with room to express the history and unique characteristics of each station. New material choices and smart industrial design elements contributed to the dramatic results. The renewed stations were rapidly transformed into organized spaces, able to function more efficiently and provide a more pleasant user experience.

Art is a key feature of the stations where the guidelines were applied. Integrated into the architecture, the art contributes to the wayfinding improvements and helps to emphasize the station identity. While permanent art is regularly included in station renovation projects, the examples highlighted in this section achieve something special. Like the initiative, these artworks are impressive in their scale and ambition. Elements of the modernization program have been adopted by the various MTA agencies. The impact of the initiative and these artworks will continue to make a difference in many communities throughout the city for years to come.

Monika Bravo, *Duration,* 2017, Prospect Avenue Station. Photo: Peter Peirce.

NANCY BLUM

ROAMING UNDERFOOT, 2018
28th Street ⑥

ROAMING UNDERFOOT features oversized magnolias, daffodils, hydrangeas, camellias, red buds, hellebores, and witch hazels. The selection of flora, notable for their ability to sustain changing climate conditions, can be found seasonally in nearby Madison Square Park.

Set in one of the original 1904 subway stations, the floral motif also relates to the history of the area, which was home to Tiffany Glass Company (later Tiffany Studios) into

the twentieth century. Working under the direction of Louis Comfort Tiffany, the Women's Glasscutting Department was managed by designer Clara Driscoll who is thought to be responsible for introducing the now-iconic leaded lamp shades. Among her many contributions, Driscoll designed the Wisteria lamp in 1901.

Nancy Blum's inspiration goes back even further in time. Using sixteenth- and seventeenth-century botanical drawings and prints as a starting point, she renders her images in ink, colored pencil, gouache, and graphite on paper. The large scale is key to the artwork's success. Blum describes her intent, "I'm depicting the environment in the subway, and that underscores everything I've done with my botanical imagery. I've always tried to make my flowers feel like they're alive and

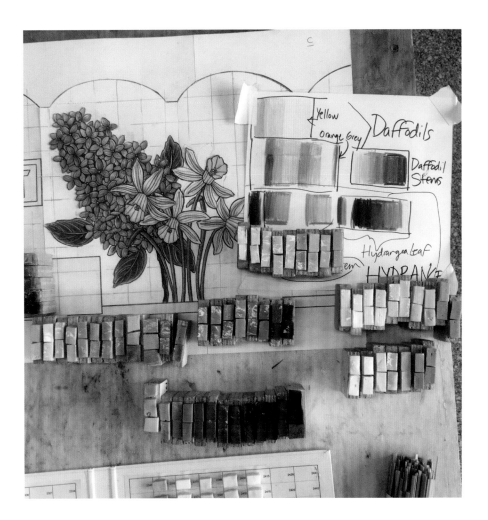

Above: *ROAMING UNDERFOOT*. Photo: Cathy Carver.

Above, right: Original drawing by Nancy Blum, paint swatches, and mosaic color matching at Miotto Mosaics Art Studios. Photo: Nancy Blum.

Right: Detail of *ROAMING UNDERFOOT*. Photo: Cathy Carver.

important like the people, placing them in the same scale. For those in the station, I'm creating an intimacy with the flowers that are around them. The plants are asking for our engagement."

Blum created detailed color studies that fabricator Miotto Mosaic Art Studios, working with Travisanutto Mosaics, used to translate her drawings into glass mosaics. Color matching was one of many critically important steps in the process to ensure that the result is true to the artist's vision. The delicate linear quality of her drawing is also integral to Blum's work. To ensure the interpretation was in keeping with her intent, Blum created a drawing of the floral images at half-scale so the mosaicists could be sure the mosaic matched the weight of the lines as they appear in the original drawing.

It was a tenet of the modernization program that historic elements not only be preserved but emphasized. Here gold Murano glass mosaic banding is used to reference large frames of American Encaustic mosaics in the original station design by Heins & LaFarge and complements Blum's contemporary artwork.

Left and above:
ROAMING UNDERFOOT.
Photo: Cathy Carver.

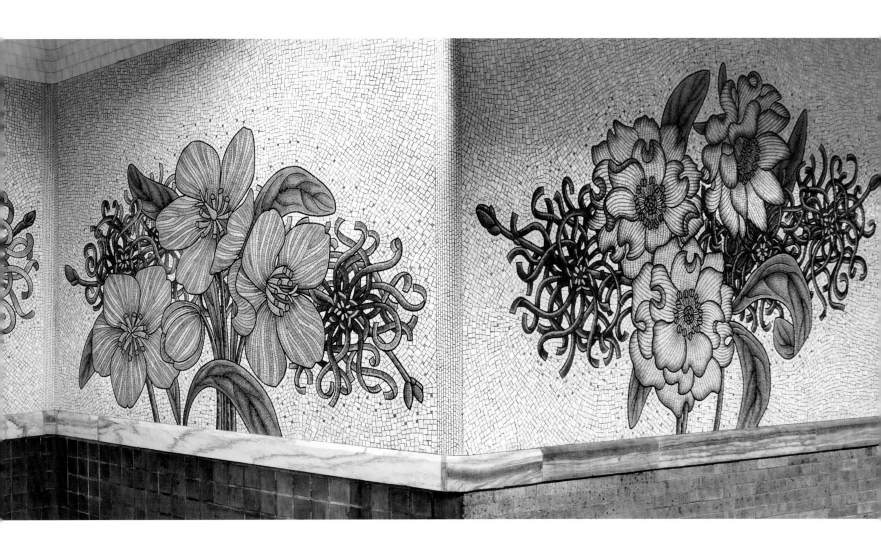

Right: Historic terra-cotta plaque with new metallic gold Murano glass banding, made by Mosaici Donà Murano of Donà Stefano. Photo: James Lane.

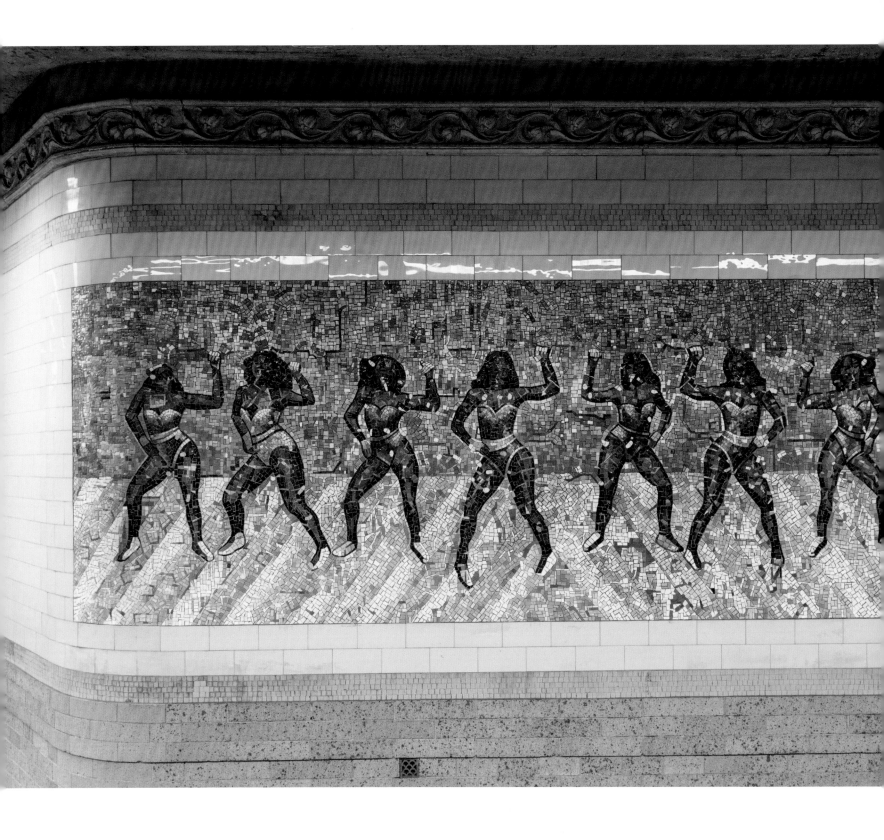

DEREK FORDJOUR

PARADE, 2018

145th Street ❸

At 145th Street, the modernization efforts pay respect to the historic ornament at the original station by Heins & LaFarge and integrates contemporary artwork into the Beaux-Arts design. Derek Fordjour's richly textured paintings and collage are the foundation of his interdisciplinary practice, which includes video, sculpture, and installation. Fordjour builds the surface of his paintings with a variety of materials through a process of tearing, cutting, painting, and drawing, designed to conceal and reveal. His work is often figurative,

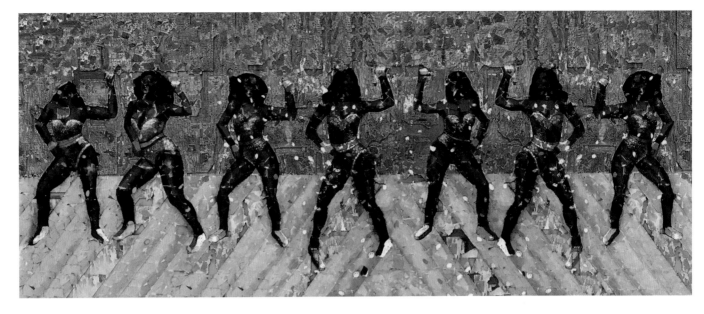

Left: *PARADE* installed below the original terra-cotta moulding. Photo: Anthony Verde Photography.

Above: Original artwork for *PARADE*. Courtesy of the artist.

Right: *PARADE* during fabrication. Courtesy of Miotto Mosaic Art Studios.

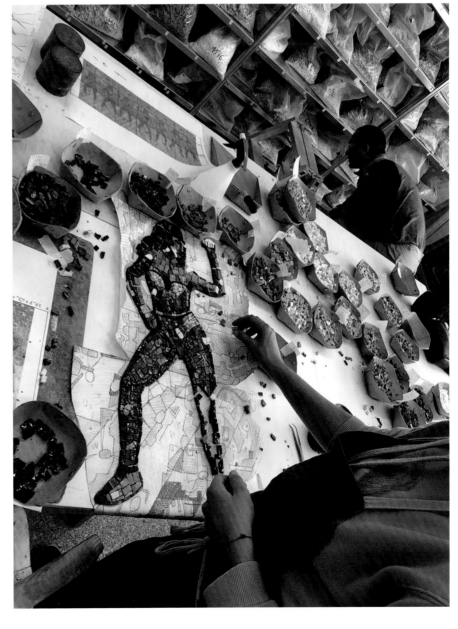

depicting Black performers, athletes, and cultural figures. The iconography of games and sports provides historical and sociological context. A Harlem resident, Fordjour felt tremendous support from the artists' community long before he was selected for the project. The artist, who considered a subway commission the pinnacle of artistic success in New York City, has said that being chosen to create art for this station fulfilled a dream.

Drawing on his familiarity with the community, Fordjour

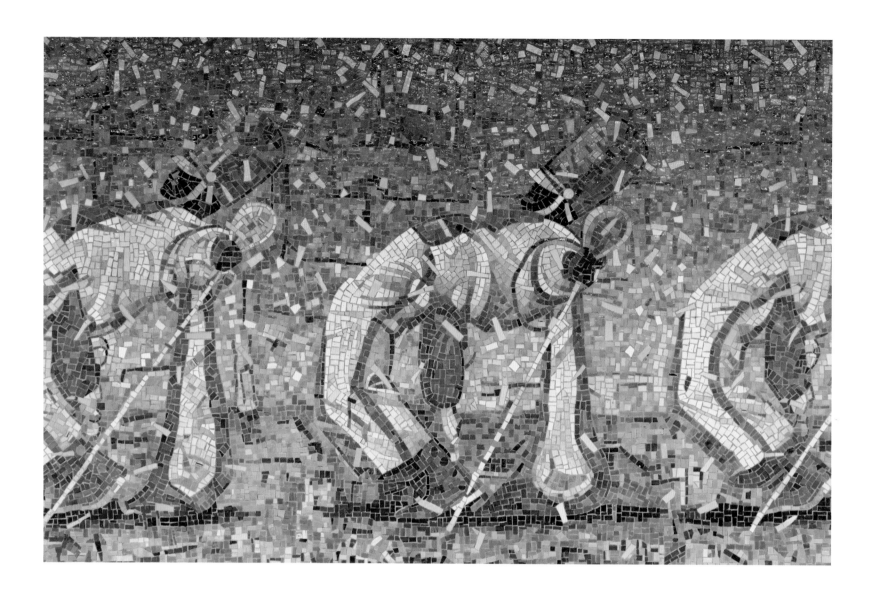

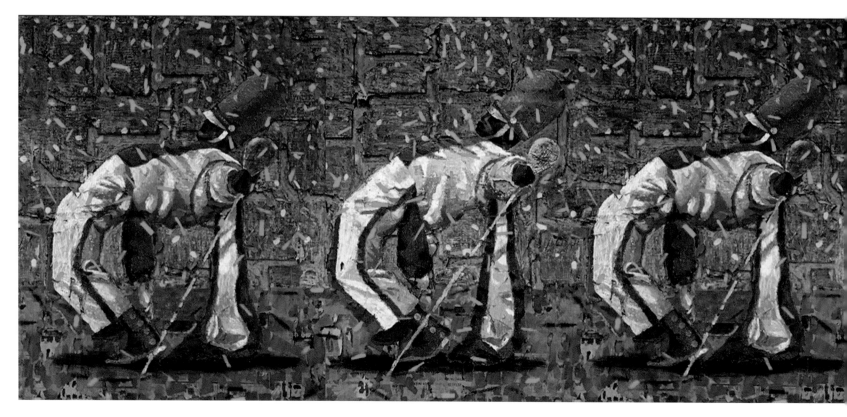

Opposite: Detail of *PARADE*. Photo: Anthony Verde Photography.

Below: Original artwork for *PARADE*. Courtesy of the artist.

Right: *PARADE* during fabrication. The fabricators work on the cartoon in reverse to create the mosaics. Courtesy of Miotto Mosaic Art Studios.

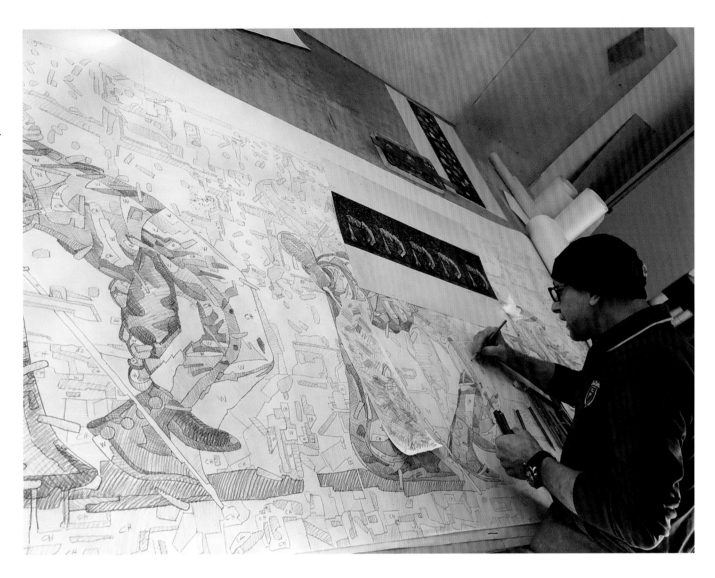

evoked the neighborhood's history, focusing on its legacy of parades steeped in pageantry, an African American tradition in Harlem. Fordjour began with the Harlem Hellfighters 369th Regiment and their parade on Fifth Avenue after World War I, moved to the African American Day Parade, founded during the Civil Rights movement in the 1960s, and on to contemporary parades with the figures marching in the direction of the trains. The designs are intended as celebration of community, identity, and history, created for those who use the station.

Fordjour worked with Miotto Mosaic Art Studios, in collaboration with Travisanutto Mosaics, to create mosaics that emulate the rich textures and material layers of his paintings. After observing Fordjour at work in his studio, master mosaicist Stephen Miotto commented, "When you feel Fordjour's hand in the work, it makes it easier to know where to go." The mosaics are composed as if they are collaged, capturing the essence of Fordjour's surfaces.

RICO GATSON
Beacons, 2018
167th Street Ⓑ Ⓓ

Gatson's *Beacons* builds on the artist's *Icon* series, exhibited at the Studio Museum in Harlem in 2017. Drawing from a body of work that references African textiles and religious iconography, the series is an exploration of Black history and identity. At the center of *Beacons* are portraits of eight celebrated African American and Latino figures with ties to the Bronx: Maya Angelou, Celia Cruz, Audre Lorde, Sonia Sotomayor, Tito Puente, James Baldwin, Reggie Jackson, and Gil Scott-Heron. Each is portrayed in a black-and-white photograph at the center of a triptych. Bold lines radiate from the figures, conveying their energy and influence on the Bronx community and well beyond.

Miotto Mosaic Art Studios, working alongside Travisanutto Mosaics, used multiple shades of gray to black tesserae to create the portraits, drawing from a mix of warm, cool, and neutral tones to achieve the likenesses caught by the photographers. The beams of color are rendered in a

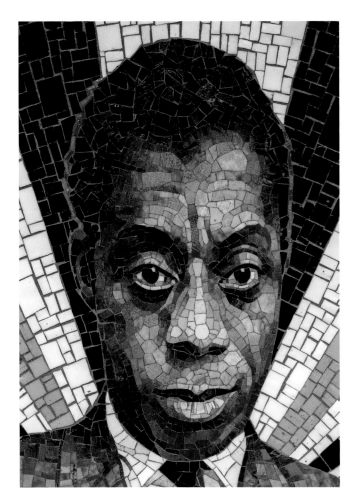

Left, above: Portrait of Justice Sonia Sotomayor based on a photograph by Timothy Greenfield-Sanders. Photo: Seong Kwon.

Left: James Baldwin portrait derived from a photograph by Steve Schapiro. Photo: Seong Kwon.

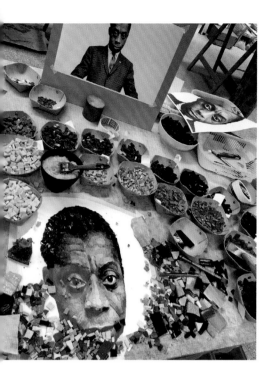

Above: Portrait of James Baldwin during fabrication. Courtesy of Miotto Mosaic Art Studios. James Baldwin portrait derived from a photograph by Steve Schapiro.

Above right: Reference portrait of Reggie Jackson (left) and the mosaic interpretation (right). Courtesy of Miotto Mosaic Art Studios.

Right: Reggie Jackson portrait derived from a photograph by Doug McWilliams and National Baseball Hall of Fame and Museum, Cooperstown, New York. Photo: Seong Kwon.

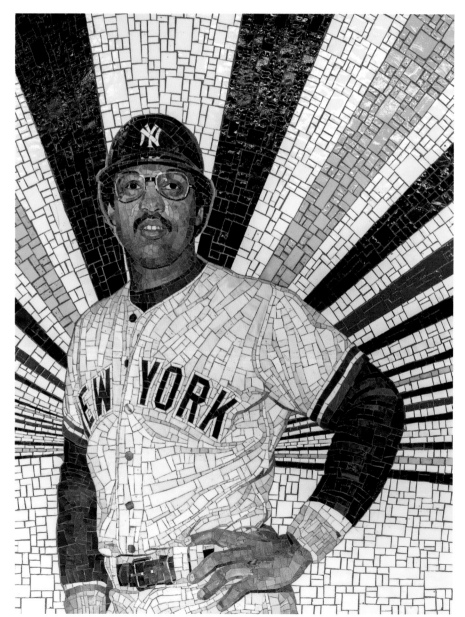

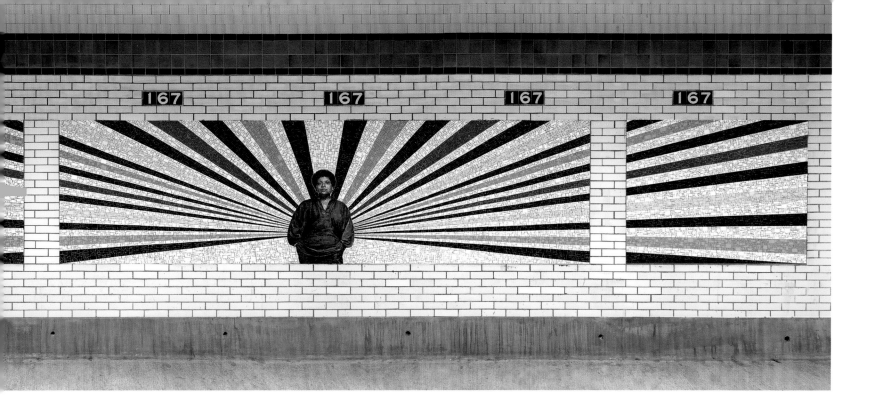

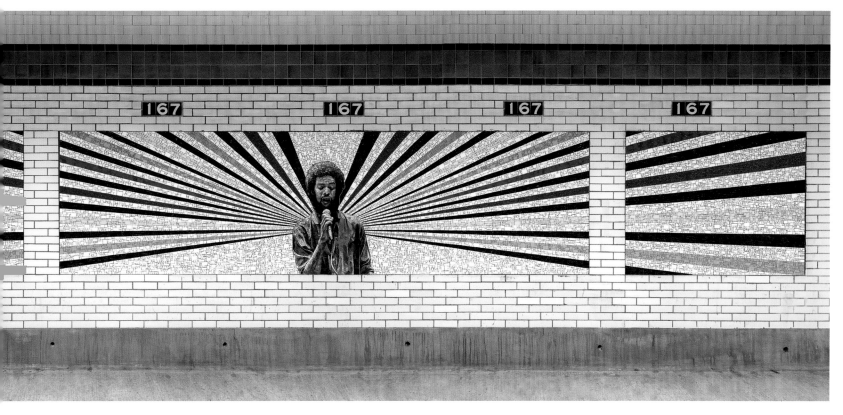

Top: Audre Lorde
portrait derived
from a photograph
by Jack Mitchell.
Photo: Seong Kwon.

Above: Gil Scott-Heron
portrait derived
from a photograph
by Paul Natkin.
Photo: Seong Kwon.

hard-edged style referencing minimalism and saturated colors connecting to African culture. Gatson describes the colors as "coming out of a Pan African sensibility of black, red and green, but expanding with yellow and orange and sometimes evolving into silver and gold."

Opened in 1932, 167th Street Station, on the Grand Concourse in the Bronx, was designed with a modernist aesthetic. The mosaic imagery builds on those elements through the bold forms and color palette. Gatson's artwork adds a vibrant identity that defines the contemporary space.

FIRELEI BÁEZ

Ciguapa Antellana, me llamo sueño de la madrugada (who more sci-fi than us), 2018

163rd Street-Amsterdam Avenue Ⓒ

Báez's artwork speaks to her Dominican-Haitian heritage and the Caribbean culture thriving in the Washington Heights neighborhood. Inspired by Dominican American author Junot Díaz's 2007 novel *The Brief Wondrous Life of Oscar Wao*, the mosaic is rich with narratives connected to Dominican folklore and African diasporic histories.

Intended to inspire hope for the future, the artwork incorporates tropical plants, plantains, and lush North American leaves and vines. Symbols and superstitions rooted in Caribbean culture are incorporated, including the hand-shaped amulet of Azabache bracelets, believed to bring good luck and protect babies from the "evil eye." *Ciguapas*—described as magical female forms that have brown or dark blue skin, bodies covered with long manes of hair, and backward-facing feet—are central to the artwork and its exploration of tradition, myth, and female identity.

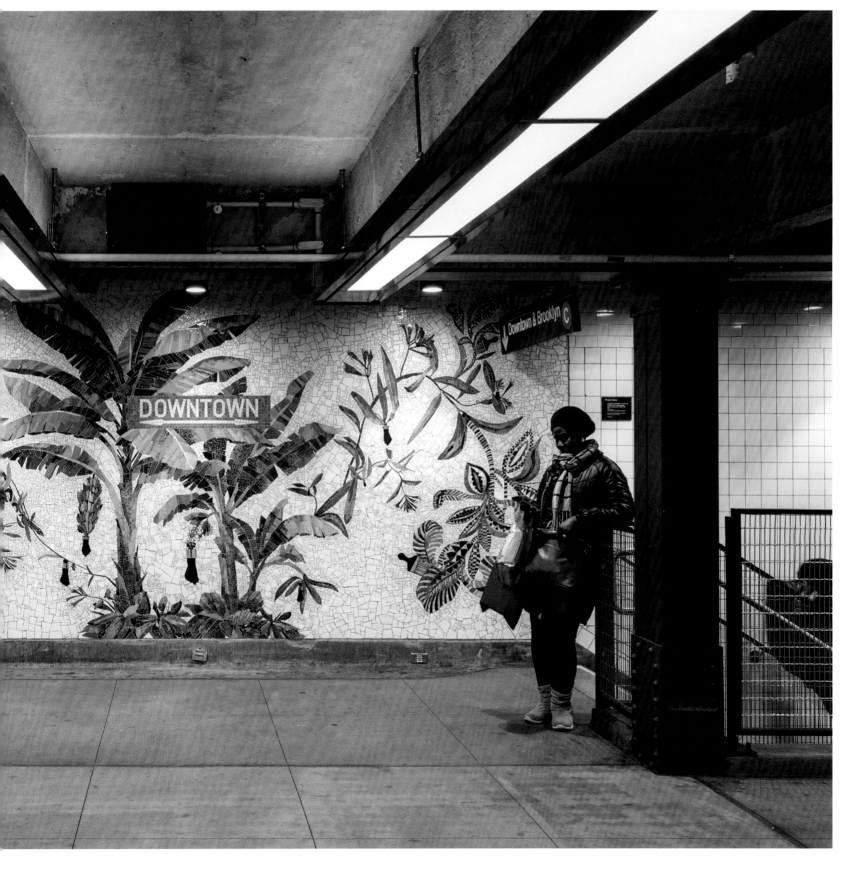

Ciguapa Antellana, me llamo sueño de la madrugada (who more sci-fi than us) Photos: Osheen Harruthoonyan (opposite), David Sundberg/Esto (below).

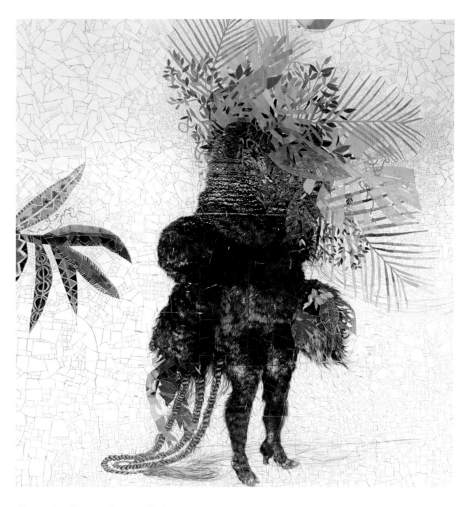

*Ciguapa Antellana, me llamo sueño de
la madrugada (who more sci-fi than us).*
Photos: Osheen Harruthoonyan (above),
David Sundberg/Esto (right).

Like a vision lifted from an early morning dream, elements
of magical realism abound. Vivid greenery sprouts in black
and white. Elsewhere recognizable plants in unnatural shades
of blue and orange gather in a bouquet resembling a plume
of feathers. Rows of sugarcane may be another nod to Díaz's
novel. Báez's scenes transport viewers to real or imagined
lands, but mosaic platform signage integrated within the
imagery reminds viewers that uptown and downtown trains
are only steps away. The works are set on a background of
solid white glass mosaic within a surround of dark columns,
beams, and ceiling fixtures that highlight the delicate linework
and rich detail. The artwork and station aesthetics combine
to create a bright and welcoming space.

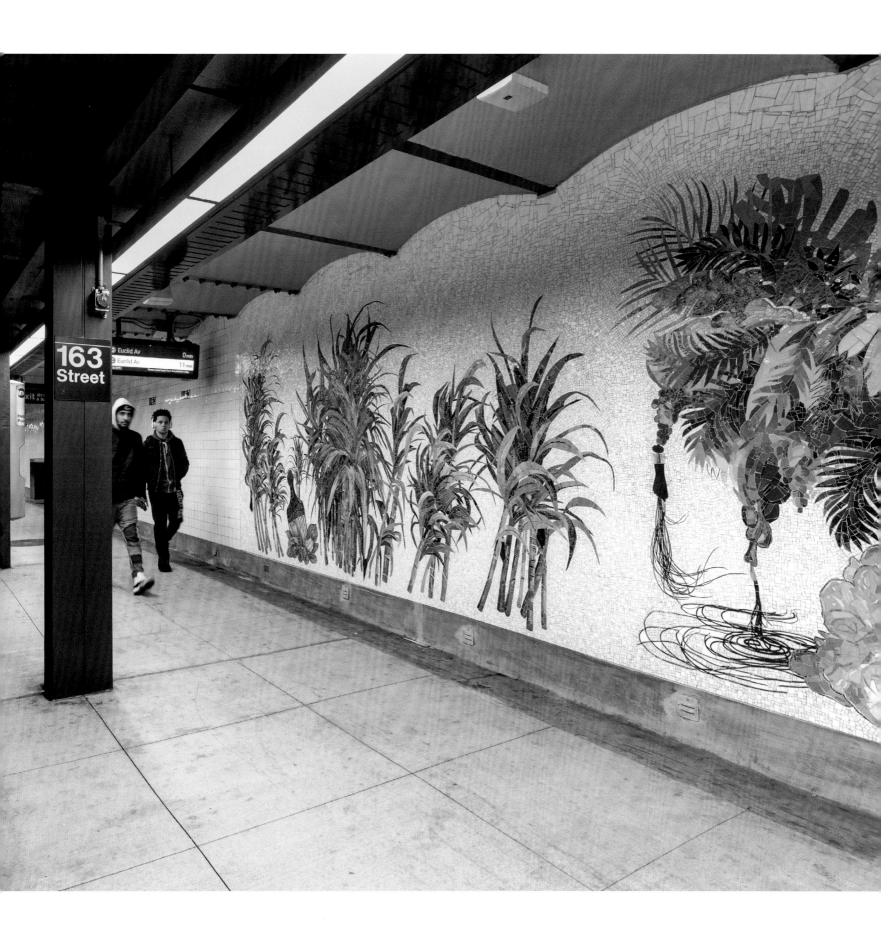

Mezzanine. Photo:
James Lane.

ALEX KATZ

Metropolitan Faces, 2019
57th Street Ⓕ

The 57th Street Station, opened in 1968, is a rare example of minimalist architecture in the MTA system. Katz's *Metropolitan Faces,* a group of fourteen portraits and five flower paintings installed on the mezzanine, add color and vibrancy that balances the cool cast stone walls and terrazzo floors of the original design.

Fabricated by Glasmalerei Peters Studios, the panels were hand-painted on the second surface—the back of the first panel of glass. The placement meant that the painting process had to be reversed, with the surface accents being applied first and the foundation layers built up as a second step. This inner position, while technically challenging to deliver, protects the artwork while offering the most vivid clarity. The painted glass is laminated to a second panel of glass containing an opaque white layer that blocks the transparency and intensifies the colors.

Metropolitan Faces features several paintings of Katz's wife, Ada, a frequent subject, as well as other family and friends. The portraits reflect those traveling through the station, and the flowers, based on scenes from summers in Maine, are reminders of the station's proximity to Central Park. Katz is a life-long New Yorker and subway enthusiast, who has commented, "It is a privilege to make art for all people."

Portrait of Choichun
Leung from
Metropolitan Faces.
Photo: Etienne
Frossard.

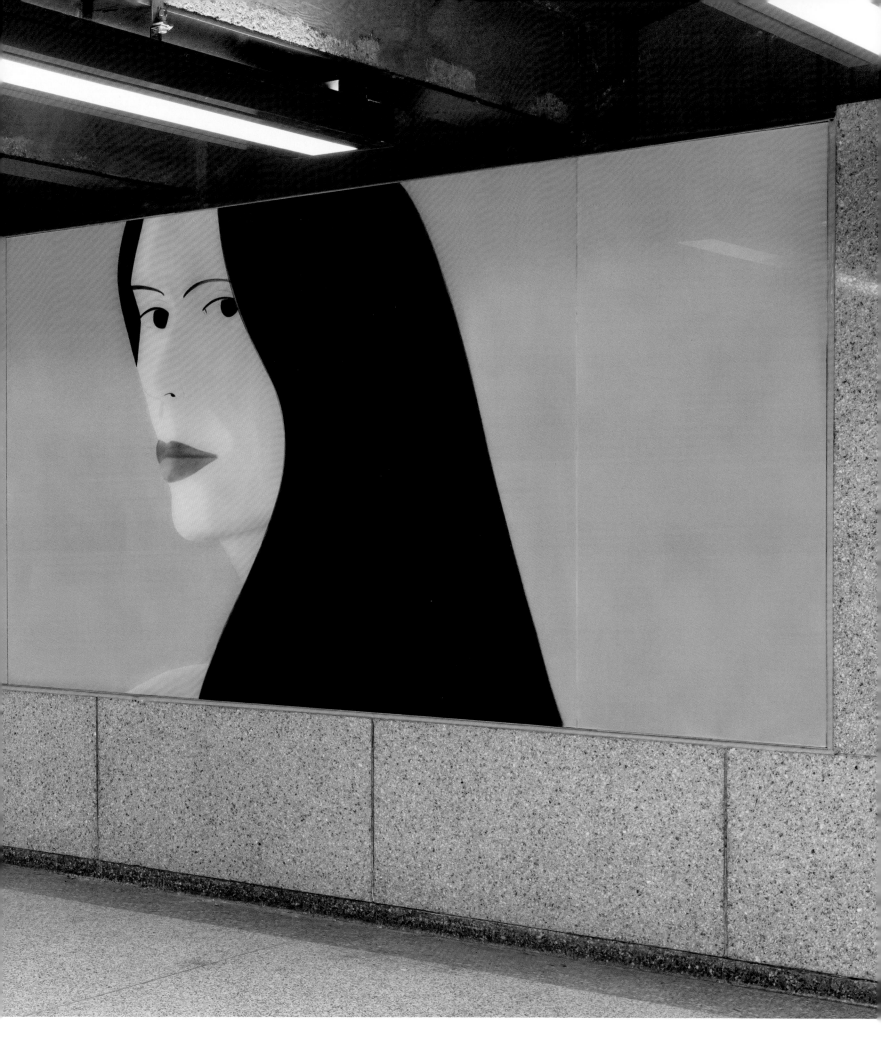

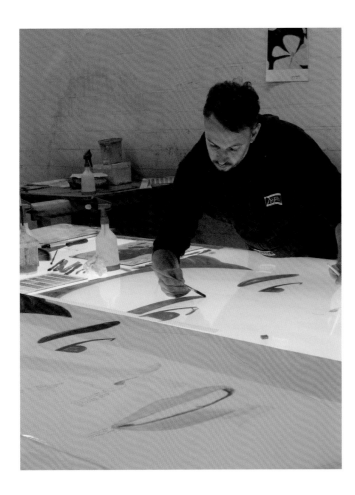

Top: *Oliver* during
fabrication. Courtesy
of Glasmalerei Peters
Studios.

Above: *Sante and
Juan* during fabri-
cation. Courtesy of
Glasmalerei Peters
Studios.

Right: *January
3, 1993* from
Metropolitan Faces
featuring Ada Katz,
wife of the artist.
Photo: Etienne
Frossard.

YOKO ONO
SKY, 2018
72nd Street Ⓑ Ⓒ

Six mosaics by Yoko Ono are installed at 72nd Street Station on Central Park West, directly below the artist's long-time residence at the Dakota, where she lived with her husband, John Lennon. Ono's work *SKY* encourages viewers to "dream," "imagine peace," and "remember love," via handwritten words floating within the mosaic's white clouds and blue skies. Of the location and composition, Ono said, "I'm thrilled that SKY is at the 72nd Street subway station just steps from my home and

Strawberry Fields, which I created in memory of my late husband. It will bring the sky underground, so it's always with us. I hope this will bring peace and joy to my fellow New Yorkers for many years to come."

The work greets riders entering the station, which was renovated with an emphasis on efficiency, simplicity, and elegance. In this hand-painted glazed-ceramic-tile mosaic, fabricator Mosaika Art & Design captured the delicate

SKY. Photos: Isabel Asha Penzlien (above),
Osheen Harruthoonyan (left).

transition of shades across the clouds and the sky. Ono's design was based on photographic images with the words superimposed in her own handwriting. The translation was sensitive to the nuanced imagery, with the glazes applied with an airbrush to achieve the softness of the nebulous forms in ceramic. The mosaic uses small, four-sided tiles of various sizes, set at a 45-degree angle. The result is a luminous sky with puffy clouds that seem to float through the scene, belying the weight and definition inherent in the medium of mosaic.

SKY. Photos: Isabel Asha Penzlien (top, left and right), Osheen Harruthoonyan (left, below).

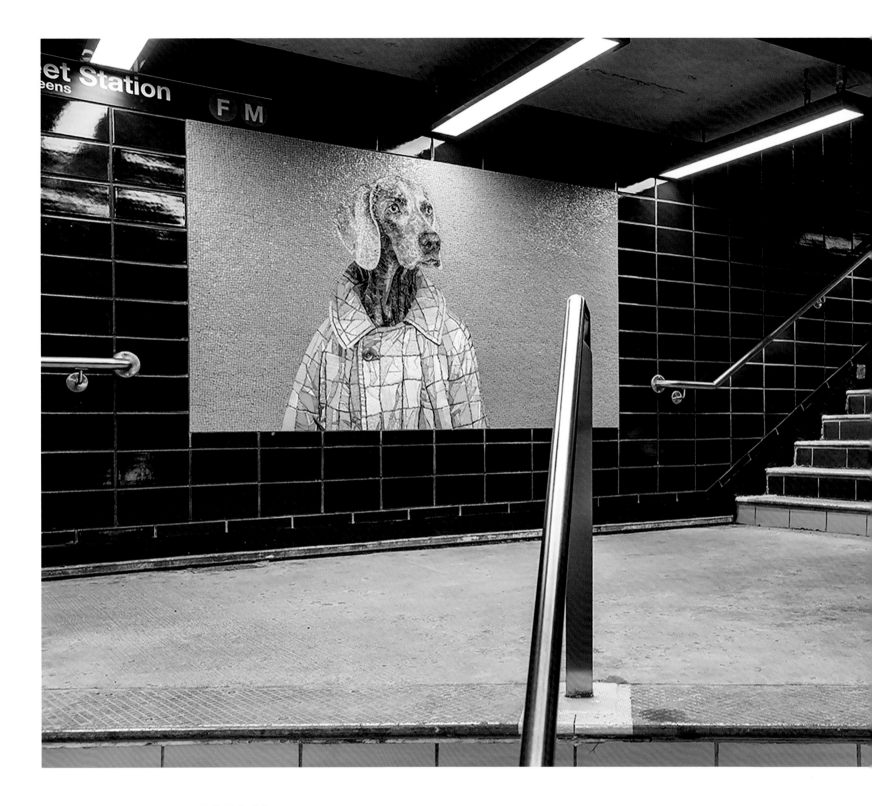

WILLIAM WEGMAN

Stationary Figures, 2018

23rd Street Ⓕ Ⓜ

William Wegman is best known for staged photographs of his Weimaraners. In the five decades since this practice began, Wegman has had ten Weimaraners, who have served as subject and muse. The dogs are posed, often in costume or with props. Anthropomorphism was never Wegman's objective; it was simply about turning the dogs into something else.

Stationary Figures consists of eleven glass mosaics depicting Wegman's dogs Flo and Topper. In some panels, they are simply posed; in others they are dressed in street clothes and jackets, bearing an uncanny resemblance to the riders entering the station and exiting the train. Surrounded by backgrounds of flat color, the dogs peer out

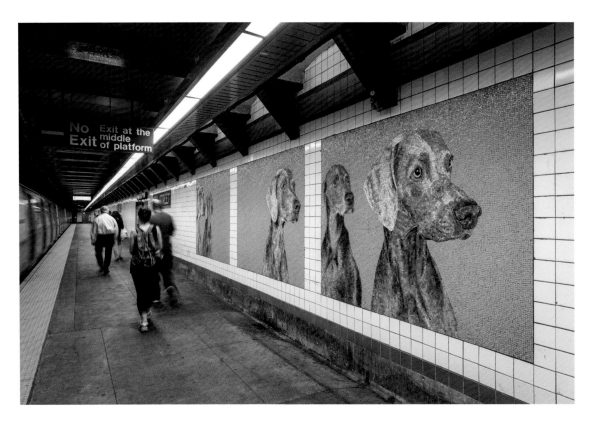

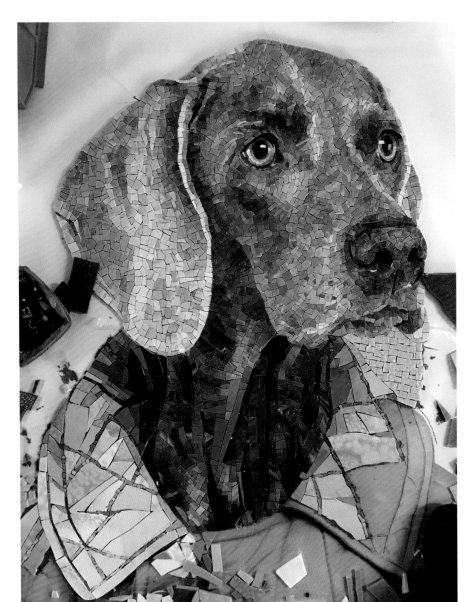

Left: *Stationary Figures* during fabrication. Courtesy of Mayer of Munich.

Stationary Figures. Photos: Patrick J. Cashin (above); James Lane (above right).

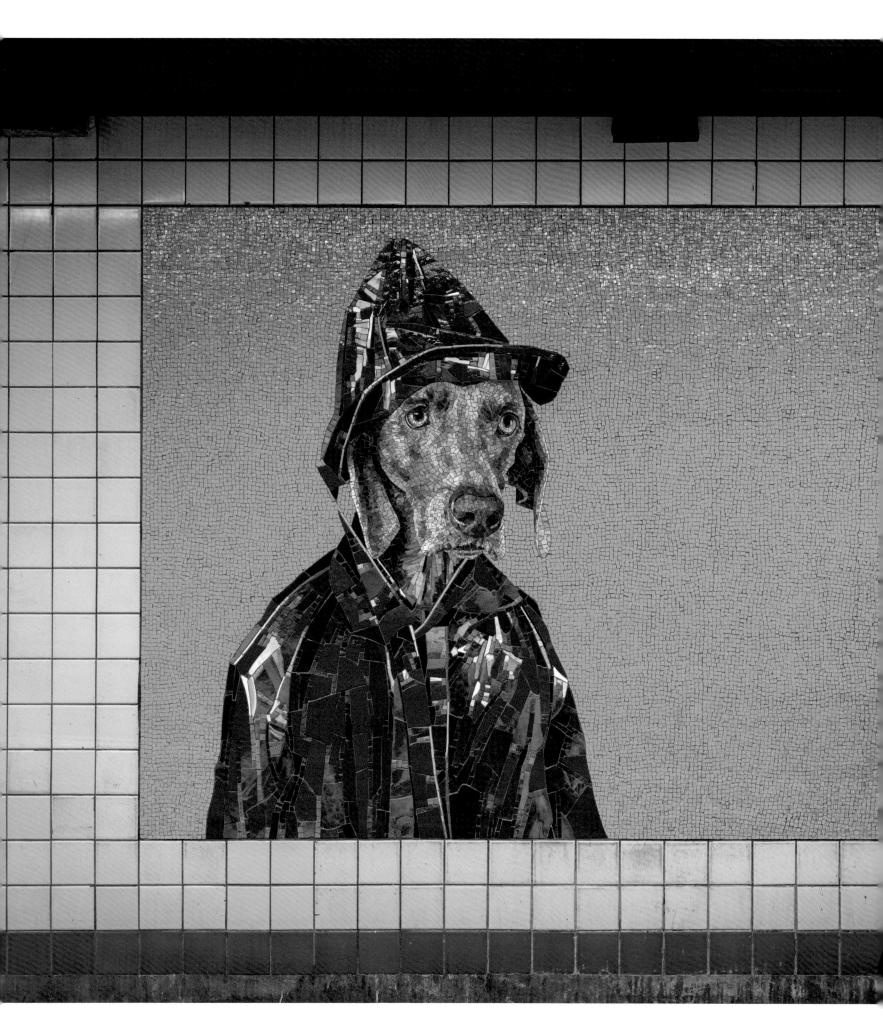

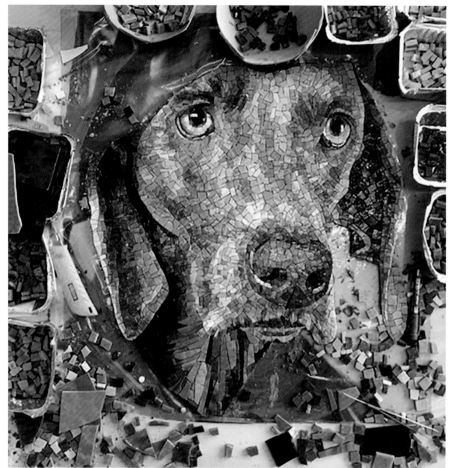

Left: *Stationary Figures.* Photo: James Lane.

Above: *Stationary Figures* during fabrication. Courtesy of Mayer of Munich.

of the scenes. Riders intuitively interact with the portraits. The memorable mosaics delight and help to guide riders by providing wayfinding cues.

The artist was delighted by the invitation to create large-scale versions of his portraits at the 23rd Street Station, near his studio-home in Chelsea. Wegman selected Mayer of Munich to fabricate the mosaics, based on a sample that perfectly captured the dog's facial expressions. As Wegman explains, "I wanted to create portraits of individual characters, people who you might see next to you on the platform. For these, I dress the dogs in more or less ordinary clothes, nothing too fashionable. I was very interested in the way in which photographs could be translated into mosaic by Mayer of Munich, who skillfully turned gray stones into gray dogs."

Mayer rose to the challenge of presenting Wegman's dogs as both readable and appealing. As is traditionally done with portraits, the mosaicists began with the eyes. Next, they built out the nose and jaw for direction. Soft gradations were used to render the fur. Set against a flat color background made up of tesserae, larger pieces of glass stylize the body and clothing.

MONIKA BRAVO

Duration, 2017
Prospect Avenue Ⓡ

Monika Bravo is inspired by geometric abstraction, modern technology, and writer Italo Calvino's *Invisible Cities*. Conceived as a mosaic tapestry, *Duration* weaves together vibrant color forms, deconstructed maps, and historical photos of the nearby Brooklyn waterfront. The work, composed of five sections each twenty-five feet long, is a richly detailed exploration of time, space, and memory.

Bravo's work is typically animated, but this static piece builds on the artist's ongoing exploration of color and rhythm. The composition is musical in character: the vibrant colors push and pull as they pulsate in place. Fabricated by Mayer of Munich, the material contrast offers viewers a physical experience that plays on the idea of *la durée* ("duration") as explained by the French philosopher Henri Bergson. The dynamic exchange is designed as a weaving of ancient and contemporary technologies, through the blending of mosaic and satellite images and a blurring of tesserae and pixels. Mayer used Mexican and Italian smalti and digitally printed glass to interpret Bravo's coded visuals and waves of energy.

The prominent horizontal line of the Unimark signage is reimagined three-dimensionally as a light fixture extending the full length of the platform. Integrated into the architecture, the artwork sits below the linear element, and above upgraded station furniture, including a cantilevered bench that floats in space. Billings Jackson Design was responsible for the detailed design of industrial elements throughout the modernization initiative.

Duration. Photo: Peter Peirce.

Top: *Untitled.*
Photo: Anthony
Verde Photography.

Above: Original
artwork for
Untitled. Courtesy
of the artist.

MICKALENE THOMAS

Untitled, 2017

53rd Street Ⓡ

Mickalene Thomas's expansive mosaic artwork *Untitled* collages textile patterns and New York State flora to reimagine the station environment by softening the space with gentle pastel tones and greenery. Apostrophe-like forms, suggestive of coiled fiddlehead ferns, reoccur throughout the panels.

Thomas is known to draw inspiration from Western art history. The concentric circle motif that repeats throughout the mosaic like a solar flare is a technique used by Harlem Renaissance painter Aaron Douglas to add depth and movement to his scenes. Other aspects of the imagery may tie back to Thomas's residency at Monet's home and gardens in Giverny, France. Made up of five mosaics on the platform level and two on the mezzanine, the compositions explore the artist's interest in plants and pattern, referencing both domestic and natural settings.

Miotto Mosaic Art Studios, working with Travisanutto Mosaics, translated the digital artwork by mixing material textures for a high degree of surface contrast to provide visual interest and to achieve the artist's collage-like style in mosaic. Sections of irregular pieces of traditional glass smalti are juxtaposed with a uniform setting of square ceramic tiles. Elsewhere larger areas of digitally printed photographs add another element of variation.

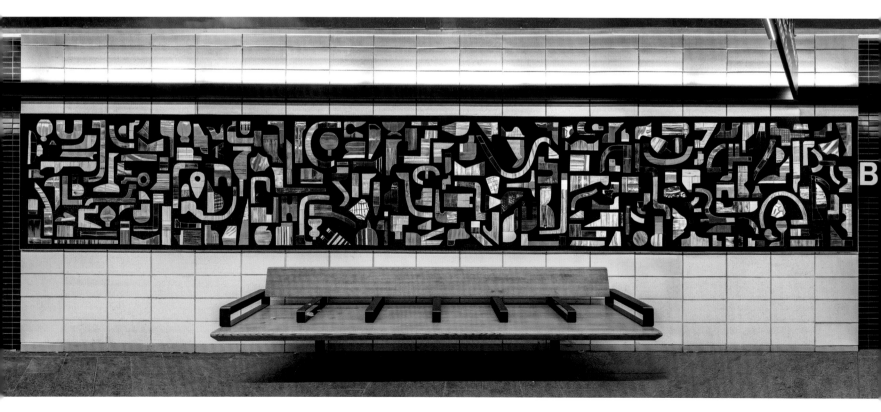

KATY FISCHER
Strata, 2017
Bay Ridge Avenue Ⓡ

Strata conjures up excavations for the Bay Ridge Avenue Station in the early twentieth century. Katy Fischer imagined hundreds of artifacts that could have been discovered during the dig and layered the hand-glazed ceramic pieces to suggest the depth at which they were unearthed. The abstract forms reference the many inhabitants over time. Shapes near the bottom represent bone fishhooks from the Lenape, layered with fragments of Delft pottery from Dutch settlers, tools and shoe buckles from colonial times; nearer the top, railroad spikes and Tiffany vases allude to the prosperous period when the subway transformed the area from farmland to a thriving community. Mosaika Art & Design hand-built the shapes in clay, then hand-glazed each "artifact" with subtle overlapping colors and textures. In addition to the five panels on the platform walls, two smaller panels on the mezzanine contain contemporary objects, such as plastic toys and painted items, made in noticeably brighter colors.

The mosaic on the Manhattan-bound platform is set in a background of white tumbled glass, suggesting daylight; while the Brooklyn-bound mosaic is set in black tumbled glass, conveying the idea of nighttime to commuters making their return trip home at the end of the day. The contrast aids wayfinding in the station, one of the first to be renovated using the new station standards.

Strata. Photos: Peter Peirce.

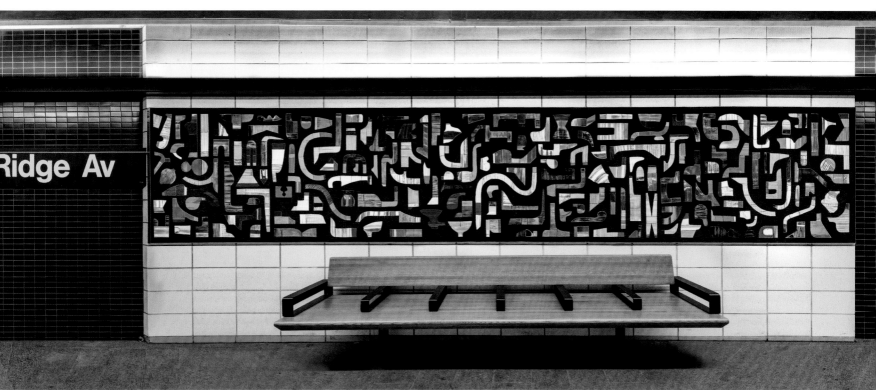

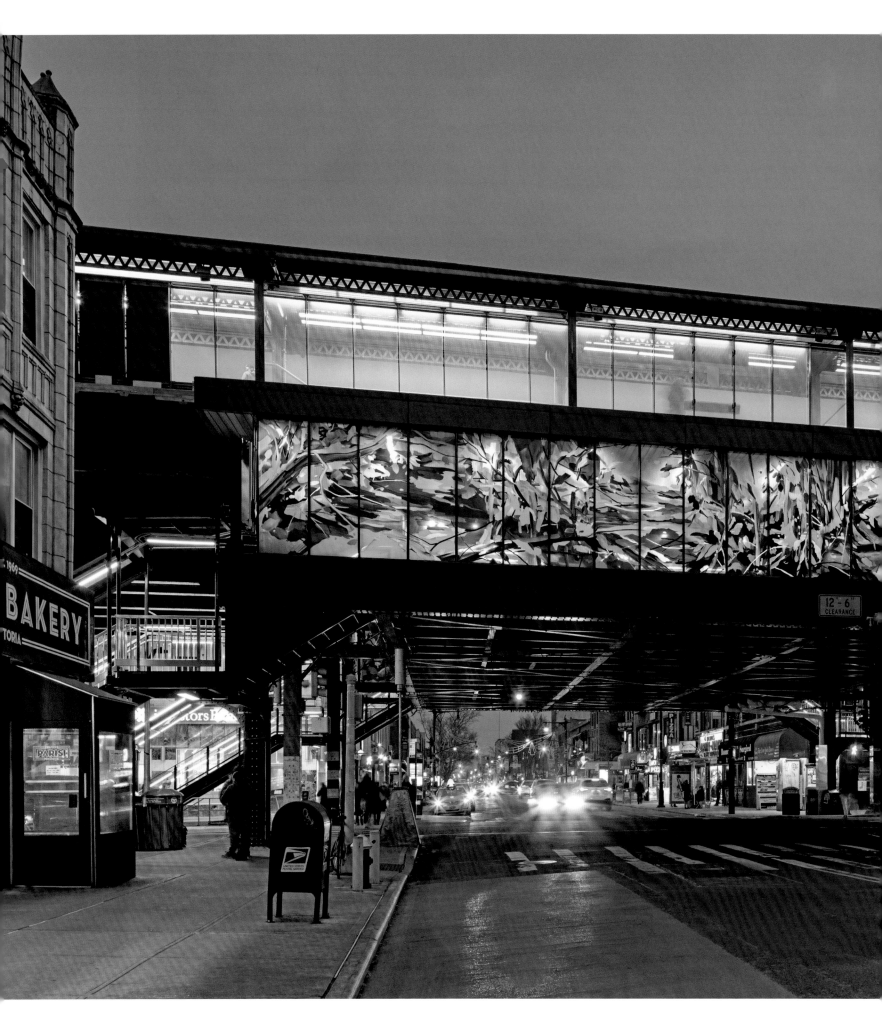

Elevated Stations

Four 100-year-old elevated stations in Astoria, Queens, were re-envisioned in a stylish, contemporary aesthetic by di Domenico + Partners, building on Grimshaw's design vision. Large-scale structural reconstruction provided an opportunity for art to be fully integrated into the architecture. Comprising more than forty panels of full-height art glass per commission, the artwork serves as the exterior facade, opening the station to views in and out. Located at either the mezzanine or platform level, the placement floods the space with color and light. At entrance ceilings and on the underside of platform canopies, Western red cedar introduced the warmth of wood to the station environment.

DIANE CARR
Outlook, 2018
Broadway Ⓝ Ⓡ

At Broadway Station, artwork by Diane Carr is captured in architectural glass panels integrated into the mezzanine facade. Based on oil paintings, *Outlook* puts Carr's bold and fluid strokes on display for all entering and exiting the station as well as viewers at street level below.

Carr is interested in concentrated color and in creating spaces that dissolve into abstraction. The original artwork is an imagined landscape connecting the past and present of the community around the station. Bordering abstraction and representation, the landscape highlights native flora, deciduous woodlands, swamps, wetlands, and meadows that once characterized the area. To connect the landscape with the present time, colors extracted from architecture, storefronts, restaurants, and public spaces in the current neighborhood were sourced for the palette of the artwork.

Carr envisioned an artwork that fills the station with light, color, and movement. The original artwork uses transparent paints to ensure the passage of natural light in the translation. As riders move through the space, they will find the vantage points in the landscapes vary in perspectives, fluctuating in the foreground one instant and receding the next moment. To achieve this vision, Carr worked with Glasmalerei Peters Studios, who utilized hand-painting and airbrushing with vitreous enamel colors to capture the painterly quality in the originals. Peters set the stage with a liquid resist. Both transparent and opaque colors were used to heighten the interaction, allowing the opacity and transparency of colors to dance off each other.

Outlook. Photo: Etienne Frossard.

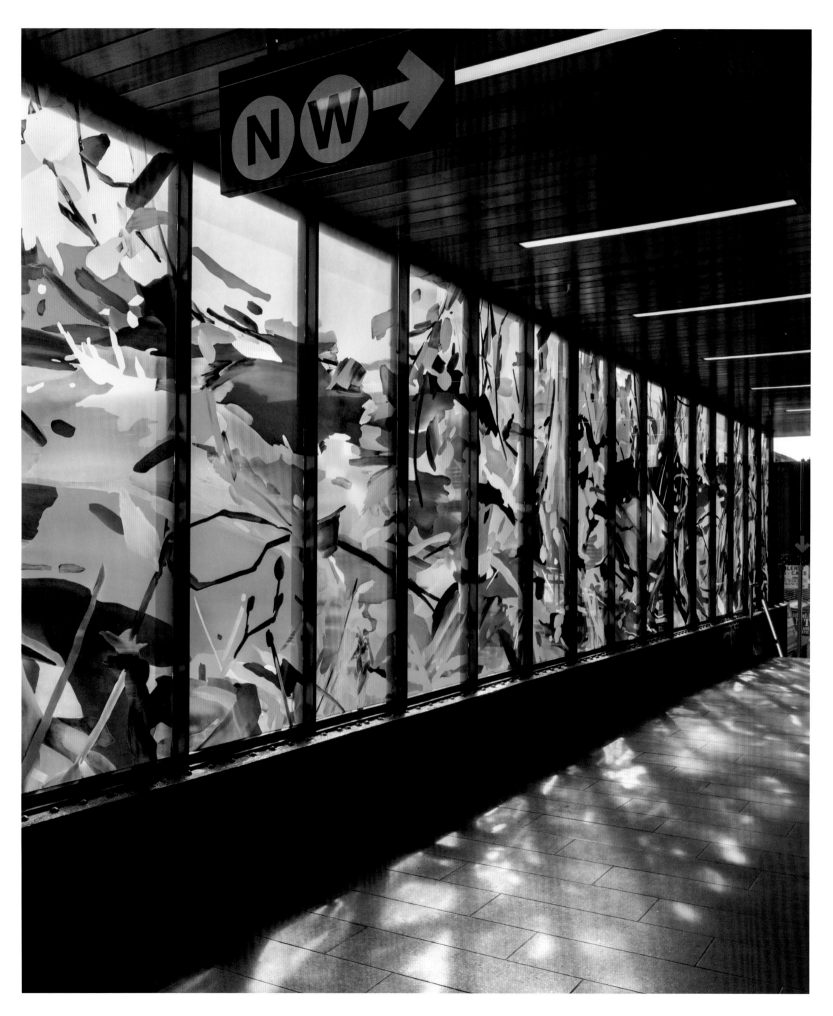

Opposite and below:
Outlook. Photos:
Etienne Frossard.

Right: *Outlook* during
fabrication. Green
paint seen on the
glass panel is liquid
resist. Courtesy of
Glasmalerei Peters
Studios.

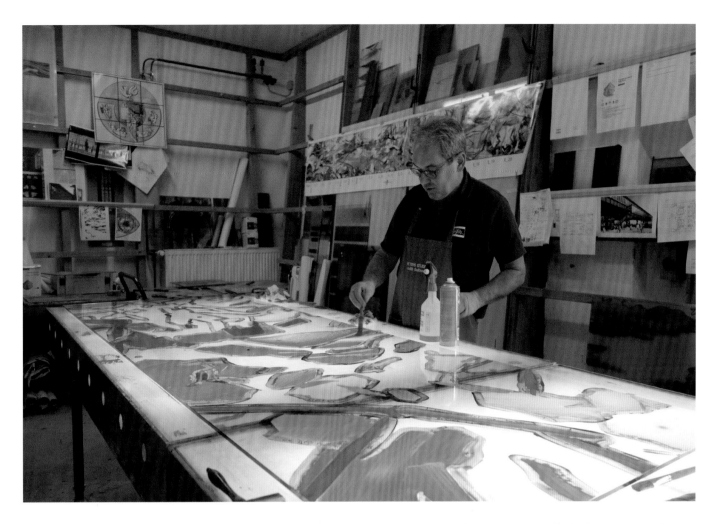

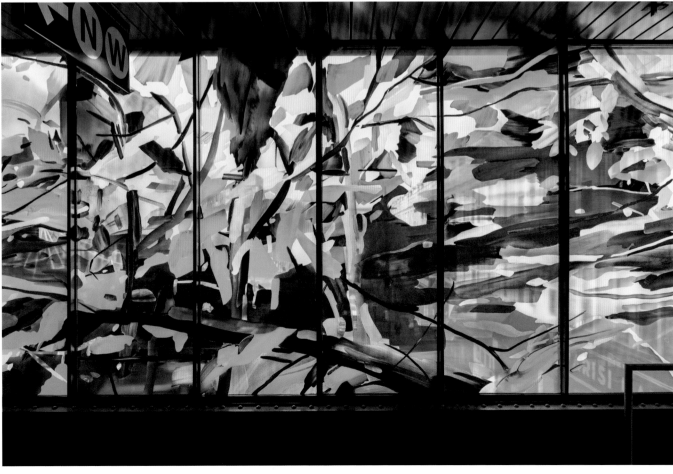

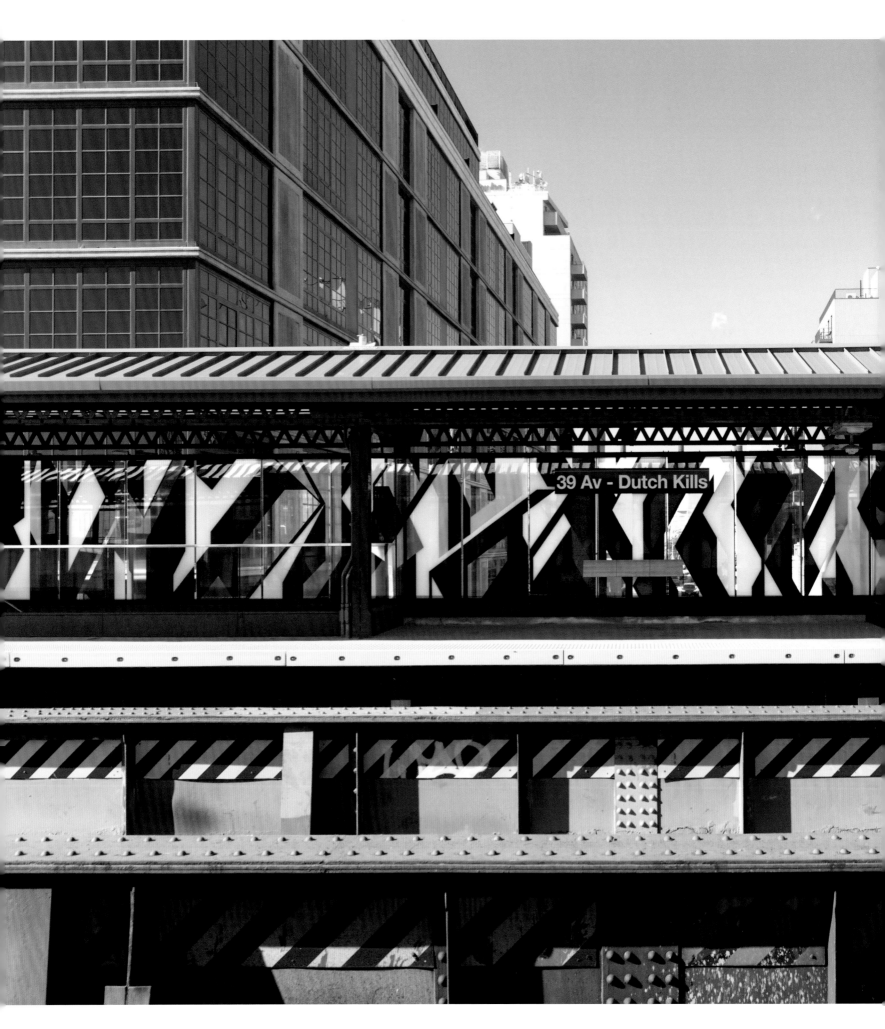

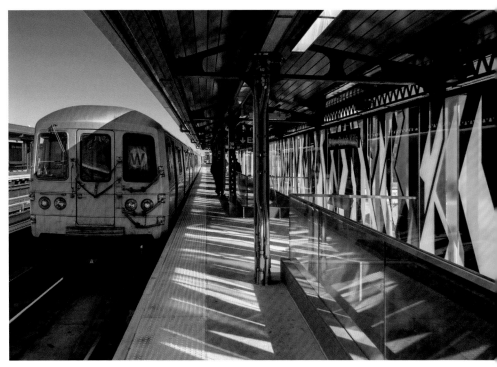

SARAH MORRIS

Hellion Equilibrium, 2018
39th Avenue-Dutch Kills Ⓝ Ⓦ

Helion Equilibrium.
Photos: Sean
Dack (left), David
Sundberg/Esto
(above).

Hellion Equilibrium is an artwork with a continuum of color and defined forms that contemplates the notions of mapping, movement, light, and social space. Forty-two panels of colored, architectural glass are installed on both the east and west platforms.

Sarah Morris is well known for abstract paintings that feature vivid color fields and graphic forms. Her films, a parallel practice to her paintings, explore the psychogeography and dynamic nature of cities in flux. *Hellion Equilibrium* is a graphic visualization of forms mirroring the action and movement in and around the elevated station. Inspired by capturing the reflection of the city, Morris imagines a QR code referencing the coordinates of the station, its digital typography, and movement. The artwork was scaled to the dimensions of the platform. The facets expand into bold patterns that mirror the motion of the train and the commuters.

The facing platforms are diametrically opposed. These lines of sight are replicated in the forms and transparency of Morris's laminated panels. Through the clear zones, pedestrians are seen traversing the street below. The colors camouflage the nearby buildings, which have been in the process of development and transformation since the artwork's installation.

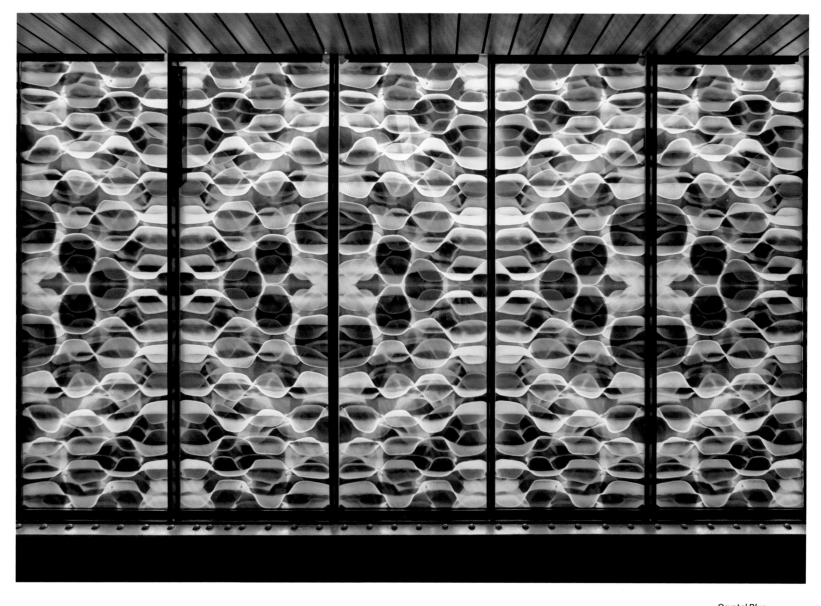

Crystal Blue Persuasion. Photo: Etienne Frossard.

MAUREEN McQUILLAN
Crystal Blue Persuasion, 2018
36th Avenue Ⓝ Ⓦ

Crystal Blue Persuasion builds on Maureen McQuillan's practice of layering translucent ink, clear acrylic polymer, and white lines on wood panels to create seemingly intertwined twirling ribbons.

The hypnotic effect found throughout the artist's multidisciplinary practice is fully captured in the translation to glass. McQuillan worked with Long Island City–based fabricator Depp Glass. Printed interlayers capture the bend and fold of undulating ripples within forty-seven panels of laminated glass. Sheer color lets light pass through, creating a sense of luminosity and infinite space across windows that span three sides of the station, washing the

dark granite floor in a bath of colored light throughout the day.

The title *Crystal Blue Persuasion* is drawn from a psychedelic rock song by Tommy James, establishing a playful connection between the hallucinatory linework and the 1960s. The positive, lighthearted, and hopeful messages in the lyrics become an intrinsic component of the artwork. For McQuillan, "The interaction of the work and its environment, reflecting the light of day in myriad ways, casting colored shadows and lines, and glowing from within at night, will incite engagement and conversation, and provide a way for commuters of all experiences, ages, and backgrounds, to stop for a moment, slow down, and share a connection."

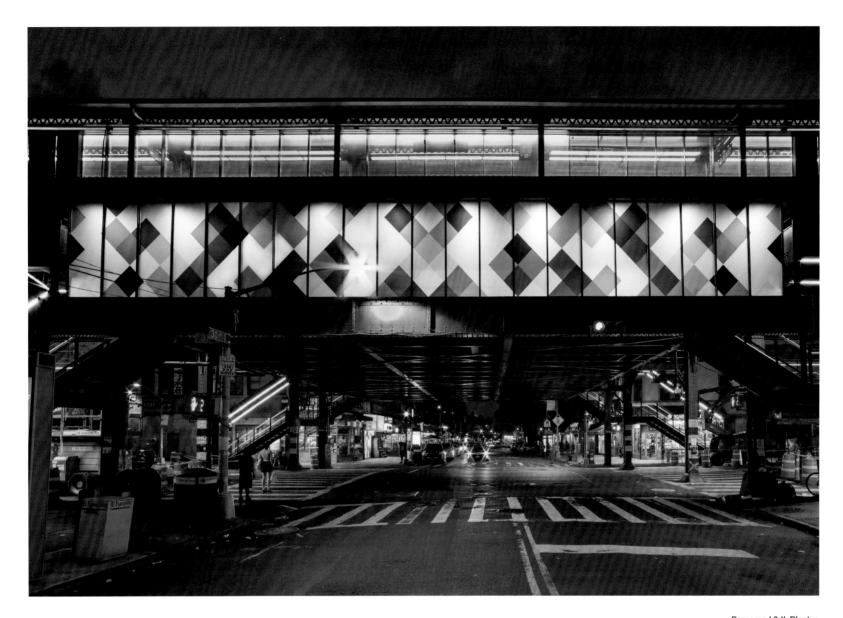

Perasma I & II. Photo: James T. Murray and Karla L. Murray.

STEPHEN WESTFALL

Perasma I & II; Dappleganger, 2018
30th Avenue Ⓝ Ⓦ

At 30th Avenue Station, three artworks by Stephen Westfall can be seen throughout the mezzanine level. *Perasma I & II* are installed on the east and west glass facades. *Dappleganger* is integrated into the south windows. Westfall's abstract, geometric patterns read as a form of architecture. The artworks are intended as contemporary friezes, designed to span the interior and in reverse on the highly visible exterior of the station that rises above an active streetscape.

Meaning "passage" in Greek, *Perasma* connects the glass works to classical architecture and the cultural identity of Astoria and its large Greek population. Symmetrical blocks of color stand out against an opaque white background, calling up notions of the white marble used in ancient Greek temples and monuments. Westfall refers to the expansive white spaces in his compositions as a requisite aeration of color, or a "mentholated" effect. The movement of the tumbling color relates to the passage of riders streaming through the station and processional themes found in classical friezes. *Dappleganger,* the smallest of the works, is full of prismatic color. Westfall worked with fabricator Depp Glass to create the forty-seven laminated glass panels that comprise the work.

Rail Stations

For more than fifty years, the subway and commuter railroads have been part of the MTA, but they are typically considered independent systems. There is an ongoing effort to change this perception by creating a seamless journey between them. The modernization program supported this goal by expanding system-wide many of the elements and approaches initially designed for the subway. The visual identity was connected, while respecting the unique character of the rail stations and the fundamental role that they play in the community. Rail stations, like a town square, are a place where one may run into friends and neighbors. They serve as an important portal in and out of the city.

Forte (Quarropas).
Photos: Steven Bates.

BARBARA TAKENAGA

Forte (Quarropas); Blue Rails (White Plains), 2020
White Plains · Metro-North Railroad

Barbara Takenaga's artwork captures her characteristic style—detailed lines and marks arranged as swirling patterns—in the mediums of glass and mosaic. Takenaga paints completely freehand, from a single circle morphing into undulating forms that radiate and recede into space.

Forte (Quarropas) celebrates the city's native name which translates as "white marshes" or "plains of white," referring to the heavy mists hovering over the swamplands near the Bronx River. The field of deep blue in the mosaic connects the work to the blue tiles at the station entrance, a feature of the modernized station. Takenaga created two triptychs as the basis for the mosaic. The paintings were digitally melded and scaled to ensure the visual information was retained in

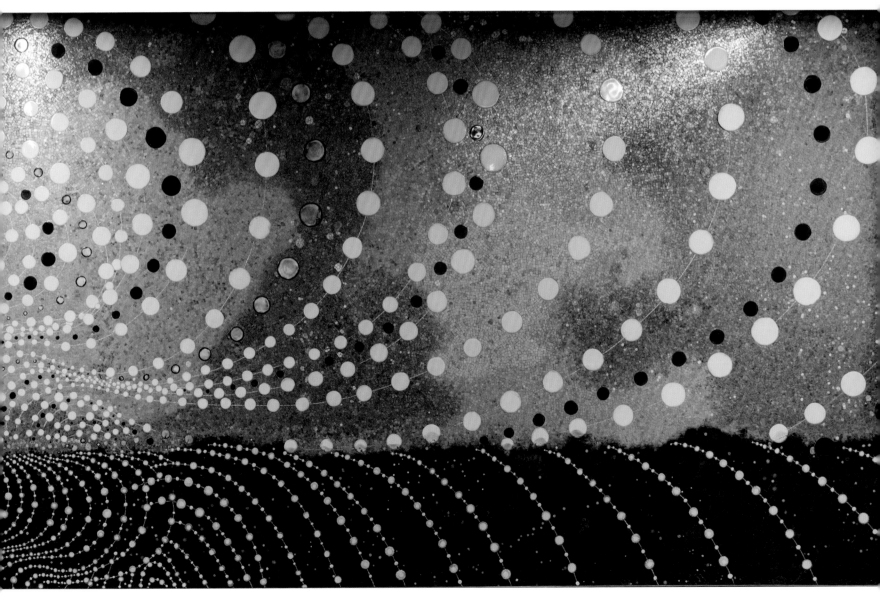

the translation. The resulting pattern was used as the basis for this buoyant mosaic fabricated by Mosaika Art & Design. Hand-glazed ceramic tiles shift as the glaze pools in the middle of the discs and breaks into iris-like filaments along the edges. The swirling dots of mists are placed against the expansive background composed of lightly tumbled iridescent Byzantine-glass smalti in soft shades of gray and mauve that shimmers and mutates as viewers walk by the work.

Blue Rails (White Plains) features a series of mirrored images in laminated glass, alternating between day and night compositions. Fabricated by Mayer of Munich, the expanse of glass features hand-painting and airbrushing. Each composition is anchored by the radiating light from a misty horizon suggesting the white mist and the disappearing tracks as they recede from the station. Animated by shifting light throughout the day, *Blue Rails (White Plains)* is a visual play and a nod to the Kurosawa film called *Dodes'ka-den*, a word that mimics the sound of the train on tracks.

Blue Rails (White Plains).
Photos: Steven Bates.

Morning Glory, Evening Splendor.
Photo: Bradley Knote.

Metal design for *The Perennial Village.*
Courtesy of the artist.

TRICIA WRIGHT

Morning Glory, Evening Splendor, The Perennial Village, 2019
Crestwood · Metro-North Railroad

Morning Glory, Evening Splendor and *The Perennial Village* celebrate the perennial rhythms of growth and renewal of village life. Set between the village square and the Bronx River, the Crestwood Station serves Yonkers, Crestwood, and Eastchester. For Tricia Wright, the station is a village landmark linking these communities. Her artwork is intended to bring the feeling of energy and positivity to the daily experience of commuting and to parallel the rhythms of village life with the rhythms of the natural world.

Fabricated by Tom Patti Design, the glass panels seen in *Morning Glory, Evening Splendor* feature floor-to-ceiling perennial flowers and buds. Larger-than-life magenta morning glories are set against the bright blue of a morning sky in the east windows. Yellow evening primroses glow within the deep rich blue of an evening sky to the west. The artwork casts dramatic shadows during the day and emits colored light at night. A decorative pattern in the classic Gothic style frames the compositions, one of the many styles of architecture that can be found in Crestwood. Architectural diversity that also includes colonial, Tudor, and Victorian styles is part of the village identity and a source of pride.

The Perennial Village, a sculptural fence in stainless steel fabricated by KC Fabrications is installed along the ADA ramp leading to the station. Reinforcing the cyclical rhythms of commuting, the railing features clock faces, intertwining morning glory, and fluid water and lily pad motifs that relate to the village and the nearby Bronx River.

The Guardian Angel.
Photo: Geandy
Pavon.

ARMANDO MARIÑO

The Guardian Angel, 2018
Brentwood · Long Island Rail Road

The Guardian Angel is a statement about trust, safety, and harmony in community, inspired by Brentwood local lore. Known colloquially as "The Legend of the Red Owl," the tale is based on the account of Charles A. Codman, a respected Brentwood resident who in 1877 claimed to be visited twice by a red owl professing to be the spirit of Indian Chief Oriwos. The mythical owl is now considered a spiritual protector of the town. Armando Mariño's artwork builds on this story, using the owl as a guardian to inspire and protect the community, urging past and present to coexist peacefully. Detailed in bright painterly gestures, native flowers representing many of the nationalities present in Brentwood's population fill the composition. Mexican dahlias, Peruvian qantu, Salvadorean flor de izote, as well as native flowers of Long Island, grow together under the protection of the guardian owl. Originally painted in watercolor on paper, the delicate brushstrokes and highly saturated colors were rendered into glass by Tom Patti Design.

Deer Park Dahlias,
Photo: James Lane.

WILLIAM LOW

Deer Park Dahlias, 2018
Deer Park · Long Island Rail Road

In *Deer Park Dahlias,* oversized flowers in a pastoral field create an experience of childlike wonder in the station waiting room. The images reference the local botanical legacy that includes supplying the first ornamental trees and shrubs to landscape Central Park as well as the famous annual dahlia festivals in Deer Park. Today, several wholesale nurseries still operate near the station.

Tom Patti Design collaborated with William Low to highlight the relationship between the artwork and the location by using Low's floral landscape of complementary dominant magenta red with a magical atmospheric depth of green foliage to open a vision through to the sky above. The transparent background becomes the sky as viewers look through to the landscape beyond.

DAN FUNDERBURGH

SHOAL, 2018

Bellmore · Long Island Rail Road

SHOAL uses swimming sea creatures as a playful allusion to commuters flowing in and out of Long Island through the Bellmore station. Covering three walls of the station house, the water imagery recalls Long Island's canals and marinas, complete with North Atlantic wildlife, including Atlantic cod, mackerel, and quahog clams. There is a sense of flow through time as well, as historic Dutch and Native American elements are scattered through the compositions. The fish and other creatures are detailed in the blue and white aesthetic of Delft pottery, and they swim around beads and pottery shards detailed with Lenni-Lenape and Shinnecock motifs. Dan Funderburgh worked with Miotto Mosaic Art Studios to combine glass mosaic with ceramic tile, digitally printed and water-jet-cut to simulate the effect of hand-painted glaze. The integration of modern technology and traditional materials in the fabrication process echoes the sense of history and present mingling in the artwork itself.

*SHOAL.*Photo:
Collin Hughes.

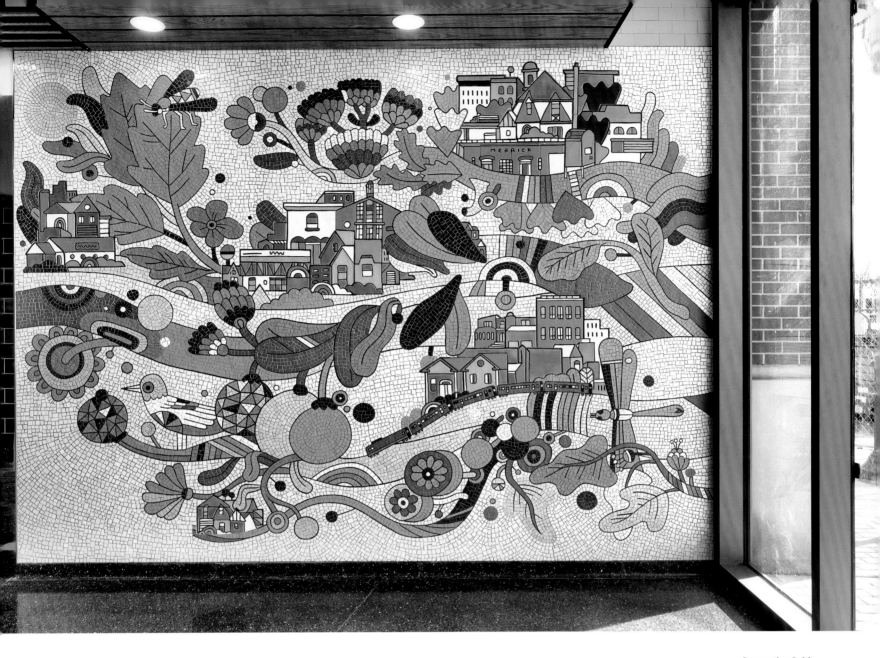

Connection Cultivating Communities.
Photo: Peter Peirce.

JAMES GULLIVER HANCOCK

Connection Cultivating Communities, 2018

Merrick · Long Island Rail Road

For the Merrick Station waiting room, James Gulliver Hancock created a map-like work. Using the iconography of transportation mapping, Hancock envisions his artwork as a tree branch and each town along the way as a blossom. He sees the community around the station depicted in each blossom. Hancock includes the Merrick Library, the Chatterton School, the Post Office, the Fire House, and Merrick Station itself. Miotto Mosaics Art Studios and Frank Giorgini Handmade Tiles collaborated to incorporate ceramic elements with glass mosaic. Working in clay in upstate New York, Giorgini had to precisely calculate the shrinkage of each piece during the firing process to create ceramic tiles that fit like puzzle pieces into the mosaics being assembled in Italy.

Mosaic

7

Mosaic is deeply associated with the New York City subway. The medium has been part of the system since its beginning in the early 1900s. More than a century later, many examples of the original mosaic name tablets and banding made for the IRT subway remain in place. Typically installed adjacent to terra-cotta plaques, the early mosaics involved glazed and unglazed tile made by the American Encaustic Tiling Company. One of the world's largest tile manufacturers at the time, their practice sometimes mixed pigment into the ceramic body to achieve the through-color inherent in glass mosaic.

Mosaic remains a popular and practical medium for the transit environment. Public art was once a genre largely reserved for artists devoted to the field, but mosaic changed that. The joining of artists and fabricators sensitive to the artwork's essence and able to translate the artist's vision into a timeless medium was revolutionary. The pairing has allowed works made in oil and acrylic paint, watercolor, pencil, photography, collage, and mixed media to become vibrant and expressive artwork impervious enough to be installed on subway platform and passage walls. The practice has also revived and sustained a small artisanal industry. By 2023 there were more than 125 contemporary mosaic commissions in New York subway and rail stations. The medium puts the work of artists exhibiting in galleries and museums into the public realm, to be seen by millions daily.

Michael Kelly Williams's *El 2 and El 5,* installed in 1992 at Intervale Avenue Station in the Bronx, was Arts & Design's first mosaic commission. The work was immediately embraced by the community. In the following decades, work by Jacob Lawrence, Elizabeth Murray, Faith Ringgold, and dozens more would become a permanent part of the subway and rail system. Examples of contemporary approaches to traditional mosaic practices are detailed in the earlier chapters focused on the work of Yayoi Kusama, Kiki Smith, Nick Cave, Ann Hamilton, Jean Shin, Vik Muniz, Chuck Close, and Xenobia Bailey, as well as the many artists whose work entered the collection as part of the modernization initiative. This chapter further explores the innovative mosaic techniques being used in the transit system today, highlighting works by artists including Marcel Dzama, María Berrío, Diana Al-Hadid, and Eamon Ore-Giron. The legacy of mosaic endures while new works continue to push the limits of the medium.

Mosaic has a tactile appeal that heightens the experience. The shape and layout of tesserae communicate aspects of the art that can be both seen and felt. Riders often pause to run their hands across the surface. This physical connection offers a level of engagement not possible in a traditional museum setting.

Mosaic is most often found in underground stations. Manhattan has the largest number of below-ground subway stations, while New York City's outer boroughs have more elevated and exposed stations in comparison. This chapter highlights examples of mosaic use at and above ground too.

Sally Gil, *Edges of a South Brooklyn Sky,* 2018, NYCT Avenue U Station. Photo: Etienne Frossard.

The Arches of Old Penn Station. Photo: Peter J. Kaiser.

Original artwork for
*The Arches of
Old Penn Station.*
Courtesy of the artist.

DIANA AL-HADID

The Time Telling, 2023
The Arches of Old Penn Station, 2018
The Arc of Gradiva, 2018
34th Street-Penn Station ❶❷❸

This trilogy of works by Diana Al-Hadid relates to the concept of time through subject matter and expressive mark making. Fabricated by Mayer of Munich, the long acrylic drips and gestural linework dominant in Al-Hadid's original line drawings on mylar have been delicately translated into slender strips of white glass, set within a traditional mosaic grid. Essentially designed to build a drawing in glass, the technique established for *The Arches of Old Penn Station* and *The Arc of Gradiva* in 2018 was carried into *The Time Telling* in 2023. Mayer's approach retains the play between the opacity and translucency of the original artworks.

In *The Arches of Old Penn Station,* the glass strips form a skeleton of Beaux-Arts architecture. A meditation on time and space, the grand interior of the legendary 1910 Pennsylvania Station is rebuilt in ghostly lines of white glass. The balance of the mosaic surface is filled with traditional smalti in shimmering aquas, grays and metallics to capture the conté, charcoal, pastel intended to look as if it is about to slip off the wall or vanish, a nod to the impermanence of the space. The historic structure appears like an apparition, connecting the modern station and an architectural marvel now gone for longer than the number of years it stood. Andrew Leicester's *Ghost Series* (1994) is a kindred spirit, featuring glazed terracotta bas-relief recreations of architectural remnants from the original building, installed throughout the adjacent corridor in the Long Island Rail Road portion of Penn Station. Among the featured elements, *Day and Night*, the allegorical clock figures from the original facade rest against a laurel wreath empty of the clock it once held. The void memorializes the beginning of demolition on October 28, 1963.

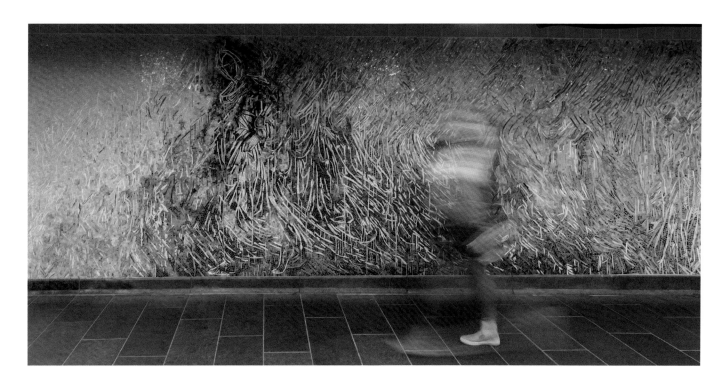

Left: *The Arc of Gradiva*. Photo: Peter J. Kaiser.

Below: *The Arches of Old Penn Station* during fabrication. Courtesy of Mayer of Munich.

Opposite: *The Time Telling*. Photo: Diego Flores.

Al-Hadid's works often draw from modern and ancient civilizations. *The Arc of Gradiva* features a mythological character from the novella *Gradiva, A Pompeian Fantasy* (1903), by Wilhelm Jensen. Published in Vienna, it is the story of an archaeologist in Italy so taken by a figure in a Roman bas-relief that he goes to lengths to have a copy made for himself, dreams of her, and eventually has a chance encounter in Pompeii with a woman he believes to be her. Gradiva has wandered walls and captivated minds for more than a century. Sigmund Freud popularized the novella's fantasy of mistaken identity and repressed desire in his analysis *Delusion and Dream in Jensen's "Gradiva"* (1907). Gradiva became a muse to the Surrealists, and later got the attention of French Poststructuralists. Al-Hadid's elusive Gradiva is part gesture, part abstraction—a figure with the ability to walk through walls, whose flowing garment stretches the length of the mosaic. She evokes memories and desires.

The third mosaic was installed at street level when a new station entrance was added at the corner of 33rd Street and Seventh Avenue. Inspired by Alfred Eisenstaedt's photograph *A Farewell to Servicemen* (1943), Al-Hadid's *The Time Telling* (2023) captures the clock from the original McKim, Mead & White station in a large-scale work that combines architectural and figurative elements. *The Time Telling* builds on the artist's recent practice of making timepieces. Al-Hadid's mosaic conjures a moment and freezes it. Her speckled fog and suspended drip marks are designed as a depiction of time. The line work is more fluid than the earlier mosaics. The surface twinkles with bits of iridescent glass. Hazy light enters the windows, forming a veil of mist before reaching the shadowy bodies crossing the floor below.

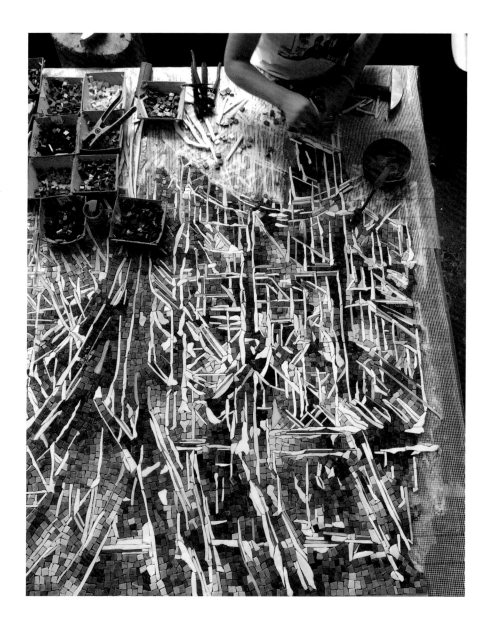

MARCEL DZAMA

No Less Than Everything Comes Together, 2021
Bedford Avenue Ⓛ

As Marcel Dzama began to develop his proposal, his mind filled with memories of moving to the United States and his first daily commute as a New Yorker. Dzama relocated from Canada in 2004 and regularly made the trip from his apartment on the Lower East Side of Manhattan to his studio in Williamsburg, Brooklyn. He recalled feelings of loneliness that lessened over time thanks to Walt Whitman's "Crossing Brooklyn Ferry." During his daily travels on the L train, Dzama read and re-read the poem, appreciating the strong tie he felt to his new home. His dyslexia motivated the repetition, which became a sort of meditation. Dzama found his own daily experience mirrored in aspects of the poem. He felt

No Less Than Everything Comes Together. Photo: Kris Graves.

increasingly connected to his fellow riders while watching and wondering about the crowds moving through the city.

The poem's passages about the sky inspired the design for *No Less Than Everything Comes Together*. Four richly detailed, contemporary Surrealist compositions center around an anthropomorphized sun and moon. A palette of gold and blue hues conveys the radiant optimism of the sun and mysterious intrigue of the moon. As Dzama explains, "In these works it is my intention to bring the sun, the sky, and the moon to the underground. What I love most about New York is its people, and for me it was important to represent them and all of their wonderful complexities and diverse beauty in

the piece. People looking and quietly observing together. In the subway, it's always a togetherness that bonds us uniquely like no other place in the world."

The compositions contain references to Williamsburg and the East Village, two of the neighborhoods connected by the L train. A dreamlike cast of characters includes historical figures such as Williamsburg's namesake Captain Jonathan Williams, Williamsburg-born mobster Bugsy Siegel, KISS frontman Gene Simmons, as well as a storybook references. The theatrical scenes are framed in curtains with a repeating motif featuring the Cheshire Cat from *Alice in Wonderland*, a stag, and a cuckoo bird. Costumed in masks and hooded

No Less Than Everything Comes Together. Photos: Kris Graves.

polka-dot attire, dancers appear throughout the enchanted tableaus. Dzama's ballerinas turn the rectangular panels into a stage as they leap and twirl. There are operatic movements. In the Goya-esque scene surrounding a full moon, a winged dancer takes flight among the owls and bats.

Dzama selected fabricator Mayer of Munich to bring the work to life in glass mosaic, using a combination of smalti, glass cake, and ceramic printed glass. The unavailability of certain materials during the height of the pandemic prompted Mayer to devise innovative solutions using self-generated techniques. For the expanse of sun rays, Mayer interprets the original artwork in frit and fused glass, details that add richness and expression to the medium. The four mosaics are installed at the mezzanine at the Bedford Avenue end of the station and at the new stairways at the Driggs Avenue end.

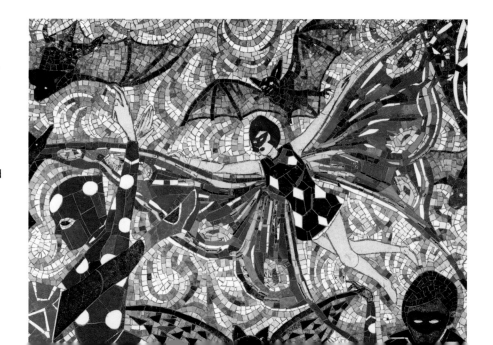

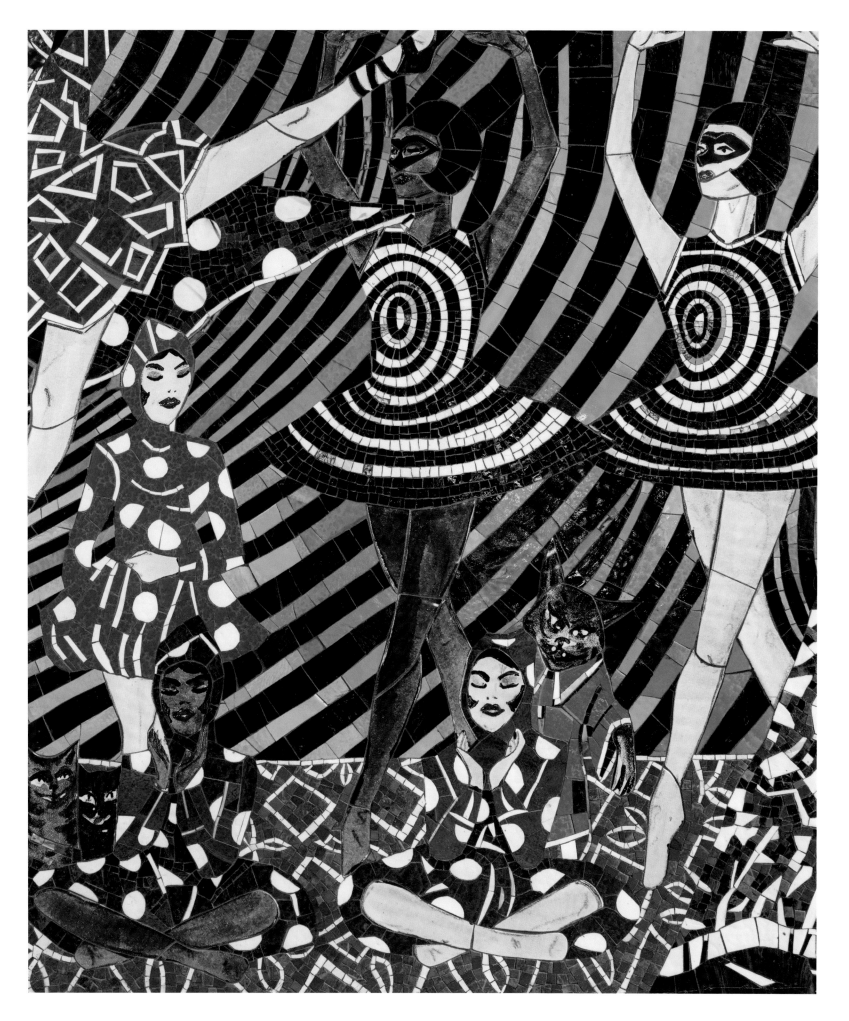

Queens of the Night. Photo: Jason Mandella.

KATHERINE BRADFORD
Queens of the Night, 2021
First Avenue Ⓛ

Katherine Bradford's *Queens of the Night* is filled with tender imaginings of the community served by the First Avenue Station. Noting that L train riders include creative and essential workers, the artist played with the idea of riders' concealed identities while creating the original paintings at her studio in Williamsburg, Brooklyn. Bradford views the stereotypical black attire of New Yorkers as "merely a cloak over an inner life that is wildly colorful and unconventional." Two caped figures, a familiar theme in Bradford's work, can be seen at the Avenue A end of the station. The pair of images, called *Superhero Responds*, is installed at the entrances to guide and protect travelers.

On the south mezzanine, a man wearing a white dress dances alone in a field of flowers, with arms outstretched as if to embrace the starry night sky. There is a soft, ethereal quality to the original paintings translated by fabricator Mayer of Munich in jewel-toned smalti. On the north mezzanine figures appear in lime green, aquamarine blue, and rosy pinks. The nocturnal scene is centered around a glowing moon that, as mosaic, bears a striking resemblance to a disco ball. Flecks of rain and lightning bolts suggest a storm of collective energy.

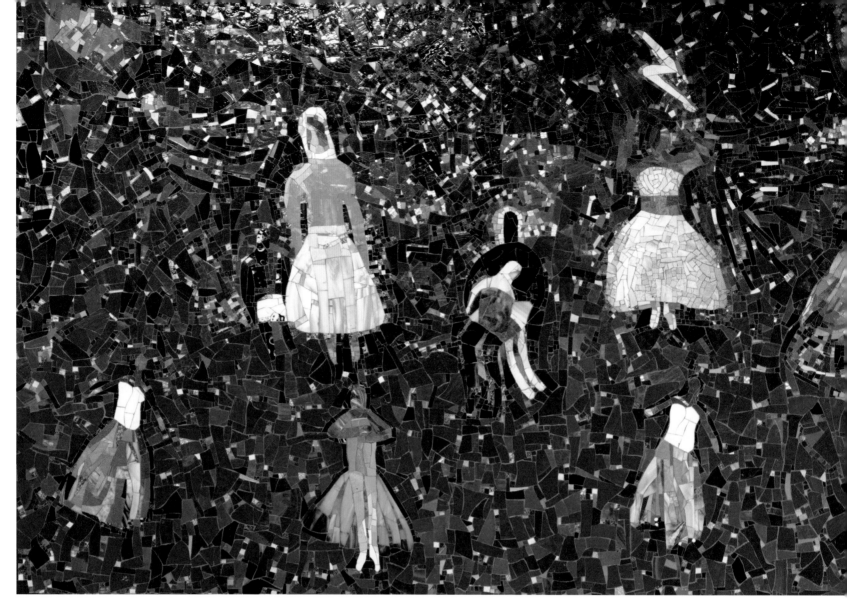

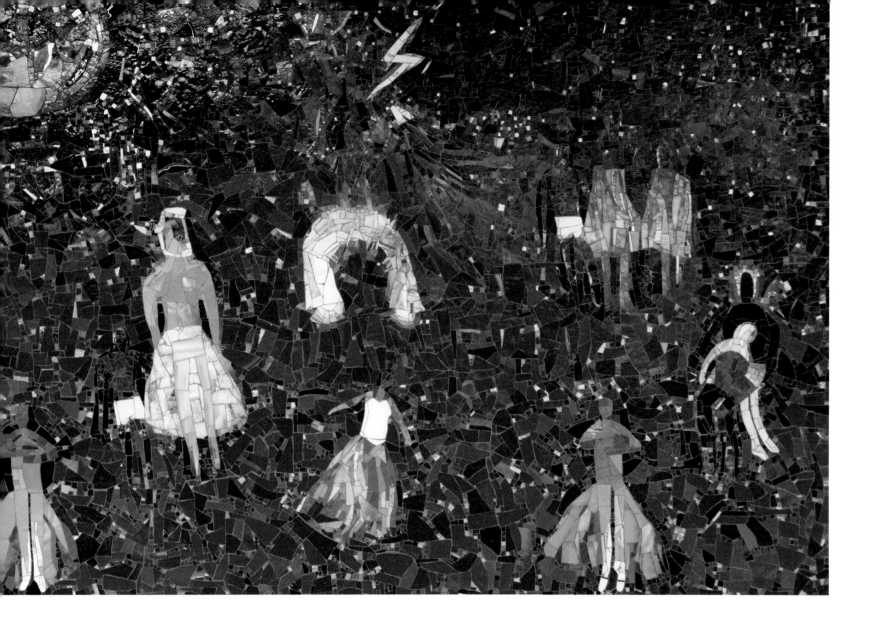

Above: *Queens of the Night.* Photo: Jason Mandella.

Opposite: *Superhero Responds.* Photos: Jason Mandella.

Bradford sees the figures as reflecting and watching over the L train riders—acknowledging that their mystical nature celebrates the energy that is created when people gather, as they do daily on their journey, and that there is power in this collective experience. When Bradford visited Mayer's studio, they worked through material sizing to find the scale best able to capture the essence of the artworks. Color selection was equally important. In Bradford's paintings, color punctuates the canvas. Mayer brings the same depth of color to the five glass mosaics. As Bradford explains, "I want to give back to these subway travelers their own sense of whimsy. I want to give them the possibility of stories that evoke enchantment over reality and a kind of technicolor backdrop to their subway experience."

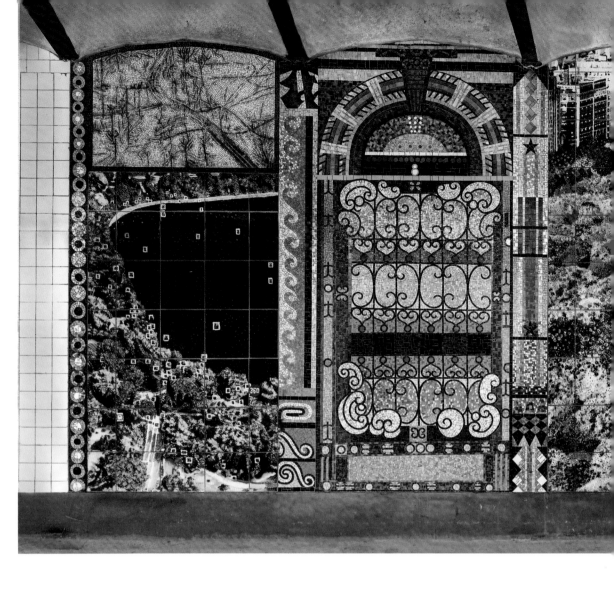

Parkside Portals.
Photo: Tom Vinetz.

JOYCE KOZLOFF
Parkside Portals, 2018
86th Street Ⓑ Ⓒ

Parkside Portals is a portrait of a neighborhood by Joyce Kozloff, a former Upper West Side resident and a founding member of the Pattern and Decoration Movement. Composed of six murals, the work captures micro and macro views of Central Park West. The images include facade details from the elegant Beaux-Arts and art deco apartment buildings, as well as satellite imagery of rooftops and street views—building on a practice of using maps that the artist began in the 1990s. Kozloff lays out the image fragments in a sort of patchworked style, integrated into the station architecture. The mosaics are installed within the vaulted arches on the upper and lower platforms and over the connecting stairs.

"Art Hysterical Notions of Progress and Culture" (1978), the manifesto of Kozloff and Valerie Jaudon, another Pattern and Decoration Movement founding member, challenges prejudice against the decorative and women's art and preference for Western art. In 1988 Jaudon created *Long Division,* an intricately patterned steel fence at the 23rd Street Station—one of the earliest Arts & Design artworks. Further uptown on the Lexington Avenue line, *4 Seasons Seasoned,*

the mosaic work of Robert Kushner, also an original member of the Pattern and Decoration Movement, can be seen at the 77th Street Station.

Kozloff returned to an established relationship with Miotto Mosaics Art Studios, working in tandem with Travisnutto Mosaics. The traditional glass mosaic is contrasted with porcelain tile that appears to be hand-painted by the artist. Taking a hands-on approach, Kozloff printed imagery from Google Earth and painted over it. The artwork manipulations were scanned and fired onto the tile surface using a high heat glaze.

Parkside Portals references Central Park, bringing the brilliant colors of the four seasons into the station. There is also a map of Seneca Village, a settlement established in 1825 that was home to the largest number of African American property owners in New York. In 1850, the land was seized by eminent domain for the construction of Central Park, displacing 1,600 inhabitants. Kozloff pays tribute this important nineteenth-century community as part of her exploration of place, gender, and power.

Joyce Kozloff's original artworks paired with mosaic color samples at Miotto Mosaic Art Studios. Courtesy of the artist.

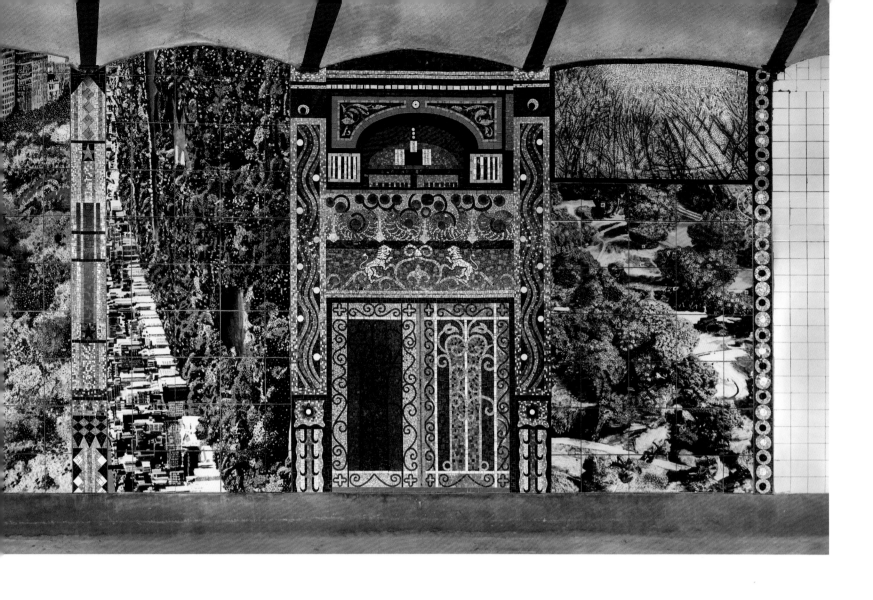

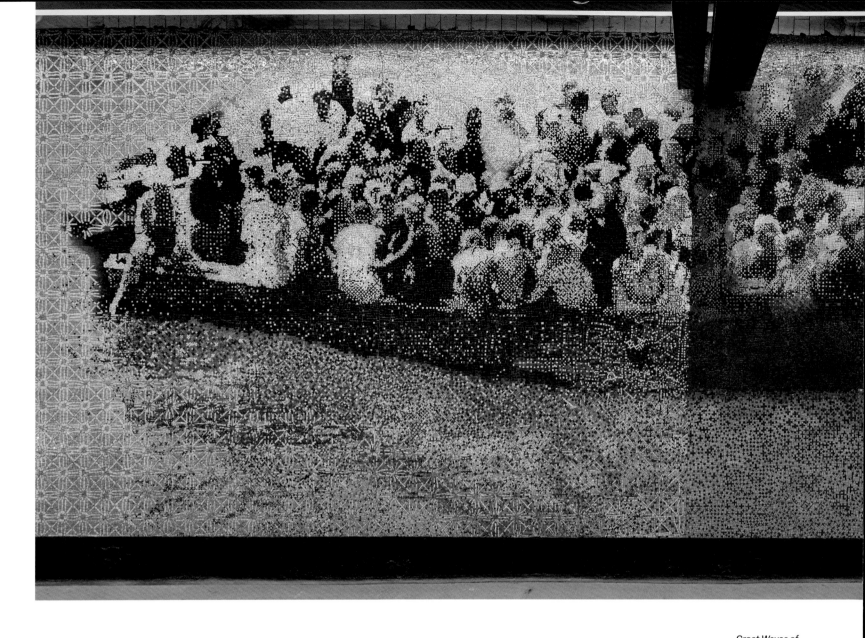

Great Waves of Immigration. Photos: Etienne Frossard.

CARMEN LIZARDO

Great Waves of Immigration, 2023
181st Street Ⓐ

Carmen Lizardo's *Great Waves of Immigration* pays tribute to the populations who have made a new home in Washington Heights, emphasizing the journey, often begun or made in full by boat. Situated at the northern end of Manhattan, the Washington Heights neighborhood has historically been a refuge for groups that include Greeks, Italians, Germans, German Jews fleeing the Nazis, and for many years now the Dominican community. Lizardo, who was born in the Dominican Republic and moved to the United States at age 19, draws on her own experience to delve into themes uniquely tied to the immigrant experience: race, class, memory, and identity.

Lizardo's mixed-media artwork was translated into mosaic by Mosaicos Venecianos de México. The largest mural depicts a crowded yola, a small boat known for transporting people fleeing the Dominican Republic for U.S. territories, often

illegally. The transition of the background colors from yellow to blue relate to the phases of the trip—departure, journey, and arrival. On the left side of the mural, the boat appears to set off in a mix of sun and shadows. At the right edge, the boat emerges from a stretch of darkness to reveal the destination. The George Washington Bridge, New York City street signs, and bare branches emerge against a pale gray sky. Lizardo's design integrates pixilated patterns and texture into the narrative.

Themes of immigration and documentation are further explored in two murals at the platform stairs. Above the downtown stairs, the image of a Dominican woman is layered with details from a certificate of citizenship. Over the uptown side, the portrait of an unidentified woman who was once a registered resident of Washington Heights, is layered with architectural references to the area. Lizardo's imagery, inspired by personal experience and historical photographs found in the New York Public Library archives, speaks to the universal theme of immigration and honors the Dominican community in Washington Heights today.

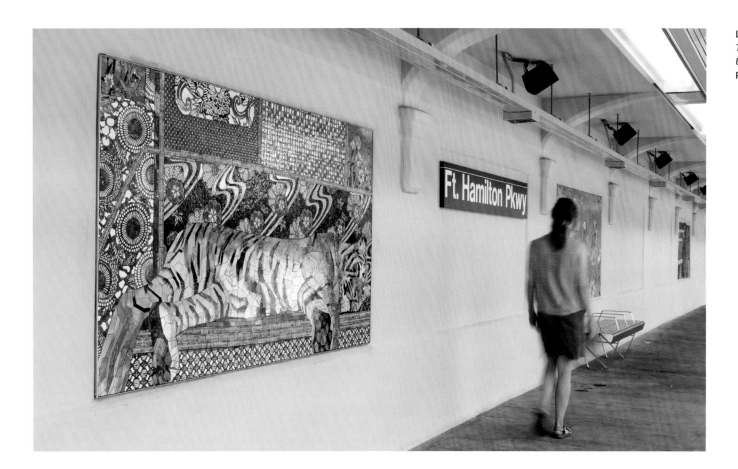

Left and opposite:
*There Is Magic
Underneath It All.*
Photos: JMay Studio.

MARÍA BERRÍO

There Is Magic Underneath It All, 2019
Fort Hamilton Parkway Ⓝ

There Is Magic Underneath It All brings María Berrío's magical realism to the subway. Fourteen mosaic panels depict highly crafted scenes that are equal parts myth and mystery. Decorative papers, often sourced from Japan, become the foundation of Berrío's work. The artist collages patterned paper, building upon the different materials and sheens with watercolor painting. Fabricator Mosaika Art & Design translated Berrío's intricate, large-scale collaged paintings into richly textured mosaic using a myriad mosaic techniques and materials. Hand-formed clay elements, printed, stamped, slip-trailed, airbrushed and hand-glazed ceramic tile, as well as both Byzantine and stained-glass mosaic were used to achieve the delicate detail of Berrío's work.

Southbound platform art captivates viewers with imagery that is both fantastical and folkloric. Berrío places women and children in worlds that quickly shift from reality to the surreal. The scenes are set in a wondrous, almost unrecognizable version of the subway. A woman in a lush floral headdress, parrot on shoulder, leans against the pole somberly holding a single rose, perhaps recalling lost lands or imagining better ones. Musicians perform guitar and accordion serenades to the sleeping tiger, swan, deer, and cheetahs who serve as fellow passengers. Outside the windows, butterflies and birds travel alongside the train. The narrative and inviting scenes encourage riders to become part of a journey filled with beauty, magic, and endless possibilities.

Distinct mosaic collages create a kaleidoscope of patterns animating the entire surface. Animals are rendered in hand-glazed ceramic, the soft lines of fur and feather contrasting with bold patterned surroundings. The fabricator shifts between shiny and matte finishes, varying large pieces with small, and ceramic with glass mosaic. Molds were used to mimic the woodblock, stamped effect in recurring elements such as the band of miniature umbrellas that frames two large macaws in flight. Elsewhere slip trailing is used to translate the textural qualities of the thicker papers. The gold highlights silkscreened onto Japanese Chiyogami Yuzen paper are rendered in gold metallic glass outlining flowers and plants. These works invite the viewer to explore many rich details that seem to meld from a distance but become distinct shapes and forms on closer inspection.

Top: Grand ... Bushwick Av... SE corner

GLENDALYS MEDINA

Gratitudes Off Grand, 2023
Grand Street Ⓛ

During the pandemic Glendalys Medina regularly took fifteen-minute walks in the Harlem neighborhood surrounding their studio. Fighting the natural tendency to be discouraged and despondent, Medina walked with the intent of finding something to be grateful for and to cultivate an attitude of gratitude. The artist later carried this walking practice into their preparation for the Grand Street Station proposal. Medina walked several blocks from the station in each direction to make observations and explore the cultures, landscapes, environments, and inhabitants of Williamsburg. *Gratitudes Off Grand* is a synthesis of the sights and sounds they witnessed and recorded.

Medina is an interdisciplinary conceptual artist born in Puerto Rico and raised in the Bronx. Their work is broadly inspired by Hip-hop and Latinx culture and music, as well

Gratitudes Off Grand.
Photos: Osheen
Harruthoonyan.

as Taíno culture. *Gratitudes Off Grand* is intended as an appreciation of those who built and transformed the neighborhood over time. After the walks, Medina would return to the studio to form a mental picture of the colors encountered and document them for development into a series of works.

Medina's artwork was translated into two large glass mosaics fabricated by Miotto Mosaic Art Studios, working in tandem with Travisanutto Mosaics. Both feature a dark background made up of forest green, tobacco brown, and other tones that the eye interprets as black, filled with geometric shapes designed to appear in flux and change just as the viewer's feelings and emotional states fluctuate. Medina pushed the fabricator to source glass with a matte sheen. At the artist's suggestion, Miotto also mixed larger

pieces of glass with traditional smalti. The shapes are accentuated with a filato border, gold smalti that has been formed as a thin rod.

Medina describes the work: "Overlapping circles and bars outline other circles and lines, calling to mind map details, schematic design drawings, and complex patterns to be decoded." On the Manhattan-bound platform, the mosaic is embedded with shapes and colors observed and documented during the changing seasons. On the Canarsie-bound side, the mosaic references East Williamsburg and Bushwick, using the colors evocative of the national flags of those who have made East Williamsburg and Bushwick their homes over time, including the native Lenape and Pan-African, Irish, Italian, Puerto Rican, and Dominican Republic immigrants.

SALLY GIL

Edges of a South Brooklyn Sky, 2018
Avenue U N

Edges of a South Brooklyn Sky is an artistic reflection of the Gravesend neighborhood in Brooklyn. Each of the fourteen mosaic murals has a strong horizon at center from which local buildings—residential properties, warehouses, churches, storefronts, and even the subway station—rise upward, or conversely appear extending downward. Honoring the indigenous people of the area, Lenape wigwam and long-houses, as well as native plants, appear throughout the compositions. Sally Gil uses the midpoint to further split the scenes into day and night. On the Manhattan-bound platform, a bright-blue sky represents daytime. Across the tracks, a black sky signals the evening return to residents.

The original mixed-media artworks combine collage and painting. Using photographs taken in Gravesend and the adjacent Bensonhurst neighborhood as her source material, Gil represents the flourishing multiethnic community. Images of everyday sweets and local delicacies such as Italian rainbow cookies, a Mexican Concha cookie, rolls, and a quail egg are shown. Gil highlights these recognizable items and places in the belief that they reveal more than they seem. In them, the artist explains, "the internal life lives, all the complex and mystifying contemplations that move us."

The artwork playfully goes beyond reality. Some of the buildings step off the dividing line to float freely or mirror themselves as if to exist in multiple dimensions. There are celestial starbursts and planetary happenings, oversized blooms, and a few supernatural surprises, such as secret doors and portals to unknown destinations.

Fabricated by Mosaicos Venecianos de México, the work is a portrait of a community's evolution, touching upon specific points of time and space. Gil intends the work as a reminder that "Every day we are making our place in the world, and the subway is the conduit that transports us. We live on a physical plane, while dwelling in our thoughts and imaginations—the world of our own stories. Ultimately I believe, although from differing places, we all want the same things: to live peacefully, with what we need and want."

Edges of a South Brooklyn Sky. Photos: Etienne Frossard.

DIANA COOPER

Double Take, 2023
Roosevelt Island Ventilation Structure ·
Long Island Rail Road

As part of the East Side Access project, Arts & Design was asked to commission artwork for the exterior of the tunnel ventilation structure on Roosevelt Island. After commissioning art for hundreds of stations, the opportunity to provide a mosaic on a perimeter wall and a sculptural gate was a unique and exciting challenge.

Initially, Diana Cooper found the building's minimalist, louvered architecture jarring, but she came to appreciate its long horizontal lines and the shadows cast by the vents. Cooper envisioned a visual device that would meld the industrial materials with the landscape, while simultaneously reflecting the architectural integrity of the building and that of nearby structures—the Queensboro Bridge, the Roosevelt Island Tram, and the FDR Memorial, among them.

Employing the World War I concept of "dazzle camouflage," Cooper's design features turquoise planar forms that snake around geometric forms in shades of blue and louver-like patterns in grayscale, intermixed with organic forms inspired by photographs of the East River and hand-drawn imagery of greenish fluid shapes that express the natural setting of the island. Cooper chose fabricator Miotto Mosaic Art Studios, in collaboration with Travisanutto Mosaics, to create the mosaic artwork that would transform

the site. Miotto worked in a variety of materials, including commercial exterior tile, granite, marble, and traditional smalti. In the painted-steel gates, made by KC Fabricators, Cooper picks up the lines of the louvers again.

As Cooper describes her concept, "I wanted to design the wall so that viewers almost feel that the ventilation building has been deconstructed, mixed with its environment, and re-presented. My hope was they will feel transported smoothly and delightfully from the canyons of the MTA to an island surrounded by a river, with mountains of skyscrapers as backdrop."

Double Take.
Photos: Trent Reeves (above), Paul Takeuchi (below).

People's Instinctive Travels: Homage to the Tribe. Photo: Peter Peirce.

EAMON ORE-GIRON

People's Instinctive Travels: Homage to the Tribe, 2019

Bay Parkway Ⓝ

Eamon Ore-Giron is an artist, musician, and DJ who employs his crafts to explore and uncover formal and cultural connections. The title of the work is an homage to A Tribe Called Quest's influential debut album "People's Instinctive Travels and the Paths of Rhythm." Ore-Giron works in a visual language of geometric forms, sometimes working his shapes by hand or tracing CDs or the dubplates he once used for recordings.

Ore-Giron's work is an ongoing exploration of the history of the Americas and Latinx identity. The artist's experience navigating between cultures informs his interest in the idea of transmutation, the state of being transformed into another form. His Bay Parkway project is a response to these exchanges that occur over time and place, particularly the societal dynamics of the changing communities around the station. The project relates to that journey of change and adaption, as well as to the more literal journey of Sea Beach line riders.

The work originates from Ore-Giron's "nostalgia for a global modernism," wherein "public works meant to create a kind of civic mindedness and unity." The proposal was first developed as drawings inspired by the artist's experiences riding the N train from which six paintings in flashe paint on linen were produced. Mosaicos Venecianos de México translated the paintings into twenty-four panels of glass mosaic. On the Manhattan-bound platform, twelve panels reference man-made mechanical systems driving an urban environment. On the Brooklyn-bound platform, twelve images of softer, sweeping arcs relate to nature and a day at the beach.

AMY PRYOR

Day Into Night Into Day, 2021
138th Street-Grand Concourse ④ ⑤

*Day Into Night
Into Day.* Photo:
Argenis Apolinario.

Amy Pryor brings a contemporary perspective to the perennial themes of the passage of time and the changing of the seasons. Using the concept of a 24-hour clock, Pryor references the shifting daylight and darkness over the four seasons. The works are as cyclical as the commuters who pass through, reflecting travel patterns across the day that are in sync with the rhythms of the morning and evening commute. Pryor depicts sunrises, sunsets, day, and night in her circular forms with prism-like rays and a palette of colors that reflect the cosmic energy that creates the length of Earth's days and nights. Star charts overlay the prismatic images reminding us of the night sky above. The five mosaic murals are fabricated by Mayer of Munich. To ensure the stars stand out against the radiant background, Mayer cut and reset them into to the composition. The inlay technique allows them to remain a distinct element or symbol.

Bronx Seasons Everchanging. Photo: Anthony Verde Photography.

ROY SECORD

Bronx Seasons Everchanging, 2018
174th-175th Streets Ⓑ Ⓓ

The annual cycle is captured in *Bronx Seasons Everchanging,* a transition across eight abstract compositions that express spring, summer, fall, and winter through color. Balancing between the simple and complex, the artist uses color block pixelation and layers of geometric shapes in arrangements that capture the essence of each period of the year. Inspired by meditative walks outdoors, the work invites mindfulness and contemplation of renewal as it relates to nature, self, and community. Roy Secord brings strength, beauty, and inspiration through the four seasons to the community in and around the station. The original artworks, painted in what

the artist describes as "ultra-contemporary" modernism, were fabricated in glass mosaic and tile by Miotto Mosaic Art Studios, with Travisanutto Mosaics.

The background grid is an important part of the design. Concerned the squares would disappear if translated through small pieces of smalti, Miotto recommended the work be a mix of printed, glazed porcelain tiles and mosaic smalti. The squares were printed within a 12-by-12-inch tile and the edges water-jet cut to give the squares a straight, pristine edge, successfully translating the artist's vision.

CHLOË BASS

Personal Choice #5, 2023
Lorimer Street Ⓛ

Using imagery of Williamsburg in the New York Public Library's Picture Collection, conceptual artist Chloë Bass created three vignettes from photographs of the area near the Lorimer Street Station: North 5th Street and Bedford, c. 2005; Berry Street, 1977; and an Orthodox Jewish area in Williamsburg, c. 1960. In keeping with her current practice, Bass cropped the images to capture gestures of touch, connection, and proximity. The images read as a single composition installed on three walls of the station.

While the faces are concealed, the first mosaic features two men from the Hasidic community, the second panel is a diverse group of teenagers, and the third is two Caucasian men. A single sentence, split across the three mosaics, reads: "Whenever I'm pulled under by the weight of all I miss,

I take some consolation that I have known, and may yet know another life." While her concept was inspired by the pandemic and the life we knew, it also mourns the gentrification of the city and especially Williamsburg. As Bass says, "The use of tender, gestural images points to the inherent intimacy of public life in a city where we live alongside more than eight million other people, many of whom are different from us; and the diversity is a reminder of who we remember to consider and call our neighbors."

Bass selected Miotto Mosaic Art Studios, with Travisanutto Mosaics, to fabricate the artwork. During her visit to Miotto's studio, Bass suggested mixing a small percentage of warmer gray tones into the black-and-white areas, to add a warmth to the images not present in the original photographs.

Personal Choice #5.
Photo: Nicholas
Knight.

DAVID RIOS FERREIRA

Landscapes adrift—cosmically woven and earthly bonded, 2023

7th Avenue Ⓕ Ⓖ

David Rios Ferreira has always delighted in the magic of the subway rushing through tunnels and the journey's split-second change from dark to light. As the F moves above ground into the light, it rises to cross the Gowanus Canal and then plunges underground as it makes its way to 7th Avenue Station in Brooklyn. Ferreira wanted to make this feeling of astonishment a permanent part of that station through his artwork.

Ferreira looked to Prospect Park for visual inspiration and found there is a collective admiration for the elusive snapping turtles and the red-eared sliders that make the park their habitat. Turtles hold personal significance to Ferreira, as they are central to the origin story from his Taíno heritage and appear in the creation stories of Indigenous peoples, as well as in Hindu and Chinese mythologies. Ferreira's original artwork melds fantasy, sci-fi, the history of the area, and its architecture, fauna, and flora into collage, highlighting a commonality found in stories from around the world: that the world arrived on the back of a turtle.

Translated by Miotto Mosaic Art Studios and Travisanutto Mosaics, a mural extends along the north mezzanine passageway and twelve panels are installed in niches at either end of the station. In his practice, Ferriera uses shimmering color to capture a sense of fantasy. Here iridescent glass in the mosaic background creates an overall effect that changes as viewers move through the space.

ANDREA DEZSÖ

Nature Wall, 2019
New Utrecht Avenue Ⓝ

At New Utrecht Avenue Station, Andrea Dezsö pays tribute to nature's impressive ability to thrive even in an urban environment of concrete and steel. Finding joy in the many wild plants that can be seen defying the odds in the unnatural habitat of the city, Dezsö titled her work *Nature Wall*.

Dezsö explains, "From abandoned lots to areas between buildings, nature found ways to grow alongside construction sites, structure of steel and concrete, even in potholes. It made me smile every time I saw an uninvited, un-nurtured plant surviving entirely on its own on the urban stage." Whimsical plants, bugs, and birds cascade across the platform walls celebrating their triumph, which Dezsö calls "urban thriving." The vibrant palette adds to the delightful quality to the piece.

Fabricator Miotto Mosaics Art Studios, in collaboration with Travisanutto Mosaics, translated Dezsö's rich, colorful drawings into fourteen glass and ceramic mosaic works. Having worked with the fabricator in the past, she followed the advice to create the artwork at a scale of an inch to a foot. This ratio offers just enough room for original details to be captured fully in the mosaic medium. The artist also provided a color chart of the pencils used, aiding the glass selection and ensuring an accurate interpretation of her vision.

Nature Wall. Photo:
Etienne Frossard.

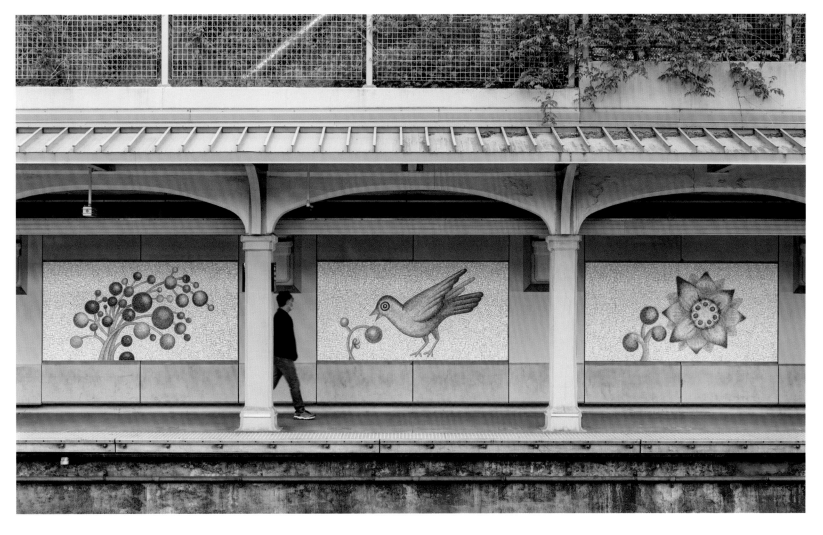

DAVID STOREY

Sea City Spin, 2019
20th Avenue Ⓝ

Sea City Spin is an abstraction of David Storey's experience riding the Sea Beach line. Working in his painterly style, he created graphic images depicting the essence of the journey. References to backyard windows, sidewalk markets, fish, and flowers are stylized but remain recognizable, executed in solid colors, as both geometric and biomorphic shapes.

Fabricator Mosaika Art & Design translated the fourteen artworks in this series in Byzantine glass smalti. Although the material is traditional, a modern technique was applied, resulting in a contemporary look to match that of the original artwork. The smalti were placed like a woven fabric respecting the right angles of a warp and weft, and cut only where the colors meet, much like cutting of a fabric

collage. The playful shapes in the mosaics seem to float and dance along the platform describing with abstractions of beach and sea as well as the sequential transitions between surrounding neighborhoods.

Sea City Spin. Photo: Jeffrey Sturges.

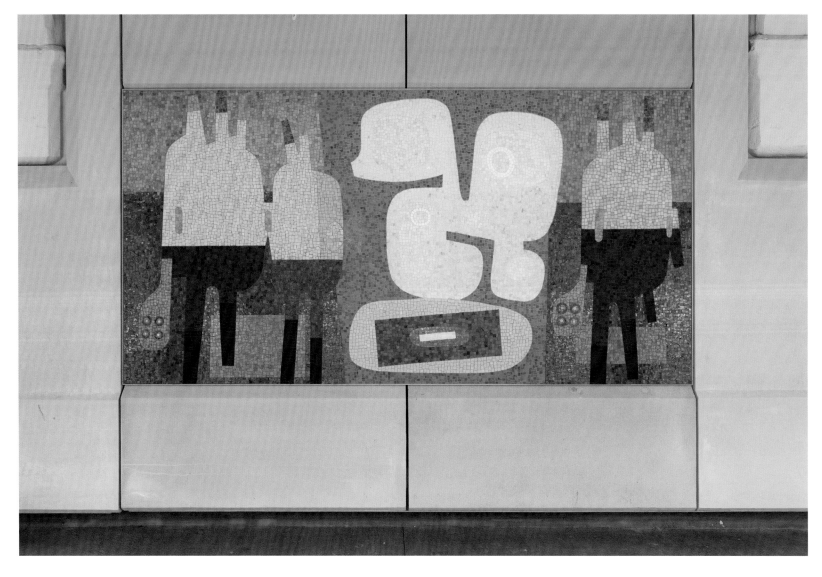

EMILIO PEREZ

Fluxus / Rhythmus, 2018
18th Avenue Ⓝ

Fluxus / Rhythmus was inspired by the subway system itself. As Emilio Perez studied the physical nature of the transit environment and its diverse ridership, he came to view the systems of infrastructure, riders, and transit workers as a beautiful and intricate living organism—simultaneously mechanical and organic. To Perez, "It was a never-ending flow of riders getting on and off trains, entering and exiting stations, creating countless interactions between the thousands of people commuting every day. A constant flow of rhythm and energy that drives the city we live in."

By carving away paint from built-up surfaces evocative of gestural brushstrokes, Perez created spontaneous compositions that convey the movement and rhythm of the subway. Organic forms contain a vast number of winding lines that seem to exist without a clear beginning or ending. Even the most distinguishable black outlines are absorbed back into the almost-fluid imagery. The lines suggest the continuous flow of the transit system as a living thing. Fabricator Mosaicos Venecianos de México translated the work into twenty-two glass smalti mosaics installed along the station's platforms. Perez commented, "It was important for the mosaic to reflect the variations of color in a brush-stroke to create the sense of movement. What I discovered is that the process used for making the different color glass creates variations of tone much like a brushstroke. This made for a seamless transition of materials."

Fluxus / Rhythmus.
Photo: GVP.

KAREN MARGOLIS

Cerebration, 2018

86th Street Ⓝ

Cerebration. Photos: Etienne Frossard.

To create *Cerebration,* Karen Margolis invoked her background in neural psychology to explore and express the imagined flow and pattern of rider thoughts. The work is broadly inspired by mental and physical structures. The circle is a common element, which she describes as "the most basic component in existence, connecting the microscopic to the universe; it is a molecule, a neurotransmitter and an Enso—a sacred symbol in Zen Buddhism, embodying perfection and infinity."

Margolis looked at the way the mind operates, using abstract imagery to express the various states of feelings thoughts produce and adding fragments of maps to bring the external world inside. Aware of the neighborhood enthusiasm for fireworks, she sought to capture their dazzling lights and bursts of color. Margolis saw the commute on the N train to be a time for thoughts, envisioning them as fireworks bursting in your head. To bring her concept to fruition, Margolis incorporated remnants of subway maps, using circles and dots to express the burst of lights, emulating the bursts of thoughts, evoking moments of celebration and the formation of memories. *Cerebration* is an exploration of the "unseen forces that shape our every thought and action."

Fabricated by Mosaicos Venecianos de México, the glass mosaics are made in a style that sets traditional Byzantine methods in a modern background composed of much larger angular pieces of white glass.

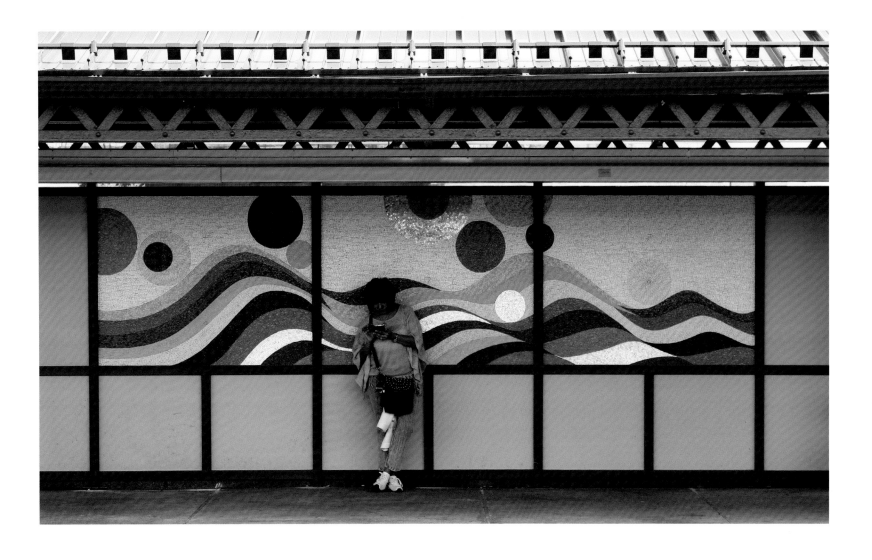

Have a Happy Day.
Photos: Soonae Tark.

SOONAE TARK

Have a Happy Day, 2015
Buhre Avenue ⑥

Soonae Tark's *Have a Happy Day* features six dynamic glass mosaics in which the bold use of color and form activates the space. Shapes symbolize elements of the city and aspects of the commute. Three mosaics on the Manhattan-bound platform are com-posed of mostly straight lines and square blocks, playfully suggesting urban architecture. Across the tracks, on the Bronx-bound platform, circles float upward and roll on undulating ribbons of color, a relaxed landscape that refers to Pelham Bay and the nearby hills.

Fabricated by Miotto Mosaic Art Studios and Travisanutto Mosaics, the artworks are installed on panels within the elevated windscreen system. The placement brings an uplifting energy to an open-air station through the traditional mosaic medium.

JAIME ARREDONDO

Garden of Earthly Delights, 2016

Zerega Avenue ⑥

Garden of Earthly Delights fills the platform with oversized lilies, roses, tulips, and other flowers. Designed to dazzle viewers with their scale and vivid colors, Jaime Arredondo's flowers relate to both Western and non-Western cultures. As the artist explains, "In Mesoamerican culture, flowers operate not as a decorative device, as in the Western world, but as a representation of a dual character, recollecting moments of the living and of the afterlife. They act not as items of embellishment but as portals to gain access to the sacred and divine. Native peoples view the flower as a living symbol of memory, faith, and spirit, concrete artifacts by which we may tap into the lives of our ancestors."

Arredondo's blooms are set on complementary backgrounds with a bright-green vine snaking through the compositions. Each of the artist's thirty-six paintings was translated into mosaic by Mosaika Art & Design. The flowers are fabricated in tumbled stained glass, installed on slightly "pillowed" concrete substrates to give a subtle dimensionality to each flower head. Low-relief glazed ceramic makes the stamen and pistils project slightly outwards. The foliage was molded and hand-carved from wet clay; glass smalti forms the background.

Garden of Earthly Delights. Photo: James T. Murray and Karla L. Murray.

CORINNE ULMANN
Croton-Harmon Station, 2016
Croton-Harmon · Metro-North Railroad

Inspired by the idealized landscapes of the Hudson River School painters, Corinne Ulmann sought to capture the natural beauty of the Hudson Valley in an artwork named for its home, Croton-Harmon Station. Hand-painted glass windows in the South Overpass were installed in 2013. Three years later Ulmann expanded the work with a mosaic at the North Overpass. Fabricated by Miotto Mosaic Art Studios, the piece depicts the New Croton Dam. Using an aerial perspective, the image captures the moment when the serene river transforms into a cascading waterfall. Color mixing contributes to the illusionary effect of the work and suggests the soothing sound of water rushing down the wall.

Croton-Harmon Station. Photo: Ngoc Minh Ngo.

CHRISTOPHER WYNTER
Migration, 2018
Cathedral Parkway (110th Street) ⒷⒸ

Installed in 1999 and expanded during station improvements in 2018, Christopher Wynter's glass mosaic artwork *Migration,* presents ideas of movement, passage, and migration in symbolic form. The work pays tribute to Frederick Douglass, a man born into slavery who escaped and went on to become one of the eminent human rights leaders of the nineteenth century. Featured are a portrait of the abolitionist, writer, orator, and activist, as well as North Star imagery representing the antislavery newspaper he founded and edited.

The work speaks to the universal call for home, and the spirit of transitions and migrations. The blocks of color represent various African ancestral homelands and a circular symbol, the *n'kisi* sacred place concept of the Nkongo people. The circle motif also relates to the power of centering. Wheels and walking feet describe faraway destinations and are intended to evoke the mass movements of Africans— both forced and voluntary—throughout history. Both of the mosaics were fabricated by Miotto Mosaic Art Studios, in collaboration with Travisanutto Mosaics.

Migration. Photo: Anthony Verde Photography.

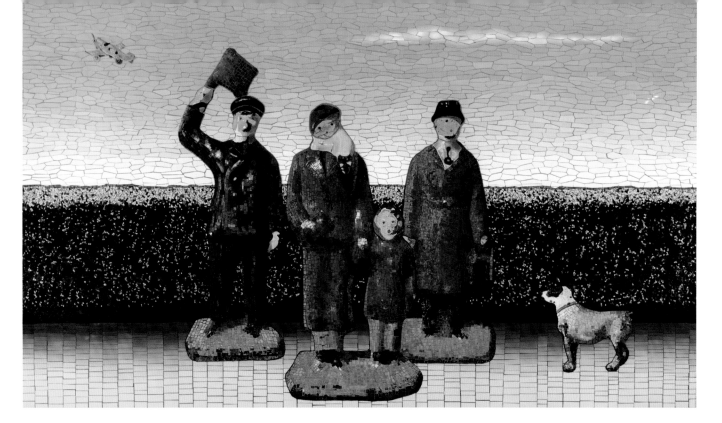

Waiting for Toydot. Photo: Jason Mandella.

PETER DRAKE

Waiting for Toydot, 2015

Massapequa · Long Island Rail Road

In *Waiting for Toydot,* Peter Drake used 1930s miniature lead figures from his father's model railroad collection to represent a group of people who appear to be waiting on a platform for a train to arrive. Describing his inspiration, Drake said, "Some of my fondest memories of growing up on Long Island are driving to the train station with my family in the morning to drop my father off to work. He would make a big production of waiting to the last minute to jump on board. We returned every evening to pick up my father and even as a child I had the sense that this was his reward for working hard every day in the city." Drake tipped his hat to the Fitzmaurice Flying Field in Massapequa Park by including a Bremen airplane to reference James J. Fitzmaurice's historic 1929 transatlantic flight.

There are three mosaic artworks overlooking the stairways and two detailing the exterior walls on the platform, one of which can be seen from nearby Sunrise Highway. Mosaika Art & Design fabricated these whimsical mosaics in ceramic and glass. To achieve the three-dimensional and toy-like quality of the original paintings, the heads of the figures were formed by hand with clay and then glazed and hi-fired. Ceramic tile as well as Byzantine smalti were used to define the various elements as can be seen in the irregularly shaped pieces of glass of the bushes and the gradation of ceramic tile in the sky. Additionally, seventeen hand-painted glass windows fabricated by Glasmalerei Peters Studios are installed in the station waiting room and above some of the stairs.

GLENN GOLDBERG

Bronx River, 2023
East 149th Street ⑥

Glenn Goldberg transports natural elements from other parts of the Bronx to a South Bronx location better known as an urban, industrial setting. Playing with the viewer's perception, *Bronx River* includes imagery of plants, trees, and animals, all common to the area around the Bronx River. Species such as the mallard, egret, and the English house sparrow are rendered through intricate patterns inspired by textiles, tapestry, and ancient calligraphy. The work is intended to spark curiosity about the river, animals, the nearby natural environments such as the New York Botanical Garden, the Bronx Zoo, Pelham Bay Park, and the Bronx River, New York City's only freshwater river. The river was heavily polluted with industrial waste for much of the nineteenth and twentieth centuries, but through the efforts of environmental groups over the past fifty years, the water quality has been substantially improved. In 2023 there were multiple dolphin sightings in the Bronx River. The artist, who was born in the Bronx, hopes that celebrating the success story of the river may also foster a greater sense of responsibility for the urban environment as well. Miotto Mosaic Art Studios, with Travisanutto Mosaics, translated the original collage artwork into two glass mosaic murals.

Bronx River.
Photo: John Berens.

Glass

MTA Arts & Design has used the medium of glass since the early days of the program. Featured prominently in elevated, outdoor stations, the collection includes more than 160 glass artworks, not counting the many examples of glass mosaics. In the 1990s and early 2000s faceted glass artworks were common. Similar to stained glass, the style involves joining shaped pieces of cut glass into a solid panel. The matrix is formed by a thick epoxy resin, offering the strength of a slab of concrete. A notable faceted glass example is Romare Bearden's *City of Glass*, designed for the Westchester Square-East Tremont Avenue Station in 1982 and realized posthumously in 1993. Faceted glass scatters its jeweled colors across the platform surface when the sun hits it directly, producing a stunning visual effect.

Confidence grew as more successful projects were completed. Glass was an obvious choice for locations with natural light. The program's first laminated-glass projects—Patsy Novell in 1996 and Sydney Cash in 2000—date back to the same period. The technique did not become widely used by Arts & Design until the mid-2000s, replacing faceted and fused glass entirely. Digitally printed interlayers can capture original artwork details with outstanding accuracy. The process also allows for hand-painting and can be enhanced though additional techniques like etching, sandblasting, airbrushing, and silkscreen.

Artwork in laminated glass block had been used for exterior walls in Coney Island and at multiple station in the Rockaways. In 2015 Moe Brooker's laminated glass panels at LIRR Wyandanch took the practice to new heights. Installed in three columns on the facade of a parking structure, the twenty-eight glass panels reach a soaring 70 feet high. The project opened up new possibilities to incorporate art in the architectural glass exterior of stations, as seen in the Astoria line artworks by Sarah Morris, Stephen Westfall, Diana Carr, and Maureen McQuillan, completed in 2018.

Glass artworks can be found throughout the MTA system in windscreens, railings, waiting rooms, platform shelters, elevator towers, and overpass bridges. In a few examples, such as Alex Katz's hand-painted panels and a mirrored-glass installation by Jim Hodges, it has found a home underground. The possibilities to experiment with this material continue to grow.

Detail of Jeffrey Gibson, *I AM A RAINBOW TOO*, 2020, NYCT Astoria Boulevard Station.
Photo: Etienne Frossard.

Radiant Memories.
Photo: Sophia Little.

JAMES LITTLE

Radiant Memories, 2020
Jamaica · Long Island Rail Road

James Little's practice is characterized by a rigorous attention to color and detail. He is a self-described perfectionist, and his abstract, geometric paintings are composed of multiple layers of hand-blended pigments bound in hot beeswax, a technique that recalls encaustic works by ancient Egyptian and Greek artists. Little's approach to color is laborious, as he often spends extended periods of time carefully crafting the colors he applies to his canvas, driven by the belief in color's universal and optimistic impact on viewers.

Little had never worked in glass before and sought out Glasmalerei Peters Studios to fabricate his vision of animated striations of color enveloping the walls of Jamaica Station's stairwell cover. "The only thing I was sure about was that I knew what I knew about color," he recalls. "How to get that to transcend onto glass was what I was really curious about."

Little envisioned the sun passing through the space in the daytime and ambient light from the interior washing over it in the evening. The goal was to create a sun-filled walkway for those moving through and a lush colorful wall to be experienced by those viewing it from a distance. Little was hands-on, working directly with Peters Studios,

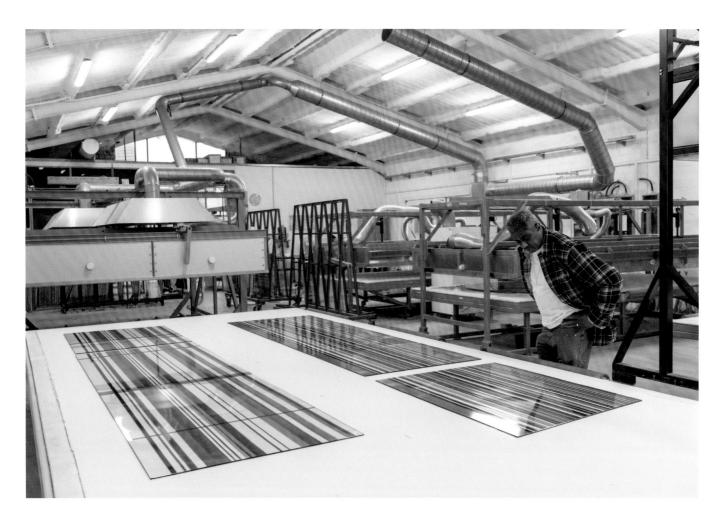

James Little inspecting glass samples. Courtesy of Glasmalerei Peters Studios.

Color charts for *Radiant Memories*. Courtesy of Glasmalerei Peters Studios.

an experience he describes as a complex negotiation and an exchange of technique and knowledge. As Little learned from artisans that dipping glass in silver heightens color's ability to dance in natural light, Peters Studio learned from Little his steadfast belief in the power of color value and tone. Little and his fabricator peered through a mass of color samples, meticulously assigning glass color coordinates to Little's drawn proposal. The duo considered every element during fabrication, from varying the widths of the bands, to minutely adjusting color choices to maximize the effect of movement, before firing the enamel on each of the thirty-three panels that comprise the work.

Each panel is built of three layers of glass. The first layer is painted and laminated to a clear piece of glass, allowing a fourth of an inch of space between the clear layer and the painted third panel. Before painting, the fabricator used film to mask out the lines. A computer-based machine sprayed on the larger bands of color. The smaller bands of color were hand-painted. The effect of layers, paint placement, and spacing allows color to move seamlessly as Little intended, rendering the illusion of gradated blocks of color.

Radiant Memories.
Photo: Sophia Little.

I dreamed a world and called it Love. Photo: Felipe Fontecilla.

JIM HODGES
I dreamed a world and called it Love, 2020
Grand Central-42nd Street ④⑤⑥❼Ⓢ

In 2019 Jim Hodges was commissioned for an artwork at Grand Central-42nd Street Station, above the busiest entrance in the subway system. The call for artists had described the opportunity as a mosaic project, but Hodges's proposal renderings showed a highly reflective artwork, akin to a mirrored-glass piece he had exhibited at a New York gallery a few years earlier. His concept for *I dreamed a world and called it Love* called for a cascading installation, starting with a gradient of light to dark tones on the upper tier nearest Grand Central Terminal and spilling down into a pool of bright colors, in contrast with the station mezzanine below.

As Hodges describes the setting, "The site, a bustling corridor in the heart of New York City, prompted a gesture that might provide a momentary illumination, a split second of image and color that frames the moment in time between places."

The design is based on camouflage, a highly urban pattern meant to reference nature, which is a signature motif in Hodges's work. The field of camo seen in the proposal had no visible seams and appeared to be floating. Like much of his work, it was deceptively simple on the surface.

In order to realize the mirrored-glass project as the artist intended while delivering the safety and durability the location required, Arts & Design worked with Hodges and his long-time fabricator Walla Walla Foundry to develop an entirely new fabrication method. The result looks remarkably similar to

I dreamed a world and called it Love during fabrication. Courtesy of Walla Walla Foundry.

Top, left: The aluminum substrate panels for *I dreamed a world and called it Love*. Courtesy of Walla Walla Foundry.

Top, right: *I dreamed a world and called it Love* during fabrication. Courtesy of Walla Walla Foundry.

Above: *I dreamed a world and called it Love* during installation. Photo: Manuela Donoso.

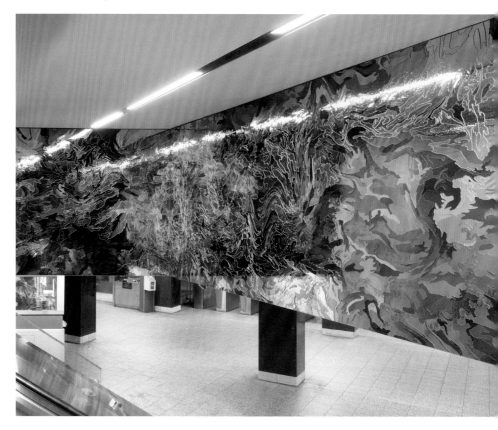

Above and opposite: *I dreamed a world and called it Love*. Photos: Felipe Fontecilla.

the gallery installation, while being both water and impact resistant. The surface appears smooth and continuous despite the installation being composed of more than three dozen panels that can be removed if necessary.

Finding the materials to support this design in the wide color palette needed was a challenge. In early 2020 Lamberts "antique" glass, often used for stained glass in cathedrals, was identified for the colored first surface. Even before the underlayers were resolved, crates of glass sheets—seventy different colors—were mouth-blown using traditional window glass methods, worked into flat panels by hand, and shipped from the manufacturer in Germany. Industrial float glass used

as the second layer was sent to Ithaca, New York, where each sheet was aluminum-coated with a moisture resistant, medical-grade mirror finish. The irregular thickness of the colored glass added to the inherent beauty of the piece, but it required a liquid laminate in place of the foil more commonly used. The glass sheets were joined with a polyresin, cured, and sent to the Walla Walla Foundry. Engineering work and impact testing were underway when the pandemic stuck.

After a pause of more than three months during the Covid shutdown, the Washington state-based foundry was able to resume fabrication using a small, socially distanced team to complete the project. The sheets of glass were water-jet cut

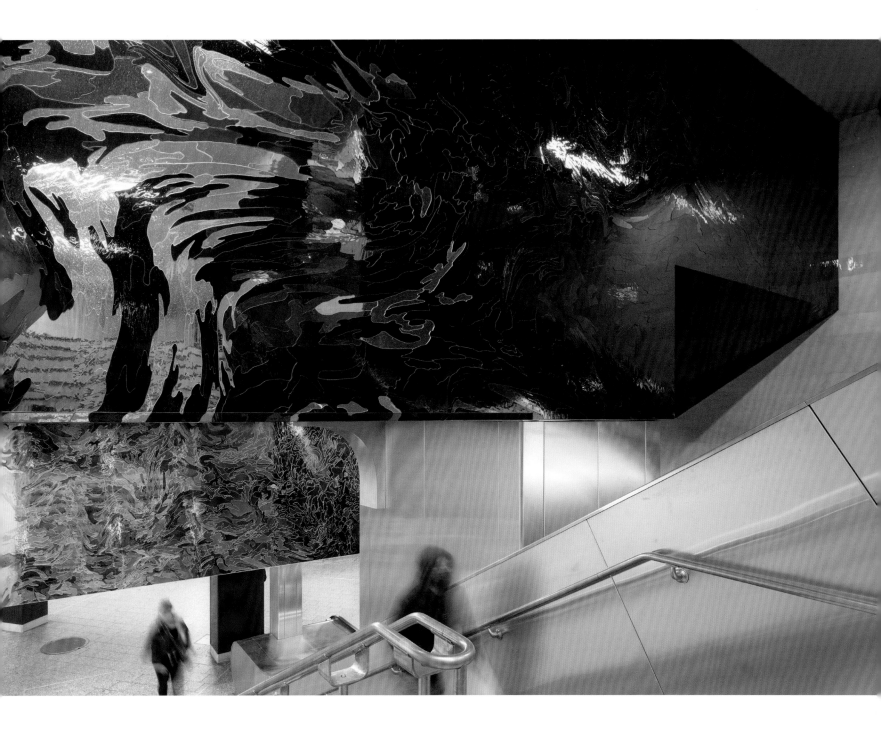

into more than 5,000 unique camo-shaped pieces. Each of the organic forms was numbered and fit perfectly onto forty-one large aluminum panels, irregularly shaped to hide the seams and carefully etched with a map showing the outlines and number for each piece of glass. To achieve Hodges's intended look, an uninterrupted floating field, the fit had to be perfect. Even the epoxy used to fill the paper-thin spaces was designed to disappear. In December 2020, Walla Walla traveled to New York to install the work in an unsettlingly quiet Grand Central.

The finished artwork is unique in the MTA Arts & Design collection. It is a testament to the artist's vision and unwavering dedication of Hodges and his team. *I dreamed a world and called it Love* is the result of a collective effort of arts professionals, fabricators, architects, engineers, contractors, and installers to deliver a highly ambitious project, full of hope, during one of the most difficult periods in the city's history. Describing its impact, Hodges notes, "The color and scale are on par with the energy of this site. The experience of moving through the powerful piece, rendered in hand-blown and mirrored glass, swells the heart, solidifying the transformative quality of public art. During these unprecedented times, the work seems to lighten the heavy loads we are bearing."

Left: *I AM A RAINBOW TOO*. Photo: Marc A. Hermann.

Below: Original artwork for *I AM A RAINBOW TOO*. Courtesy of the artist.

JEFFREY GIBSON
I AM A RAINBOW TOO, 2020
Astoria Boulevard Ⓝ Ⓦ

I AM A RAINBOW TOO is an expression of the cultural and ethnic diversity of Queens and of New York City as a whole. The work is a symphony of colors, pulsating from red to purple—the spectrum of a rainbow—and coalescing with skin tones, transforming the station into an immersive visual concert.

Jeffrey Gibson is an interdisciplinary artist who makes paintings, sculptures, and installations with mixed media—beads, jingles, fringe, punching bags, wool blankets, thread, and acrylic paint. The artist is a member of the Mississippi Band of Choctaw Indians and of Cherokee descent. His work merges traditional Indigenous material meanings with those of Western contemporary art to create a new hybrid visual vocabulary.

I AM A RAINBOW TOO is a continuation of Gibson's series of works bearing the same title. Music and text are important elements for the project and visible throughout the artist's studio practice. Gibson cites 1980s house music as an influence and inspiration for his artmaking, which provided sanctuary space for people of different backgrounds to gather and celebrate each other. The title was taken from a lyric from the Bob Marley song "Sun Is Shining." *I AM A RAINBOW TOO* has also been graphically reappropriated by embedding lettering from the title into some of the designs, stacking a word or two on each line into faintly legible font like mark-making.

The artwork is composed of 102 unique designs made by Gibson and translated into laminated glass by Tom Patti Design. Each group is light-specific to a unique location. On the mezzanine level, a thirty-panel series can be viewed from Grand Central Parkway. Thirty-six panels split into two groups on the platforms face Hoyt Avenue, overlooking the RFK Bridge. Four nine-panel compositions are set in stairwell windows on the platform. Altogether, this highly visible artwork can be seen from the neighborhood and major roadways below and experienced as riders enter and move through the station.

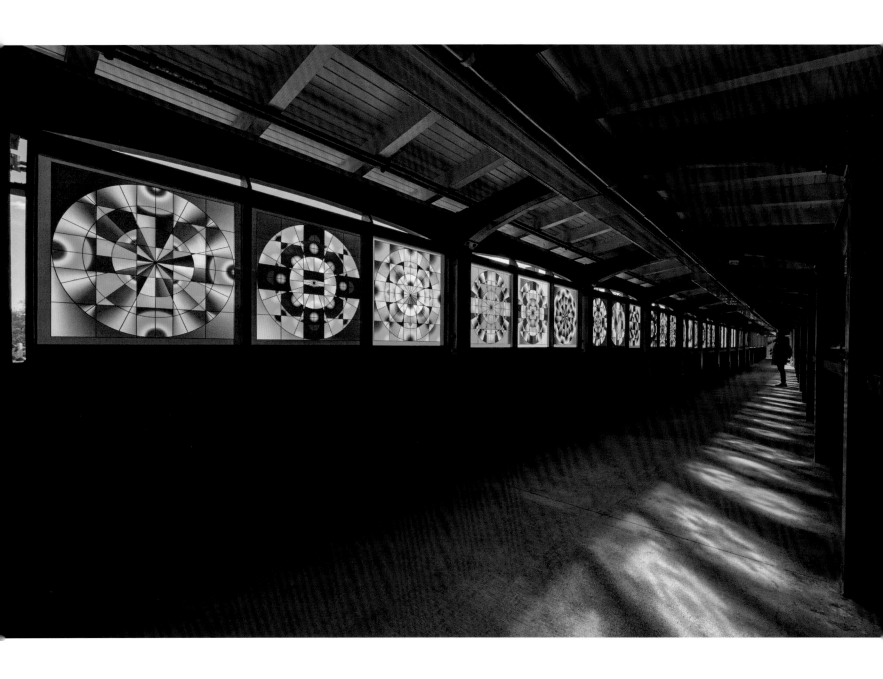

Gibson notes, "I designed the three sites to be a cohesive series, while each acts as unique iteration reflecting an expansive version of the rainbow. The sphere is used as a primary design element constructed using a variety of colors that transition from one to another. It can be interpreted in an abstract planetary way and more specifically as the sun or the moon."

I AM A RAINBOW TOO is bold and graphic; it can be understood from a distance, but it is also visually interesting and intimate when seen up close. At night, the artwork is an illuminated beacon of inclusivity and hope for New Yorkers and international visitors from multiple generations and cultural backgrounds. While remaining true to his studio practice both formally and conceptually, Gibson designed the artwork with its surrounding environment in mind, interweaving the shapes and colors in the artwork with transitory elements from the street below or the subway riders passing through the station.

*I AM A RAINBOW
TOO*. Photos:
Etienne Frossard.

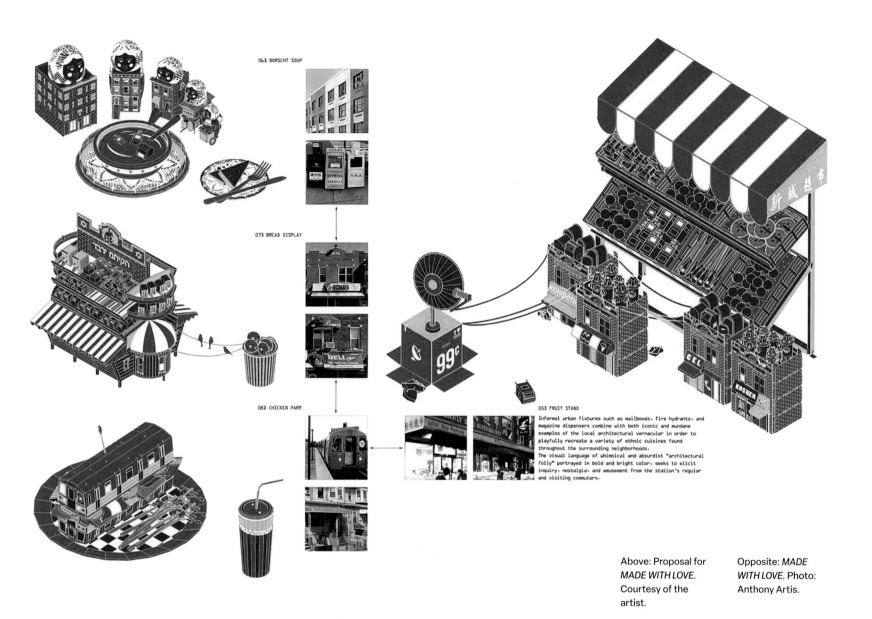

Above: Proposal for *MADE WITH LOVE.* Courtesy of the artist.

Opposite: *MADE WITH LOVE.* Photo: Anthony Artis.

OLALEKEN JEYIFOUS

MADE WITH LOVE, 2019

8th Avenue Ⓝ

MADE WITH LOVE turns popular foods into building blocks. Installed at the 8th Avenue Station in Sunset Park, Brooklyn, the artwork explores connections between food, culture, and the built environment through the lens of architecture. The piece is composed of twenty-nine laminated-glass panels that form triptychs depicting urban elements and foods known and loved by the diverse local community and the many visitors they attract.

Sunset Park is one of the most diverse neighborhoods in New York City. Following the opening of the first Chinese American grocery store and the first Cantonese-style seafood restaurant on 8th Avenue in the mid-1980s, an extensive stretch has since developed into an affluent Chinatown and food destination in Brooklyn. Some claim that the Chinese

settled on 8th Avenue because the number eight is commonly thought to be lucky for financial matters, and "8th Avenue" can be loosely interpreted as "a road to wealth." Today, the neighborhood is home to thriving immigrant communities of Chinese and Hispanics together with Northern Europeans, Irish, and Italians.

Extending beyond language and culture, diversity is an experience shaped through time as long-established groups share spaces with recent arrivals. For Nigerian-born Olaleken Jeyifous, food and architecture are two important forms of cultural expression. As he describes it, "As new ethnic groups arrive, they live in the same spaces as those who came before them. Yet each group grafts its own cultural practices onto these spaces, both inside and out. This tension between

old and new permeates through architecture, since well-established patterns of design and construction are in some instances wiped away, and in other instances preserved and cherished."

Building facades, mailboxes, subway cars, street signs, and electric cable are morphed into cake, bread, churros, noodles, and an ice cart. For instance, in the *MADE WITH LOVE* triptych "Fruit," urban fixtures like mailboxes, manhole covers, and hydrants are displayed on the fruit stands of a local produce market. The stands take the shape of long-established row houses bearing the cultural marks from their previous inhabitants, juxtaposing with lanterns.

Working with hand drawing and digital illustration, Jeyifous digitally manipulated and flattened architectural details and urban fixtures in bold and graphic forms to assimilate iconic foods in local communities. Originally conceived primarily in red and blue, additional colors were introduced by Jeyifous in the final process of colorings. These compositions were then hand-cut and stenciled into full scale work in laminated glass using an airbrushed application of vitreous enamels, in collaboration with fabricator Glasmalerei Peters Studios.

MADE WITH LOVE
during fabrication.
Courtesy of
Glasmalerei Peters
Studios.

MADE WITH LOVE.
Photo: Anthony Artis.

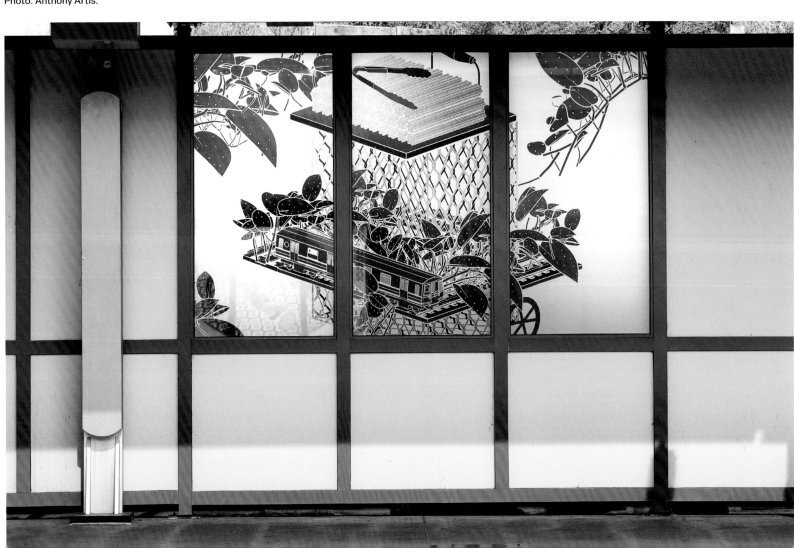

Push/Pull. Photo: Alan Wiener.

LISA SIGAL

Push/Pull, 2018
Avenue N ⒻF

Lisa Sigal's *Push/Pull* highlights the rich social and visual tapestry of Brooklyn, captured in refractive photographs of specific streetscapes near the Avenue N Station. Reflections of public, private, and commercial sites give the appearance of image overlay or digital rendering; however, each image is a single photograph. The unique combination of angle and time of day creates the visual illusion of multiplicity while also illustrating the movement present in a single scene.

The title *Push/Pull* references the instruction for access or passage between places, suggesting the swift transitions of subway riders from neighborhood to neighborhood. The terms "push" and "pull" are also used by painters, as planes of color push or pull the eye to create or negate depth in two-dimensional work. The images were digitally printed on the inner surface of the glass panels by Depp Glass.

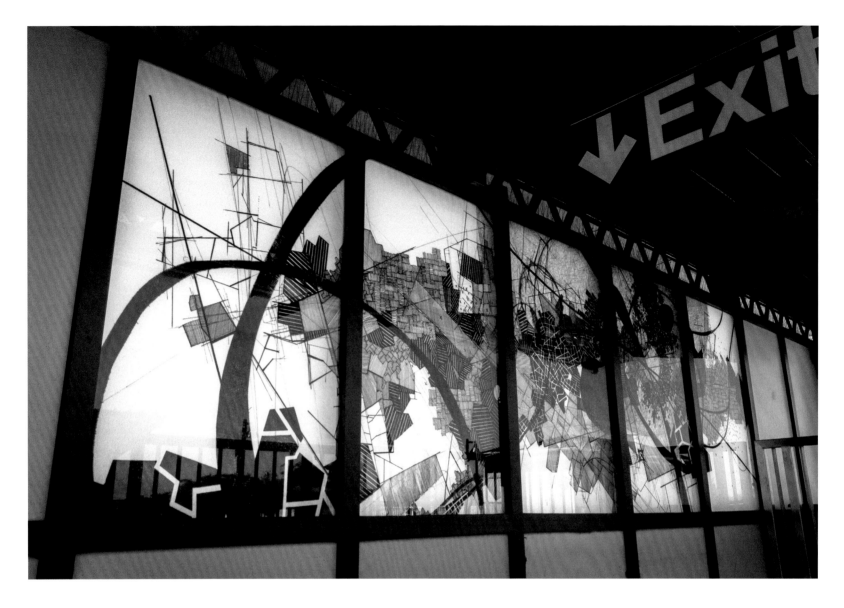

AVEX1-6(station).
Photo: Derek Lerner.

DEREK LERNER

AVEX1-6(station), 2017
Avenue X Ⓕ

Inspired by and referencing the geographic location of the Avenue X Station and the meandering lines throughout the transit system, Lerner meticulously culled satellite imagery and maps to create complex flowing forms for each drawing featured in *AVEX1-6(station)*. The artwork plays with the idea of macro and micro scale, an essential visual language in the artist's practice.

Derek Lerner explores systems and their creation, control, use, and experience. He is interested in human interaction with technology and nonlinear information, such as internet, code, and mapping. From an aerial vantage point, his compositions grow, line by line, through an additive, extemporaneous process into fictional spaces where layers of information co-exist.

Lerner worked with Depp Glass to reproduce his drawings in thirty laminated-glass panels. The six ink drawings were photographed at high resolution to scale and crop the compositions to the specified sizes for fabrication. Sandwiched between two sheets of glass, these evocative drawings float on semi-translucent background to maintain clear and consistent contrast on both sides, allowing natural light to pass through and illuminate the work.

The artwork, installed in platform windscreens visible from the platform and the street below, is intended to inspire and intrigue viewers on a poetic and mystical level. Each glass panel has multiple X's woven into the composition, a reference to the location and to the complex and systematic crossing between the mass transit system and New York's evolving metropolis.

Above: Original artwork for *AVEX1-6(station)*. Courtesy of the artist.

Right: Detail of *AVEX1-6(station)*. Photo: Derek Lerner.

TOMO MORI

The Wheels on the Bus, 2017

Manhattanville Bus Depot · MTA Bus Company

The Manhattanville Bus Depot is a community-facing facility in Harlem. Most Arts & Design projects are located within subway stations, but this project offered an opportunity to highlight the significance of city buses and the vital role they play in the Harlem community, carrying thousands of residents to their destinations daily.

The Manhattanville Bus Depot holds a garage for buses, administrative offices, and a facility for the bus crews. Tomo Mori's proposal was designed as an expression of appreciation for those who work inside, as well as the residents who rely on their work. The title, *The Wheels on the Bus,* was meant to appeal to younger members of the community.

Brightly colored circular forms and patterns create a welcoming energy for those who enter the depot daily. The artist's message is one of forward motion, intended as encouragement for all viewers. Mori incorporated vivid colors and patterns from more than twenty fabrics from around the world to reflect a global community. In the windows above the entrance, Mori used a forest of greens, with yellow and blue, to bring the outside into the depot.

To create the glass, Mori worked with the fabricators at Glasmalerei Peters Studios. Through experimentation they were able to capture the essence of watercolors with the textile patterns suspended in the layers of airbrushed laminated glass. A three-dimensional bus wheel over the door adds a bold sculptural impact. Working with Art Metal Industries (AMI), Mori used layers to create a bas-relief effect, juxtaposing textures in the metals with the richness in the surface texture of the fabrics in the adjacent glass, varying them from shiny to grainy to smooth.

The Wheels on the Bus.
Photos: Filip Wolak.

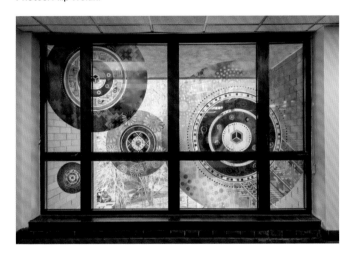

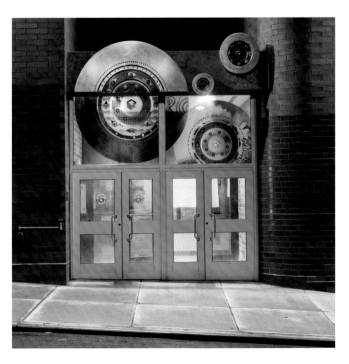

Proposal for *The Wheels on the Bus.* Courtesy of the artist.

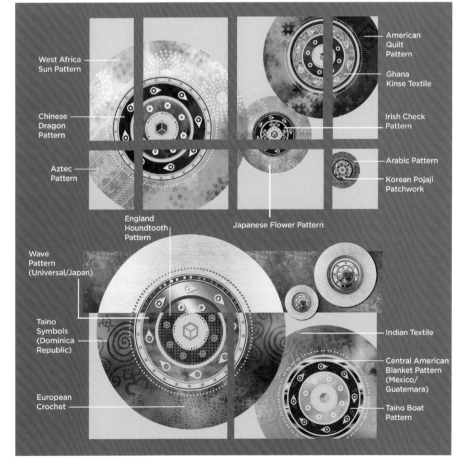

DERRICK ADAMS

Around the Way, 2019
Nostrand Avenue · Long Island Rail Road

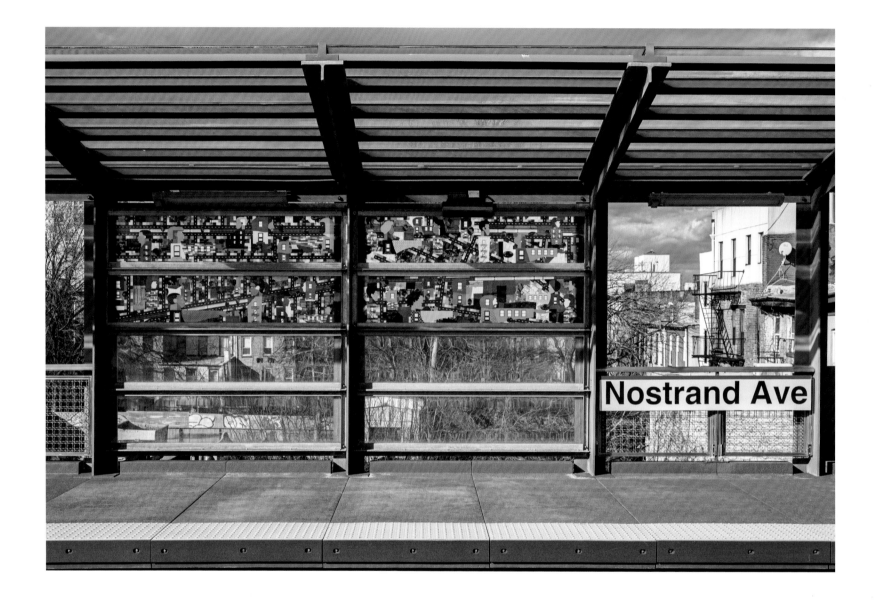

Around the Way is a stylized journey through the Brooklyn neighborhoods of Crown Heights and Bedford-Stuyvesant. Derrick Adams comments, "As a longtime resident, I was inspired to create this work as a response to the vibrant cultural surroundings and diverse population that I see in motion on a daily basis. The figures fuse with architecture and nature as a representation of the progressive impact left by generations of growth. These hybrid structures represent the many important components which reside together to form a thriving community."

Fabricated by Depp Glass, the collage-style artwork is composed of eighty-five panels of laminated glass installed in the platform windscreens and four pedestrian bridges. The imagery centers around deconstructed figures representing the people who live nearby. Buildings resembling those around the station serve as the body and foundation, relating to the idea of home and the rich history of the area. The cityscape is vivid and verdant. Trees sprout from the outstretched hands the figures offer each other, suggesting a community that is generous, healthy, and growing. The bright color-blocking background is layered with maps and aerial photos. The individuals are linked by a web of streets and train tracks, emphasizing the importance of transportation and train as a connector both in and out of the neighborhood. The artwork is a dynamic and joyful tribute to the artist's home.

Around the Way.
Photos: Emil
Horowitz.

DARRYL WESTLY

Illuminations, 2022

Westbury · Long Island Rail Road

To create *Illuminations*, Darryl Westly researched Westbury and its history extensively, reading *The Underground Railroad in Long Island* by Kathleen Velsor and *A History of Westbury Long Island* by Richard Panchyk. He was inspired by the area's notable figures and by its great societal significance. The artist notes, "I found myself entranced by Elias Hicks. His dedication to abolition and manumission in the face of transgression touched me deeply. It was his efforts on outlawing slavery within the Society of Friends that eventually paved the way for slavery to end in New York, far in advance of the Emancipation Proclamation."

Westly's brightly colored landscapes pay homage to the community's many houses of worship as well as Lt. Colonel Spann Watson, a celebrated Tuskegee airman with ties to Long Island. The imagery includes familiar Westbury locations like the Hicks family estate and nurseries, and Roosevelt Field and Raceway.

Glasmalerei Peters Studios fabricated the twenty-six laminated-glass panels, translating Westly's rich watercolor paintings into hand-painted glass with incredible accuracy. Floral motifs from the glass are incorporated in his design for the metal fencing for the station. Fabricated by KC Fabrications, the metal artwork also features images of contemporary attractions and the Old Westbury Waterpump as a meeting ground, surrounded by intertwined vines and chains to represent the history of linking various communities in Westbury.

Opposite: *Illuminations*. Photo: Jason Mandella.

Left: Original artwork for the platform shelters. Courtesy of the artist.

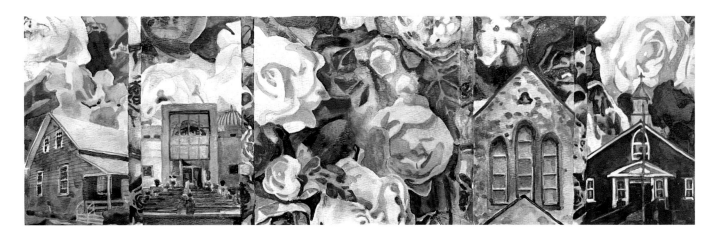

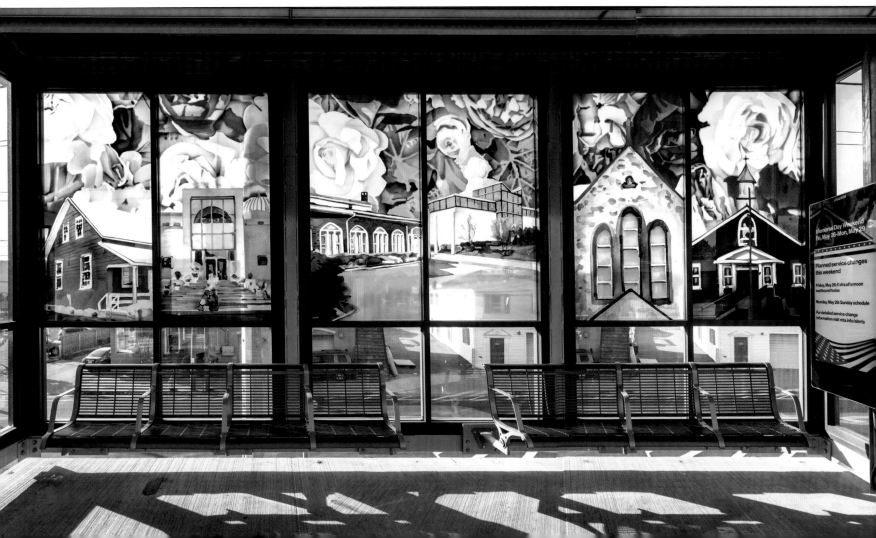

CARA ENTELES
Commuting Through Nature, 2020
Merillon Avenue · Long Island Rail Road

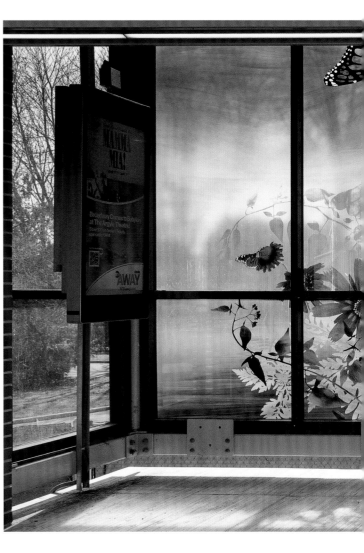

Above: *Commuting Through Nature*. Photo: William Mebane.

Top: *Commuting Through Nature* during fabrication. Courtesy of Glasmalerei Peters Studios.

Above: Original artwork for *Commuting Through Nature*. Courtesy of Glasmalerei Peters Studios.

Artwork by Cara Enteles at the Merillon Avenue Station has another kind of commuter in mind: the monarch butterfly. *Commuting Through Nature* focuses on this impressive creature, which flies 3,000 miles each year. Merillon Avenue Station falls in the butterfly migration path every September, as the insects travel from Canada to Mexico for the winter.

Installed in the station waiting rooms and towers as well as on the platforms, the glass artwork mimics the aesthetic of Enteles's hybrid practice, in which she combines silkscreen printing and oil painting on aluminum panels and plexiglass sheets. She plays with transparency and reflection in pursuit of the atmospheric quality of natural light.

In *Commuting Through Nature*, the majestic orange butterflies flutter amid the lush Long Island landscape, taking nourishment from the nectar of flowers while pausing their journey to restore themselves. Local riders will recognize imagery from Garden City and the Garden City Bird Sanctuary.

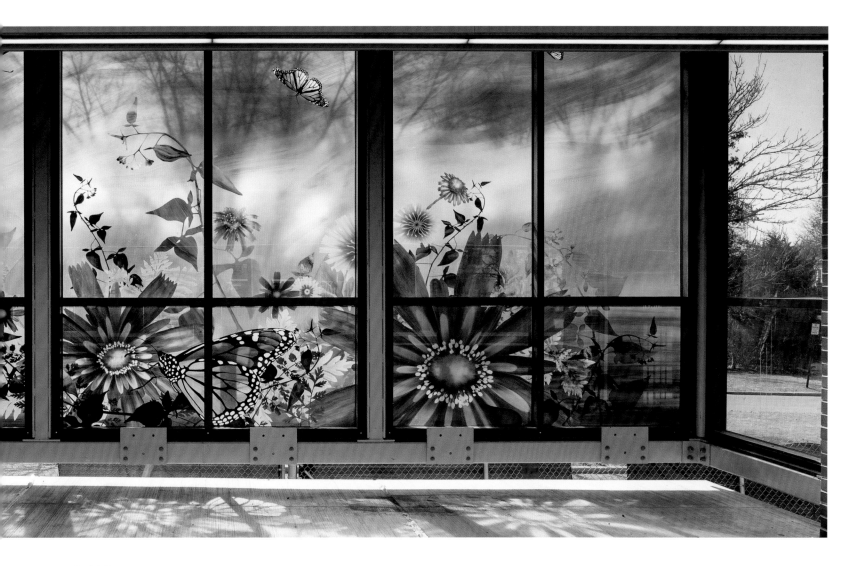

Below: The fabricator (left) and Cara Enteles discussing color choices for *Commuting Through Nature*. Courtesy of Glasmalerei Peters Studios.

Native plants such as Queen Anne's lace, chicory, butterfly weed, and, most importantly, milkweed—the monarchs' source of sustenance and a species on decline due to urban development—are incorporated as reminders to take care of the beautiful place that these "commuters" call home.

Glasmalerei Peters Studios fabricated the works in laminated glass, their masterful hand-painting in delicate layers closely capturing the artist's touch. Light filters through bodies of water and dramatic, sweeping skies as the glass takes on stained-glass quality that makes the scene feel like something sacred. Painterly gestures prompt riders to contemplate the effect of human behavior and the vulnerability of our shared environment.

Enteles also designed the metal fence along the pedestrian bridge, fabricated by Triton Builders and incorporating butterflies and their floral environments in a symmetrical pattern set against vertical stripes.

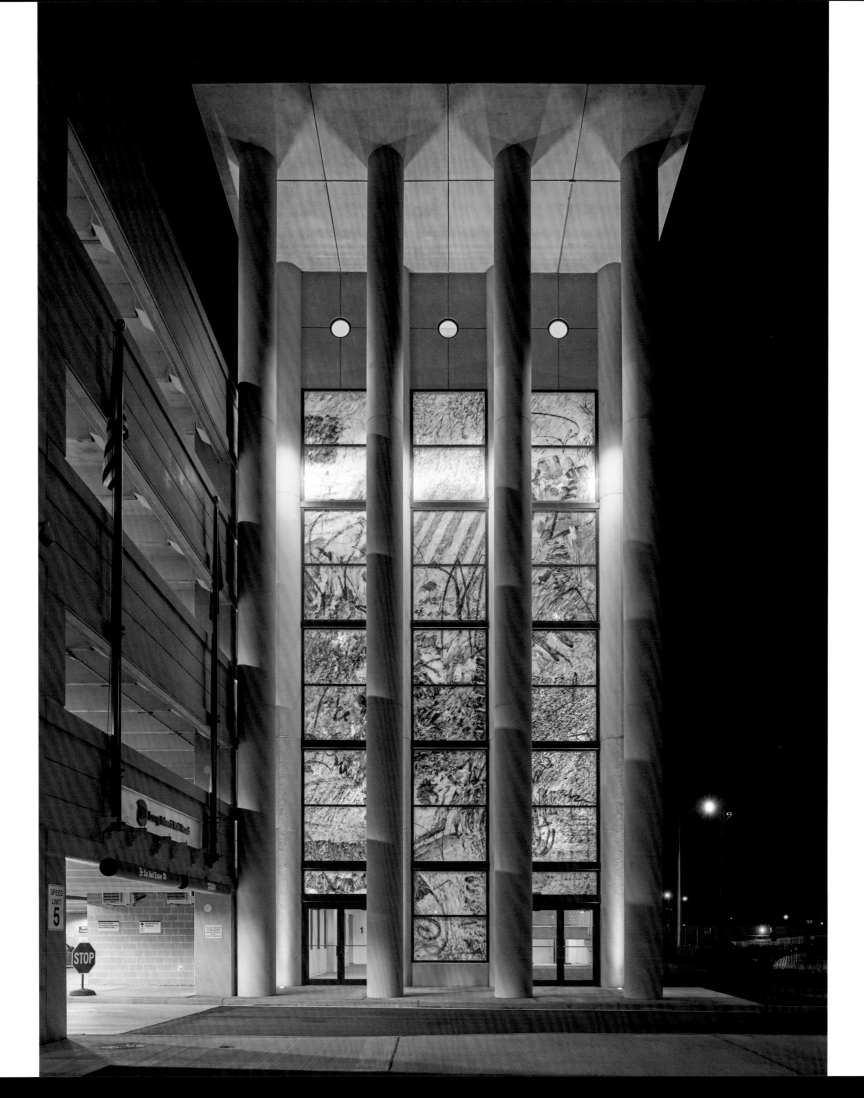

Opposite: *Just Jazz.*
Photo: Sid Tabak.

Right: Original
artwork for *Just Jazz.*
Courtesy of the artist.

MOE BROOKER

Just Jazz, 2015
Wyandanch Parking Garage · Long Island Rail Road

A new parking structure at the Wyandanch Station offered Moe Brooker an opportunity to integrate art into its elevator tower. Brooker's approach to mark-making is grounded in music—the energy of jazz riffs and the rhythms of the Black church where Brooker grew up as the child of a minister. Brooker recalls, "There was difference in the language of sound, the cadence of the preacher's sermon, the antiphonal replies of the congregation, and it all splashed together abstractly. In retrospect, I understand the cultural heritage that informed my thinking visually."

Brooker chose Mayer of Munich to interpret his oil pastel drawing in twenty-eight panels of glass. Created with hand-painted colors that melt when fired to the glass at temperatures of approximately 1,150 degrees, the artwork is lightfast and durable. Mayer continues the tradition of ceramic glass melting colors, a technique that has been used since the sixteenth century.

A composition layered with stripes, scribbles, shapes, and fields of color, Brooker's work embodies the unpredictability and excitement of improvisational jazz while achieving a visual quality evocative of textiles. The patch-like surfaces can be tied to the artist's early memories of his grandmother, a quilter. "She pieced cloth of varying colors, sizes and shape, placed them together and amazed me with her sense of design and her incredible sensitivity in the selection of color, shape and pattern," he recalls. The five-story tower is an illuminated beacon at night, shining from within, with its inspired rhythms and movements creating a welcoming and familiar energy.

ARMANDO VEVE

Boat House Buggy, 2021
Port Jervis · Metro-North Railroad

Boat House Buggy. Photos: Gordan Stillman.

Armando Veve's *Boat House Buggy* features symbols, objects, architectural forms, and industries of Port Jervis, detailed with mechanical and natural elements characteristic of the artist's style. Composed of two double-sided laminated-glass panels facing each other in the station's platform shelter, the artwork draws inspiration from Victorian dollhouses. Riders are invited to peer into the scene described by the artist as "part home, part boat, part parade float."

On the track side, the drawing reveals the interior of the hybrid architectural structure, with elements that evoke the city's history as an industrial hub—a cargo ship in a glass bottle commemorating the Delaware and Hudson Canal, and stoneworkers preparing bluestone for shipment. On the ramp side, the windows of the boat house become peepholes for viewing and passages for light.

Fabricator Tom Patti Design achieved Veve's intended viewing experience following multiple rounds of testing the opacity of the panels. Patti recalls, "The work had to be opaque enough to maintain the front image and also translucent enough to see the image behind it because visually opposing walls combine to create exterior images and a secure platform space."

KAMBUI OLUJIMI
Where the Sky Begins, 2018
Avenue I Ⓕ

Where the Sky Begins captures kaleidoscopic images from Kambui Olujimi's photographs of the sky that capture weather patterns and times of day around the world, including Jerusalem, Beijing, Brooklyn, Rio, and Rome. The artwork reflects the international character of Brooklyn and New York City as well as notions of global community and interdependence. "Among the shifting clouds, we find a place for wandering—an abstract space of infinite wandering," Olujimi says. The series of abstract compositions was fabricated in laminated glass by Depp Glass.

Where the Sky Begins.
Photos: Etienne Frossard.

ANDREA BELAG

Brooklyn Transitions, 2018
Avenue U Ⓕ

Brooklyn Transitions celebrates the energy and movement of New Yorkers across thirty glass panels installed on the platforms. Andrea Belag's gestural mark-making alludes to the movement of the human body in space, while her vibrant palette evokes colors from those available in the early 1900s, when the communities surrounding the Avenue U Station were established. The colors blend into one another, suggesting harmony in diversity through the language of abstraction.

Of her use of abstraction, Belag has written: "Abstraction makes visible an invisible world of emotion and sensation and it strives for timelessness." Belag worked closely with fabricator Mayer of Munich to create the hand-painted laminated glass panels.

Original artwork for *Brooklyn Transitions*. Courtesy of the artist.

Detail of *Brooklyn Transitions*. Photo: Etienne Frossard.

LESLIE WAYNE

Neptune's Garden, 2018

Bay Parkway Ⓕ

Situated on the route to Coney Island, *Neptune's Garden* celebrates the ocean's beauty and its broad appeal for New Yorkers. In creating the artwork, Leslie Wayne considered the public's shared interests and concerns for the environment and surrounding bodies of water, as well as New Yorkers' enjoyment of the beaches year-round, from summer days to Polar Bear Plunges.

Layers of glass panels create a fantastical panorama of the sea floor with coral, floating seaweed, and ferns detailed in colorful, organic forms. Each layer of glass presents a cross-section of one of Wayne's paintings, originally made with oil paint built up into textural surfaces. Wayne worked with Derix Glasstudios for the fabrication of the artwork, incorporating hand-painting and other techniques in laminated layers to create a sense of depth.

Neptune's Garden.
Photo: Dario Lasaghi.

JACKIE BATTENFIELD

Tree Canopy, 2018
Avenue P Ⓕ

In *Tree Canopy*, Jackie Battenfield applies chromatic hues to branching trees in the neighborhoods surrounding the Avenue P Station, including beech, dogwood, and maple trees. The artist describes her inspiration: "Brooklyn is full of mature trees, whose canopy shades our walk to and from the subway, shelters us during an unexpected rain shower, and provides nature's graceful antidote by softening the urban geometry."

Referencing her original paintings on mylar, tangles of flowering branches are set against a solid white sky. Natural forms become pattern and abstraction, aided by the effect of pigment pooling in unpredictable ways upon mylar's nonporous surface. Fabricated in laminated glass by Depp Glass and installed in platform windscreens, the panels capture the ethereal nature of Battenfield's work in durable material.

Tree Canopy. Photos:
Dario Lasaghi (below),
MTA Arts & Design
(right).

CARA LYNCH
Inheritance: In Memory of American Glass, 2016
Ditmas Avenue Ⓕ

In *Inheritance: In Memory of American Glass,* Cara Lynch draws upon decorative elements found in household glassware mass-produced during the late nineteenth and first half of the twentieth centuries, the same period when Brooklyn neighborhoods were developing rapidly and subway stations were being built. Patterns commonly seen in American pressed glass, milk glass, cut glass, Depression glass, and carnival glass are transformed in vibrantly colored kaleidoscopic abstractions that mirror the diversity of the neighborhoods.

Incorporating details from Gothic Revival architecture, the artist imagined the subway platform as "a secular chapel of the American Dream." Fabricated by Glasmalerei Peters Studios, the laminated glass includes layers of screen printing, colored vitreous enamels, and sandblasted details. The five sets of panels evoke the hopes of those who first settled in the neighborhood the station serves.

Inheritance: In Memory of American Glass.
Photos: Etienne Frossard.

Urban Idyll.
Photos: Phillip Reed.

ELISABETH CONDON

Urban Idyll, 2019

Astoria-Ditmars Boulevard Ⓝ Ⓦ

Urban Idyll is a series of thirty-six glass panels installed throughout the station mezzanine. Images of flowers in bloom and birds in flight meet liquid pours of color and sweeping gestures, flowing rhythmically across the panels. The linear, elongated compositions recall musical notations and film frames, as Elisabeth Condon was especially inspired by Raymond Ditmars's 1921 film *The Four Seasons,* which romanticized Astoria's natural beauty and musical and cinematic histories.

Working with fabricator Tom Patti Design, Condon translated her large-scale paintings into laminated glass. The artwork is based on multiple images, but it is intended to read as one continuous painting. Each composition is designed to scan right to left like a scroll, recording the passage of time through transitional color from the yellows of sunrise through by pops of orange and red to evening sunset hues.

ALISON SAAR

copacetic, 2018
Harlem-125th Street · Metro-North Railroad

Station improvements provided an opportunity for Alison Saar to expand her artwork, installed along the north and south platforms in 1991. The original piece, *Hear the Lone Whistle Moan*, carries a simple narrative throughout the work. Six freestanding bronze relief sculptures depict the journey of two people at different stages in life: a businessman traveling to a home removed from the bustle of the city, and a young woman full of ambition who has just arrived. Saar explains, "I believe these two scenarios to be examples of how many Americans have used the railroads to and from New York throughout history. Yet I was also addressing the specific and rich tradition of the role of the railroad in general in the lives of African Americans." There is a third figure, a train conductor, near the stairs. The title, taken from a spiritual, refers to the train as a metaphor for the passage to heaven.

Music is a more direct-reference in *copacetic*, which portrays the heyday of Harlem. Fabricated by Glasmalerei Peters Studios, twenty-four laminated-glass panels made from the artist's original woodcut prints show nightclub scenes set in the 1930s and 1940s jazz era. Intended as a celebration of the neighborhood's rich history, the imagery "gives a nod to the work of the many great African American artists of the Harlem Renaissance who have used the same medium [woodcut prints] in their practice, such as Elizabeth Catlett, Hale Woodruff, and Aaron Douglas." Musicians, singers, and dancers perform against a yellow background. Both artworks touch on the theme of labor, which is frequently woven into Saar's larger exploration of gender, race, and history. Installed within four platform shelters, the glass panels include a decorative motif at the top, inspired by designs from the African diaspora as well as wrought-iron work in the station.

copacetic. Photo: Anthony Verde Photography.

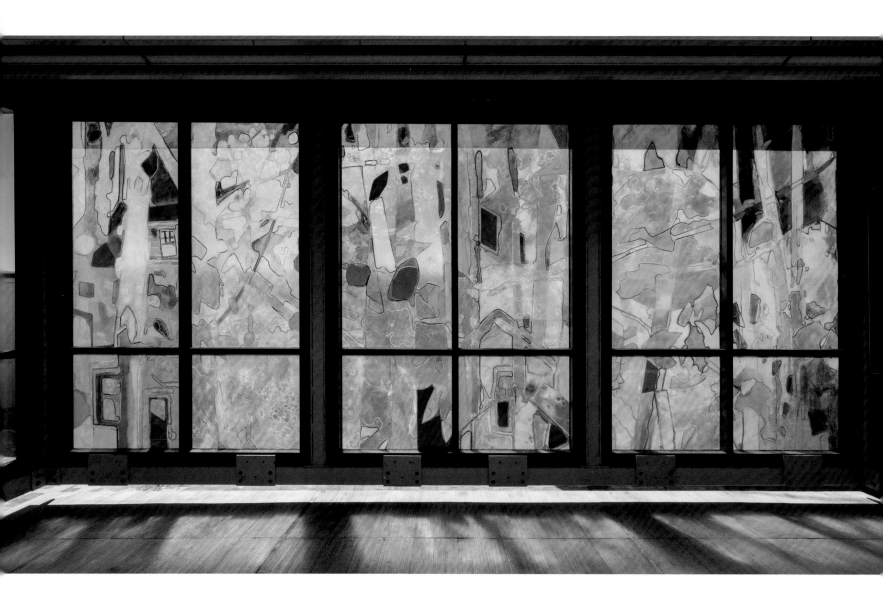

Forestation Syncopation. Photo: Etienne Frossard.

SANDY LITCHFIELD

Forestation Syncopation, 2021
New Hyde Park · Long Island Rail Road

Sandy Litchfield's glass artwork presents the view from the train in a stylized form. *Forestation Syncopation* refers to tree growth in the area and to a style of rhythm that stresses an irregular beat. The title speaks to the artist's intention for the work to have a visual flow containing a sense of rhythm and off-beats like a musical score. The watery translucent color and semi-defined forms of the background recede as long lines and geometric shapes enter the foreground. The work shape-shifts between full abstraction and identifiable references to nature or the built environment—trees, streetlights, and water towers. Color conveys a sense of season and time of day, as the changing light progresses across the landscape.

Litchfield began by taking snapshots of the area from a window seat on the train. She then developed them into a composite work using a hybrid process of drawing, gouache painting, photography, collage, and digital media. Her method moves back and forth between analog and digital technologies: hand drawings and paintings are scanned, worked in layers with photoshop, printed, and then painted over in a repetitive manner until they are resolved. Fabricator Mayer of Munich translated Litchfield's work onto glass using a blend of techniques including hand drawing, painting, and digital manipulation. Thirty-six laminated-glass panels are installed within three platform shelters. According to Litchfield, "Each window portrays a distinct and enigmatic view—more an impression than a complete scene."

GAIL BOYAJIAN

Aviary, 2020

Carle Place · Long Island Rail Road

Aviary explores themes of flight in a nod to the nearby Cradle of Aviation Museum, Grumman headquarters, and airports. Playfully suggesting humankind's inspiration for flying, the composition features images of birds sharing the sky with historical flying contraptions, from balloons and blimps to passenger planes and specific aircraft made by Grumman.

The birds include those native to the Carle Place area of Long Island as well as extinct species, such as the Passenger Pigeon and Carolina Parakeet, that flourished at the time of early attempts at human flight. Frogs and marshland habitats also appear in several panels, referencing the history of the community and its original name, Frog Hollow. Based on Gail Boyajian's original artwork produced with both paint and digital tools, *Aviary* is made up of forty-two hand-painted laminated-glass panels fabricated by Glasmalerei Peters Studios.

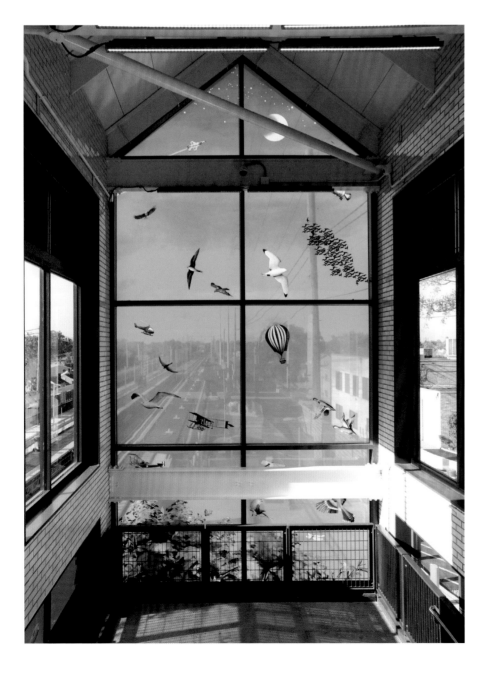

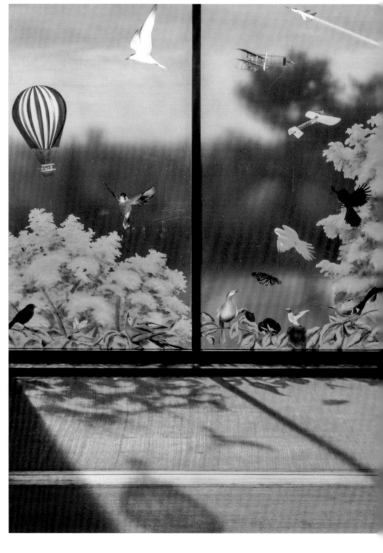

Aviary. Photos: Jason Mandella.

Come Back Home.
Photo: Seong Kwon.

TIMOTHY HYUNSOO LEE

Come Back Home, 2018
Stewart Manor · Long Island Rail Road

Come Back Home is a series of forty-five laminated-glass panels based on the artist's original watercolors. Timothy Hyunsoo Lee worked with fabricator Tom Patti Design to translate the paintings into screens of opaque and translucent hues inspired by the flora of nearby Garden City.

Fractalized, undulating forms initially appear landscape-like, but closer inspection reveals abstraction in repetitive shapes and colors that echo the cycle of seasonal change. The vibrant greens of spring morph into autumnal yellows, reds, and browns. This cyclical rhythm relates to the daily commute and extends to the philosophy that all that begins must come to an end.

MARY JUDGE

American Season, 2018

Wyandanch and Pinelawn · Long Island Rail Road

American Season is a meditation on the transitions in both nature and society that come to pass over time. Patterns reference and pay tribute to Long Island's Native American communities, the diverse communities of the present, and the American Craftsman design style of the station house.

Rich colors radiate and envelop viewers passing through the Wyandanch Station overpass bridge and the Pinelawn Station platform shelters. Bold lines recall the flare of approaching train headlights or the acceleration and deceleration of a train.

Mary Judge's original watercolors were translated into hand-painted and printed laminated-glass panels by Mayer of Munich.

Picking up the broad arches and intersecting lines seen in the surrounding architecture, Wyandanch also features a terrazzo floor piece in the station house.

Below: Proposal for *American Season*. Courtesy of the artist.

Bottom: *American Season*. Photo: Seong Kwon.

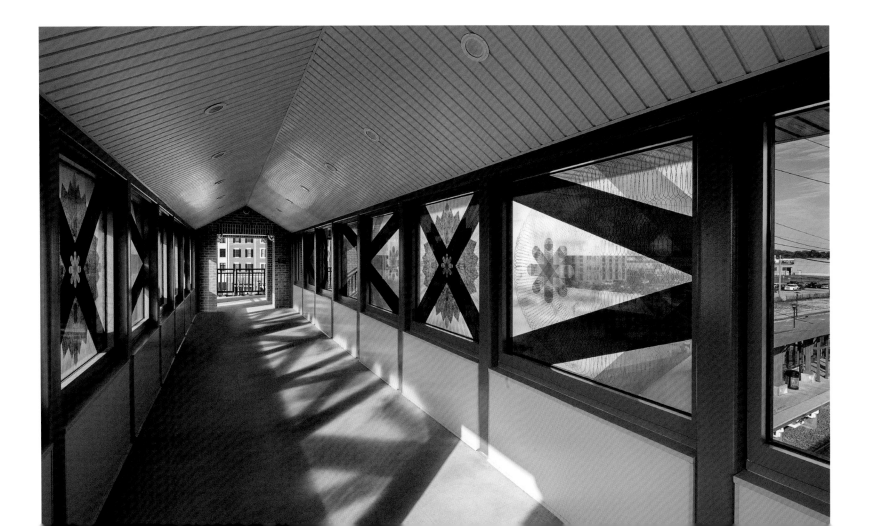

Where Dreams Come to Play. Photos: Jason Mandella.

MARC DENNIS

Where Dreams Come to Play, 2018
Wantagh · Long Island Rail Road

Where Dreams Come to Play imagines a picture-perfect day at nearby Jones Beach. Set under a bright-blue sky, Marc Dennis's detailed scenes include seagulls, beachgoers, colorful umbrellas, seashells, a dolphin, and even the snowy owl known to nest there during the off season. There are a few surprising and humorous elements too, such as cloud-gazing dogs and a sky-banner of emojis. The artist worked with Glasmalerei Peters Studios to translate his hyper-realistic oil paintings into thirty laminated-glass windows, using airbrush and hand-painted enamel techniques. In addition to the glass installed in the platform waiting room, Dennis worked with Mayer of Munich to produce a pair of mosaic panels capturing a sunrise and sunset over the ocean that expand the work at the two main stairways.

ROY NICHOLSON

Hempstead Plain, Morning & Evening, 2018
Hicksville · Long Island Rail Road

Hempstead Plain, Morning & Evening. Photo: Patrick J. Cashin.

As part of the renovation of the Hicksville Station, Roy Nicholson was invited to expand *Hempstead Plain, Morning & Evening*, which was installed in 2002. He designed work for new laminated-glass panels, fabricated by Glasmalerei Peters Studios, in the four platform waiting rooms and two stair enclosures as well as two mosaics above the stairs at the platform's west end. Continuing a dialogue with his earlier mosaic landscapes in the station building, the new works offer panoramic views of the natural environment, abstracted by lengthy brushstrokes that simplify the landscape to line and color.

The horizontal motion of the paint on glass embodies the feeling of a train swiftly rushing through the open Hempstead Plain, while the palette evokes the different times of day a commuter would pass through. Inspired by the writings of naturalist Henry Hicks, whose grandfather Isaac Hicks developed the first plant nursery in the area, each waiting room is labeled with a tree name and a painting of that species. The new mosaic, fabricated by Miotto Mosaic Art Studios, depicts the Hempstead Plain covered with violets, the Nassau County flower.

SHAWNA X

Cyclical Everything, 2022
Elmont-UBS Arena · Long Island Rail Road

Cyclical Everything.
Photos: Collin
Hughes.

The artwork for the new Elmont-UBS Arena Station by Shawna X features an oval motif referencing the nearby racetrack and arena. The form represents the evolving and transformative nature of Elmont, and the many distinctive cultures at home around this historic attraction.

Ten laminated-glass panels fabricated by Tom Patti Design line the pedestrian overpass windows. The designs depict bodies in motion, referencing the musicians, athletes, and performers at the nearby newly built UBS Arena. Each brightly colored glass section is connected by the grounding motif of the racetrack. Strong lines and shapes link the sections and provide portals to the surrounding area. A unique balance of opacity and varying degrees of translucency allow light to be transmitted and reflected simultaneously with strong cast shadows bringing the work into the walkway.

The metal screen and railing by KC Fabrications extend the repetition of the oval form, using bold black lines that abstract the motif of the track into striking rhythmic forms.

JENNA LUCENTE

Tottenville Sun, Tottenville Sky, 2017
Arthur Kill ⓈⒾⓇ

Tottenville Sun, Tottenville Sky reflects the surrounding community in twenty-eight panels of laminated glass. Located on the South Shore of Staten Island, the Tottenville neighborhood is bounded by water on three sides. The artwork depicts the wildlife surrounding the station, including the egrets and spotted sandpipers frequently seen in the native marshlands, and prominent structures such as the Outerbridge Crossing, a cantilevered bridge connecting Staten Island and New Jersey, and Conference House, a pre-1680 stone building, now a National Historic Landmark.

Jenna Lucente's original artwork, drawings made with pencil and acrylic on mylar with manipulated image underlay, were translated by Mayer of Munich into hand-painted and printed, layered glass compositions. The scenes are framed by a common architectural detail. The area's natural history is shown prominently in the foreground, with softer renditions of community architectural highlights behind. The artist uses yellow hues to suggest the morning commute

at daybreak and blues for the dusky evening return. The artwork is installed throughout the elevated level of the newly built Arthur Kill Station, within the two station towers and the pedestrian overpass.

Tottenville Sun, Tottenville Sky.
Photos: Michael McWeeney.

Metal

No single material is more important to the transit system than metal. It forms the 2,000 miles of tracks operated by the MTA's New York City Transit, Metro North Railroad, and Long Island Rail Road and provides structural support for the 722 stations served by these agencies. Steel and iron have a long history of use in the built environment, but metal is equally important in the art world. Contemporary sculpture and grille work is often formed of bronze, aluminum, wrought iron, or stainless steel, and metals are prevalent in outdoor sculptures and public artworks. The reason for this, of course, is versatility and foremost, durability.

Most of Arts & Design's earliest works were entirely or partially metal: Houston Conwill's *Open Secret* (1986) in bronze, Nancy Holt's *Astral Grating* (1987) in steel with lighting, Valerie Jaudon's *Long Division* (1988) in painted steel, as well as a number of porcelain-enamel-on-steel artworks. Tom Otterness's bronze installation *Life Underground* (2001)

running throughout 14th Street-8th Avenue station has been a favorite among New Yorkers for more than twenty years.

Metal does not have the vibrancy of mosaic or glass, and detail can be more difficult to achieve, but the use of paint, patina, and finishes like etching and welding can add depth and character. Despite its relative limitations, metal has several advantages beyond durability and ease of maintenance. New York State is home to many high-quality fabricators able to translate artwork, including some based in New York City. Metal is the medium most often fully or partially self-fabricated by artists. Metal can serve as a framework for other materials. Best of all, metal offers the ability to work three-dimensionally. It has an accessible, physical presence and provides unique sensory experiences—from the dramatic shadows cast to the various tactile qualities.

Detail of Amanda Schachter and Alexander Levi, *Cross-Bronx Waterway*, 2015, NYCT Middletown Road Station. Photo: Andreas Symietz.

RAY KING

Connections, 2015
Rockaway Boulevard Ⓐ

Ray King's preferred medium is light and how it interacts with glass and optics. With his passion for color, he distills his work down to the elements of glass, metals, light, and color, creating lenses that "change colors and your perception of how you view them." Forms from nature, mathematics, and sacred geometry influence the composition of his structures, while holographic and dichroic laminate films and coatings bend or split light wavelengths to produce a variety of special effects. Creating dynamic and dramatic works of art since the 1970s, King has harnessed the sun in sculpture.

Connections activates the space at the Rockaway Boulevard Station and animates it with light, shadow, and texture. More than 500 circular, colored lenses are set like jewels into twelve sculptural panels. Installed in the platform windscreens, the structural framework is made up of a tessellation pattern that has been laser cut into stainless steel, sandblasted, and electropolished. Commonly used for medical equipment, the electrical chemical process removes the top surface of the metal, resulting in a specular, reflective sheen that is without porosity and thus unable to hold dirt. As daylight passes by, the multi-colored lenses throw vivid colors while the panels cast a dramatic web of shadows onto the concrete platform.

The dichroic glass lenses are activated as sunlight passes through. When this happens, the color splits, resulting in a lens that will project blue; without sunlight, the lens reflects a yellow or orange complement. There is a dynamic nature to the color change, depending on the angle of light. If the light passes straight through, it is a short distance; and if it is going through at an angle or a longer distance, it changes the frequency and thus the color of both the lens and the shadow. Only some of the lenses have dichroic treatment; others are transparent color laminated between the layers of glass, which furthers the interplay across the surface and with the projections onto the platform.

Gradation among the glass "dots" provides a sense of movement. The density of the colored circles decreases in a slow sweep, opening up the composition in the direction of the subway car motion. The streetscape once hidden from view on the platform is revealed through the open grille. King's work creates a memorable sense of place and connection. For this project he produced and placed the hundreds of glass lenses. The panels were cut by Surbeck Waterjet. Coatings to both glass and metal offer increased safety and durability.

Proposal for
Connections.
Courtesy of the artist.

Connections.
Photos: Ray King.

Right: Plaster
model of *Bessie and
Roxey* before
bronze casting.
Photo: Donald Lipski.

Opposite: *Bessie
and Roxey.* Photo:
Jason Mandella.

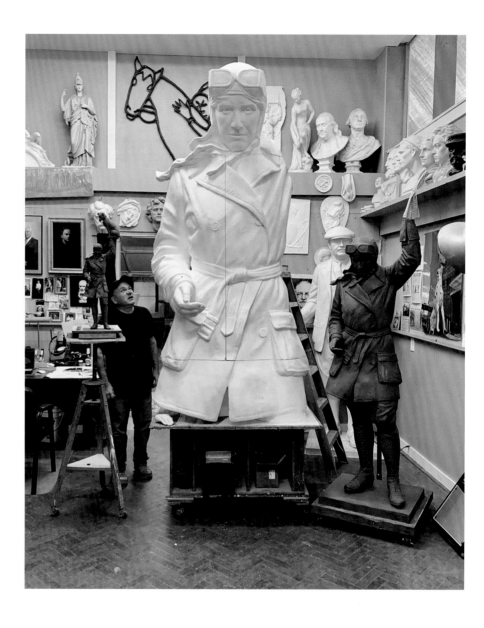

DONALD LIPSKI

Bessie and Roxey, 2023
Mineola · Long Island Rail Road

Donald Lipski's towering bronze sculpture *Bessie and Roxey* brings attention to aviator Bessica (Bessie) Raiche and Roxey, the Long Island Rail Road dog—two legends of Long Island from the early twentieth century. In researching the area, Lipski found these unconnected stories that fell within a similar time and place.

Bessica Raiche (1875–1932) took her first solo flight on September 16, 1910, in a biplane she and her husband, Francois, constructed at their home in Mineola. The Aeronautical Society of America credited Raiche as the "First Woman Aviator of America." Raiche and her husband set up an airplane manufacturing company and gave flying lessons on Long Island until they moved to California. There Raiche resumed her career as a physician, becoming one of the first women specialists in obstetrics and gynecology. She is recognized by the Cradle of Aviation Museum as a "maverick and pioneer of her times; blazing the way in aviation, medicine and women's rights."

Roxey was a stray dog found at the nearby LIRR Garden City Station in 1901. He was named and adopted by the station master. As an unofficial mascot, Roxey rode the railroad independently all day, so beloved that he sat anywhere on the train, returning to the Garden City station master at night. President Theodore Roosevelt let Roxey travel in his private car and visit Sagamore Hill, his home in Oyster Bay. Roxey was buried in 1914 at the Merrick Station next to the Sunrise Highway.

Over the last twenty-five years, Lipski has become best known for his public artworks, often quite large and equally amusing. At twenty feet high and standing on a stone base, Bessie and Roxey are visible to the surrounding community and to train passengers as they pass through the station. Lipski was inspired by the Statue of Liberty's iconic pose, with Raiche holding up Roxey in place of the torch. *Bessie and Roxey* was fabricated in bronze by Art Castings of Colorado, the first major bronze casting for Lipski, who collaborated with Christopher Collings to model the portraits.

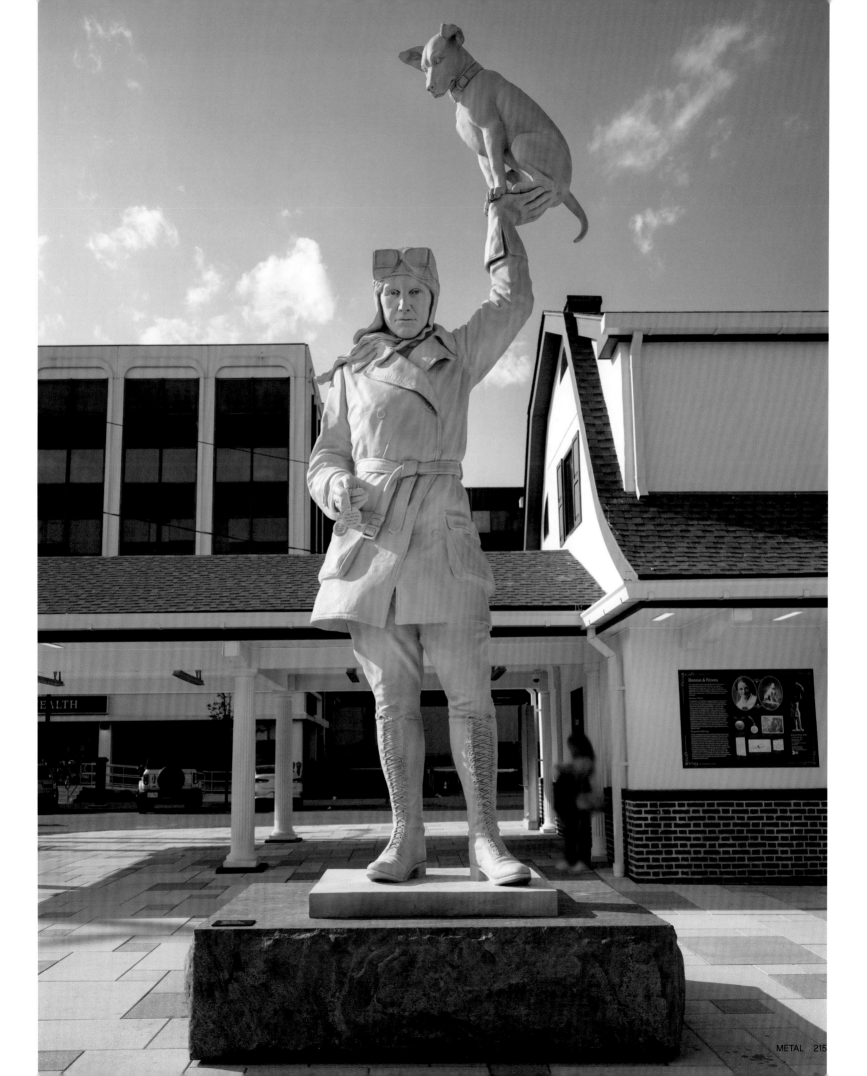

DAN FUNDERBURGH
Eureka, 2016
Fordham · Metro-North Railroad

Four "rose windows" designed by artist and illustrator Dan Funderburgh grace the northbound platform at Fordham Station in the Bronx. Funderburgh married his illustrative style and penchant for the decorative to create an ornamental metal grille inspired by the Collegiate Gothic buildings on the Fordham University campus. The title refers to Edgar Allen Poe's 1848 prose poem "Eureka," written in his Bronx cottage. Funderburgh connects Poe's thoughts on the origins of the universe, as expressed in "Eureka" to the Big Bang theory and the plantings at the New York Botanical Garden. The artist imagines his rose-window forms as four "big bang bursts." Smaller orbiting discs reference a diverse selection of plants including bonsai, orchids, and succulents.

Funderburgh's original artwork, constructed using 3-d printed forms, was translated by KC Fabrications into panels consisting of two waterjet-cut aluminum layers. The first layer is painted in black to match the surrounding fencing; the second layer is brushed aluminum painted in gold to provide contrast and evoke the Gothic Revival era.

Eureka during fabrication at KC Fabrications' studio. Photo: Dan Funderburgh.

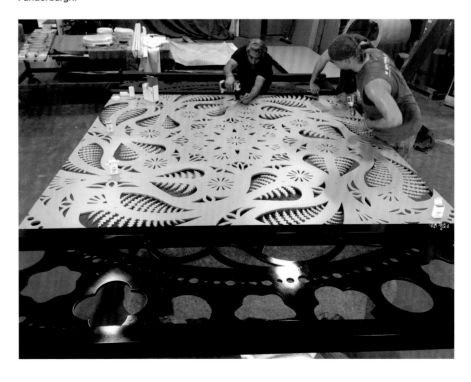

Opposite: Proposal for *Eureka*. Courtesy of the artist.

Above: *Eureka*. Photo: Brian Kelley.

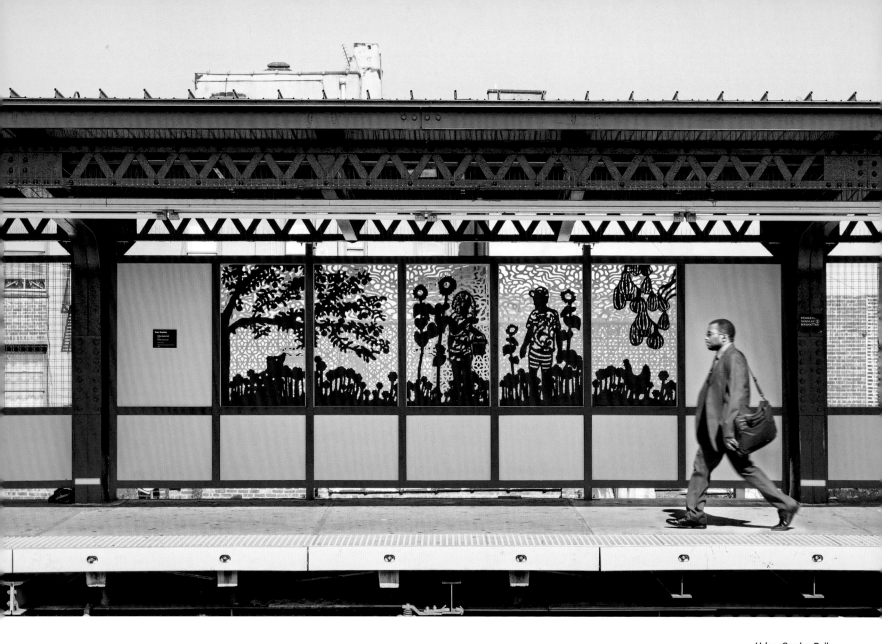

Urban Garden Rail.
Photo: Peter Peirce.

SAYA WOOLFALK

Urban Garden Rail, 2017
Pennsylvania Avenue ❸
Van Siclen Avenue ❸

Based on the community-led gardens and urban farms near the stations, *Urban Garden Rail* honors those who re-envisioned empty lots and transformed them into gardens and green spaces to educate and address food justice. Their efforts to cultivate the land have yielded thousands of pounds of produce grown by and for local residents and markets of East New York. The three urban farms are a model of sustainable, community-led economic development, with the youth farm producing more than seventy varieties of vegetables.

Saya Woolfalk walked the neighborhood to experience the farms and gardens, many of which are visible from the elevated station platforms. Her work is based on photographs shared with her by East New York Farms, which helped to identify the workers and volunteers that Woolfalk transformed into silhouettes. Kammetal translated her concept into twenty-four stainless-steel panels divided between the two station platforms windscreens. The panels are composed of two layers of stainless steel, a top layer in dark green of the figures of workers and animals standing amid plants and an ornate background layer in beige paint and natural metal finish, displaying patterns from various cultures as a nod to the spirit of inclusivity flourishing among the plants. The colors align with adjacent finishes, simplifying maintenance and tying the work to the station architecture.

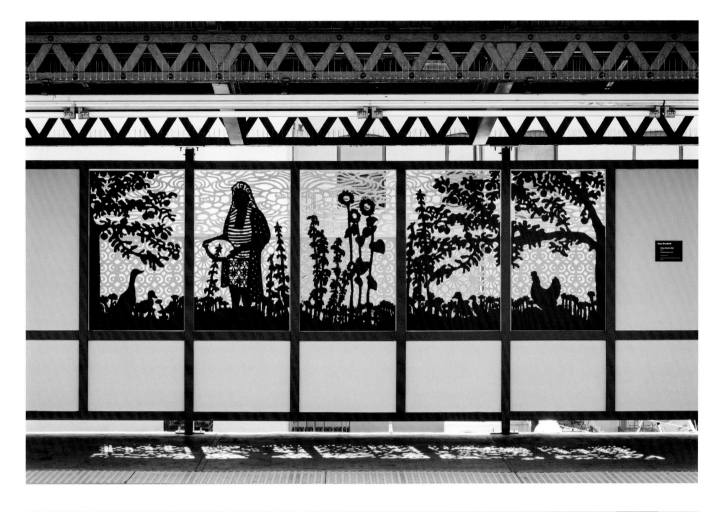

Urban Garden Rail.
Photo: Peter Peirce.

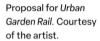

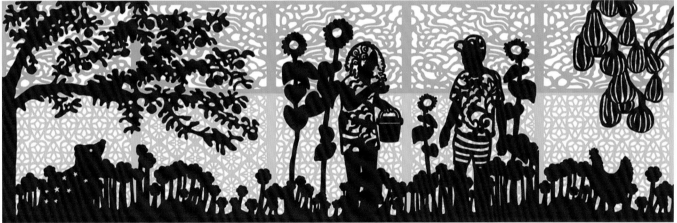

Proposal for *Urban Garden Rail.* Courtesy of the artist.

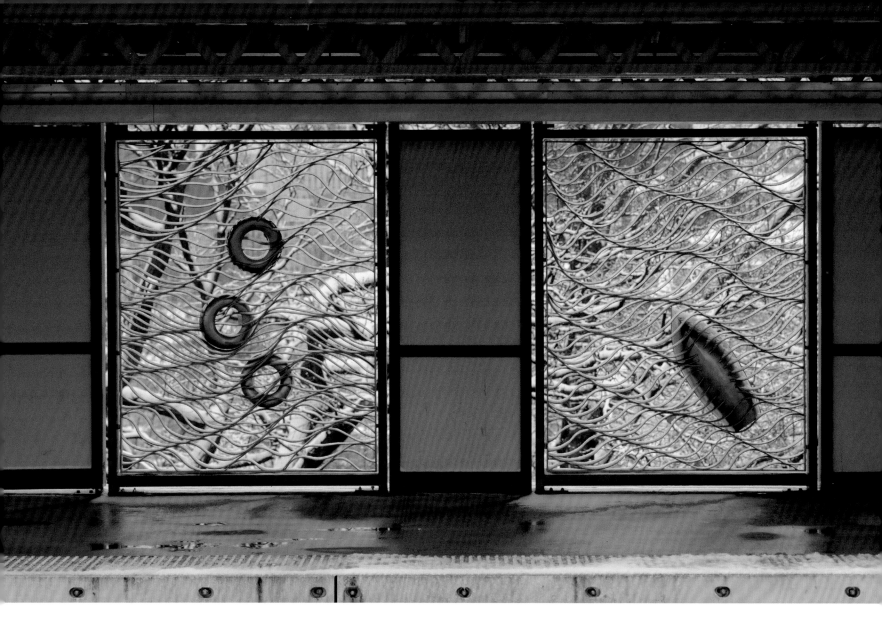

Cross-Bronx Waterway.
Photos: Andreas Symietz.

AMANDA SCHACHTER AND ALEXANDER LEVI

Cross-Bronx Waterway, 2015
Middletown Road ⑥

On its run between the Harlem and Pelham Bay neighbor-hoods, the 6 train travels over and under riverbeds of the Harlem, Bronx, and Hutchinson Rivers, Westchester Creek, and Pelham Bay watersheds. Fabricated by Art Metal Industries (AMI), *Cross-Bronx Waterway,* composed of eight stainless-steel grilles rendered as undulating ribbons, high-lights activities on these waterways.

Sculptures of wildlife and floating vessels are affixed to rippling ribbons of steel, suggesting views from above and below the water's surface. By including debris such as bottles and tires among the boats and wildlife, Schachter and Levi reference pollution problems of the not-so-distant past, while focusing on current recreational uses (kayaks, sailboats, and rowboats) as well as the egrets, fish, and horseshoe crabs supported by the ongoing clean-up efforts of these natural areas.

As Schachter and Levi note, "Through each panel of upturned abstracted river surface and the corresponding transfigured vessel, we can see the real streetscape, with its city blocks, steeples, school building, blue sky, and cumulus clouds beyond. Which brings us back to our hovering outdoor mid-air ride on a New York City subway car in the Bronx, navigating the elevated rails now with the buoyancy of a river voyage."

Proposal for *Cross-Bronx Waterway.* Courtesy of the artist.

Above and opposite,
below: *Chandelier*.
Photos: Max Yawney.

NANCY BAKER

Ailanthus, 2017
Sutter Avenue-Rutland Road ❸
Chandelier, 2017
Saratoga Avenue ❸

Nancy Baker constructs multi-layered, mixed-media works based on digitally printed shapes often manipulated through painting, scraping, or gouging the forms and the application of glitter, gold leaf, and other materials. Installed at neighboring stations, *Ailanthus* and *Chandelier* are pictorial love letters intended to honor "the strength and determination of the people of Brooklyn." The title *Ailanthus* refers to the tree memorialized in Betty Smith's *A Tree Grows in Brooklyn*, whose seedlings are often seen forcing their way through

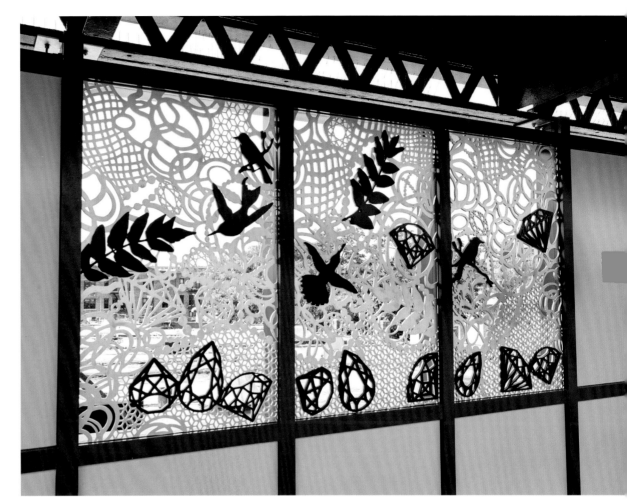

Above: *Ailanthus.*
Photo: Max Yawney.

cracks in concrete and subway tracks. In *Chandelier*, high-energy hummingbirds flutter with outsized speed and power. The title suggests the idea of home and is intended as a "lighting of the way." Both artworks are designed to instill a child-like sense of wonder and awe. Jewels and pearls throughout represent hidden treasures waiting to be found. Ferra Designs, a metal fabricator located in the Brooklyn Navy Yard, translated Baker's work into twenty-four panels of water-jet-cut stainless steel with painted metal applique.

MIA PEARLMAN

SOAR, 2016

80th Street Ⓐ

SOAR originates in Mia Pearlman's fascination with the expansive views of the sky from the elevated stations of the Rockaway line and the mesmerizing changes in color and cloud formations. Pearlman used paper to create delicate, miniature sculptures that were then transformed into eighteen three-dimensional sculptural steel panels inset into the windscreens. Polich Tallix Fine Art Foundry, a fabricator Pearlman had worked with previously, transformed the fragile paper works into strong, sculptural forms that can withstand the environment, yet maintain their fragility. Some are double-framed and have the artist's signature layers of unique, swirling waves. In Pearlman's words, "These gently curving, perforated sheets of metal echo the air currents that flow through the station and the sky above. The timeless abstract shapes composing *SOAR* suggest universally recognizable natural forms." This fluid transformation from paper to shimmering steel creates an unexpected experience for travelers.

SOAR. Photos: Jason Mandella.

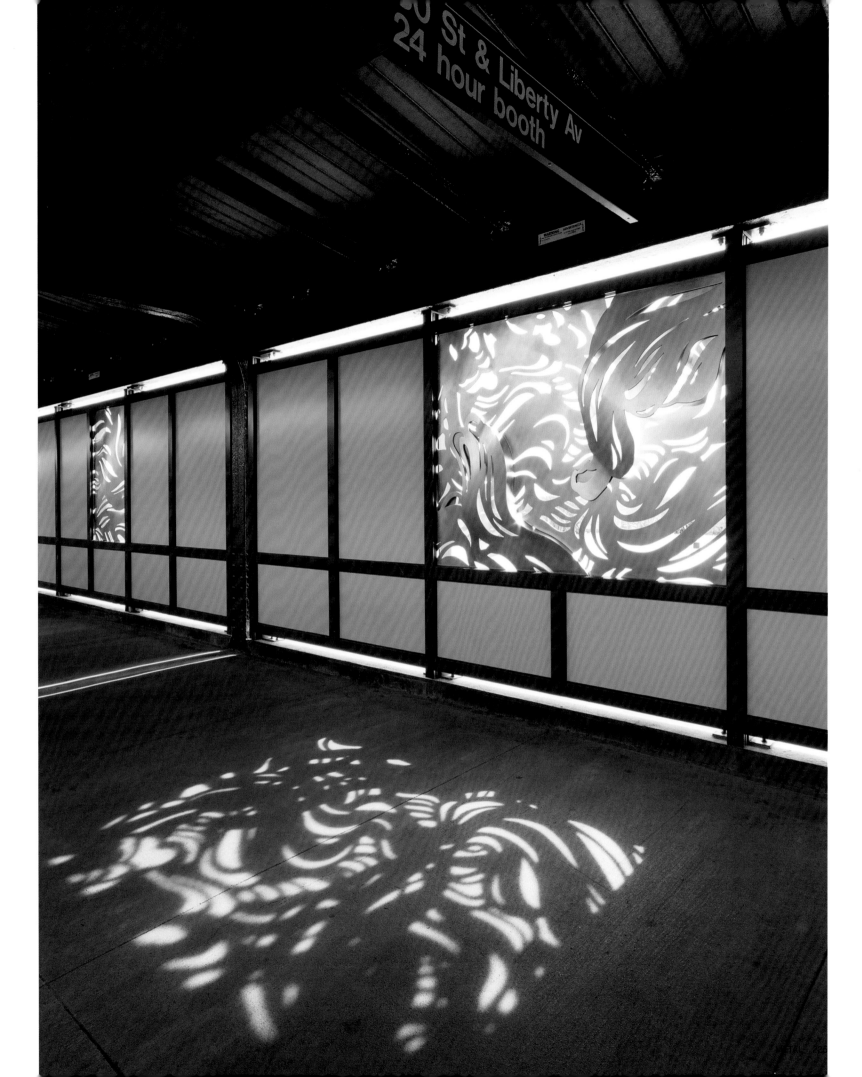

Right: Laser-cutting
stainless steel
during the fabrication
of *A Portrayal of
Life at Mill Creek* at
Kammetal's studio.
Photo: KPerrine.

Above and opposite:
*A Portrayal of Life
at Mill Creek*. Photos:
KPerrine.

EVERET

A Portrayal of Life at Mill Creek, 2018
Richmond Valley ⬤

Fascinated with natural forms and the intricate patterns found in nature, self-taught artist Everet considers the symbiotic relationship between humans and the plants and animals that have nurtured them as food and medicine throughout history. To create *A Portrayal of Life at Mill Creek*, she looked closely at Richmond Valley, focusing on the wetlands, the streams, and the ponds. The piece is made up of twenty-six stainless-steel panels laser cut to depict the plants, animals, and insects living there. The positive and negative spaces portray wildlife pairing such as the tobacco plant with the snapping turtle, the nightshade vine with the Appalachian brook crayfish, the cattail with the calico pennant dragonfly, and the yellow trout lily with the morning cicada. Working with fabricator Kammetal, Everet was exacting in her artwork designs to ensure compatibility with the machine-cutting requirements. Set into the platform railings, the grilles are intended to encourage environmental awareness and increase appreciation for these local habitats.

". . . the vast and endless sea." Photos: Jan Barcaz.

DAVID McQUEEN
". . . the vast and endless sea," 2018
Port Jefferson · Long Island Rail Road

Sculptor and installation artist David McQueen's practice employs nautical iconography to create hand-made maritime sculptures that delve into the mysterious territory that exists between science and romance. The title, *". . . the vast and endless sea,"* borrows a phrase from Antoine de Saint-Exupery's writings: "If you wish to build a ship, do not divide the men into teams and send them to the forest to cut wood. Instead, teach them to long for the vast and endless sea."

Chris Ryan, Port Jefferson Village Historian, notes that there have been at least forty different shipbuilding yards and more than five hundred major ships were built in the area. McQueen's stainless-steel sculpture features three boats,

inspired by a schooner, a yawl, and a sloop, supported by stilt-like boat stands. The vessels are envisioned by McQueen to "sail through its consciousness" in a formation as if in the sea. The steel ships are stacked, curved as if built for riding the waves, but appear not quite finished; they are elevated on boat stands, as if in a drydock. Explaining his concept, McQueen notes, "A boat on land is essentially wrong. Was it abandoned by the sea, robbed of its home, or simply deemed un-seaworthy? That same vessel on boat stands, however, is loved. It is being built, or repaired, or protected. It is temporarily aground but bound for the ocean." Constructed by KC Fabrications, the tall, freestanding sculpture is installed outside the station near the parking area.

TOM FRUIN

Sail, 2019
Syosset · Long Island Rail Road

Tom Fruin is known for architectural-scale sculpture, composed of brightly colored scraps of discarded plexiglass encased in a steel structure, an effect described by the artist as a "found-object quilt." *Sail* is part of the artist's ICON series—large-scale, outdoor sculptures that represent a city's architecture or economy. Shipbuilding was an important industry when Syosset and the Oyster Bay area were founded; today sailing is a favorite pastime. Symbolizing past and present, Fruin's sculpture is installed on the plaza outside the recently renovated station.

 Sail is a beacon, welcoming Long Island Rail Road riders to Syosset. Whether illuminated by sunlight or plaza lighting, the vibrant shades of acrylic and plexiglass create a kaleidoscope of colors. *Sail* has become a treasured part of the community.

 Tom Fruin Studio focused on an imperative to build an elegant work requiring minimal maintenance. The studio designed and self-fabricated a lattice structure that provides the strength needed to withstand strong winds. The finished work meets strength requirements without compromising its elegance.

Sail. Photos: James Lane (opposite); Trent Reeves (left).

Above: Mold created for *Sail* during fabrication. Courtesy of Tom Fruin Studio.

JULIEN GARDAIR

We are each others, 2018

18th Avenue Ⓕ

Kings Highway Ⓕ

We are each others.
Photos: Peter Peirce.

We are each others is composed of eight sculptural benches and fourteen windscreens installed at neighboring stations in Brooklyn. Julien Gardair's design for the piece is based on a single continuous line drawing that could be cut and folded to the desired form. The flat windscreens were also designed to use the single line technique, splitting the panel in two to create positive and negative images. This mirroring technique is most easily seen in the panels installed directly across the platform from "each other."

The joyful imagery for the seating was inspired by neighborhood characters. The life-sized bench figures represent both historical and contemporary South Brooklyn, including Andrew Culver, founder of the Coney Island Railroad; Lady Deborah Moody, the first known female landowner in New Netherland and founder of nearby Gravesend, Brooklyn; a baseball player for the Brooklyn Dodgers; a person enjoying ice cream; a headphone-wearing commuter; mothers carrying young children; and a person carrying a bag of cans to a redemption center near the 18th Avenue Station.

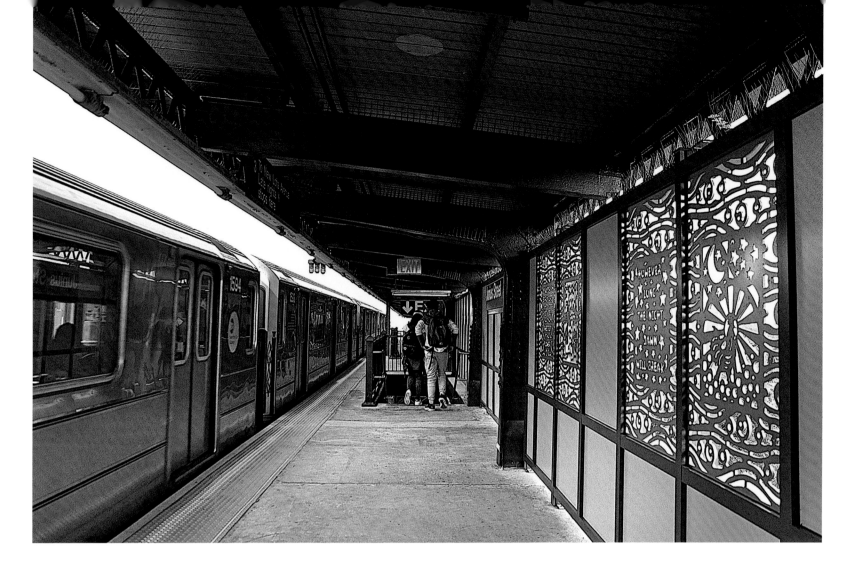

BÉATRICE LEBRETON

Paroles Vagabondes/Wisdom Along the Way, 2017
Junius Street and Rockaway Avenue ③

*Paroles Vagabondes/
Wisdom Along the Way.*
Photos: Trish Mayo.

Béatrice Lebreton uses mixed media, often including fabrics, beads, and paint on canvas to tell stories with text inserted into the works. *Paroles Vagabondes/Wisdom Along the Way* draws upon her multicultural heritage, travels throughout Europe and Africa, as well as studies that include a Masters of Ethno-aesthetic, with a concentration in African Art from the Sorbonne.

To realize the project, Lebreton worked with fabricator Kammetal to transfer her work into a digital format for the process of cutting steel. Within the sixteen stainless-steel panels, there are proverbs from Jamaica, Guyana, Haiti, Barbados, and Puerto Rico that pair with the surrounding imagery to read like pages of a children's book. The selections, which the artist calls "cultural fingerprints," speak to the thriving African American and Caribbean communities in the area but are intended to reflect the multiculturalism of the city more broadly. Lebreton considers the stories, language, and culture brought by immigrants that is both visible and audible throughout the city—especially on the train. Installed within the windscreen on the platforms, the panels brighten and shimmer in the sun, while the cutout areas project shadows on the floor with the shifting light of day. The everchanging installation has a playful interactive quality.

MORPHING88.
Photos: Bill Kontzias.

HARESH LALVANI

MORPHING88, 2015

88th Street Ⓐ

Haresh Lalvani's work is inspired by patterns observed in nature, even those not visible to the naked eye. His work is a pursuit of structures based on new geometries with the use of higher dimensional mathematics. *MORPHING88* was created using principles derived from his processes. After researching the geography of the Ozone Park neighborhood, Lalvani used information, such as the angle at which each street intersects with the A train line and the degrees they are from the equator, to plug into an algorithm that created a unique pattern for each of the twenty-four laser-cut stainless-steel panels installed on the station platforms. The GPS coordinates of twelve streets served by 88th Street Station determined twelve designs each on the eastward and westward bound directions. The resulting patterns represent shapes giving the illusion that each panel morphs from one into the next. The patterns are still images from a pattern continuum in space representing the continuous nature of time which underpins travel. Fabricated by MILGO/BUFKIN, using its Milgo-Lalvani proprietary technology, the twelve panels represent the number of months in a year. The unique patterns have a curve or sway to the face of the surface, and each panel has 365 openings representing the constant nature of travel and mass transit.

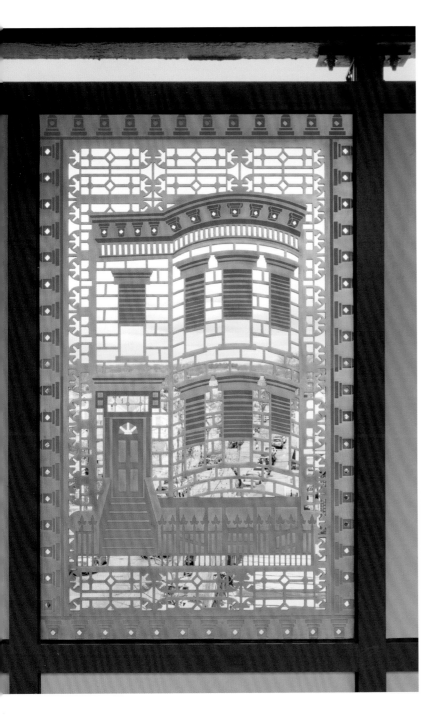
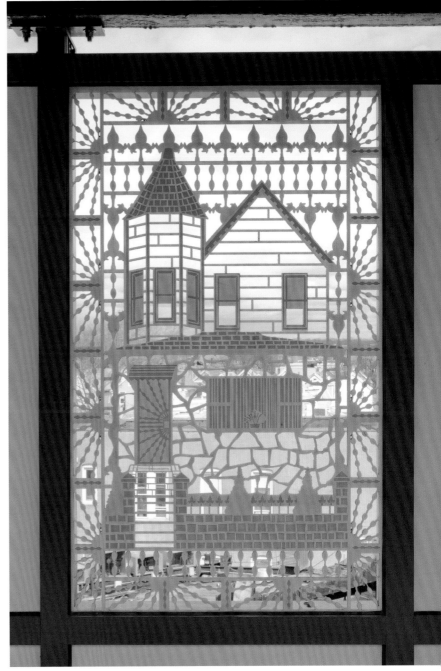

Home Sweer Home.
Photos: Kevin Noble.

LINDA GANJIAN
Home Sweet Home, 2016
111th Street Ⓐ

Home Sweet Home is inspired by patterns of lace. Linda Ganjian applies the visual vocabulary of the craft to depict the architecture of the Ozone Park and South Richmond Hill neighborhoods. Describing her process, she explains, "From the rows of houses, I take inspiration from the forms, patterns, and textures that make each unique—from diagonally-oriented aluminum siding to Baroque ironwork on fences, from zig-zag tiles to elephant garden statues. These ubiquitous but often overlooked decorative details are part of our aesthetic subconscious, defining how we experience the city." KC Fabrications translated digital prints into twenty-four stainless-steel panels, water-jet cut to into a seemingly delicate web resembling lace. Surface etching is used to provide additional detail. The work is intended as a tribute to the craftsman and architects responsible for the architecture.

PRISCILA DE CARVALHO

Bronx: Heart, Homeland, 2015
Castle Hill Avenue ⑥

Imagery in *Bronx: Heart, Homeland* is designed to connect to the literal and metaphorical ideas of heart and home. Eight full-height, stainless-steel panels are set in the platform windscreens, each depicting a scene related to life in the Bronx, past and present. Ideas of identity, culture, and home are woven throughout the scenes of everyday life. Residents are shown biking, skateboarding, walking, playing, and selling books. Twentieth- and twenty-first-century infrastructure and iconography of development—the subway line, telephone poles, and electrical cables—represent the "system-builders"

of past, present, and future. Priscila De Carvalho's original paper-cut artwork was translated into stainless steel by KC Fabrications. Working in a digital format, De Carvalho envisioned the positive and negative spaces, adjusting the thickness of lines as she worked with the fabricator to create the finished work. Additional layers of metal in select areas add detail and focal points. The steel panels are powder-coated in black to emphasize the silhouettes and relate to the original artwork.

*Bronx: Heart,
Homeland.*
Photos: Ken Shung.

On the Right Track.
Photos: Etienne
Frossard.

BÉATRICE CORON

On the Right Track, 2015
104th Street Ⓐ

Conceived to uplift and inspire positive energy among riders, *On the Right Track* offers a series of twenty-four daily intentions. The affirmation text is paired with visuals of the practice in play, inspired by tarot and playing cards. Béatrice Coron's work invites viewers to select and embody a quality each day. "Curious" is represented by a stargazer looking into a telescope. "Strong" holds a dumbbell overhead. "Unique" is conveyed by a man with a walking stick and top hat. "Clever" is a juggler, "Smart" a scientist. Coron intends the work to be interactive, inviting viewers to see and experience it as full of "fun, divination, and mindfulness." The title invites riders to control their frame of mind and stay "on the right track" as they go about their daily journeys and routines. Twelve cards were executed as laser-cut, stainless-steel grilles and installed in the station windscreens. Working with KC Fabrication, Coron chose to retain the natural stainless-steel finish to ensure the longevity and beauty of the panels. The outlines of central figures were welded to create a trim of shimmering, tiny metal beads that adds texture and accentuates the body in action.

Percolate. Photos:
©John Muggenborg.

SITU STUDIO

Percolate, 2015
North White Plains Parking Garage · Metro-North Railroad

Cellular forms depicting water droplets extend across the metal mesh cladding covering openings in the walls of the multilevel garage. Approximately 125 stainless-steel panels are installed on the facade, each a reference to the heavy mist for which early traders named White Plains. Mimicking the natural formation of water bubbles, clusters of droplets the appear to be in an ever-changing state.

Percolate is the work of SITU Studio, a team of artists and designers who describe their approach as "an unconventional architecture practice that uses design, research, and fabrication for creative and social impact." Kammetal, a fabricator with expertise in architectural and ornamental metals, laser cut and applied the water droplets to the mesh to create the interplay of small rigid details and dynamic organic forms that appear to be vaporizing into the air or shimmering from a distance, emulating the reflection of sunlight on the water's surface.

BERNARD GREENWALD

Images of Port Chester, 2019
Port Chester · Metro-North Railroad

In 2011 Bernard Greenwald created *Port Chester Scenes,* a series of forty-eight glass panels installed in the clerestory windows of the platform's three shelter sheds as part of a station reconstruction project. He returned to the station in 2018, expanding the work in metal along a new ramp to the platform. Greenwald composed a series of fifteen pen-and-ink drawings which bring cars, buses, pedestrians, and buildings together to create vignettes of life in Port Chester. KC Fabrications collaborated with the artist to capture the village's daily energy from the perspective of a drive or walk through the streets or as seen from a passing train. The stainless-steel panels are water-jet cut and surface etched to reveal negative and positive compositional shapes.

Images of Port Chester.
Photo: Douglas Baz.

KERI SHEHEEN
Creeping On Where Time Has Been, 2023
New Dorp ⑪

Creeping On Where Time Has Been looks closely at two Staten Island treasures: its natural environment and its historic architecture. A Staten Island native, Keri Sheheen researched images of New Dorp homes and buildings at the archives of Historic Richmond Town and the New York Transit Museum. The artist and her mother, both grew up in the area. Sheheen attended high school in the neighborhood and now lives in the family home a few blocks from the station. The connection to the community offered an abundance of memories and first-hand accounts to draw from.

The six glass panels fabricated by Mayer of Munich focus on the landmarks and celebrities of Staten Island. A rooster greets morning commuters and honors the area's agricultural past, paired with an image of the New Dorp cottage of Nathanial Lord Britton, founder of the New York Botanical Garden. On the Tottenville side, a serene evening scene, reflecting commuters returning home, features a deer peering

at an image of the Vanderbilt Mausoleum, a tribute to Cornelius Vanderbilt. Beach bungalows, hotels, a lighthouse, and other remnants of New Dorp's past as a popular summer destination are depicted in the cut-metal panels with colorful glass square borders. A border of colorful glass squares set into the metal panels references the station's original stained-glass windows.

Sheheen uses ivy as a framing device to tie together the natural landscape with the development of the Island. In the 1960s New Dorp evolved from a farming economy into a bedroom community for Manhattan workers. At that time, much of the historic architecture was covered in ivy, leaving a vivid impression of lush greenery in the area. The motif is carried throughout the glass in station porticos and into the glass-and-metal artwork on the Tottenville-bound elevator walkway. The nine fiber laser-cut and painted stainless-steel panels were fabricated by Ferra Designs.

Creeping On Where Time Has Been. Photos: Sean Sweeney.

Art That Bridges

10

Public art has power. Public art can help shape a place, speak to its people, and transform a cityscape. *Contemporary Art Underground* focuses on the power unleashed by monumental artworks installed in enormous stations such as Times Square-42nd Street, WTC Cortlandt, and Grand Central Madison. The materials from which those and other equally impressive artworks were fabricated amplify our sense of power when viewing them. But the stations and the materials are just part of the Arts & Design story. A more significant and arguably more important part of the story lies behind every artwork: the human element— why and for whom a project is created. Community input equals community benefit—with the community at its heart, site-specific artwork can touch many lives.

Arts & Design's primary goal is to commission work that engages its audience. The four projects highlighted in this chapter are integrated into bridge structures over Metro-North's New Haven Line train tracks in the City of Mount Vernon, New York, in ways that can affect pedestrians, drivers, and train passengers. Featuring public artwork on a vehicular or pedestrian bridge rather than on a subway platform or in a rail station diverges from the department's usual fare. Still, bridges are a vital part of the transportation world. The story of the MTA bridges in Mount Vernon illustrates how public works and public art can impact a community.

First settled in 1664, Mount Vernon is an ethnically diverse city just north of the Bronx. The growth of its population mirrored the migration patterns in the northeast United States through the subsequent years. The New Haven and Hartford Railroad's southern expansion into and through downtown Mount Vernon in 1848 brought new life into the rapidly expanding city. Many African Americans migrated to Mount Vernon in the 1860s, post-Emancipation. By the 1890s, African Americans, Italians, and Jews made up most of the population. These demographic shifts in Mount Vernon are at the heart of a more complex story unfolding as more cultures contribute to its citizenry. Today Mount Vernon's population is more than 60 percent African American and 20 percent Hispanic.

The railroad greatly benefited the city in the mid-1800s, but it also gave rise to unexpected safety issues. In the 1890s, street-level pedestrian deaths due to horse carriage and rail car clashes were common. To eliminate the safety issues, the railroad decided to lower the tracks deep below street level into a trench that became known as the "Cut," a name that has lasted for more than a century. While lowering the tracks into the Cut reduced pedestrian deaths, it also sliced through the downtown area of Mount Vernon along First Street, bifurcating the city into the more prosperous, suburban North Side and the poorer and more urban South Side. In the absence of a street network,

Detail of Mark Fox, *40°54'37.9"N 73°50'33.5"W*, 2021, on the 10th Avenue Bridge in Mount Vernon. Photo: James T. Murray and Karla L. Murray.

Metro-North's predecessor railroad built ten pedestrian and vehicular bridges to close the gap and ensure that the two halves were at least physically, if not economically and socially, connected. Mount Vernon Mayor Shawyn Patterson-Howard recently described the economic and racial divide attributed to the Cut: "It was environmental redlining before the banks started redlining."

More than a century later, the bridges are still lifelines for Mount Vernon residents; they serve as vehicular and pedestrian passages connecting people to schools, grocery stores, emergency medical services, and each other. While the MTA replaced the Park Avenue/1st Avenue Bridge in 2011, other bridges were closed for more than a decade, intensifying Mount Vernon's divisions. But the slow maintenance and replacement of the century-old bridges anguished the community.

Acknowledging the deteriorating bridges, MTA-Metro-North initiated the rebuilding of all ten. When describing Mount Vernon's New Haven Line bridge replacement program, *New York Times* reporter John Freeman Gill referenced its effect on the city: "Ten bridges have historically served as sutures over the Cut, joining Mount Vernon's two halves."

In 2018 MTA Metro-North began the replacement of six bridges spanning downtown Mount Vernon and charged Arts & Design with developing a concept and commissioning artwork. Armed with the knowledge of the Cut and its effect on Mount Vernon, Arts & Design envisioned artworks that would bridge people, create dialogues, and celebrate the city's rich history.

Ribbon cutting for the completion of the 3rd Avenue Bridge Renewal Project in Mount Vernon, August 10, 2021. Photo: Marc A. Hermann.

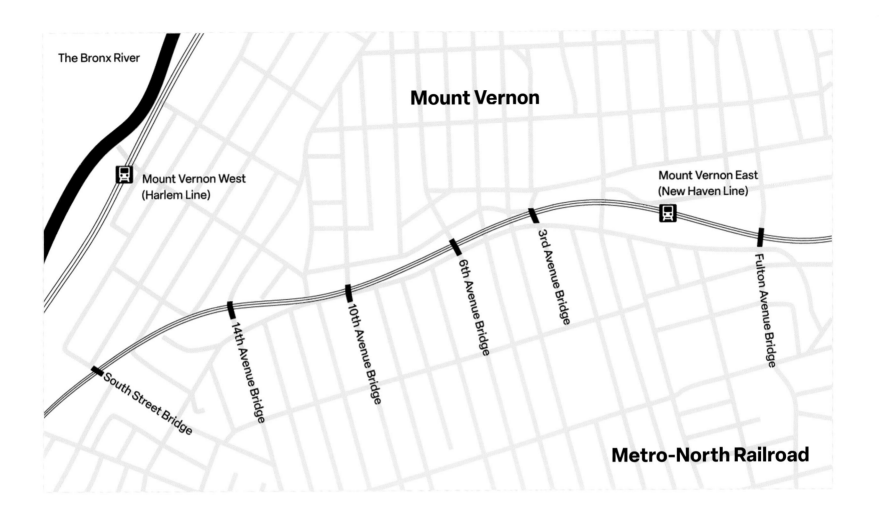

Epilogue

Arts & Design acknowledges that art is not a panacea for a community's travails, but it can heal, uplift, and change the dialogue. From the beginning of the process, the projects were conceived as a collection of public art. This overarching concept was furthered when Arts & Design, knowing the bridges were a walkable distance from each other, saw that the artworks would enhance the bridge-to-bridge relationship. The artists envisioned artworks that would help the community refocus its attention to the richness surrounding them in the past, present, and future City of Mount Vernon.

With the artwork for these bridges, Arts & Design aspired for the artists to change a place for the better. The story of Mount Vernon is no longer just a story of the tearing apart of a city but one of healing. Consequently, the highly visible and inviting new artworks begin a dialogue that may help to reshape the cityscape and perhaps even contribute to healing the wound created by the Cut.

DAMIEN DAVIS

Empirical Evidence, 2021
3rd Avenue Bridge

The 3rd Avenue Bridge reopened on August 10, 2021, to great fanfare. As the fourth of four bridges completed in less than four years, the mayor and other distinguished guests praised the positive effect its opening would have on the city of Mount Vernon. "When we invest in our infrastructure at the federal, state, and city level, we're investing in not just people's safety and security, but in the vitality and economic opportunity of our cities," said Congressman Jamaal Bowman. The celebration was heightened by the timing. It was not only a day to mark the importance of the reunification of the north and south sides of Mount Vernon, it also marked the act of gathering once again as it was the first public event that included Arts & Design since the start of the pandemic.

Damien Davis's work for the 3rd Avenue Bridge is a study of Black history and culture. *Empirical Evidence* consists of eleven panels of milled aluminum featuring iconography drawn from the artist's ongoing exploration of the representation of Blackness. The title refers to information the senses receive through observation and documentation of patterns and behavior. Images of Nefertiti, a basketball, a hair pick, and a hoodie with arms raised are featured—selections that touch on ancient and contemporary times, trace the development and displacement of cultures and language in a non-linear narrative.

Empirical Evidence.
Photos: Etienne Frossard.

The multimedia artist deconstructs and reconstructs the visual language of local and global cultures as iconographies to build a constantly growing visual lexicon. After creating a vector file for each icon, Davis returns to them to tell new stories by remixing pairings, color, and material choices.

"Ultimately, the work is about language and how powerful language can be. I want all my work to serve as a bridge— I think about language as a bridge and symbols as language," Davis explains. "For me, the question becomes how we take these larger complicated ideas that can be hard to explain, break them down into simple shapes, and then allow new dynamic, complicated conversations to form around them."

KC Fabrications rendered the artwork in sheets of 3/16-inch CNC-milled aluminum, painted in silver, gold, and black. The panels are installed on the bridge's east facade, steps away from downtown. Light shines through various motifs cut into the panels, some resembling patterns seen in African mud cloth. The icons appear to be fastened to the panels using visible nuts and bolts, a detail consistent with the assembly of Davis's laser-cut acrylic artworks. The icons are installed on both sides of the bridge, allowing them to be seen by those crossing it and those viewing from a distance.

In Davis's view, "Mount Vernon has existed for a very long time as a site of Black excellence. When I think about the history of Black excellence in a larger context—the ancient, the current, and the future—I see Mount Vernon as having a critical role in all of it. I see this project as a celebration of, an amalgamation of, the work we have done; the work we continue to do; and the work that still needs to be done."

JOSUÉ GUARIONEX

CROSSCUT, 2020
6th Avenue Bridge

The 6th Avenue Bridge reopened, and Josué Guarionex's *CROSSCUT* debuted on September 12, 2020, paving the way for vehicles and pedestrians to gain access to the city's main artery. "For years, our city has been divided by closed bridges, but today is the next step in bridging the gap between our community," said Mount Vernon Mayor Shawyn Patterson-Howard at the opening ceremony. "The upgrade and completion of the 6th Avenue Bridge is a milestone for Mount Vernon. It is a gateway to our hospital, our downtown business district, and our public safety departments."

A second-generation woodworker, Guarionex creates wooden sculptures with organic and constructivist aesthetics. *CROSSCUT* is an interactive installation composed of lines representing crossing train tracks interspersed with interactive and playable forms. The solid forms representing

CROSSCUT.
Photos: Josué Colón.

percussion instruments from various cultures invite passersby to pause and interact through the universal language of music.

Guarionex's work embraces a refined sense of artisan labor fused with political undertones to raise awareness about the differences between power and social classes. For him, the history of Mount Vernon is a familiar story of changing communities. He explains, " *CROSSCUT* reflects that encounter and exchange of ideas, the sharing between a community and its cultural values. Using the same elements that are at the location—the train tracks, metal sounds, and the need to cross the bridge, my installation hopes to generate a 'meeting point' between these two communities, creating a place where neighbors can meet and forge friendships through familiar sounds and music."

The artist collaborated with KC Fabrications through all engineering and fabrication phases, from material testing to final finishing. A unique web of crisscrossing lines in polished aluminum represents the train tracks and interconnected histories. Metal percussion musical instruments finished with Birchwood Casey, a durable and protective solution that mimics the warmth of antique metalwork, were embedded in open spaces between the lines—the appearance of the playable and uniquely sounding instruments contrasted with the polished aluminum.

The interactivity of the artwork lies in the proximity and sharing between community members who cross the bridge daily. *CROSSCUT* provides a meeting point where music and sound can spark community camaraderie.

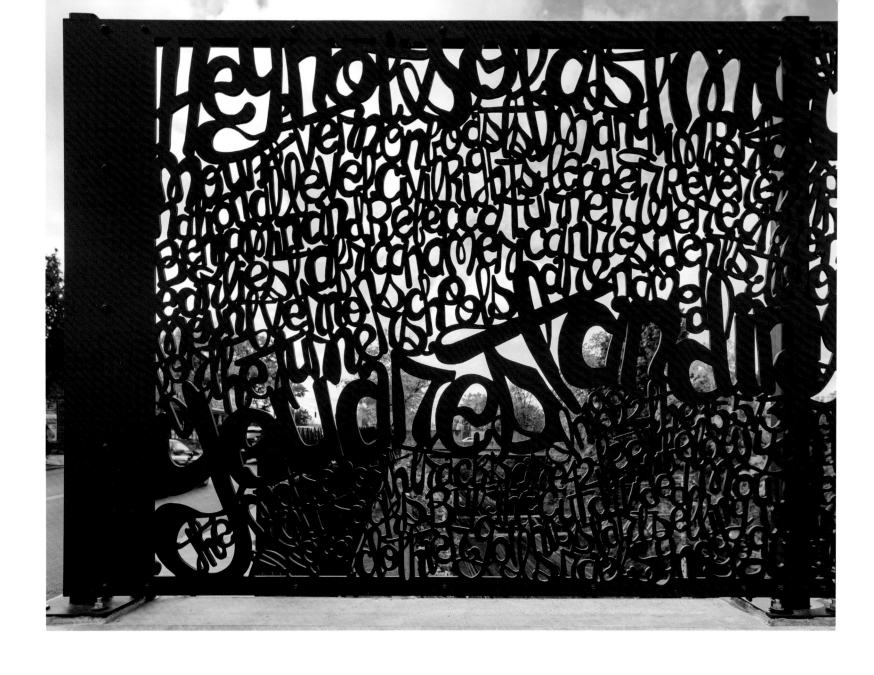

MARK FOX

40°54'37.9" N 73°50'33.5"W, 2021
10th Avenue Bridge

On June 3, 2021, with the reopening of the bridge, Mayor Shawyn Patterson-Howard echoed the sentiments of Mount Vernon residents, exclaiming, "We are excited to see the reopening of the 10th Avenue Bridge this month. For years it has been closed, depriving residents and our public safety vehicles a key access point to cross our city."

Hey, not so fast Mount Vernonite
There are 31,536,000 seconds in a year
You only need 20 seconds to cross this bridge
So slow down come closer
Spend a little time and keep me company

Speaking as the first-person voice of the 10th Avenue Bridge, the artwork by Mark Fox playfully recounts exciting

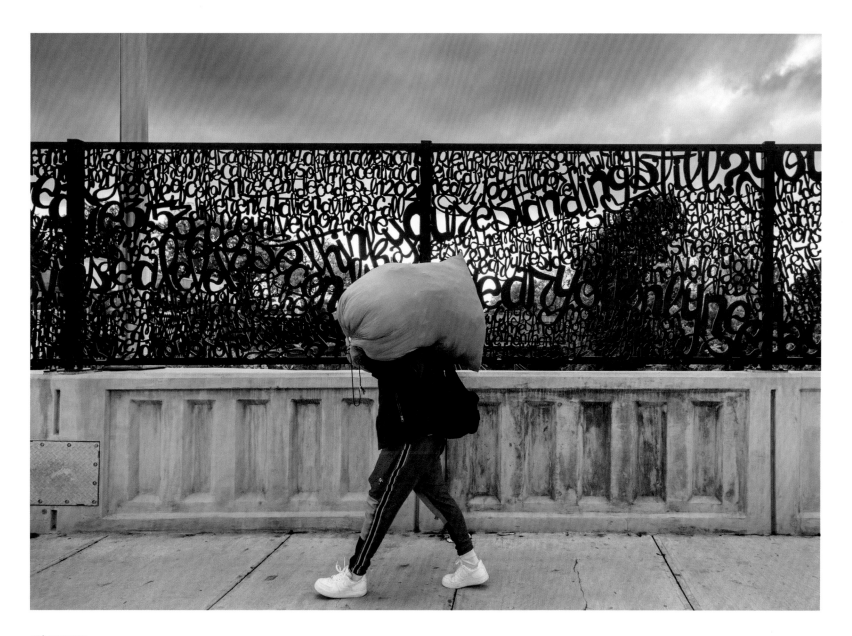

40°54'37.9" N
73°50'33.5" W.
Photos: James T.
Murray and
Karla L. Murray.

facts about the bridge and the city in a mysterious text-based design that is not readily apparent and only vaguely legible. To create the content, Fox researched the history of Mount Vernon, reflected on his own experience in the city, and undertook in-depth conversations with local historians.

The artwork is composed of words in shifting scales, undulating throughout the composition and forming an all-over pattern. Fox worked with Brooklyn-based MILGO/BUFKIN to create the work based on his hand-drawn brush and ink text. The loose, exaggerated text determined the design matrix for the fourteen dynamic waterjet-cut aluminum panels spanning the entire west face of the bridge. The final artwork retains the fluid marks and paintbrush edges of the original drawings.

The text is intended to be savored, revealing itself slowly. It is a playful statement from the point of view of the bridge, its place in the world and time, and its relationship to the train that runs below. As the artist has written, "My idea for the 10th Avenue bridge was to create a work that is visually fluid and lively while engaging passersby in a game of discovery about the site of the bridge and its relationship to the city and surrounding area. The design, formed with handwritten cursive, is an original legend that includes details about Mount Vernon's history and people and scientific facts about the viewer's experience at the site. I want the legend to function as a kind of game so passersby can literally 'read' this bridge. For Mount Vernonites who cross frequently, I hope they will continue enjoying new discoveries over time."

FRANCES GALLARDO

Line to Line, 2018
14th Avenue Bridge

The 14th Avenue Bridge reopened on July 3, 2019, with artwork by Frances Gallardo. Her sculptural grilles *Line to Line* are attached to the bridge's pedestrian walls, incorporating lacelike patterns depicting the anatomy, movement, and personal routes of the city's residents and visitors as viewed from various vantage points, laid over an abstract map of Mount Vernon. Inspired by Mount Vernon's history, Gallardo researched the blueprints of its original planning design and collaged the blueprint and satellite imagery of city land plots to emulate the dynamism of movement.

Gallardo hand-cut printouts of vintage maps to create intricate patterns, then combined different pieces into a patchwork akin to a woven tapestry. These designs were subsequently generated as computer files for waterjet cutting of the painted aluminum panels by the fabricator MILGO/BUFKIN.

Line to Line connects abstracted forms of the city in the artwork and the lines of the train tracks below, creating a rhythm of visual interest that will evolve as pedestrians create their own paths through the city and pause, on occasion to contemplate the artwork on the bridge.

Original artwork for
Line to Line. Courtesy
of the artist.

Line to Line. Photos: Jason Mandella.

Index of Artists

MTA Arts & Design Permanent Collection

1986

John Cavanagh, *Commuting/Community*, NYCT Woodside–61 St
Houston Conwill, *The Open Secret*, NYCT 125 St
Milton Glaser, *Untitled*, NYCT Astor Pl

1987

Rhoda Andors, *Kings Highway Hieroglyphs*, NYCT Kings Hwy
Nancy Holt, *Astral Grating*, NYCT Fulton St*
Ray Ring, *Clark Street Passage*, NYCT Clark St

1988

Valerie Jaudon, *Long Division*, NYCT 23 St
David Wilson, *Transit Skylight*, NYCT Newkirk Av
Steve Wood, *Fossils*, NYCT 137 St–City College
Nina Yankowitz, *Tunnel Vision*, NYCT 51 St**

1989

Matt Mullican, *Untitled*, NYCT 50 St
Nitza Tufiño (in collaboration with Grosvenor Neighborhood
 House student muralists), *Westside Views*, NYCT 86 St

1990

Sandra Bloodworth, *South Sails*, NYCT South Ferry*
Arthur Gonzalez, *The Finder/The Seekers*, MNR Tuckahoe
Arthur Gonzalez, *Time Catcher*, MNR Fleetwood
Arthur Gonzalez, *The Discovery*, MNR Crestwood**
Kathleen McCarthy, *Five Points of Observation*, NYCT Cypress
 Hills*, 75 St*, Woodhaven Blvd, 104 St, and 111 St
Harry Roseman, *Subway Wall*, NYCT Wall St
Dan Sinclair, *Fast Track and Speedwheels*, NYCT Grand Central–
 42 St
Nitza Tufiño, *Neo-Boriken*, NYCT 103 St

1991

Rolando Briseño, *At the Table*, MNR North White Plains
Norman B Colp, *The Commuter's Lament or a Close Shave*, NYCT
 42 St–Port Authority Bus Terminal
Michele Oka Doner, *Radiant Site*, NYCT 34 St–Herald Sq
Sam Gilliam, *Jamaica Center Station Riders, Blue*, NYCT Jamaica
 Ctr–Parsons/Archer
Michelle Greene, *Railrider's Throne*, NYCT 116 St–Columbia
 University
Wopo Holup, *River to River*, NYCT 125 St
Wopo Holup, *Elevated Nature I-IV*, NYCT 207 St, 215 St**, Marble
 Hill–225 St**, 231 St**
Martha Jackson-Jarvis, *Travelin' Time*, MNR Mount Vernon West
Tom Nussbaum, *Travelers*, MNR Scarsdale
Tom Nussbaum, *Workers*, MNR Hartsdale
Nicholas Pearson, *Halo*, NYCT 34 St–Herald Sq
Alison Saar, *Hear the Lone Whistle Moan*, MNR Harlem–125 St

1992

Brit Bunkley, *Bay Shore Icons*, LIRR Bay Shore
R. M. Fischer, *Brooklyn-Battery Tunnel Clock*, B&T Hugh L.
 Carey Tunnel
Frank Olt, *Temple Quad Reliefs*, NYCT Court Sq–23 St
David Provan, *Yab-Yum*, NYCT 34 St–Herald Sq
David Saunders, *Conductor's Watch and Key Chain*, (relocated
 from LIRR Westbury, 2001), LIRR Great Neck
Michael Kelly Williams, *El 2 and El 5*, NYCT Intervale Av

1993

Romare Bearden, *City of Glass*, (installed posthumously), NYCT
 Westchester Sq–E Tremont Av
Alan Sonfist, *The Narrative History of Merrick*, LIRR Merrick
Alan Sonfist, *The Narrative History of Bellmore*, LIRR Bellmore

1994

Laura Bradley, *City Suite*, NYCT 96 St
Deborah Brown, *Platform Diving*, NYCT Houston St
Lee Brozgol, *The Greenwich Village Murals*, NYCT Christopher
 St–Sheridan Sq
Andrew Leicester, *Ghost Series (Corinthian Capital, Plinth*, Day and
 Night, Mercury Man, Broken Column, Drawing of Old Pennsylvania
 Station)*, LIRR Penn Station
Maya Lin, *Eclipsed Time*, LIRR Penn Station**
Patsy Norvell, *Garden Stops*, NYCT Beverley Rd* and Cortelyou
 Rd
Liliana Porter, *Alice: The Way Out*, NYCT 50 St
Josh Scharf, *Carnegie Hall Montage*, NYCT 57 St–7 Av
Susan Tunick, *Brighton Clay Re-Leaf Nos. 1-4*, NYCT Prospect Park
 and Parkside Av
Emmett Wigglesworth, *CommUnion*, NYCT Union St

1995

Alice Adams, *Planting (dedicated to Long Island Tree Farmers)*,
 LIRR Ronkonkoma
Willie Birch, *Harlem Timeline*, NYCT 135 St
Ralph Fasanella, *Subway Riders*, NYCT 5 Av/53 St*
Jane Greengold, *Wings for the IRT: The Irresistible Romance of
 Travel*, NYCT Grand Army Plaza

1996

Muriel Castanis, *Flatbush Floogies*, NYCT Flatbush Av–
 Brooklyn College
Mark Gibian, *Cable Crossing*, NYCT Brooklyn Bridge–City Hall/
 Chambers St*
Jimmy James Greene, *Children's Cathedral*, NYCT Utica Av
Robert Hickman, *Convex Disk at Roosevelt Island*, NYCT Roosevelt
 Island
Christopher Janney, *Reach New York, An Urban Musical Instrument*,
 NYCT 34 St–Herald Sq
Elizabeth Murray, *Blooming*, NYCT Lexington Av/59 St

José Ortega, *Una Raza, Un Mundo, Universo (One Race, One World,
 One Universe)*, NYCT 3 Av–149 St
Faith Ringgold, *Flying Home: Harlem Heroes and Heroines
 (Downtown and Uptown)*, NYCT 125 St
Robert Taplin, *Three Statues (A Short History of the Lower Hudson
 Valley)*, MNR Cortlandt
Pablo Tauler, *In Memory of the Lost Battalion*, NYCT
 Woodhaven Blvd
Manuel Vega, *Sábado en la Ciento Diez (Saturday on 110th Street)*,
 NYCT 110 St

1997

Mel Chin, *Signal*, Featuring *Wampum Message of Peace*, by G.
 Peter Jemison (Heron Clan - Seneca), (rededicated 2018),
 NYCT Broadway–Lafayette St
James Garvey, *Lariat Seat Loops*, NYCT 33 St
Margie Hughto, *Trade, Treasure and Travel*, NYCT Cortlandt St
Roberto Juarez, *A Field of Wild Flowers*, MNR Grand Central
 Terminal
Ann Schaumburger, *Urban Oasis*, NYCT 5 Av/59 St
Anton van Dalen, *Work & Nature*, NYCT Nevins St

1998

Ellen Driscoll, *As Above, So Below*, MNR Grand Central Terminal
DeBorah Goletz, *Postcards from Sheepshead Bay*, NYCT
 Sheepshead Bay
Elizabeth Grajales, *When the animals speak…*, NYCT 34 St–Penn
 Station
Maren Hassinger, *Message from Malcolm*, NYCT Central Park
 North (110 St)
Kristin Jones & Andrew Ginzel, *Oculus*, NYCT Chambers St/
 Park Pl
Bing Lee, *Empress Voyage 2.22.1794*, NYCT Canal St
Donald Lipski, *Sirshasana*, MNR Grand Central Terminal Market
Mary Miss, *Framing Union Square*, NYCT 14 St–Union Sq
Owen Smith, *An Underground Movement: Designers, Builders,
 Riders*, NYCT 36 St
Joe Zucker, *For My Grandfather Noye Pride, a Locomotive Engineer*,
 LIRR Huntington

1999

Terry Adkins, *Harlem Encore*, MNR Harlem–125 St
Sheila Levrant de Bretteville, *At the Start… At Long Last*, NYCT
 Inwood–207 St
Millie Burns, *IL7/Square*, NYCT Botanic Garden/Franklin Av
Dan George, *Mermade/Dionysus and the Pirates*, NYCT
 Brighton Beach
Dimitri Gerakaris, *Woodside Continuum*, NYCT Woodside–61 St
Verna Hart, *Jammin' Under the EL*, NYCT Myrtle Av*
Yumi Heo, *Q Is for Queens*, NYCT 33 St, 40 St, and 46 St
Ik-Joong Kang, *Happy World*, NYCT Flushing–Main St

Ed McGowin, *Bayside Story*, LIRR Bayside

Eric Pryor, *Life and Continued Growth*, NYCT Franklin Av

Isha Shabaka, *Units of the Free*, NYCT Park Pl

Vincent Smith, *Minton's Playhouse (uptown), The Movers and Shakers (downtown)*, NYCT 116 St

Christopher Wynter, *Migration*, NYCT Cathedral Pkwy (110 St)

2000

Sydney Cash, *Columns*, NYCT Queensboro Plaza

Jackie Chang, *Signs of Life*, NYCT Metropolitan Av/Lorimer St

Jackie Ferrara, *Grand Central: Arches, Towers, Pyramids*, NYCT Grand Central–42 St

Frank Giorgini, *Passages*, NYCT Whitehall St

Frank Leslie Hampton, *Uptown New York*, NYCT Tremont Av

Anne Huibregtse, *Arrival*, MNR Wassaic

Frederick Dana Marsh, *Marine Grill Murals*, c. 1913 for the McAlpin Hotel (installed 2000/2011), NYCT Fulton St

MTA Arts & Design Collaborative, *For Want of a Nail*, NYCT 81 St–Museum of Natural History

Christopher Sproat, *V-Beam*, NYCT Grand Central–42 St

2001

Jack Beal, *The Return of Spring*, NYCT Times Sq–42 St

Marjorie Blackwell, *Tranquility*, MNR Mount Vernon East

Louis Delsarte, *Transitions*, NYCT Church Av

Eric Fischl, *The Garden of Circus Delights*, NYCT 34 St–Penn Station

Jacob Lawrence, *New York in Transit*, (installed posthumously), NYCT Times Sq–42 St

Al Loving, *Brooklyn, New Morning*, NYCT Broadway Jct

Walter Martin and Paloma Muñoz, *A Gathering*, NYCT Canal St

Elizabeth Murray, *Stream*, NYCT Court Sq–23 St

Tom Otterness, *Life Underground*, NYCT 14 St–8 Av

Nancy Spero, *Artemis, Acrobats, Divas, and Dancers*, NYCT 66 St–Lincoln Center

2002

Vito Acconci (Acconci Studio in collaboration with di Domenico + Partners), *Wall-Slide*, NYCT 161 St–Yankee Stadium

Helene Brandt, *Room of Tranquility*, NYCT 161 St–Yankee Stadium

Ron Calloway, *Euphorbias*, NYCT Kosciuszko St

Annette Davidek, *Roundlet Series*, NYCT Lorimer St

Maria Dominguez, *El Views*, NYCT Chauncey St

Keith Godard, *Memories of Twenty-Third Street*, NYCT 23 St

Jane Greengold and Kane Chanh Do, *Almost Home*, MNR Pleasantville

Mark Hadjipateras, *City Dwellers (for Costas and Maro)*, NYCT 28 St

Mara Held, *El in 16 Notes*, NYCT Hewes St

Robert Hickman, *Laced Canopy*, NYCT 72 St

Samm Kunce, *Under Bryant Park*, NYCT 42 St–Bryant Pk

Roy Lichtenstein, *Times Square Mural*, (installed posthumously), NYCT Times Sq–42 St

Max Neuhaus, *Times Square*, 1977 (Restored 2002), NYCT Times Sq–Broadway/46 St

Roy Nicholson, *Morning Transit, Hempstead Plain and Evening Transit, Hempstead Plain*, LIRR Hicksville

Chris Wade Robinson, *Dream Train*, NYCT Gates Av

Timothy Snell, *Broadway Diary*, NYCT 8 St–NYU

Tova Snyder, *Railroads and Rooftops*, MNR Harrison

2003

Raúl Colón, *Primavera*, NYCT 191 St

Lisa Dinhofer, *Losing my Marbles*, NYCT 42 St–Port Authority Bus Terminal

Valerie Maynard, *Polyrhythmics of Consciousness and Light*, NYCT 125 St

2004

Ellsworth Ausby, *Space Odyssey*, NYCT Marcy Av

Naomi Campbell, *Animal Tracks*, NYCT West Farms Sq–E Tremont Av

Hugo Consuegra, *Good Morning and Good Night*, NYCT Crown Hts–Utica Av

Daniel del Valle, *A Trip Up the Bronx River*, NYCT 174 St

Ming Fay, *Shad Crossing, Delancey Orchard*, NYCT Delancey St/Essex St

Al Held, *Passing Through*, NYCT Lexington Av/53 St

Michael Krondl, *Looking Up*, NYCT Neptune Av

Robert Kushner, *4 Seasons Seasoned*, NYCT 77 St

MTA Arts & Design Collaborative, *New York City Architectural Artifacts from the Collection of the Brooklyn Museum*, NYCT Eastern Pkwy–Brooklyn Museum

Tom Patti, *Passage*, NYCT Jackson Hts–Roosevelt Av/74 St–Broadway

Peter Sis, *Happy City*, NYCT 86 St

George Trakas (in collaboration with di Domenico + Partners), *Hook (Archean Reach), Line (Sea House), and Sinker (Mined Swell)*, NYCT Atlantic Av–Barclays Ctr

Robert Wilson, *My Coney Island Baby*, NYCT Coney Island–Stillwell Av

Janet Zweig and Edward del Rosario, *Carrying On*, NYCT Prince St

2005

Vito Acconci (Acconci Studio in collaboration with Daniel Frankfurt), *Wavewall*, NYCT W 8 St–NY Aquarium

Jack Beal, *The Onset of Winter*, NYCT Times Sq–42 St

Josie Gonzalez Albright, *Children at Play*, NYCT Woodlawn

Ron Baron, *Lost and Found: An Excavation Project*, LIRR Hempstead

Robert Blackburn, *In Everything There Is A Season*, NYCT 116 St

Toby Buonagurio, *Times Square Times: 35 Times*, NYCT Times Sq–42 St

Ellen Harvey, *Look Up, Not Down*, NYCT Queens Plaza

Stephen Johnson, *DeKalb Improvisation*, NYCT DeKalb Av

Moses Ros, *Patriasana, Wholesomeland*, NYCT Fordham Rd

Barbara Segal, *Muhheakantuck (The River that Flows Two Ways)*, MNR Yonkers

Joy Taylor, *The Four Seasons*, MNR Larchmont

Anita Thacher, *Illuminated Station*, LIRR Greenport

2006

Candida Alvarez, *B is for Birds in the Bronx*, NYCT Bronx Park East

Andrea Arroyo, *My Sun (Mi Sol), My Planet (Mi Planeta) and My City (Mi Ciudad)*, NYCT Gun Hill Rd

Amir Bey, *The Procession of Folk #3*, NYCT Mt Eden Av

Michele Brody, *Allerton Mandalas*, NYCT Allerton Av

Dina Bursztyn, *Views from Above*, NYCT 170 St

Noel Copeland, *Leaf of Life*, NYCT Nereid Av

Béatrice Coron, *Bronx Literature*, NYCT Burke Av

Joseph D'Alesandro, *Homage*, NYCT 219 St

Andrea Dezsö, *Community Garden*, NYCT Bedford Park Blvd–Lehman College

Nicky Enright, *Universal City*, NYCT 225 St

Cadence Giersbach, *From Earth to Sky*, NYCT Myrtle–Wyckoff Avs

Skowmon Hastanan, *A Secret Garden: There's No Place Like Home*, NYCT 233 St

Robin Holder, *Migration*, NYCT Flushing Av

Dennis Oppenheim, *Rising and Setting*, MNR Riverdale

Juan Sánchez, *Reaching Out For Each Other*, NYCT 176 St

2007

Tomie Arai, *Back to the Garden*, NYCT Pelham Pkwy

Nancy Blum, *Floating Auriculas*, MNR Dobbs Ferry

Amy Cheng, *Las Flores*, NYCT Cleveland St*

Barbara Ellmann, *The View From Here*, NYCT Van Siclen Av

Daniel Hauben, *The El*, NYCT Freeman St

Michael Ingui, *Crescendo*, NYCT E 105 St

Daru-Jung Hyang Kim, *Wheel of Bloom-Soak up the Sun*, NYCT Crescent St*

Margaret Lanzetta, *Culture Swirl*, NYCT Norwood Av*

Mario M. Muller, *Urban Motif*, NYCT Kingsbridge Rd

Takayo Noda, *The Habitat for the Yellow Bird*, NYCT Sutter Av

Scott Redden, *Untitled*, NYCT Alabama Av*

Carol Sun, *A Bronx Reflection*, NYCT 167 St

Eugenie Tung, *16 Windows*, NYCT New Lots Av

Philemona Williamson, *Seasons*, NYCT Livonia Av

2008

Malin Abrahamsson, *On the Trail of the Rising Sun*, LIRR Valley Stream

Lisa Amowitz, *Urban Renewal*, NYCT Simpson St

Laura Battle, *How to get to the moon…*, NYCT Burnside Av

Bill Brand, *Masstransiscope*, 1980 (restored 2008/2013), NYCT DeKalb Av

Jane Dickson, *Revelers*, NYCT Times Sq–42 St

Felipe Galindo, *Magic Realism in Kingsbridge*, NYCT 231 St

Corinne Grondahl, *Metromorphosis/Birth of a Station*, NYCT Mosholu Pkwy

KK Kozik, *First on the Beach and Wednesday Night Fireworks*, NYCT Rockaway Park–Beach 116 St

Jose Ortiz, *Many Trails*, NYCT 183 St*

Jean Shin, *Celadon Remnants*, LIRR Broadway

SOL'SAX, *SOL'SCRYPT*, NYCT Halsey St

Marina Tsersekaya, *Bronx. Four Seasons*, NYCT Prospect Av

2009

Joseph Cavalieri, *North, South and Home*, MNR Philipse Manor

George Crespo, *Latin American Stories*, NYCT Jackson Av

Carson Fox, *Blue Sky Pursuit*, LIRR Seaford

Ellen Harvey, *The Home of the Stars*, MNR Yankees–East 153rd Street

Sol LeWitt, *Whirls and twirls (MTA)*, NYCT 59 St–Columbus Circle

Ben Snead, *Departures and Arrivals*, NYCT Jay St–MetroTech

Doug & Mike Starn, *See it split, see it change*, NYCT South Ferry

Allan & Ellen Wexler (in collaboration with di Domenico + Partners), *Overlook*, LIRR Atlantic Terminal

2010

Alfredo Ceibal, *Permanent Residents and Visitors*, NYCT Wakefield–241 St

Maria Cristalli & Marc Brown, *The Land Between Two Waters*, NYCT Morrison Av–Soundview

Robert Goodnough, *K–M–G*, MNR Ossining

Barbara Grygutis, *Bronx River View*, NYCT Whitlock Av

Deborah Masters, *Coney Island Reliefs*, NYCT Ocean Pkwy

Liliana Porter and Ana Tiscornia, *Untitled with Sky*, MNR Scarborough

Masamichi Udagawa & Sigi Moeslinger, *Bloemendaal*, NYCT 96 St

2011

George Bates, *Symphonic Convergence 1&2*, NYCT Beach 36 St

Amy Bennett, *Heydays*, NYCT 86 St

Luisa Caldwell, *Station Villa*, NYCT E 180 St

Ingo Fast, *On and Off the Board Walk*, NYCT Beach 67 St

James Garvey, *Lariat Tapers*, NYCT Wall St

Bernard Greenwald, *Port Chester Scenes*, MNR Port Chester

Callie Hirsch, *Vast*, NYCT Beach 105 St

Simon Levenson, *The Beaches of New York City*, NYCT Beach 60 St

Mauricio Lopez, *Past/Present/Future*, NYCT Beach 25 St

William Low, *A Day in Parkchester*, NYCT Parkchester

Rita MacDonald, *Bird Laid Bare*, NYCT Avenue J

Rita MacDonald, *Hare Apparent*, NYCT Avenue M

Jason Middlebrook, *Brooklyn Seeds*, NYCT Avenue U

Michael Miller, *Surf Station 90*, NYCT Beach 90 St

Alison Moritsugu, *Community (Acer rubrum, Rosa palustris, Smilax rotundifolia, Carya cordiformis)*, NYCT St Lawrence Av

Matt Mullican, *Untitled*, MNR Rye

Jill Parisi, *Coom Barooom*, NYCT Beach 44 St

Duke Riley, *Be Good or Be Gone*, NYCT Beach 98 St

Jason Rohlf, *Respite*, NYCT Far Rockaway-Mott Av

Mary Temple, *West Wall, East Light, Morning*, NYCT Neck Rd

Jean Whitesavage and Nick Lyle, *Bronx Trees*, NYCT Elder Av

2012

Amy Cheng, *Rediscovery*, NYCT 25 Av

Andrea Dezsö, *Nature Rail*, NYCT 62 St

Tricia Keightley, *Hunters Point Avenue Project*, NYCT Hunters Point Av

Ed Kopel, *Brooklyn Bucolic*, NYCT Avenue H

Joan Linder, *The Flora of Bensonhurst*, NYCT 71 St

Portia Munson, *Gardens of Fort Hamilton Parkway Station*, NYCT Fort Hamilton Pkwy

Odili Donald Odita, *Kaleidoscope*, NYCT 20 Av

Christopher Russell, *Bees for Sunset Park*, NYCT 9 Av

Holly Sears, *Hudson River Explorers*, MNR Tarrytown

Francesco Simeti, *Bensonhurst Gardens*, NYCT 18 Av

Xin Song, *Tree Of Life*, NYCT Bay Pkwy

Susanna Starr, *A Continuous Thread*, NYCT 79 St

Joy Taylor, *Jan Peeck's Vine*, MNR Peekskill

Leo Villareal, *Hive (Bleecker Street)*, NYCT Broadway–Lafayette St/Bleecker St

Dan Zeller, *Internal Connectivity*, NYCT Bay 50 St

2013

George Bates, *Generation Dynamica*, NYCT Central Av

Laura F. Gibellini, *Dom (Variations)*, NYCT Seneca Av, Fresh Pond Rd, Forest Av

Wopo Holup, *Birds in Flight-Moon View*, 1991/2013, NYCT Dyckman St

Cal Lane, *The Digs*, NYCT Knickerbocker Av

Alyson Shotz, *Nautical Charts–Gowanus & Red Hook from 1733– 1922; Fathom Points + Compass Bearings*, NYCT Smith–9 Sts

Shinique Smith, *Mother Hale's Garden*, MTA Bus Company Mother Clara Hale Bus Depot

Corinne Ulmann, *Croton-Harmon Station*, MNR Croton-Harmon

2014

James Carpenter Design Associates, Grimshaw Architects, and Arup, *Sky Reflector-Net*, NYCT Fulton Center

Kim Cridler, *Where the Sweet Waters Fall*, MNR Mamaroneck

Loren Eiferman, *HOME: INSIDE/OUTSIDE*, MNR Pelham

2015

Jaime Arredondo, *Garden of Earthly Delights*, NYCT Zerega Av

Xenobia Bailey, *Funktional Vibrations*, NYCT 34 St–Hudson Yards

Moe Brooker, *Just Jazz*, LIRR Wyandanch Parking Garage

Béatrice Coron, *On the Right Track*, NYCT 104 St

Priscila De Carvalho, *Bronx: Heart, Homeland*, NYCT Castle Hill Av

Peter Drake, *Waiting for Toydot*, LIRR Massapequa

Ray King, *Connections*, NYCT Rockaway Blvd

Haresh Lalvani, *MORPHING88*, NYCT 88 St

Amanda Schachter and Alexander Levi, *Cross-Bronx Waterway*, NYCT Middletown Rd

SITU Studio, *Percolate*, MNR North White Plains Parking Garage

Soonae Tark, *Have a Happy Day*, NYCT Buhre Av

2016

Dan Funderburgh, *Eureka*, MNR Fordham

Linda Ganjian, *Home Sweet Home*, NYCT 111 St

Cara Lynch, *Inheritance: In Memory of American Glass*, NYCT Ditmas Av

Mia Pearlman, *SOAR*, NYCT 80 St

Corinne Ulmann, *Croton-Harmon Station*, MNR Croton-Harmon

2017

Nancy Baker, *Ailthanus*, NYCT Sutter Av–Rutland Rd

Nancy Baker, *Chandelier*, NYCT Saratoga Av

Monika Bravo, *Duration*, NYCT Prospect Av

Chuck Close, *Subway Portraits*, NYCT 86 St

Katy Fischer, *Strata*, NYCT Bay Ridge Av

Béatrice Lebreton, *Paroles Vagabondes/Wisdom Along the Way*, NYCT Junius St and Rockaway Av

Derek Lerner, *AVEX(1-6)station*, NYCT Avenue X

Jenna Lucente, *Tottenville Sun, Tottenville Sky*, SIR Arthur Kill

Tomo Mori, *The Wheels on the Bus*, MTA Bus Company Manhattanville Bus Depot

Vik Muniz, *Perfect Strangers*, NYCT 72 St

Jean Shin, *Elevated*, NYCT Lexington Av/63 St

Sarah Sze, *Blueprint for a Landscape*, NYCT 96 St

Mickalene Thomas, *Untitled*, NYCT 53 St

Saya Woolfalk, *Urban Garden Rail*, NYCT Pennsylvania Av and Van Siclen Av

2018

Diana Al-Hadid, *The Arches of Old Penn Station; The Arc of Gradiva*, NYCT 34 St–Penn Station

Firelei Báez, *Ciguapa Antellana, me llamo sueño de la madrugada (who more sci-fi than us)*, NYCT 163 St–Amsterdam Av

Jackie Battenfield, *Tree Canopy*, NYCT Avenue P

Andrea Belag, *Brooklyn Transitions*, NYCT Avenue U

Nancy Blum, *ROAMING UNDERFOOT*, NYCT 28 St

Diane Carr, *Outlook*, NYCT Broadway

Everet, *A Portrayal of Life at Mill Creek*, SIR Richmond Valley

Marc Dennis, *Where Dreams Come To Play*, LIRR Wantagh

Derek Fordjour, *PARADE*, NYCT 145 St

Dan Funderburgh, *SHOAL*, LIRR Bellmore

Frances Gallardo, *Line to Line*, MNR Mount Vernon 14th Avenue Bridge

Julien Gardair, *We are each others*, NYCT 18 Av and Kings Hwy

Rico Gatson, *Beacons*, NYCT 167 St

Sally Gil, *Edges of a South Brooklyn Sky*, NYCT Avenue U

James Gulliver Hancock, *Connection Cultivating Communities*, LIRR Merrick

Ann Hamilton, *CHORUS*, NYCT WTC Cortlandt

Mary Judge, *American Season*, LIRR Wyandanch and Pinelawn

Joyce Kozloff, *Parkside Portals*, NYCT 86 St

Timothy Hyunsoo Lee, *Come Back Home*, LIRR Stewart Manor

William Low, *Deer Park Dahlias*, LIRR Deer Park

Karen Margolis, *Cerebration*, NYCT 86 St

Armando Mariño, *The Guardian Angel*, LIRR Brentwood

David McQueen, *". . . the vast and endless sea"*, LIRR Port Jefferson

Maureen McQuillan, *Crystal Blue Persuasion*, NYCT 36 Av

Sarah Morris, *Hellion Equilibrium*, NYCT 39 Av-Dutch Kills

Roy Nicholson, *Hempstead Plain, Morning & Evening*, LIRR Hicksville

Kambui Olujimi, *Where the Sky Begins*, NYCT Avenue I

Yoko Ono, *SKY*, NYCT 72 St

Emilio Perez, *Fluxus / Rhythmus*, NYCT 18 Av

Alison Saar, *copacetic*, MNR Harlem–125 St

Roy Secord, *Bronx Seasons Everchanging*, NYCT 174-175 Sts

Lisa Sigal, *Push/Pull*, NYCT Avenue N

Leslie Wayne, *Neptune's Garden*, NYCT Bay Pkwy

William Wegman, *Stationary Figures*, NYCT 23 St

Stephen Westfall, *Perasma I & II; Dappleganger*, NYCT 30 Av

Christopher Wynter, *Migration*, NYCT Cathedral Pkwy (110 St)

2019

Derrick Adams, *Around the Way*, LIRR Nostrand Avenue

María Berrío, *There is Magic Underneath It All*, NYCT Fort Hamilton Pkwy

Elisabeth Condon, *Urban Idyll*, NYCT Astoria–Ditmars Blvd

Andrea Dezsö, *Nature Wall*, NYCT New Utrecht Av

Tom Fruin, *Sail*, LIRR Syosset

Bernard Greenwald, *Images of Port Chester*, MNR Port Chester

Olaleken Jeyifous, *MADE WITH LOVE*, NYCT 8 Av

Alex Katz, *Metropolitan Faces*, NYCT 57 St

MTA Arts & Design and The Museum of Modern Art, New York, *The Subway: Design for a Modern Icon*, NYCT 5 Av/53 St

Eamon Ore-Giron, *People's Instinctive Travels: Homage to the Tribe*, NYCT Bay Pkwy

David Storey, *Sea City Spin*, NYCT 20 Av

Tricia Wright, *Morning Glory, Evening Splendor; The Perennial Village*, MNR Crestwood

2020

Gail Boyajian, *Aviary*, LIRR Carle Place

Cara Enteles, *Commuting Through Nature*, LIRR Merillon Avenue

Jeffrey Gibson, *I AM A RAINBOW TOO*, NYCT Astoria Blvd

Josué Guarionex, *CROSSCUT*, MNR Mount Vernon 6th Avenue Bridge

Jim Hodges, *I dreamed a world and called it Love*, NYCT Grand Central–42 St

James Little, *Radiant Memories*, LIRR Jamaica

Barbara Takenaga, *Forte (Quarropas); Blue Rails (White Plains)*, MNR White Plains

2021

Katherine Bradford, *Queens of the Night*, NYCT 1 Av

Damien Davis, *Empirical Evidence*, MNR Mount Vernon 3rd Avenue Bridge

Marcel Dzama, *No Less Than Everything Comes Together*, NYCT Bedford Av

Mark Fox, *40°54'37.9"N 73°50'33.5"W*, MNR Mount Vernon 10th Avenue Bridge

Sandy Litchfield, *Forestation Syncopation*, LIRR New Hyde Park

Amy Pryor, *Day Into Night Into Day*, NYCT 138 St–Grand Concourse

Armando Veve, *Boat House Buggy*, MNR Port Jervis

2022

Nick Cave, *Each One, Every One, Equal All*, NYCT Times Sq–42 St

Yayoi Kusama, *A Message of Love, Directly from My Heart unto the Universe*, LIRR Grand Central Madison

Kiki Smith, *River Light; The Presence; The Spring; The Sound; The Water's Way*, LIRR Grand Central Madison

Darryl Westly, *Illuminations*, LIRR Westbury

Shawna X, *Cyclical Everything*, LIRR Elmont–UBS Arena

2023

Diana Al-Hadid, *The Time Telling*, NYCT 34 St–Penn Station

Chloë Bass, *Personal Choice #5*, NYCT Lorimer St

Diana Cooper, *Double Take*, LIRR Roosevelt Island Ventilation Structure

Glenn Goldberg, *Bronx River*, NYCT E 149 St

Donald Lipski, *Bessie and Roxey*, LIRR Mineola

Carmen Lizardo, *Great Waves of Immigration*, NYCT 181 St

Glendalys Medina, *Gratitudes off Grand*, NYCT Grand St

David Rios Ferreira, *Landscapes adrift—cosmically woven and earthly bonded*, NYCT 7 Av

Keri Sheheen, *Creeping on Where Time Has Been*, SIR New Dorp

*Artwork is partially or fully concealed or removed from view
**Artwork has been permanently deaccessioned

Selected Bibliography

Applebome, Peter. "Before Hosting 'Bandstand,' Growing Up in a City with a Complicated Story." *The New York Times,* April 21, 2012.

"Ask Me About the Red Owl." *Brentwood Historical Society.* https://www.brentwoodhis.org/the-legend-of-the-red-owl/.

Ayres, William, and Sandra Bloodworth. "Terra Cotta Incognita: Turn-of-the-Century Ceramic Art in the New York City Subway System." *19th Century,* 11, nos. 3 and 4 (1992).

Bailey, Xenobia. "The Miraculous Life of an Early Black America Abolitionist and Craftsman." *Hyperallergic,* June 15, 2023. https://hyperallergic.com/827925/the-miraculous-life-of-an-early-black-american-abolitionist-and-craftsman/.

Beckenstein, Joyce. "Public Responsibility: A Conversation with Donald Lipski." *Sculpture,* June 14, 2022. https://sculpturemagazine.art/public-responsibility-a-conversation-with-donald-lipski/.

"Before Central Park: The Story of Seneca Village." Central Park Conservancy, January 8, 2018. https://www.centralparknyc.org/articles/seneca-village.

Battaglia, Andy. "Best Practices: Derek Fordjour's Art Stares Down Shared Fears and Vulnerabilities." *Art News,* November 10, 2020. https://www.artnews.com/art-news/artists/derek-fordjour-artist-studio-visit-1234576168/.

Carlson, Jen. "Wowza, Is This the Most Instagrammable Subway Station In NYC?" *Gothamist,* February 20, 2019. https://gothamist.com/arts-entertainment/wowza-is-this-the-most-instagrammable-subway-station-in-nyc.

"Charles Codman's Home." *New York Heritage Digital Collections.* https://cdm16694.contentdm.oclc.org/digital/collection/p15281coll20/id/1237.

"Clara Driscoll and the Tiffany Girls." *New York Historical Society,* March 27, 2015. https://www.nyhistory.org/blogs/tiffany-girls.

Cohen, Li. "Dolphins spotted in Bronx River for the first time in years, highlighting cleanup efforts." *CBS News,* January 24, 2023. https://www.cbsnews.com/news/dolphins-bronx-river-new-york-city/.

Correa, Caitlin. "Making the Work with Painter Glenn Goldberg." *I Like Your Work Podcast,* September 2, 2022. https://www.ilikeyourworkpodcast.com/post/making-the-work-with-painter-glenn-goldberg.

"Cuban Artists, Public Art—Recent Projects and Commissions." *Cuban Art News Archive,* February 6, 2019. https://cubanartnewsarchive.org/2019/02/06/cuban-artists-public-art-recent-projects-and-commissions-in-us/.

Cudahy, Brian J. *Under the Sidewalks of New York: The Story of the Greatest Subway System in the World.* Vermont: Stephen Greene Press, 1979.

Diehl, Lorraine B. *Subways: The Tracks that Built New York City.* New York: Clarkson Potter, 2004.

Dunlap, David W. "At Cortlandt Street Subway Station, Art Woven From Words." Section A, *The New York Times,* April 29, 2015.

"Eamon Ore-Giron: Working with Sound." MCA Denver, https://mcadenver.org/exhibitions/eamon-ore-giron/working-with-sound.

Fischler, Stan. *The Subway: A Trip Through Times on New York's Rapid Transit.* New York: H & M Productions II, 1997.

Fortini, Alex. "Katz Everlasting." *T The New York Times Style Magazine,* p. 124, August 21, 2022.

Fountain, Henry. "A Play on Nature's Patterns." Section D, *The New York Times,* February 5, 2013.

Gómez, Edward M. "In New Paintings, Elisabeth Condon Pours on Color and Unexpected Forms." *HYPERALLERGIC,* September 10, 2016. https://hyperallergic.com/321693/elisabeth-condon-bird-and-flower-lesley -heller-workshop.

Greenberger, Alex. "Before Yayoi Kusama Made 'Infinity Rooms,' She Created Standout Political Works." *Art News,* May 18, 2020. www.artnews.com/feature/yayoi-kusama-most-famous-works-12026875472/.

Greenwald, Alice M., and Clifford Chanin. *No Day Shall Erase You: The story of 9/11 as Told at the September 11 Museum.* New York: Rizzoli Electa, 2016.

"History of White Plains." *City of White Plains.* https://www.cityofwhiteplains.com/469/History-of-White-Plains#:-:text=White%20Plains%2C%20the%20county%20seat,or%20white%20marshes%20or%20plains.

Hood, Clifton. *722 Miles: The Building of the Subways and How They Transformed New York.* Maryland: John Hopkins University Press, 1995.

Interborough Rapid Transit. *The New York Subway: Its Construction and Equipment.* New York: Fordham University Press, 1991.

Johnson, Ken. "Saya Woolfalk: 'ChimaTEK: Hybridity Visualization System'." Section C, Page 21, *The New York Times,* February 20, 2015.

Jordan, Eliza. "Darryl Westly: Painting a Representational, Abstract World." *Whitewall,* January 13, 2020. Https://whitewall.art/art/darryl-westly-painting-a-representational-abstract-world.

"Key Figures of the Pattern and Decoration Movement." *Ideel Art,* April 17, 2019. https://www.ideelart.com/magazine/pattern-and-decoration-movement.

Kramer, Peter D. "MTA Brings Public Art to its Mount Vernon Bridges." *The Journal News,* December 13, 2019. https://www.lohud.com/story/news/local/westchester/mount-vernon/2019/12/13/mta-mount-vernon-bridges-art/4397089002/

Kusama: Infinity. Directed, written, and produced by Heather Lenz, co-written by Keita Ideno, and produced by David Braun, David Koh, and Karen Johnson, Magnolia Pictures, 2018.

Lakin, Max. "A Nick Cave Survey: Brutality, Bedazzled." Section C, *The New York Times,* November 24, 2022.

Lampert, Adam. "William Wegman by Adam Lampert." *Bomb,* July 25, 2022. https://bombmagazine.org/articles/william-wegman/.

Lesser, Casey. "Ride this Art Train through the Most Beautiful Route in the Alps." *Artsy,* February 24, 2017. https://www.artsy.net/article/artsy-editorial-sarah-morris-made-art-train-beautiful-route-alps.

Levin, Jennifer. "Xenobia Bailey: Functional Funk." *Pasatiempo,* July 15, 2016. https://www.santafenewmexican.com/pasatiempo/art/xenobia-bailey-functional-funk/article_a04090b1-7375-5a8d-8694-ee7eeddSc3cf.html.

Loos, Ted. "Now Arriving: Yayoi Kusama and Kiki Smith's Grand Central Madison Mosaics." *The New York Times,* November 30, 2022.

Marshall, Sydney. "The Captivating Glass Creations of Ray King." University Museums, January 6, 2021. https://www.museum.iastate.edu/virtual/blog/2021/01/06/the-captivating-glass-creations-of-ray-king.

Michalska, Magda. "Gradiva: What Did Freud and the Surrealists See in Her?" *Daily Art Magazine,* April 27, 2020. https://www.dailyartmagazine.com/gradiva/.

Miranda, Carolina A. "In the 'cacophony' of the Americas, painter Eamon Ore-Giron finds elegant patterns." *Los Angeles Times,* May 12, 2022. https://www.latimes.com/entertainment-arts/story/2022-05-12/in-the-cacophony-of-the-americas-painter-eamon-ore-giron-finds-elegant-patterns.

Nargi, Lela. "How clean is the Bronx River? Snapping turtles help scientists figure it out." *The Washington Post,* August 13, 2019. https://www.washingtonpost.com/lifestyle/kidspost/snapping-turtles-help-scientists-figure-out-how-clean-the-bronx-river-is/2019/08/13/33896b56-9db2-11e9-b27f-ed2942f73d70_story.html.

"New York - New York County." *National Register of Historic Places.* https://nationalregisterofhistoricplaces.com/ny/new+york/state.html.

New York Transit Museum and Vivian Heller. *The City Beneath Us: Building the New York Subways.* New York: W. W. Norton & Company, 2004.

Noor, David (Ed.). *Firelei Báez: to breathe full and free.* New York: Gregory R. Miller & Co. And James Cohan, 2022.

O'Grady, Megan. "Nick Cave is the Most Joyful Critical Artist." *The New York Times Magazine,* October 20, 2019.

Olding, Rachel. "What can William Wegman's dogs tell us about

being human?" *The Sydney Morning Herald*, December 7, 2018. https://www.smh.com.au/entertainment/art-and-design/what-can-william-wegmans-dogs-tell-us-about-being-human-20181130-h18kwp.html.

O'Mahoney, John B. "Mount Vernon Project to Cover Railroad Cut." *The New York Times*, October 2, 1983. https://www.nytimes.com/1983/10/02/nyregion/mount-vernon-project-to-cover-railroad-cut.html.

Pagel, David. "Jeffrey Gibson: American. Native American. Gay. An artist's life outside labels." *Los Angeles Times,* October 7, 2017. https://www.latimes.com/entertainment/arts/la-ca-cm-jeffrey-gibson-20171007-htmlstory.html.

Pantuso, Phillip. "Crossing Brooklyn: Lisa Sigal." *Brooklyn*, November 5, 2014. https://www.bkmag.com/2014/11/05/crossing-brooklyn-lisa-sigal/.

Rass, Heike. "Quietly Soulful to Exuberantly Passionate: Moe Brooker." *CAN Journal,* March 2022. http://canjournal.org/2022/03/quietly-soulful-to-exuberantly-passionate-moe-brooker/.

"Red Owl Legend." *William G. Pomeroy Foundation.* https://www.wgpfoundation.org/historic-markers/red-owl-legend/.

"Rico Gatson: Icons 2007–2017." *The Studio Museum.* https://studiomuseum.org/exhibition/rico-gatson-icons-2007–2017.

Roniger, Taney. "Convenient Gratification." *The Brooklyn Rail,* July, 2014. https://brooklynrail.org/2014/07/artseen/derek-lerner-convenient-gratification.

Ruppenstein, Andrew. "Red Owl Legend." *The Historical Marker Database,* December 10, 2019. https://www.hmdb.org/m.asp?m=143385.

Schmelzer, Erika June. "The American Encaustic Tiling Company (1875–1937) and 'Art Tiles' in the West Franklin Street Historic District, Richmond, Virginia," VCU Scholars Compass, 2003. https://core.ac.uk/download/pdf/51295835.pdf.

Sheets, Hilarie M. "James Little, Unapologetic Abstractionist Painter, Catches the Limelight." Section F, *The New York Times*, October 23, 2022.

Shin, Yoon. "Artists Reimagine Watertowers As Urban Light Catchers." *The Architect's Newspaper,* June 4, 2012. https://www.archpaper.com/2012/06/watertower-as-light-catcher/.

Sims, Chantel. "A Deeper Dive Into the Bronx River." *Fordham Observer*, April 28, 2022. https://fordhamobserver.com/69209/recent/news/a-deeper-dive-into-the-bronx-river/.

Sorkin, Jenni. "Yayoi Kusama's Ornamental Urgency." *Yayoi Kusama: Festival of Life*. New York: David Zwirner Books, 2018.

Smith, Roberta. "The Audience as Art Movement." Section C, *The New York Times*, December 7, 2012.

Ohio State University. "Art Professor Creates Installation for NYC Subway Station Destroyed During 9/11." *College of Arts and Sciences,* September 11, 2018. https://artsandsciences.osu.edu/news/art-professor-creates-installation-nyc-subway-station-destroyed-during-911#:~:text=September%2011%2C%202018-,Art%20professor%20creates%20installation%20for%20NYC%20subway%20station%20destroyed%20during,subway%20station%2C%20which%20reopened%20Sept.

Spayde, Jon. "Words to Reunite Us: *CHORUS* by Ann Hamilton." *Public Art Review*, no. 58 (2019).

Spruill, Larry H. *Mount Vernon*. Arcadia Publishing, 2009.

"Stories cut from paper." *TED*, uploaded by Béatrice Coron, March 2011, https://www.ted.com/talks/beatrice_coron_stories_cut_from_paper/transcript?language=en.

Tatehata, Akira, Laura Hoptman, Udo Kultermann, and Catherine Taft. *Yayoi Kusama*. New York: Phaidon, 2017.

Tauranac, John. "Art and the I.R.T. : The First Subway Art." *Historic Preservation* XXV no. 4 (October-December, 1973).

"The Ornamentation of the New Subway Stations in New York." *House and Garden* V no. 2 (February 1904).

José de Goya y Lucientes, Francisco. *The Sleep of Reason Produces Monsters (El sueño de la razon produce monstruos)*. 1797–1798, Philadelphia Museum of Art, Philadelphia, PA, United States.

Velie, Elaine. "The Incredible Synergy of Toni Morrison and Alison Saar." *HYPERALLERGIC*, April 13, 2013. https://hyperallergic.com/812895/the-incredible-synergy-of-toni-morrison-and-alison-saar/.

Vickers, Squire J. "Architectural Treatment of the Stations on the Dual System of Rapid Transit in New York City." *Architectural Record* 45, no. 1 (January 1919).

Vincler, John. "Nick Cave Goes Underground." Section C, *The New York Times*, May 16, 2022.

Wang, Jenna. "New York City Subway Station Destroyed on 9/11 Finally Reopens." *Forbes,* September 11, 2018.

Whitman, Walt. *Leaves of Grass*. 1856. Facsimile edition, Ann Arbor: Microfilm International, 1980.

Wullschläger, Jackie. "Derek Fordjour on painting the African-American experience." *Financial Times*, October 20, 2020. https://www.ft.com/content/fca5cf82-c83d-4bdc-9ef1-3aa067b86b2d.

"Xenobia Bailey, African-Hat Designer." Style Section, *The New York Times*, August 19, 1990.

Young, Pauline. "Funk and the Spirit." *American Craft Council*, May 19, 2021. https://www.craftcouncil.org/magazine/article/funk-and-spirit.

Zornosa, Laura. "Nick Cave Digs Deep, With a Symphony in Glass." Section C, *The New York Times*, September 7, 2021.

Acknowledgments

Since joining MTA Arts & Design in 1988, I have been indebted to many people instrumental in building this massive public collection of art. *Along the Way* and *New York's Underground Art Museum,* two earlier books co-coauthored with Bill Ayres, cover the program's first quarter-century. *Contemporary Art Underground* picks up where the last left off and offers a rare view of the creation and technical aspects of fabrication. This approach was accomplished with co-author and Arts & Design Deputy Director Cheryl Hageman, whose deep respect for the collection and the people who made the works is evident throughout these stories. *Contemporary Art Underground* would not have been possible without the tremendous efforts and skills of Arts & Design Assistant Managers Maggie Murtha and Hannah Rothbard, who were crucial to the creation of the book.

The output reflected in this book is the work of many extraordinary individuals. Of course, the hundred-plus artists and their fabricators are at the heart of that statement, but these projects would not have happened without Arts & Design staff, past and present. Many of these projects were managed by Arts & Design Deputy Director Yaling Chen, Senior Manager Lydia Bradshaw, and Manager Bridget Donlon. Manager Alejandra Hernandez and Assistant Manager Rob Wilson were critical to ongoing collection care. We were fortunate to add two new members to our team in 2023; Managers Andrew Gardner and Heather Reyes-Duke will be an important part of our future. Former staff managed and supported a number of these outstanding works, in particular former Deputy Directors Lester Burg and Amy Hausmann. Former Managers Alli Arnold, Tara Foster, Katherine Meehan, and Javier Plasencia, and former Assistant Managers Victoria Statsensko and Tamar Steinberger all helped guide these works to fruition. As well our gratitude is extended to the dozens of selection committee members who participated in our process, with special thanks to Kendal Henry and Jodi Moise, former staff whose current roles re-engaged them in this practice.

If the artworks reflected in the book were all we had accomplished in the last decade, I would be proud. But the reality is that the book's focus on only our latest permanent commissions overlooks a huge amount of the department's work during this period. Highlights from the long list of temporary art and special events include a thriving Digital Arts program, frequent commissions of illustrators and photographers for our Poster program and Photography lightbox locations, perennial favorite Poetry in Motion produced with Poetry Society of America, the post-pandemic comeback of Music Under New York, and special projects including the exceptionally meaningful TRAVELS FAR: a memorial honoring our MTA colleagues lost to COVID-19. These works are frequently featured on our social media platforms, our newly redesigned website, and most recently made accessible via an app-based guide available through Bloomberg Connects.

We owe a debt of gratitude to Elizabeth White of Monacelli, for her enthusiastic embrace of the public art collection and willingness to share these stories of the artwork in subway and rail stations we affectionately call an "Underground Art Museum." Her guidance and editorial sensibilities, paired with the design skills of Shawn Hazen, brought a fresh and dynamic quality to this book.

We thank the friends and family who have encouraged us from the beginning, and particularly those whose patience and enthusiasm sustained us throughout this project. Invaluable insights were provided by Linda Tonn who is a key partner in the program, along with Aaron Donovan, Connie Depalma, Eve Michel, and Peter Cafiero, who shared institutional and historical knowledge. I particularly want to thank Nancy Blum, for insisting that there be a third book, and the three people who have provided me with constant support and an endless supply of humor: Michele Butchko, John O'Grady, and my best friend, Fred May.

Sandra Bloodworth
Director
MTA Arts & Design

Recognitions

Former New York City Deputy Mayor and MTA Board Member Ronay Menschel's conviction that art would enliven stations and transform the MTA system gave birth to the Arts & Design program in 1985, established as Arts for Transit, with Wendy Feuer as director. It has been almost forty years and over four hundred commissions since she made the case that a relatively small number of dollars spent on an art program would have an enormous impact. Today it is impossible to imagine New York's transit system without the diverse collection of world-class public artwork that riders have come to expect.

It is no easy feat to commission art in this environment. To do so requires the support and cooperation of many. MTA leadership, including its Board of Directors, embraces the mission to include art in the transportation environment as MTA Chair and CEO Janno Lieber, has articulated in his Preface to this book. Many others also deserve a huge round of applause for their commitment to including art in the lives of MTA customers: Chief of External Relations John McCarthy, who oversees Arts & Design, and Deputy Chief Juliette Michaelson; Communications Director Tim Minton, First Deputy Renee Price, and the tremendous media staff; Deputy Chief of Government & Community Relations Will Schwartz, Director of Public Affairs Joe O'Donnell, and the outstanding Office of State and Local Affairs team; Chief Safety and Security Officer Patrick Warren, and Vice President Carl Hamann; MTA Senior Advisor for Communications and Policy and Acting Chief Customer Officer Shanifah Rieara, and Senior Director of Marketing Production Eugene Ribeiro, and the incredible team of talented marketing and creatives.

Our success is possible thanks to the leadership of MTA constituent agencies, in particular: **MTA Construction & Development** President and Chief Development Officer Jamie Torres-Springer, Deputy Chief Development Officer of Delivery Mark Roche, and Stations and Railroads Business Unit Leaders William Montanile and Anthony Tufano, with Vice President Deputy Program Executives Linda Tonn and Anthony Febrizio; **New York City Transit** President Richard Davey; Senior Vice President of Subways Demetrius Crichlow, and our many supporters within the Department of Subways; **Metro-North Railroad** President Cathy Rinaldi, and Chief of Executive Office Operations Anthony Greco; **Long Island Rail Road** leadership including Cathy Rinaldi who served as interim President during the opening of Grand Central Madison, and Senior Director of External Affairs Hector Garcia; **Bridges & Tunnels** President Cathy Sheridan.

Arts & Design relies on so many in the MTA family to realize and maintain our permanent works. Communications, Facilities Maintenance, Government & Community Relations, Legal, Marketing, Procurement, Safety and Security, and Stations, among others, regularly troubleshoot with us from the earliest stages through the ongoing care. Architects and engineers, in-house and consulting, have been our partners in supporting these installations since the 1980s, in particular Peter Hopkinson (Chief Architect for Grand Central Madison during five years of critical design), who could not have envisioned a more perfect canvas for those projects. Director Concetta Bencivenga and our colleagues and collaborators at the New York Transit Museum lend their support daily by promoting Arts & Design-related items and publications, online and in Transit Museum stores, as well as highlighting our collection in their programing.

Our gratitude goes out to everyone who believes in this program, and all who have helped it along the way!

This book is dedicated to the artists and fabricators whose skill and creativity has transformed the MTA system and to the Arts & Design staff that has shepherded this collection into creation.

Copyright © 2024 The Metropolitan Transportation Authority (MTA) and
The Monacelli Press

First published in the United States by The Monacelli Press. All rights reserved.

Library of Congress Control Number: 2023951518
ISBN: 9781580936422

Design: Shawn Hazen

Printed in China

MTA Arts & Design
www.mta.info/art
@MTAArtsDesign
#mtaarts

Monacelli
A Phaidon Company
111 Broadway
New York, New York 10006
www.phaidon.com/monacelli
@monacellipress